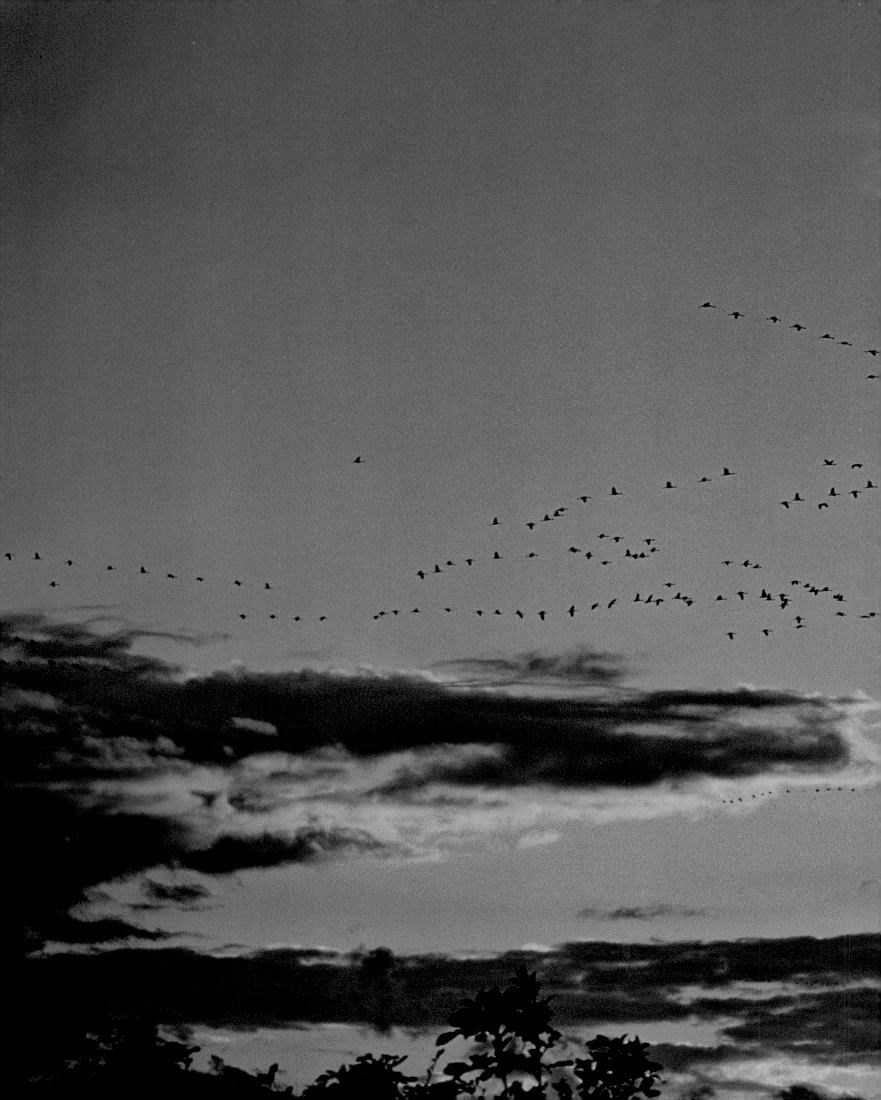

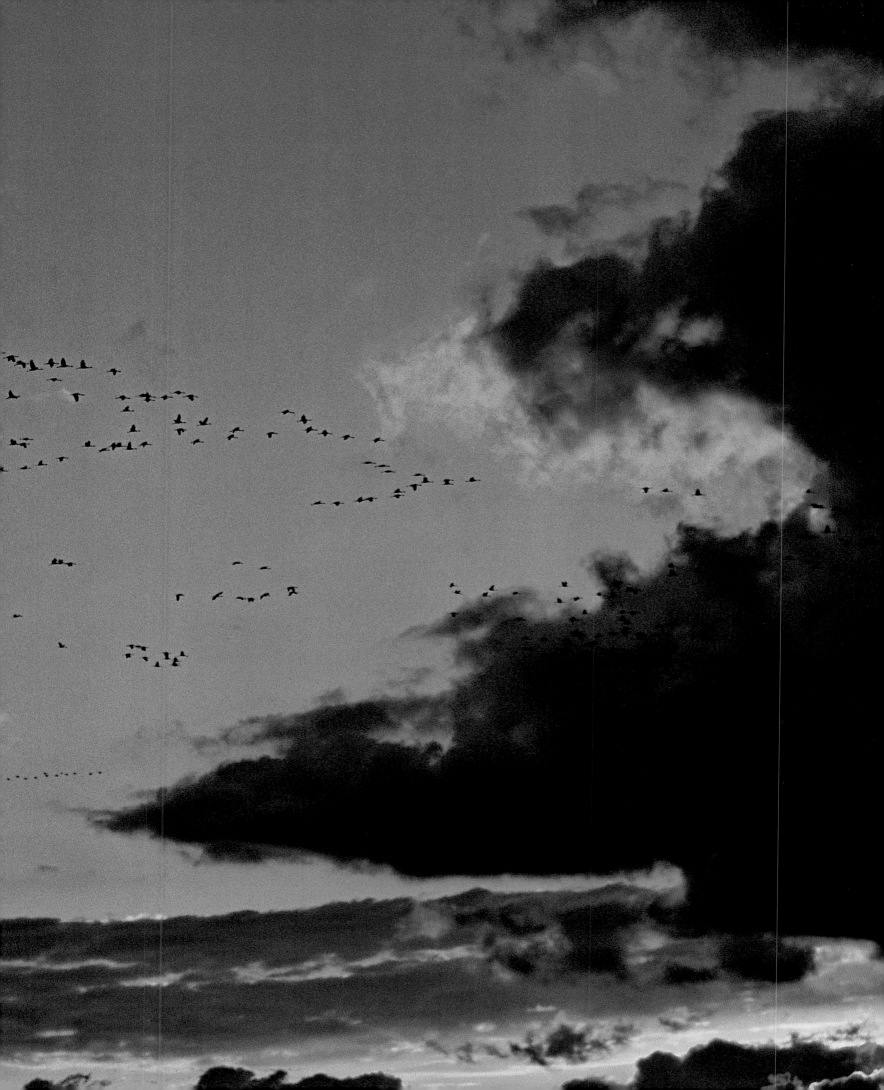

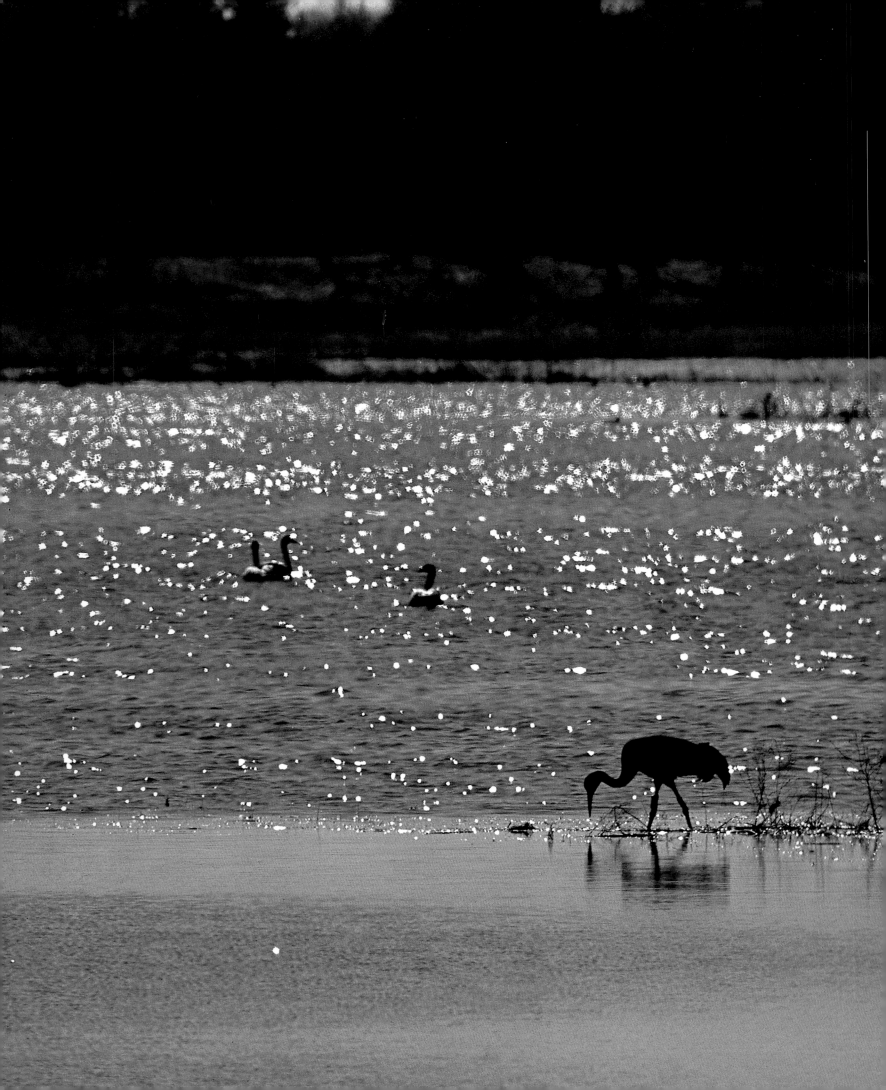

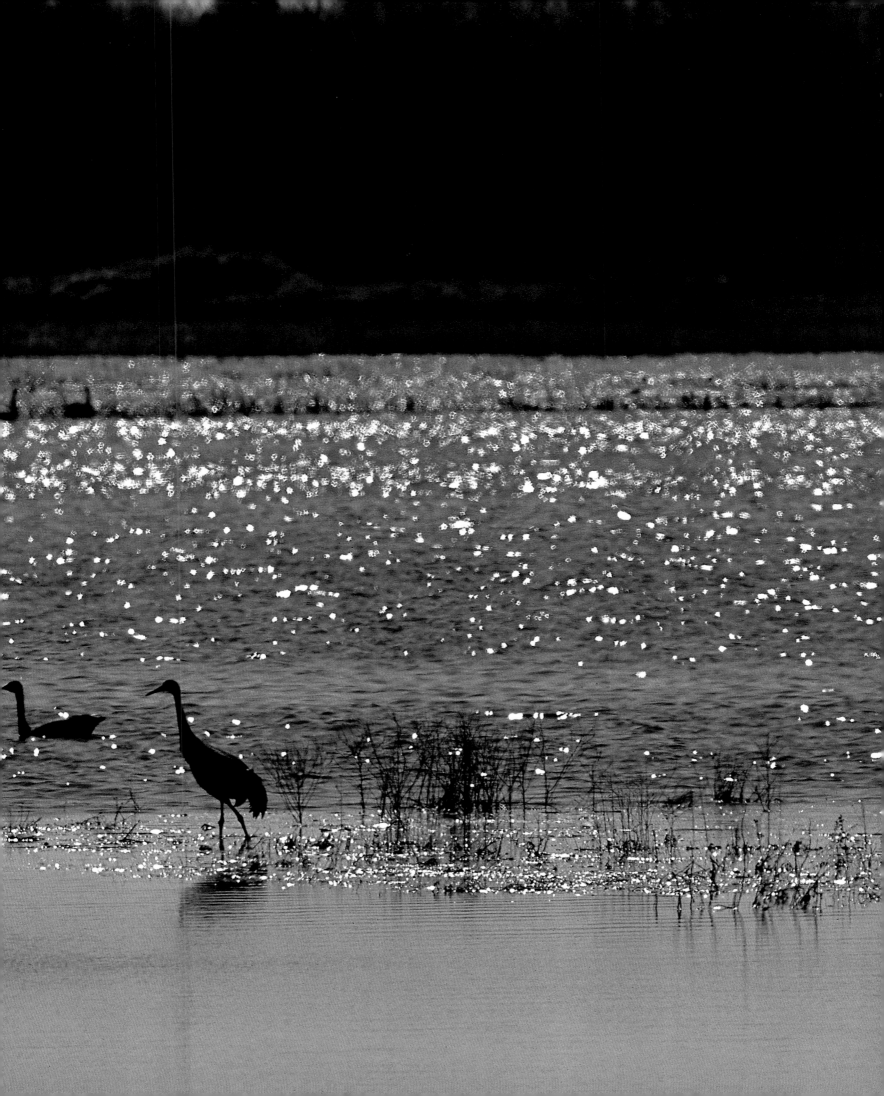

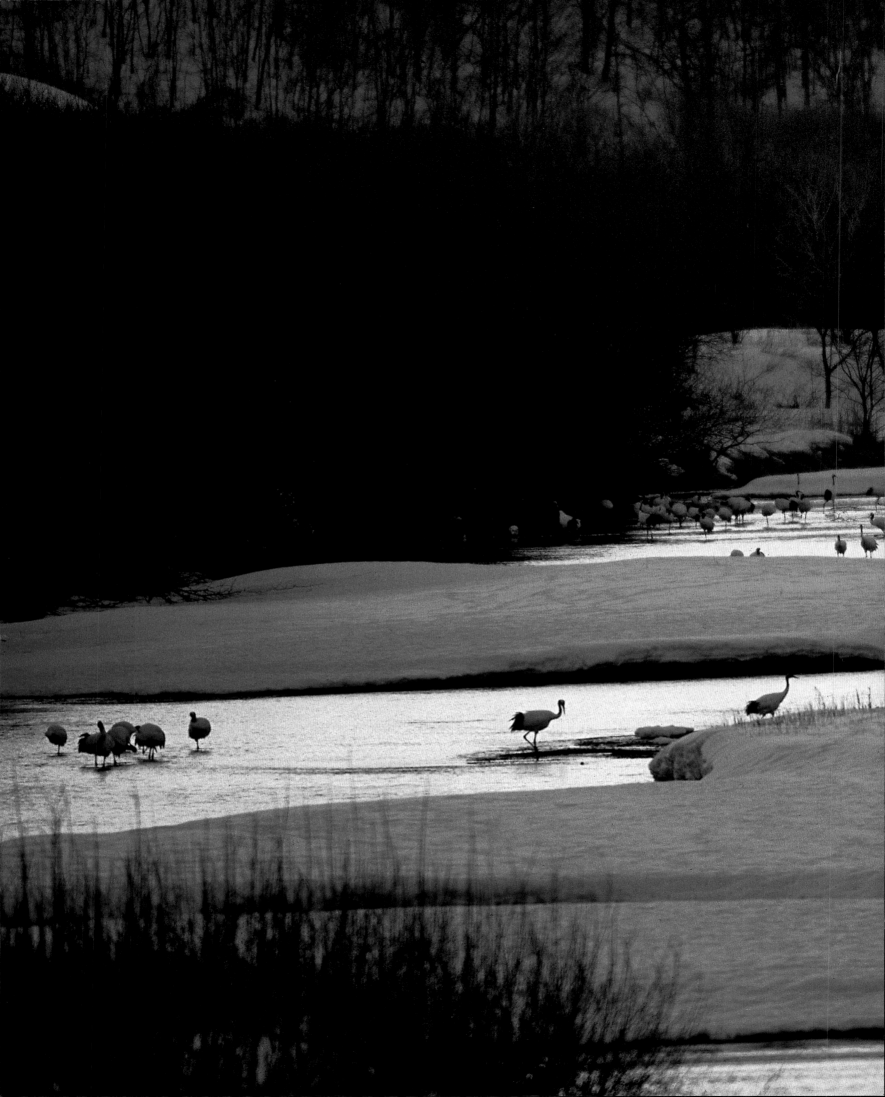

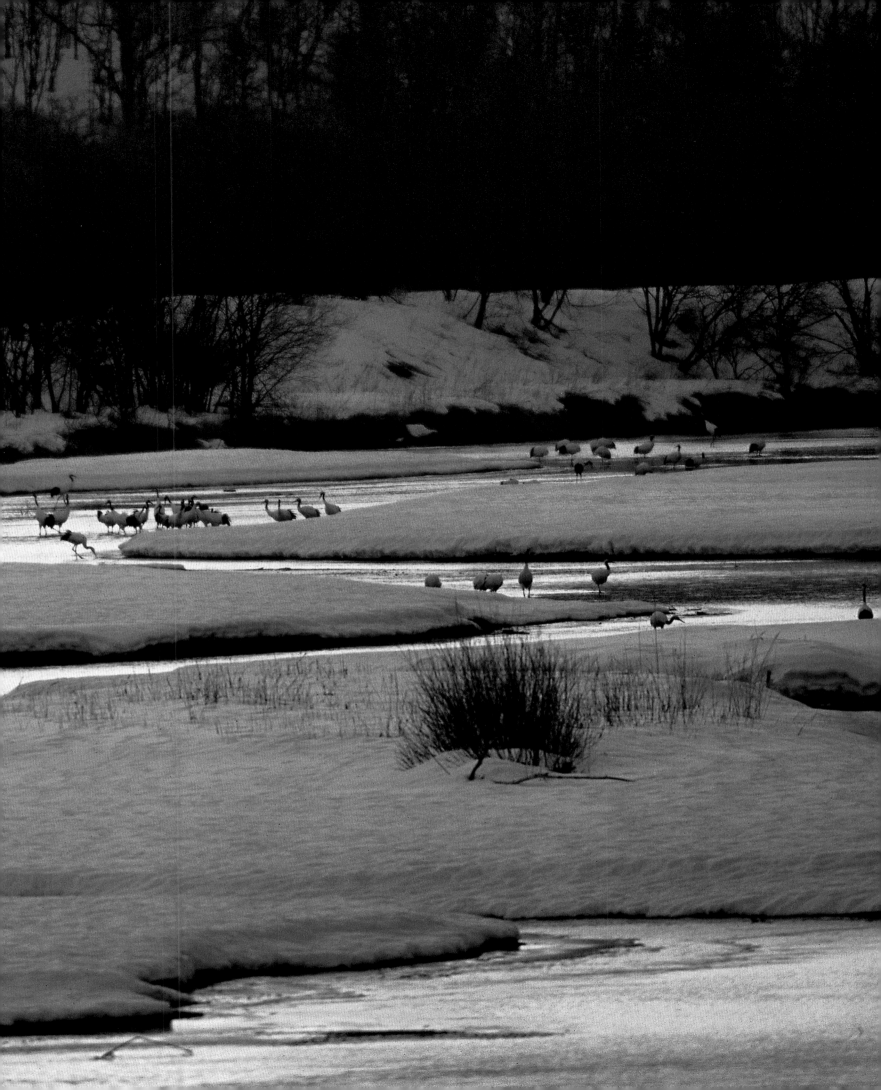

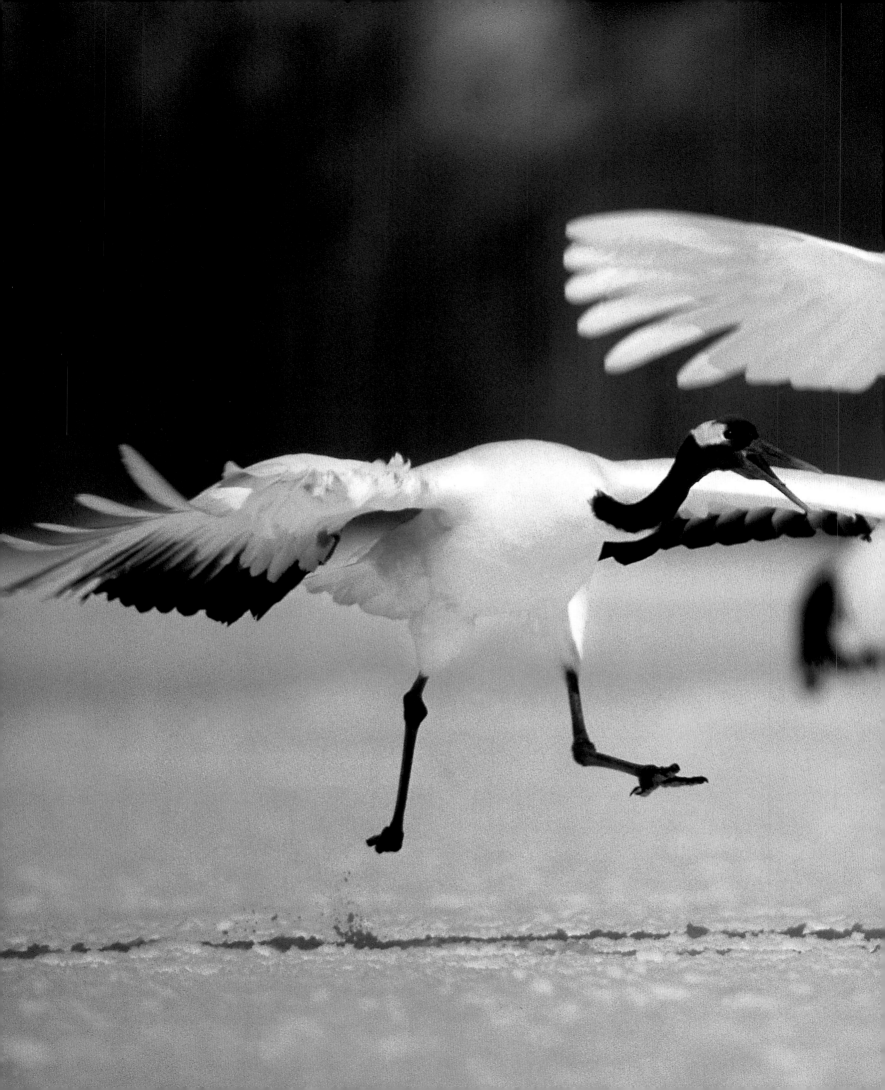

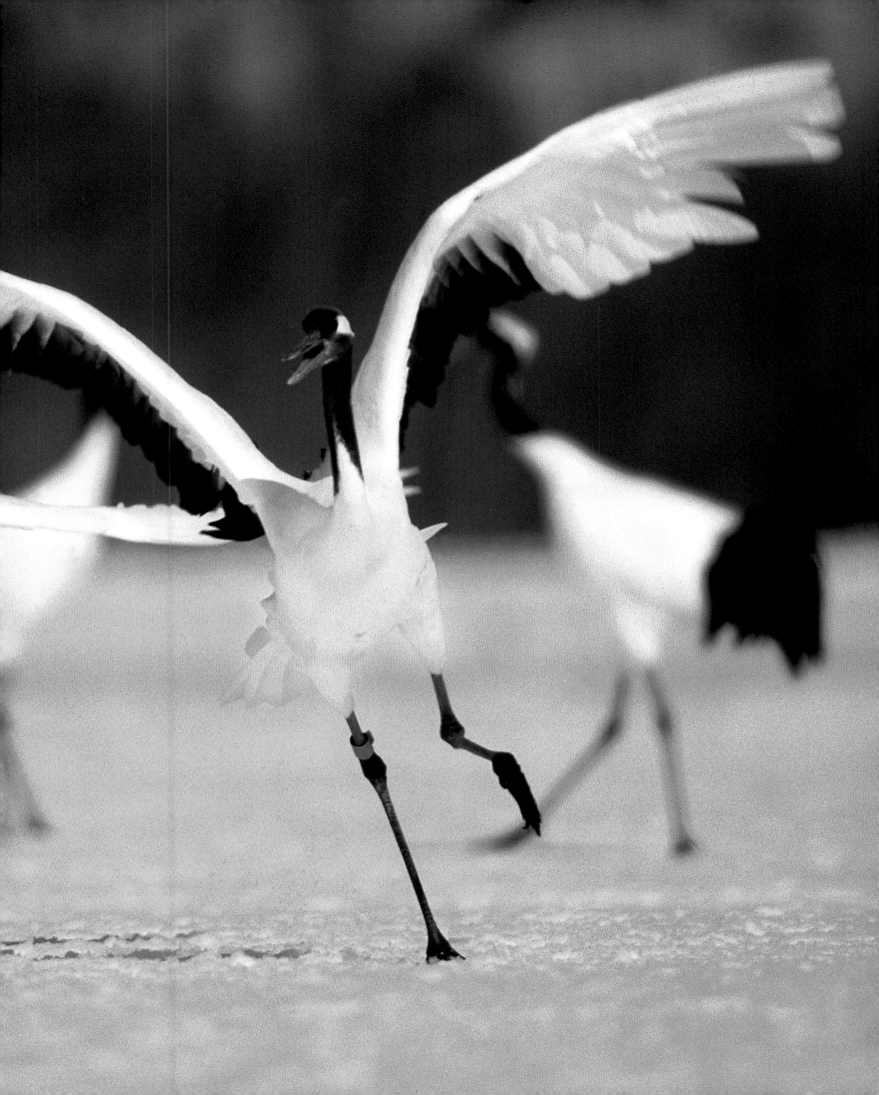

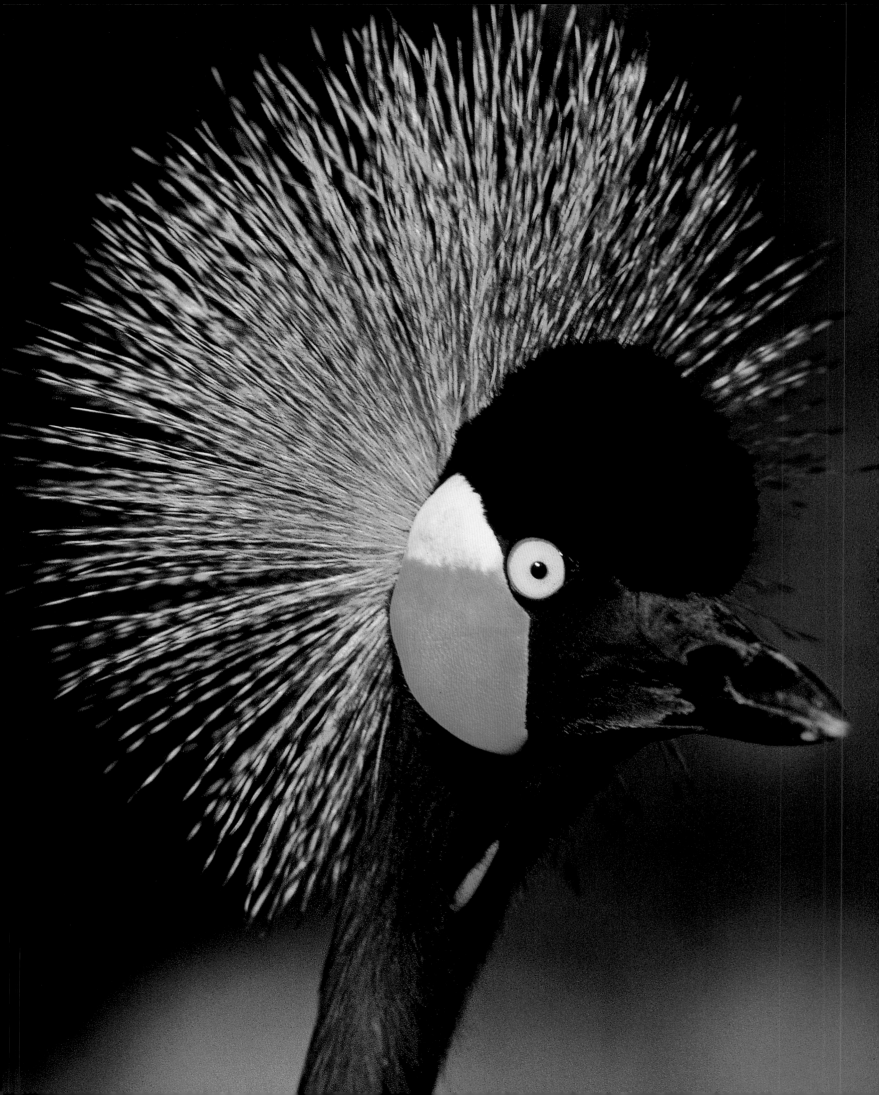

Carl-Albrecht von Treuenfels

THE MAGIC OF CRANES

Translated from
the German by
Matthew D. Gaskins
and Ben Posener

Abrams, New York

The cranes they fly in sharp formation
Across the grey autumnal sky
This fragile line, this navigation
Their voices, coarse, we hear on high.

Southwest they soar, their long parade
To unknown lands where they will stay.
They fly persistent, unafraid
With stars at night to show the way.

The firmament with voices rings;
They tell of ease and tell of pain.
It is as if their souls could sing
Quite happy, then quite sad again.

The large birds know how far along
And where their trip will take them,
But I must wait and miss their song
Until next spring awakens.

When in the winter for them I yearn
My heart so often hopes they will
Be longing, as I am, to return
Back home, this valley, so tranquil still.

And then one day I hear their call,
A duet crossing from the moor
An end to icy winter's pall.
Their calls of love unlock spring's door.

Luck, one says, is what their art is,
As heralds of fate on heavenly wing.
Are they the souls of our departed?
Then let them live, for joy they bring!

Contents

Introduction

For decades now, my sense of the seasons, my appointments book, vacation and travelling schedules, work habits, and visits to, or by, friends have all been determined to a considerable extent by cranes. It all began—albeit on a small scale—during my schooldays in the Duchy of Lauenburg District (Kreis Herzogtum Lauenburg), in the German state of Schleswig-Holstein.

It was there, near my rural home, a forty minute bike ride away from the Lauenburg Latin School in Ratzeburg, that a few Eurasian Cranes (Grus grus) had built their nests. In the 1950s they belonged to a group of only about twenty to thirty breeding pairs of this species that were left in western Germany. Their departure in autumn and their subsequent return from their winter quarters, in what seemed to me at the time to be mystical and far distant locations 'somewhere in Africa', moved me as much as their clearly audible—yet, at the time, rarely observable—courtship rituals in the springtime.

Each year, when long lines and V-formations of these large birds would pass over our farm in March and April, I was always overcome by a strange longing for the distant, deserted marshes and forests of Scandinavia and Eastern Europe. And in the autumn, I would accompany them in my thoughts on their passage 'to the tropics'. Only later did I learn that these imaginings were wrong. And yet, a fair amount of the mystery and magic that surrounded these creatures when I was a child still mesmerises me today. Although I have, for forty-five years now, followed the fifteen species of cranes to the remotest corners of the planet and witnessed field work conducted with cutting-edge technology, these elegant birds still enchant me just as much as when I was a young boy.

I am not the only one to have succumbed to their spell. All over the world, there are growing numbers of crane enthusiasts or self-proclaimed crane fanatics—'craniacs', as they are known internationally. Most of them work together in environmental protection groups or share their observations, experiences, and knowledge within crane societies. I know many of these people personally, and with quite a few of them I have friendships that extend beyond a fascination for cranes. Others have had the same experience: their interest in cranes and commitment to the birds' well-being and survival have connected them to people all over the world—across cultural, social, political, and linguistic divides. This mutual understanding—of the birds and of each other—generates a special energy and feeling of solidarity within the 'crane community' for which I owe the cranes my gratitude.

Indeed, the cohesive force behind this network— with people contacting one another and starting new initiatives on an almost daily basis—is our shared concern for the fate of these 'birds of happiness'. The internet has empowered this unique global community dedicated to the study of cranes. Data and news concerning the appearance and disappearance of particular flocks during the migratory season are exchanged; colour combinations of leg rings and coordinates beamed from transmitters on the backs of individual cranes are noted and passed on; the number of cranes resting in staging areas, as well as in their winter habitats, is disseminated, news of the first arrivals on the breeding grounds reported; continuous monitoring of complex reintroduction programmes takes place; news about poisoned cranes or of wetlands saved from destruction is passed on. At the same time, initiatives for the protection of cranes are launched and experiences exchanged concerning how to handle complaints by farmers whose crops have been damaged.

When the Blue Crane preens its feathers, there is not much evidence of the bird's usual, elegant demeanour (Steenkampsberg, Mpumalanga, South Africa).

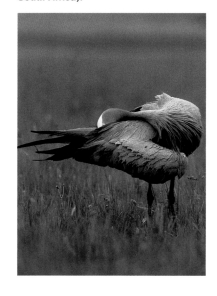

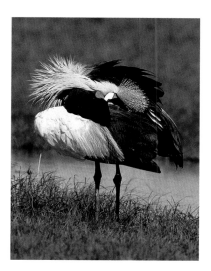

Whilst preening itself, the Grey Crowned Crane becomes a colourful ball of feathers (Serengeti National Park, Tanzania).

The more comprehensive and effective this information network gets, the clearer it becomes how the well-being and fate of these birds are linked to the human condition. This realisation may be related to the fact that cranes are 'birds the size of humans', as the Sami of northern Scandinavia put it. But it almost certainly stems, as well, from the cranes' dependence on intact wetlands—which humans also need as water reservoirs. These large birds have therefore become flagship species for comprehensive preservation efforts concerning natural resources upon which humans, animals, and plants depend. During the past fifty years, many cranes have been forced, at least during certain seasons, to change from being creatures wary of civilisation to animals dependant on farmers' crops and food from humans. As a result, cranes have, in many places, become more accessible to people. Above all, the increasing numbers within certain crane species have led to the reappearance of these birds in locations where, for many years, they had been absent. During their seasonal migratory flights, the cranes pass over an increasing number of areas and cities where their V-shaped flocks had long since disappeared and their trumpet calls been silent. It is, however, only a minority of the fifteen species of cranes that thus draws attention to the family of cranes as a whole. Eleven species are considered endangered or even threatened with extinction, a situation that requires a different kind of attention from humans—one that is not always immediately apparent to the public at large, but is often all the more passionate.

This second, comprehensive book on cranes—for which I was again given generous support by Lufthansa, who for decades have been a reliable partner in matters of national and international crane conservation—is dedicated to the protection of these wonderful creatures and to all those who have devoted themselves to this task. The photographs contained in this volume have a special significance. They are meant to convey the magic that enchants so many people across the globe. I have taken most of the photos displayed here during the past seven years, either in Germany or on my travels to more than ten countries. Of the photographs taken before this time and in different countries, I chose, with the exception of two, only those that have not been published before.

During the eight years since the publication of the second edition of *Kraniche – Vögel des Glücks* (Cranes – Birds of Happiness), now long since out of print, further answers to questions posed back then have emerged and are discussed here. Nevertheless, these global flyers and elusive breeders are still good for a riddle or two. And so it should be. Not only because it gives future generations of crane enthusiasts fodder for exploration and riddles to solve—hopefully done with the necessary care and respect, but also because it lends these longlegged messengers of the heavens an aura of mystery and other-worldliness that draws scores of observers to the cranes' staging grounds in spring and autumn and has thousands of people transfixed as they gaze skyward to spot the birds' V-shaped flocks and listen for their calls in the night. Cranes are ambassadors of nature, whose majestic appearance and distinctive calls encourage us to see that there are other unique beings in this world—beings that also have a right to exist.

Carl-Albrecht von Treuenfels

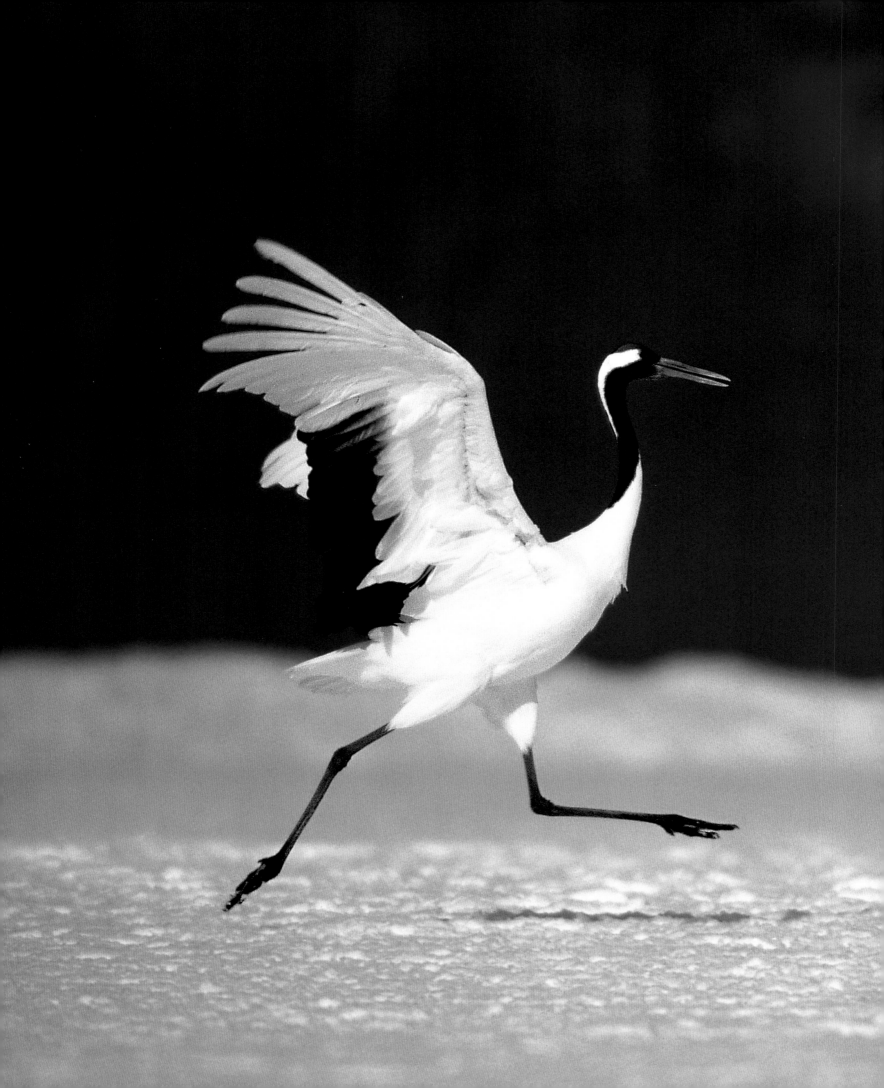

Beauty and Elegance
on Long Legs

Cranes are not just impressive because of their size; they are extraordinary creatures in general. Humans have known this for thousands of years and have expressed their admiration in a variety of ways. Many ancient paintings, buildings, and vessels bear witness to the long-standing ties between humans and cranes, showing the almost God-like veneration in which these animals have been held, the supernatural qualities attributed to them, and even, in a more practical sense, their usefulness as guards or as a source of nutrition. Since the earliest times and in many cultures, cranes have not only served as pets or status symbols, but have also enriched people's lives in artistic representations, symbolising a myriad of virtues. Already in pre-Christian times, these elegant birds appeared on coats of arms or served as highly revered companions in this life or the hereafter. The Chinese, Japanese, Egyptians, Greeks, and Romans regarded them as symbols of fate and heavenly messengers. (More on this topic in the chapter 'Unique Among Birds as Icons of Art and Culture'.)

This special relationship between humans and cranes has continued to the present day. Regarded from an ecological point of view, these large birds can be described as an indicator species: because they thrive on wetlands and, depending on the season, live in different regions and even varying climatic zones, the appearance—or disappearance—of cranes in a particular area is a clear indication of that area's condition. In this way, these birds have become flagship species for entire communities of animals and plants. Yet cranes would surely not be regarded today as such superb indicators of ecological health were they not such charismatic creatures. Indeed, their size, beauty, and elegant appearance—as well as their flying formations, piercing calls, and elaborate 'dances'—even impress

people who otherwise have little interest in nature and free-living animals.

Twice yearly, as the cranes migrate steadfastly between their breeding grounds and wintering habitats—passing in their impressive formations and with their loud calls across a host of countries and even continents—many observers get a sense that something primal or even mystical is taking place. More than any other migratory bird or sign of nature, cranes help our souls become attuned to the change of seasons—to the coming and passing of life. Perhaps at the sight and sound of these largest of all birds of flight, people subconsciously realise that these global wanderers were already soaring the planet in the dim and distant past. When cranes appear high above, they somehow, miraculously, touch on the very roots of our existence. The sense of the unknown that surrounds a flock of migrating cranes moves us, awakening an inexplicable longing for limitless range and freedom—a dream of pristine nature free of human interference. We imagine a perfect world, and as flocks of cranes pass by, calling loudly from the sky, many observers feel a shiver run down their spine. And often, whilst standing at an observation post during the crane's migratory season, you can hear people exclaim: 'It's hard to believe that something so wonderful still exists!'

Flying Crosses

And so it is wherever cranes appear, be it at their breeding grounds, staging places, or wintering habitats: people ask one another, 'Are the cranes here already?' or 'Did you hear the cranes last night?' The fact that it is sometimes wild geese the people hear flying over the village is beside the point. Quite often, precisely the opposite mistake is made: the (louder) cranes are taken to be geese. The hoarse,

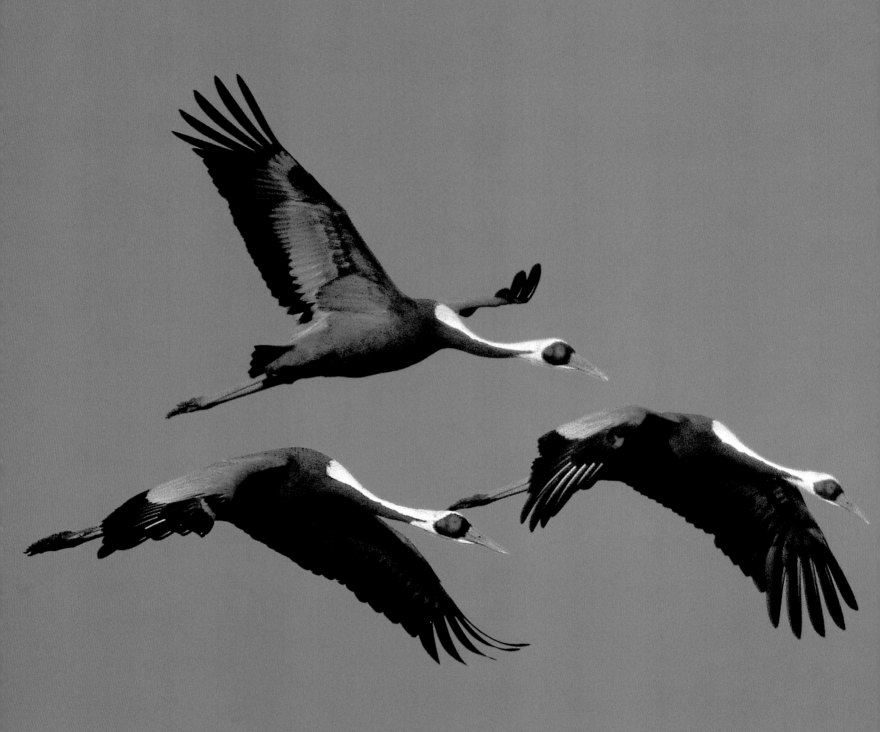

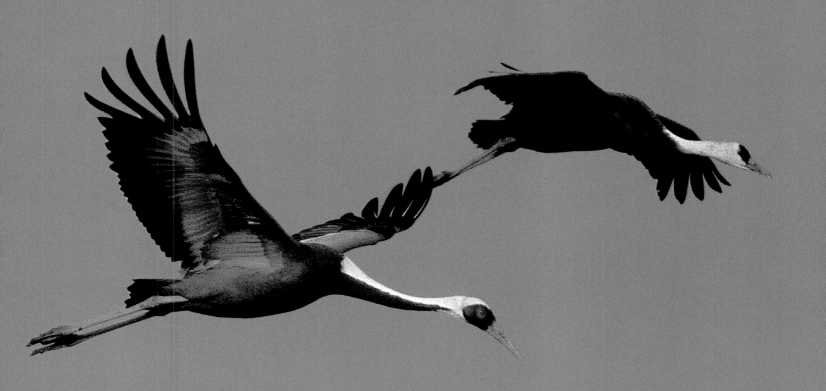

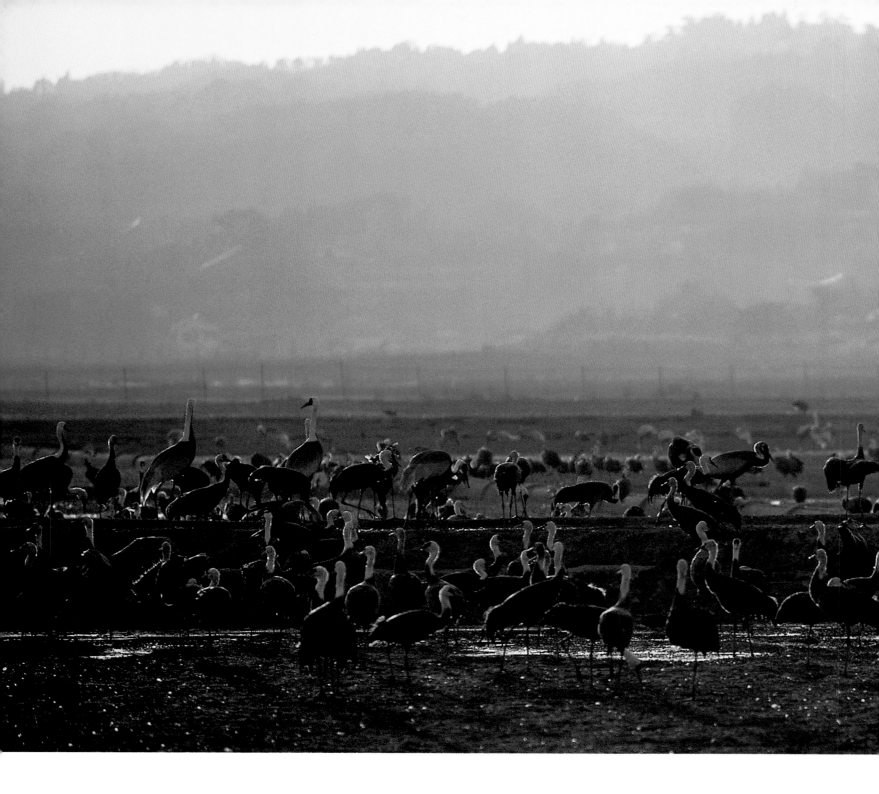

TOP

Evening ambience on winter fields reserved primarily for Hooded and White-naped Cranes from China and Russia (Arasaki, near Izumi on the island of Kyushu, Japan).

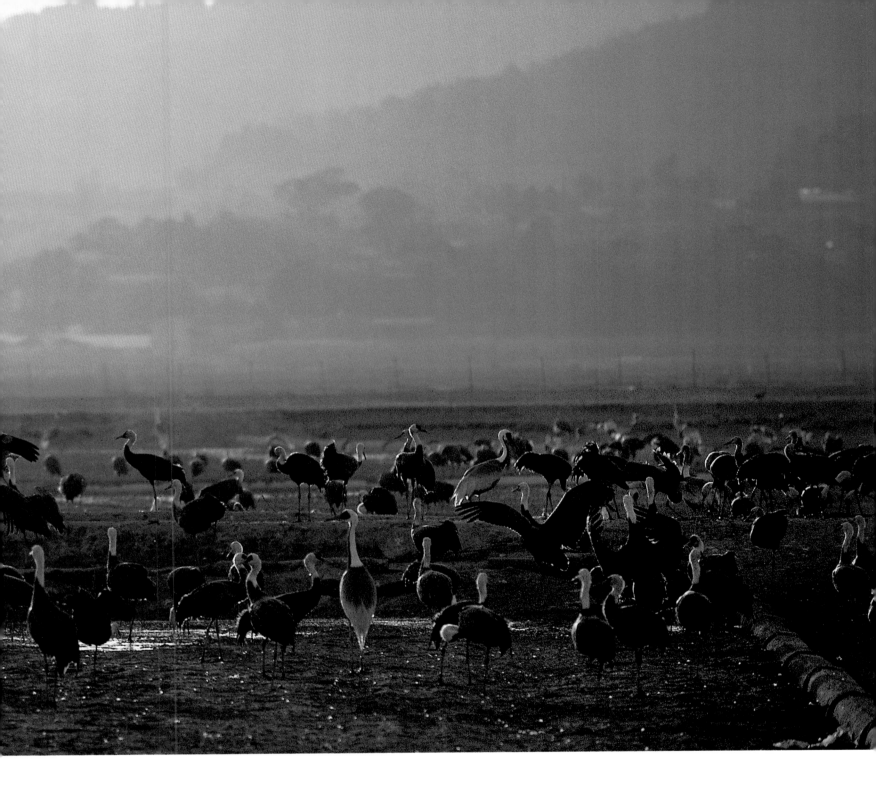

FOLLOWING DOUBLE PAGE
**Mass flight of Hooded Cranes
as the car bringing the sacks of grain
approaches (Arasaki, near Izumi,
Kyushu, Japan).**

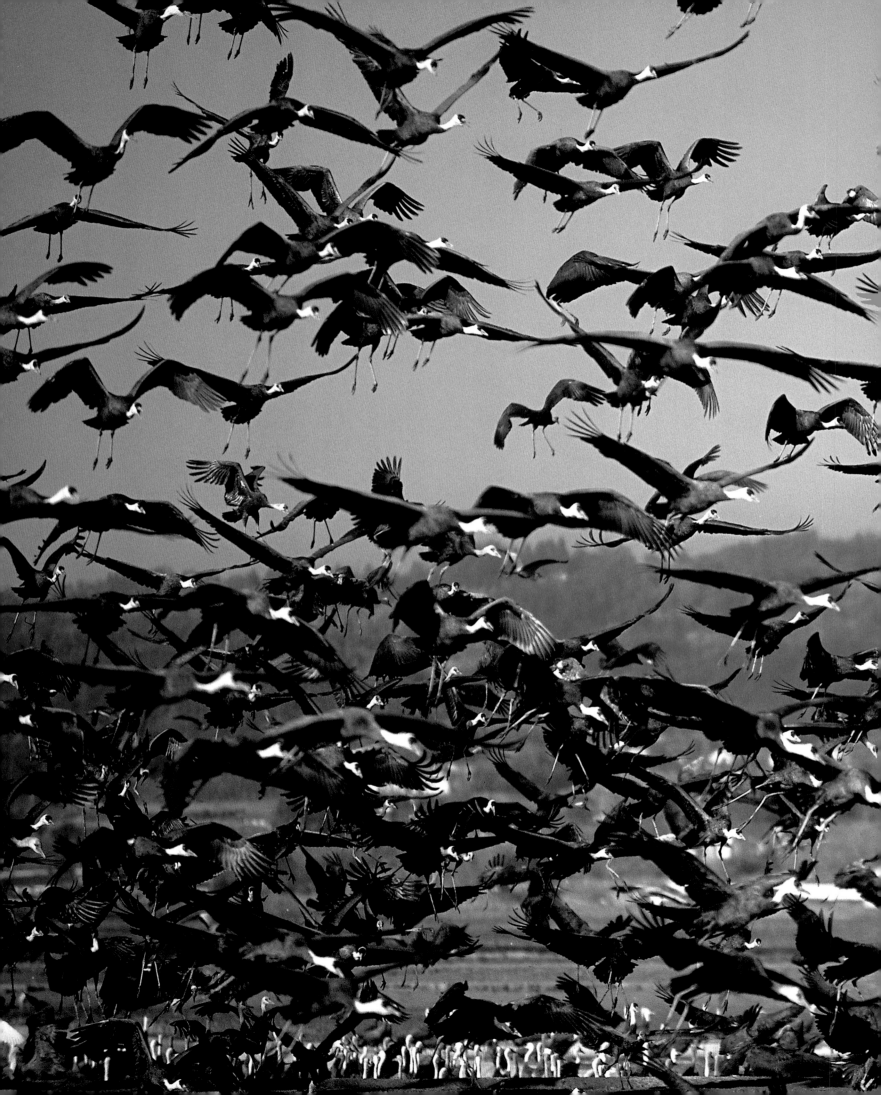

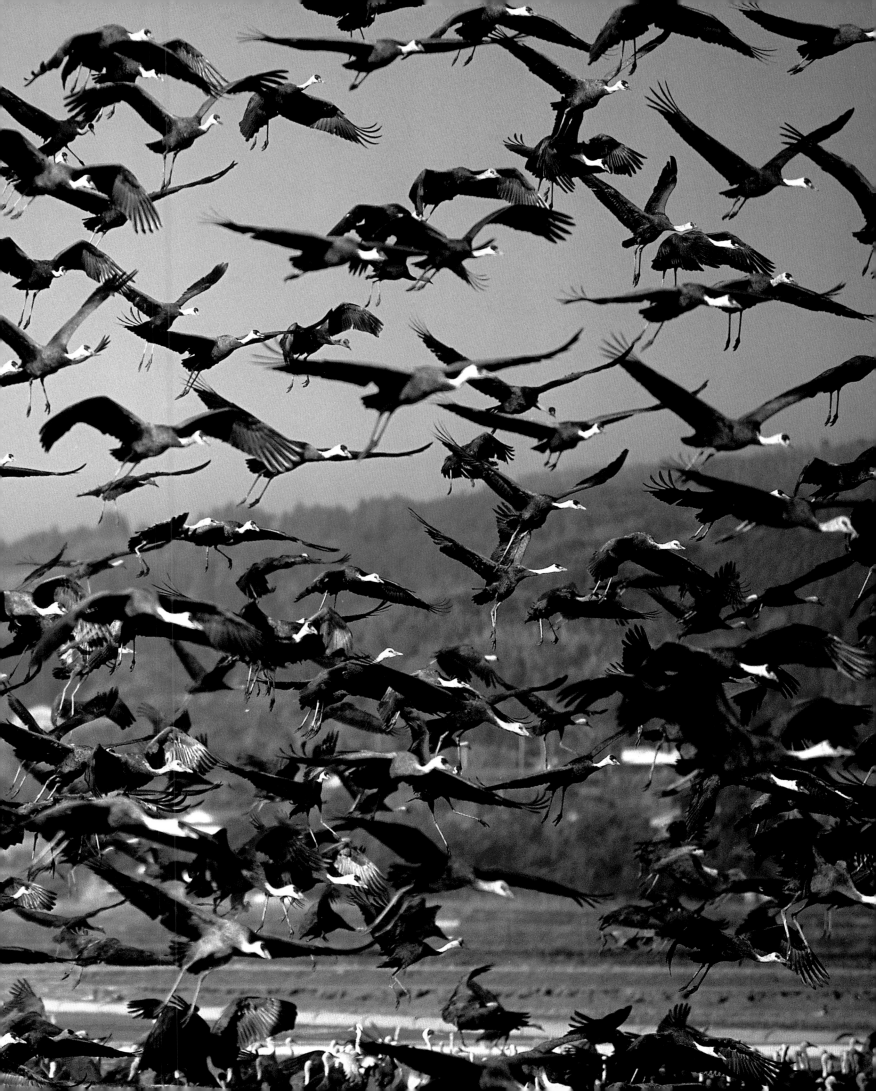

yet magical, calls of migrating geese as they pass overhead are indeed similar to those of cranes. But cranes nevertheless have a grandeur about them that is unique. One simple reason for this is that some species are almost as tall as humans; they stand upright on their long legs, head held high, and they walk and run as we do. And when cranes fly, they do so in a dignified manner, not just flapping their wings about, but sweeping them up and down in a regular, extended motion. Or they spread their wings wide and glide effortlessly through the skies for a time.

But whether the cranes flap their wings or glide on wind currents, their necks are always stretched far forward, while both legs are joined, extended behind them. In this posture, the birds look similar to flying crosses. When they come in to land, cranes demonstrate that they are also masters of other flying techniques. With angled wings and hanging legs, they spiral down from great heights, or plunge down at dizzying speed, waiting until they almost hit the ground or the surface of the water before breaking their descent with mighty wing-strokes. And then their calls! They have a resonance that 'opened a secret compartment in my soul, to which I myself did not possess the key', as the Swedish author Bengt Berg (1885–1967) movingly described in his book *To Africa With the Migratory Birds*. But the calls of the cranes, often almost trumpet-like in their sound, also seem—from a human perspective—to express self-confidence and a desire to be heard from a distance and more loudly than other animals. Until quite recently, however, cranes never needed to make themselves heard against a noisy backdrop; during most of their existence as a species, at least, they have not had to compete with humans and their many sources of artificial noise. However, although humans appeared only quite late in the evolutionary development of cranes, they have had an increasingly negative effect on the

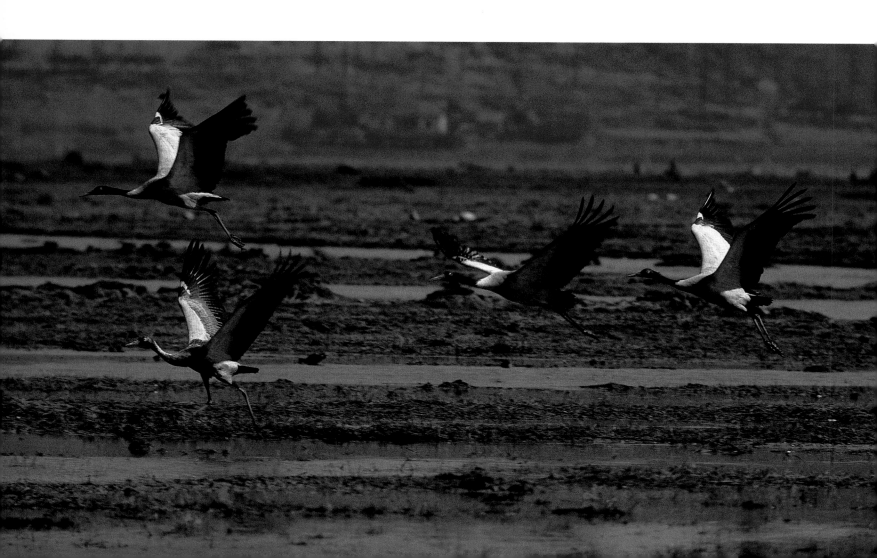

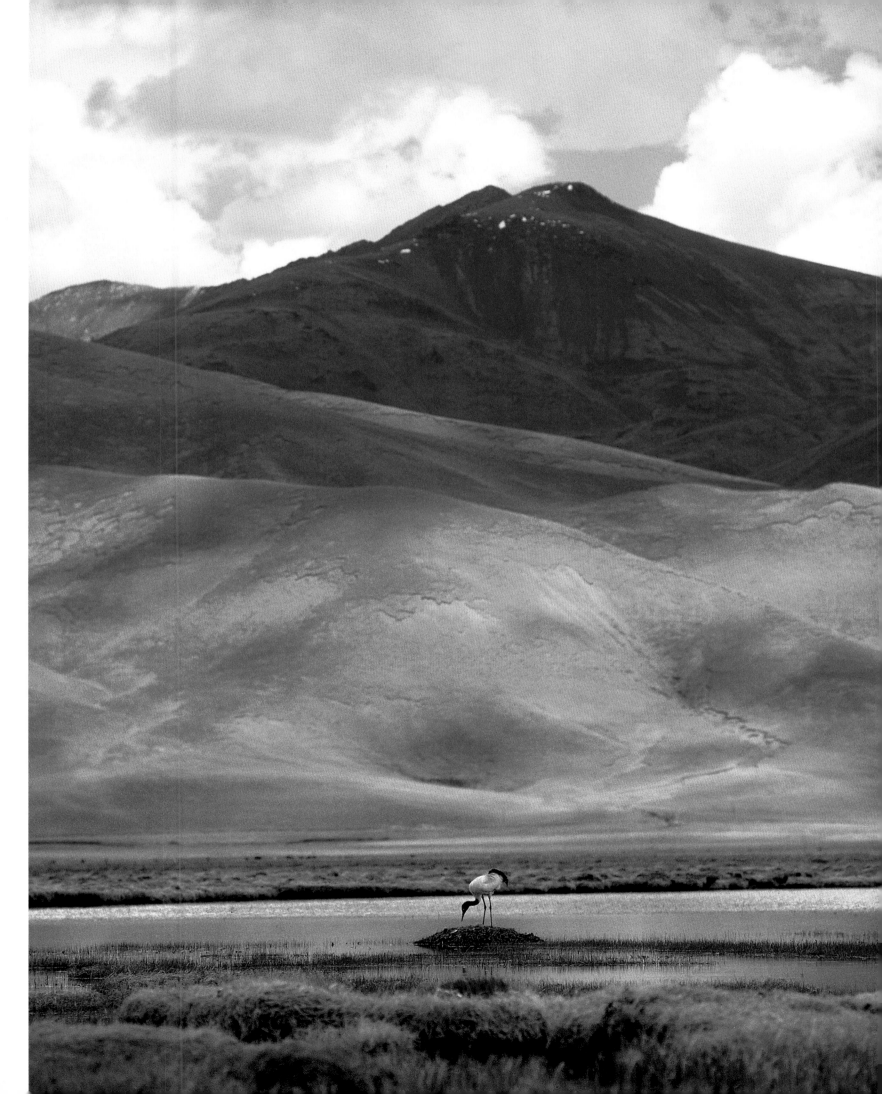

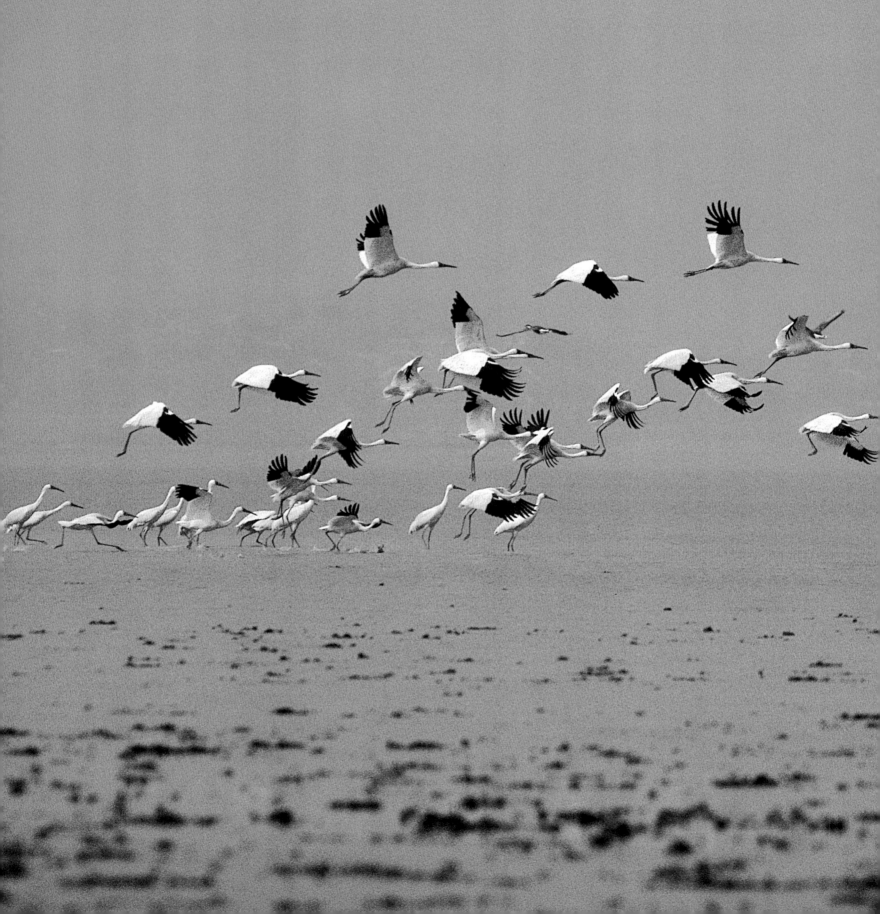

Hundreds of Siberian Cranes congregate in the shallow waters of Poyang, where tubers of the aquatic plant species *Vallisneria spiralis* abound. Ninety-five percent of the world's Siberian Cranes spend the winter here (Poyang Nature Reserve, Jiangxi Province, China).

This pair of Siberian Cranes and their young one were among the last of their kind to winter in northern India before the turn of the millennium. This population, breeding in western Siberia, appears to have gone extinct (Keoladeo Ghana National Park, Rajasthan, India).

fate of these animals, especially in recent times. (This, and the different calls made by cranes, are topics that will be dealt with more thoroughly later on in this volume.)

Sixty million years ago, when neither *Homo sapiens*, nor even his forbears were around to leave their footprints on African soil, there already existed birds that had characteristics found today within the fifteen species of cranes that have been grouped within the *Gruidae* family of birds. A crane bone that scientists discovered in a layer of volcanic ash in the US state of Nebraska has been dated at nine million years; however, despite being from the Miocene period, it would fit almost exactly into the skeleton of a crane living today. Since this long-ago time when the crane shared its habitat with other species that have since ceased to exist (such as relatives of the rhinoceros), the bird's anatomy seems hardly to have changed. And the Sandhill Crane even demonstrates geographical continuity: Nebraska, which is located in the centre of the United States, is still a focal point of pan-American crane migration millions of years later. Indeed, the

state has the largest number of Sandhill Cranes anywhere in the world. At least half a million members of this species, along with slightly more than 200 Whooping Cranes, rest here between the second half of February and mid-April on their journey from the south to the north.

An Extensive Family

The fifteen species of cranes in existence today are spread in varying numbers across every continent except South America and Antarctica. Of these species, the two American ones represent statistical extremes: the Sandhill Crane, with its six subspecies, is the most common, and the Whooping Crane the rarest. During their evolutionary development, and up to the present day, cranes have had some ups and downs. It is thought that there were periods during which at least twice the number of cranes existed at one time on the planet as do today. In South America, from the Oligocene (38–25 million years ago) to the Pliocene epoch (5–2.5 million years ago), there existed within the ranks of more than two dozen species a family of

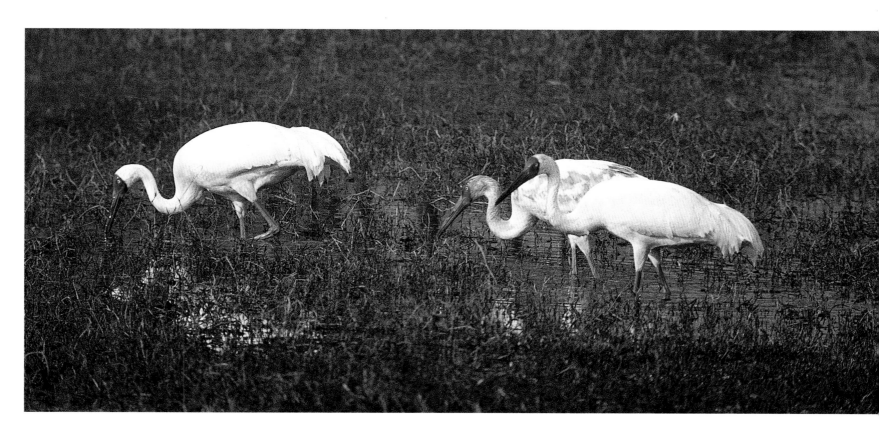

giant, carnivorous crane-like birds *(Phororhacidae)*, which, up to three metres tall and unable to fly, had little in common with modern cranes except for some aspects of their anatomy.

Nevertheless, there are relatives of this long-since extinct, ostrich-like member of the order *Gruiformes* living in South America today. These include serie-mas *(Cariamidae)* and limpkins *(Aramidae)*, the latter of which also live in Central America and the southern United States. Apart from the family of cranes itself *(Gruidae)*, and the two aforementioned varieties, eight further families of birds belong to this order, including the rails *(Rallidae)*; the Kagu *(Rhynochetidae)* found in New Caledonia; the twenty-two varieties of bustards *(Otididae)* found in Africa, Europe, Asia, and Australia; trumpeters *(Psophiidae)*, which live in South America; and—the furthest relatives, hence often not regarded as relatives at all—seventeen varieties of buttonquails *(Turnicidae)*, divided into two subfamilies whose habitats are in Africa, Asia, and Australia. Therefore, cranes are related to coots, Purple Swamphens, Corn Crakes, and Great Bustards, but not, as is often assumed because of the physical resemblance, to storks, herons, or even flamingos.

The relationships between the different members of the crane family are subject to ongoing debate among scientists. Only since 1980 do most crane experts agree that there are fifteen species of cranes living in the world today. Before blood tests, DNA analysis, and behavioural research revealed that the genus of Crowned Cranes *(Balearica)* consists not of one, but of two species—namely the Black Crowned Crane *(Balearica pavonina)* and Grey Crowned Crane *(Balearica regulorum)*—fourteen species were thought to exist. In the past, cranes were classified into as many as nineteen species. Even the great Swedish naturalist and taxonomist Carl von Linné (1707–1778) got it wrong at first when he classified certain species of cranes as herons. The status quo at present is as follows: in addition to the subfamily of Crowned Cranes, which, in evolutionary terms, are regarded as the oldest surviving cranes, there is a second subfamily, the *Gruinae*, which consists of three genera: *Anthropoides* (the

Demoiselle Crane, or *Anthropoides virgo*, and the Blue Crane, or *Anthropoides paradisea*), *Bugeranus* (the Wattled Crane, or *Bugeranus carunculatus*), and *Grus* (the Siberian Crane, or *Grus leucogeranus*; the Sandhill Crane, or *Grus canadensis*; the Sarus Crane, or *Grus antigone*; the Brolga, or *Grus rubicundus*; the White-naped Crane, or *Grus vipio*; the Hooded Crane, or *Grus monachus*; the Common Crane, or *Grus grus*; the Whooping Crane, or *Grus americana* [not *americanus*]; the Black-necked Crane, or *Grus nigricollis*; and the Red-crowned Crane, or *Grus japonensis*).

Even when it comes to assigning species to the different genera, ornithologists and zoologists do not always see eye to eye. For example, because of its similarity to the African Wattled Crane, some experts will classify the Asian Siberian Crane as *Bugeranus*. Others even place the Siberian Crane in its own distinct genus: *Sarcogeranus*. Sometimes there are also different opinions concerning the

Each day, this pair of Sarus Cranes and their two roughly four-week-old young ones roam far afield across their breeding grounds in search of food, but in the evenings they always return to the vicinity of their nest (Lumbini, near Bhairawa, Nepal).

subspecies into which several species of cranes are subdivided. We will take a closer look at these in the portraits section, under the heading 'Similar, yet Different'.

Keeping Neighbours at a Distance

Although they live far apart from each other and are spread across several continents and climatic zones, cranes have many characteristics in common, especially in terms of behaviour. This is not altered by the fact that the different species of cranes range in size from ninety to almost 180 centimetres; that some of them embark on twice-yearly migratory flights of more than 5000 kilometres, while others remain year-round residents in one area; that some will lay their eggs on bare ground, whereas most build their nests in shallow water; or that Black Crowned Cranes perch on branches in tall tress, especially at night when sleeping, while other species prefer shallow waters as their roosting place.

Despite these and other peculiarities, all fifteen varieties display behaviour that is common to the family of cranes as a whole.

There is the obvious fact, for example, that all cranes display two modes of interaction, especially within their own species. Outside the breeding season—which encompasses the egg laying and incubation periods, as well as the nurturing of the young until fledging—cranes are very gregarious animals. They will spend day and night in the company of other cranes, including those of other species and often in large numbers. A thousand birds—even tens of thousands on occasion—may congregate in one area. This is especially the case among the various *Grus* species, such as the Sandhill, Eurasian, Hooded, and White-naped Cranes. Other species may gather 'only' in groups of a few hundred at their staging areas during the migration period or in their winter home; this is because their populations, as a whole, are smaller.

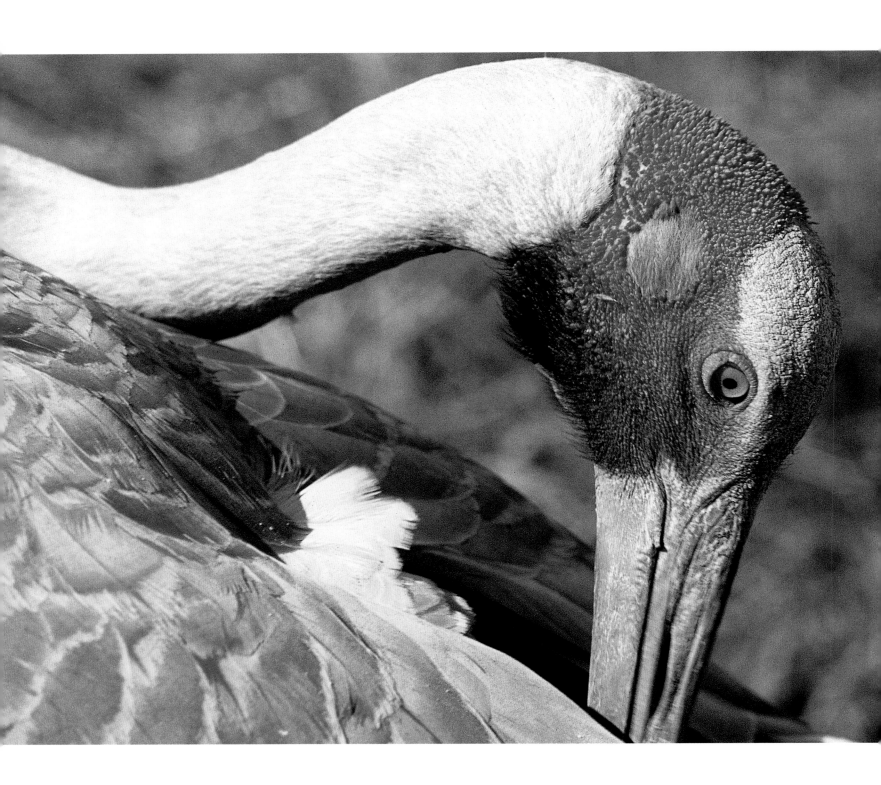

Less red, more grey, and a small
skin pouch, or dewlap, under the
throat: these are the main charac-
teristics that distinguish the Brolga
from the Sarus Crane (Serendip,
Victoria, Australia).

This is the case with the four African species: the Black and Grey Crowned Cranes, Blue Cranes, and Wattled Cranes, the latter rarely forming groups of more than a hundred birds. Demoiselle Cranes also gather in large numbers outside the breeding season; in some staging and sleeping areas in India or Africa, many thousands will congregate on a narrow stretch of shallow water.

The American Whooping Crane is the notable exception. Even while migrating between the Gulf of Mexico (where the population winters on the Texas coastline) and the wilderness of Wood Buffalo National Park (where they breed), these white birds will rarely gather in groups of more than ten to fifteen. Most of them remain within their family clan. When in their winter home, Whoopers will staunchly defend their territory, even against their own kind: couples will vehemently ward off intruders from their feeding grounds, regardless of whether the intruder is a close relative, including offspring from previous years. Only the very latest arrival—Whooping Cranes rarely raise more than one chick—is tolerated and protected. The same also applies to the Whooping Cranes that have been reintroduced to Florida since 1993 and which now form a non-migratory group. We will learn more about them and their fellow group, the latter of which migrates back and forth between Wisconsin and Florida each year, in the next chapter.

When it comes to reproduction, all migratory cranes act the same as the Whooping Cranes. In the spring, most of them fly back from the south in large flocks. But the closer the cranes, which tend to stay loyal to one partner all their lives, come to their breeding grounds, the more they detach themselves from the group. If two cranes have already established their own territory in previous years, they will head straight there. Their fondness for a specific site, once chosen, is almost as great as their loyalty to their partner. There are cranes that have built their nests within the same one hundred square metre area for more than ten consecutive years. And within their territory, they will not tolerate the presence of any other cranes except for that of their partner and, later, of their most recent offspring. Males, especially, will rigorously defend territorial boundaries, often leading to intense fighting. However, there are exceptions. Eurasian Cranes, for example, are sometimes known to establish neighbourhoods; pairs occasionally occupy nests only ten to fifteen metres apart, their territories extending in opposite directions. Such behaviour may occur when the number of breeding pairs in one area is very high, which can happen at times. (Ornithologists call this 'population pressure', which, if sustained over many years, will generally lead to an expansion of the breeding area). Another reason could be that couples have lost a nearby nesting place and need to make alternative arrangements, or that they will tolerate breeding neighbours because they happen to be offspring from previous years. But such neighbourly breeding arrangements are less common amongst cranes than among many other birds.

Keeping distance between nests does make biological sense. It ensures that there is less competition for food within a limited area. The territory has to be large enough to ensure that all members of the family have a sufficient amount to eat, especially the young ones. The chicks (usually two) hatch after twenty-eight to thirty-two days. (Crowned Cranes lay three, sometimes even four eggs, whilst

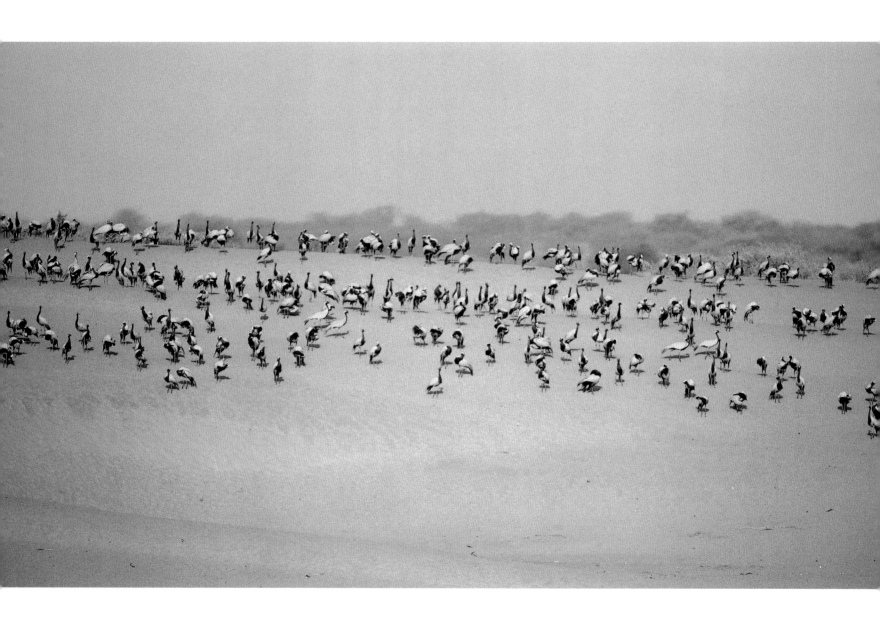

Even when there is no water nearby,
a flock of Demoiselle Cranes will
occasionally land in the desert. The
clear view affords protection from
enemies (Thar Desert, near Khichan,
Rajasthan, India).

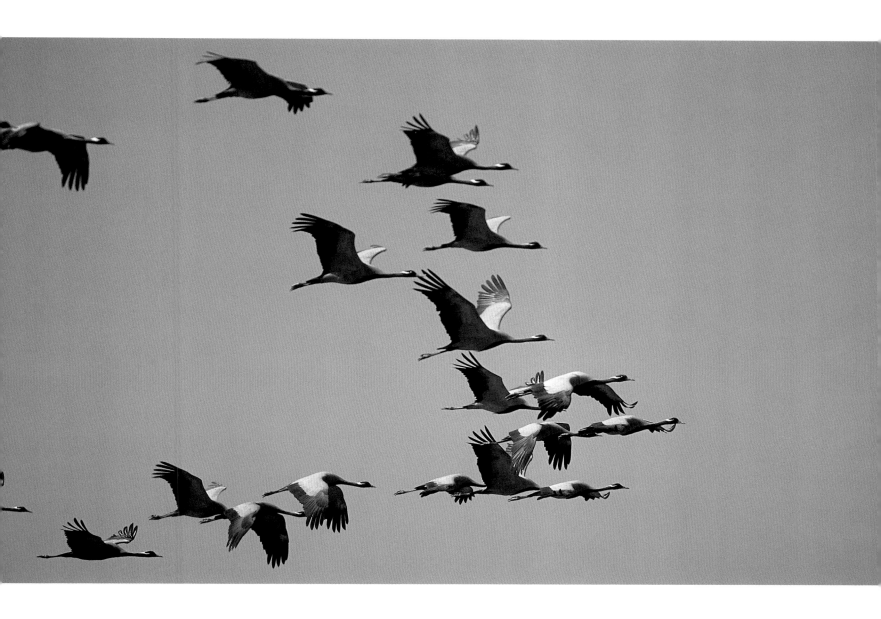

Demoiselle Cranes fly thousands of
kilometres from their breeding grounds
to their wintering grounds. Many have
to cross over the Himalayas (Little
Rann of Kutch, Gujarat, India).

Wattled Cranes often lay only one egg, which, however, takes a good five weeks to hatch.) And these young ones need to eat a lot of insects in the beginning, because insects have plenty of protein, which enhances the growth of bones.

Loving Parents

The attention that crane pairs lavish on their offspring is exemplary. Since the parents share incubation duties, the chicks hatch two or, more rarely, three days after one another in the order in which they were laid. After freeing itself of its shell, the chick—even before its brown-yellow down is dry— slides under the breast of the parent that happens to be on shift at the time and snuggles up in the plumage. But after only a day, the little one climbs onto its parent's back with its wobbly legs and, from there, surveys the nest's surroundings. At the same time, the chick does not shy away from testing its innate abilities as a swimmer. These skills are often

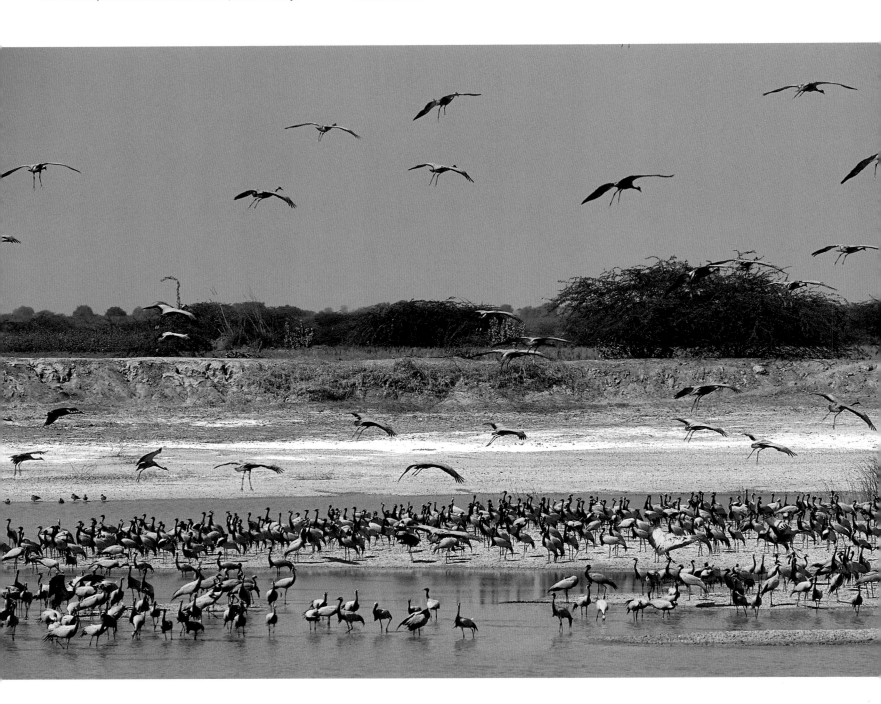

During their daytime break, Eurasian
Cranes also feel best when standing
in shallow water, as these birds in
Israel are doing during the wintering
season, which lasts from mid-Novem-
ber till mid-March. (Agmon Park,
Hula Valley, Israel).

needed during the first weeks, since most cranes
begin life surrounded by water. Fully grown cranes
can also swim if they have to: sometimes, when
there are heavy downpours during the breeding
season, the water level rises so high that the adult
cranes, despite their long legs, can no longer walk
to their nest. So they remember their childhood,
when they would follow their parents by swimming.
While chaperoning their young, the parents will
often separate during the daytime, each with one
chick. This minimises the risk that both chicks will be
eaten should a predator attack. It also enhances
the chicks' feeding situation, since the young engage
in a sometimes unhealthy, even deadly, competition
to be 'number one'—a status usually claimed by
the first-born.

It is impressive how well the large birds can camou-
flage themselves, regardless of whether their breed-
ing ground is the reed-covered periphery of a lake,
a wooded swamp, or open marshland or tundra.
The same applies to the care they take with the nest.
When the parents hand over incubation duties, they
come and go with extreme stealth. The same caution
is applied when the parents and their respective
chicks re-unite at the end of the day to sleep in a
shallow-water nest that has been quickly construc-
ted from aquatic plants, reeds, grass, and twigs. Given
sufficient food, most cranes require only ten weeks
to grow from being fluffy chicks, weighing only a
few grams, to young, airborne birds weighing five
kilos. (Here, too, the Wattled Crane is the excep-
tion, requiring twelve to fifteen weeks before being
able to fly. Blue Cranes also need more time before
fledging. Demoiselle Cranes, in contrast, need only
eight weeks before they can take to the sky.)

Every two to four years during the breeding season,
crane parents need to be particularly careful. This
is when *Grus* cranes (with the exception of the Aus-
tralian Brolga) and the Blue Cranes lose nearly all
the wing feathers essential to flight within just a few
days. The wing-feather moult lasts anywhere from
four to almost eight weeks. While the new feathers
are growing, the adult cranes remain grounded. Dur-
ing this time, the birds become particularly cautious,
having only their long legs to rely upon in cases of

acute danger. Usually, the male and female part-
ners moult during different years so that one bird is
always capable of flight. Young birds renew their
wing feathers for the first time after two years. The
small feathers that cover their bodies are replaced
continually. Some staging areas thus have centi-
metre-thick layers of feather fluff lying about on the
ground or floating on the water.

Travellers Between Worlds

Crane families keep a low profile until their young
ones have fledged. But even after this, they main-
tain close family ties for at least six or seven months.
As soon as the young cranes are relatively good
at keeping up with their parents in flight, the fami-
lies make increasingly extensive forays within the
vicinity of the nesting grounds, until, finally, one
evening in late summer or early autumn, they join
a larger group of cranes for the night. If this sleep-
ing area is near the nesting ground, the family will
return to the latter during the day, since they are
familiar with the territory. But as the days grow
shorter, more and more birds choose to go hunting
for food together with the flock, rather than with
the family. Crane communities residing in the more
central latitudes of the continents are thus joined
by cranes from the north.

As the cranes travel south in a funnel-shaped
formation, their numbers continue to grow. Heading
towards staging and sleeping areas that have been
used for generations, they follow geographic land-
marks such as riverbeds and coastlines. Sometimes
they will fly 500 kilometres in a single day—and, in
exceptional circumstances, even more than 1000.
Incidentally, outside the breeding period, the major-
ity of Crowned, Wattled, and Blue Cranes spend
most of their time in groups of varying sizes spread
across their home region, but they never really
migrate. Having said this, there are Wattled and
Blue Cranes that will engage in regional movements
involving journeys of several hundred, and some-
times more than a thousand, kilometres. The Cuban,
Florida, and Mississippi Cranes—all subspecies of
the Sandhill Crane—stay in their original breeding
grounds throughout the year.

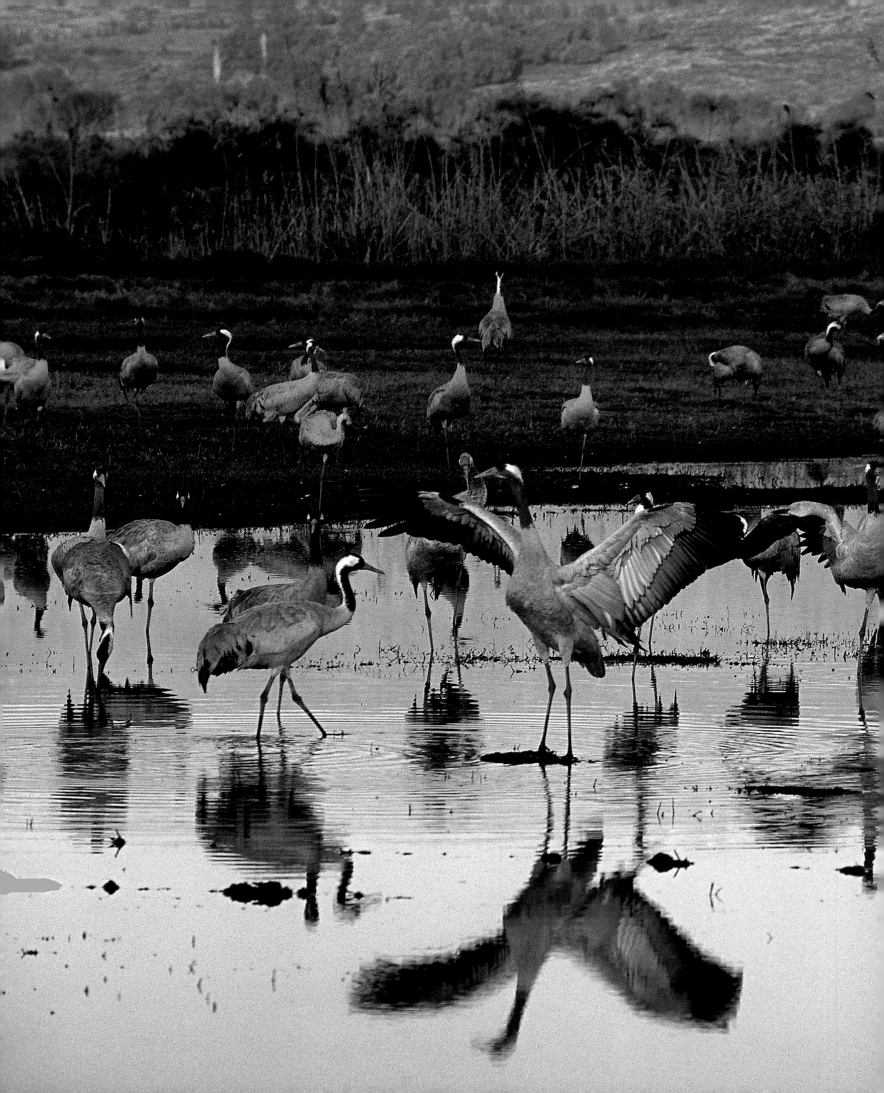

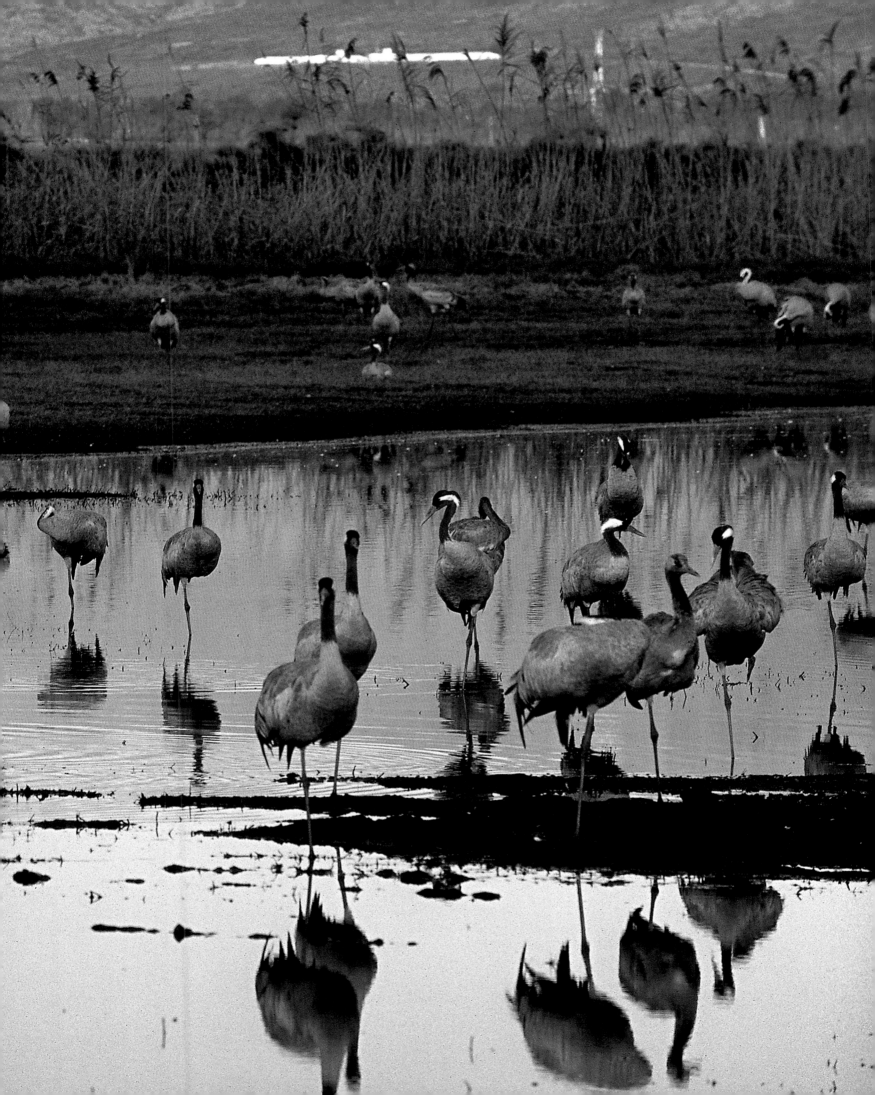

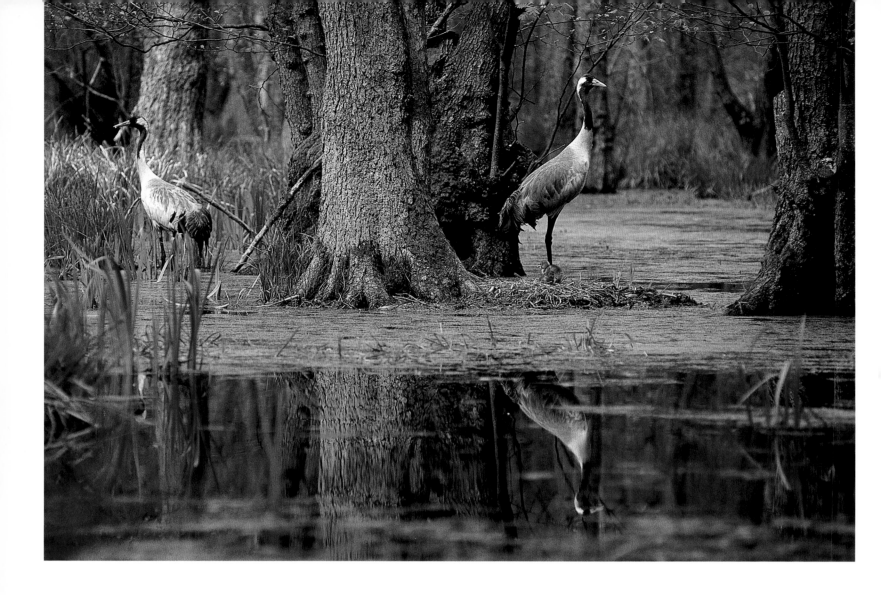

In the autumn, tens of thousands of Sandhill and Eurasian Cranes often spend weeks in large congregating areas. During the autumn migration, the time spent at stop-over areas along the way is much longer than during the spring migration, because the young, less experienced flyers are now part of the flock. The young ones are still growing and, like their elders, need to build up fat reserves as an energy source for the long flight south. A grown crane requires 350 grams of food per day. In the autumn, the birds' favourite feeding grounds are fields that have been harvested, where fallen grains are found. But the birds also like to feed on freshly sown fields, much to the chagrin of farmers. Cranes are omnivores that will eat anything from insects and worms to crabs, snails, frogs, mice, snakes, birds' eggs, and fish. However, once the cranes are fully grown and independent, most species tend to be vegetarians that live on a diet of seeds, fruit, vegetable roots, and grains. Non-meat foodstuffs are simply more abundant and reliable, and less dependent on the weather. But this does not mean cranes will abstain from the occasional meaty morsel when it comes their way.

In the spring, cranes generally follow the same flight routes in reverse, but they are also in a far greater hurry than in the autumn, pulled as they are by a powerful instinct towards their breeding grounds. The birds will only pause and bide their time further to the south if their destination is still covered in snow.

This being said, cranes can, in fact, survive for some time in snow-covered regions; the cold is not a problem for them. Even when the temperature drops below minus twenty degrees centigrade, they adapt quite happily, as long as they have open water to roost in and can find enough to eat. The Red-crowned Cranes residing on the northern Japanese island of Hokkaido are the best example of this.

TOP

A pair of Eurasian Cranes with their day-old chick in a northern German alder marsh (Duchy of Lauenburg District, Schleswig-Holstein, Germany).

A Body Language of Colours, Feathers, and Movements

Although young cranes will remain near their parents until the following spring, large congregating areas provide the youngsters with the opportunity to practice their social skills outside their family and apply the behavioural rituals they have inherited. In principle, the young birds are able to cope on their own by this point, although they are still fed the occasional grain, crab, or snail by their parents and enjoy the elder birds' protection. But when it comes to dealing with other cranes, the young birds are increasingly left to their own devices. In fact, they have already learnt from their parents how they must behave in order to impress others, for crane parents do not only engage in mating rituals. They also jump up and down, bend their long legs, flap, extend, and spread out their wings, briefly fly up and drop down again, stretch and curl their necks, lower their heads, use their beaks to toss up stones,

clumps of earth, and plants, and run around. This behaviour, which is generally described as the 'dance of the cranes'—and which used to be regarded as a kind of impulse for courtship and mating—is, in fact, practised by cranes of all ages and during all seasons. Using this rich array of movements, the birds can express moods and communicate in different ways. The young cranes practice these dances even prior to fledging and before their calls develop the characteristic sound of adults. Usually a single bird, or a pair of birds, will begin with these occasionally rather odd-looking performances. Sometimes, when this happens in a larger flock, other birds will follow suit, resulting in a mass spectacle of dancing animals. These displays do not last long, but can take place several times a day. Young birds seem to take particular pleasure in these events and will participate even if their parents do not.

When they begin practicing these skills, the young birds do not yet have all the attributes of adult birds,

A parent prepares to take over nesting duties for a day or two, incubating the second egg and keeping the already-hatched chick warm (Duchy of Lauenburg District, Schleswig-Holstein, Germany).

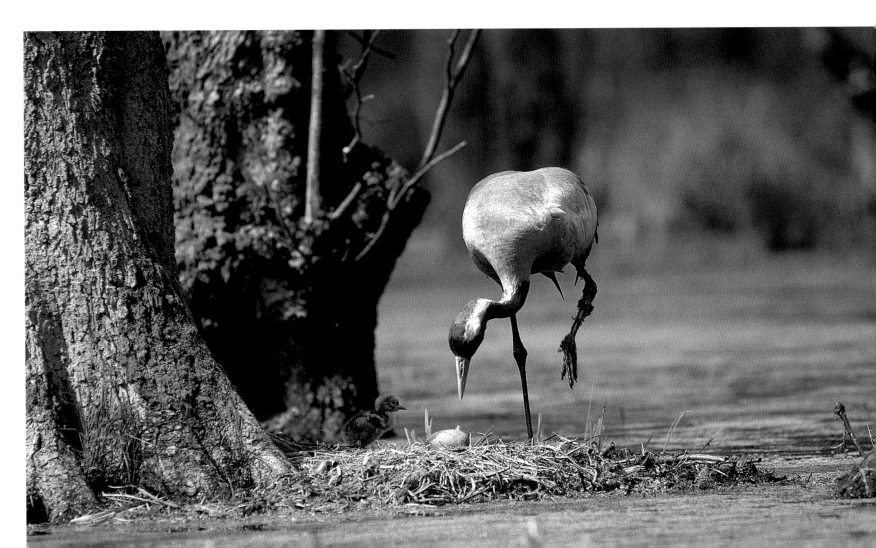

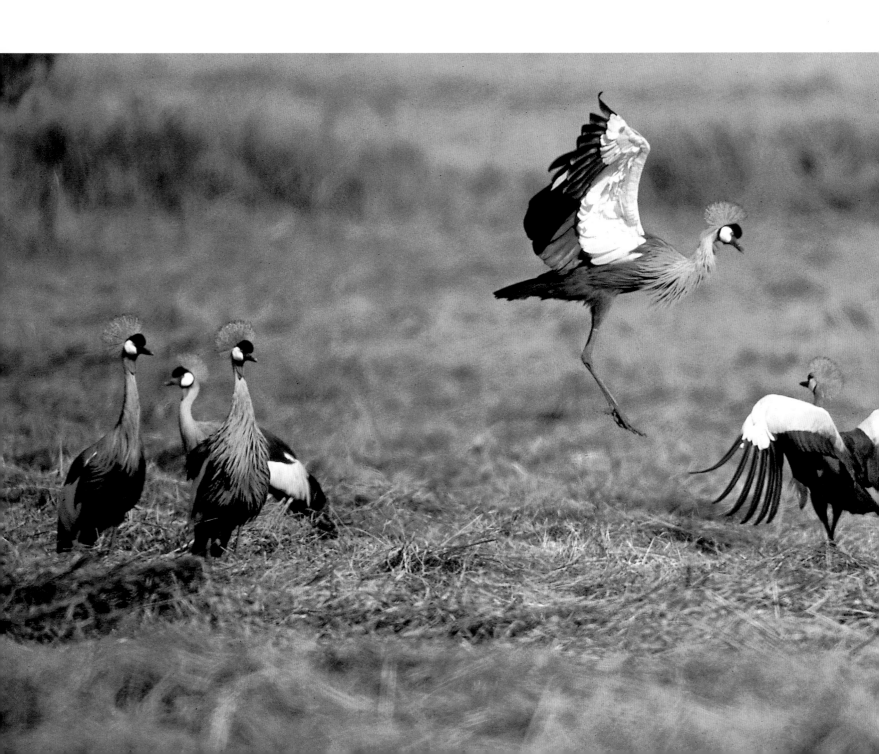

BOTTOM
Here, Grey Crowned Cranes perform a dance during a feeding session on a harvested maize field. Dancing is not always done just for fun, but frequently to settle a dispute (near Nottingham Road, KwaZula-Natal, South Africa).

FOLLOWING DOUBLE PAGE
Black Crowned Cranes also profit
from agriculture. But what is the use of
expanding farmland when doing so
infringes upon the natural wetlands
these birds need for breeding? (Akaki,
near Addis Ababa, Ethiopia).

especially those associated with the *Grus* species. Plumage plays an important role when it comes to impressing other birds, and within the first year, the young crane's plumage is predominantly brown, rather than grey or white. If a crane engages in this posturing, it will lift its long secondary feathers, splaying them broadly. When its wings are folded, the secondary feathers attached to the upper arm of the wing closest to the body—also referred to as tertial feathers—cover its short tail and produce the impression of a prominent bustle. In fact, in this position, the tertials are sometimes mistaken for tail feathers. These 'display feathers' do not reach their full length until after the birds have moulted and renewed their main flight feathers for the first time. (Blue Cranes have particularly impressive tertials that reach the ground, whereas Crowned Cranes have the shortest).

Aside from the secondaries and tertials, the primary feathers also play an important role in body language. When adopting a threatening or boasting posture, the primaries are spread downwards like a fan. This is particularly impressive in the case of the three 'white' species: Siberian and Whooping Cranes have black primaries and white secondaries; with Red-crowned Cranes, it is the other way around. After the first moulting of main flight and smaller feathers, the plumage colours and patterns typical to each species become more pronounced. In addition, most cranes (with the exception of Demoiselle and Blue Cranes) have patches of naked, red-coloured skin on their heads and necks. These patches vary in size depending on the species. When the birds get excited, these bald areas, which look like they are covered in warts, swell and become larger. During disputes, cranes lower their heads and display these red segments as a warning signal.

Warbling, Growling, and Trumpeting

Red warning signs are not the only attributes young cranes have to do without during their first year, and sometimes even into their second. Their voices, which play an important role in the birds' social lives, are also not fully developed. Even before

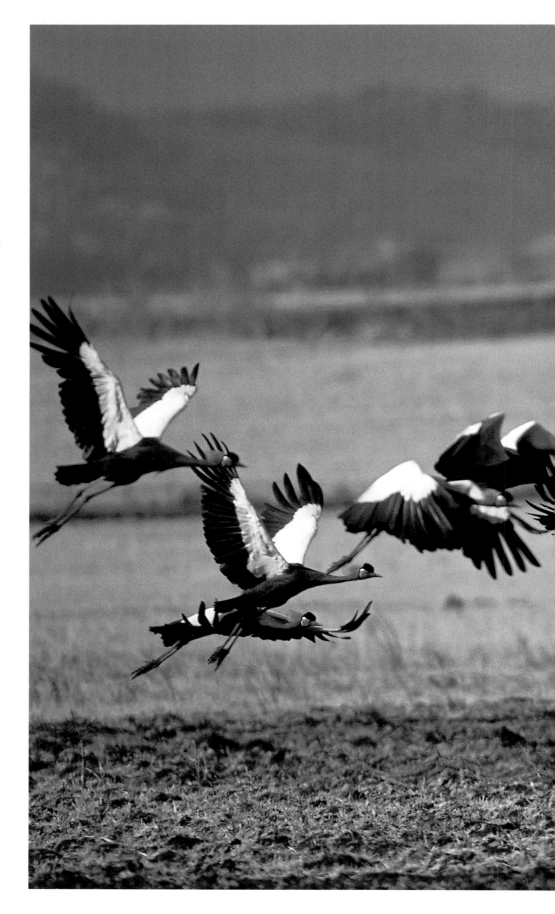

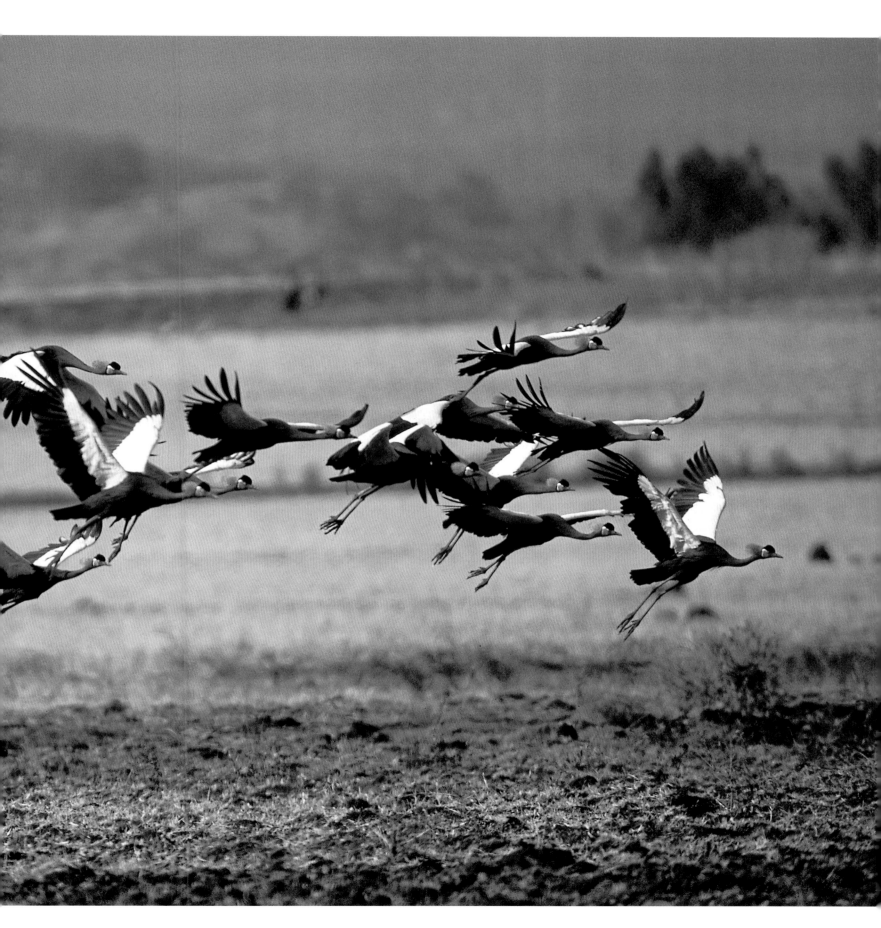

they hatch, the chicks make little squealing and warbling sounds to establish contact with their parents through the shell; a few weeks later, they still make these sounds to maintain contact with the older birds. When the young ones are afraid, they can transform these tender cries into piercing tones. Later, when the young birds are able to cope for themselves, their utterances become more mellow, but are still high-pitched and audible from afar. Indeed, the calls the young cranes direct at their parents, even while flying in large flocks, led North American natives to believe that cranes carried songbirds in their plumage, taking them along to the south. The fact that such large birds (which the youthful cranes are) can emit such high-pitched, almost pitiful sounds is still hard for observers who hear them for the first time to comprehend—especially when the parents seek to comfort their young ones with trumpeting sounds or low growling noises. This fairly quiet growling, which can only be heard close-up, is also used by pairs when one partner takes over nesting duties from the other. In contrast, the sounds that adult cranes make when comforting their young ones could better be described as cooing. And when seeking to drive an intruder away from the nest, the

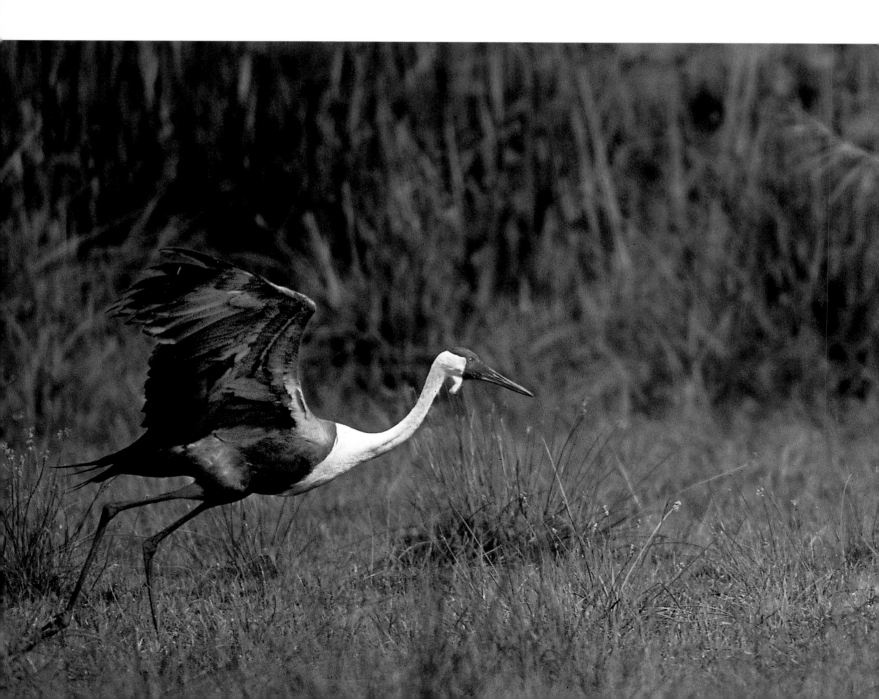

adults make sharp hissing noises, reminiscent of snakes.

The adult cranes give their most impressive rendition, however, when they are on their own territory or on the staging or wintering grounds. This is where the birds make their signature 'unison calls'— upon which, incidentally, their scientific name *Grus* is thought to be based. (The Latin word 'congruere' means, among other things, 'to combine harmoniously' or 'to coincide'.) These calls can be heard from miles away and are comprised of alternating, fanfare-like bursts of sound. The space between the calls is so short, in fact, that it seems as if they were uttered by one bird. These special duets play a crucial role in initiating and maintaining pair bonds. Other important vocalisations are the territorial call (made especially in the early morning), the guard call (uttered as a warning), and the powerful alarm call (often uttered by a single bird, too, if it feels threatened).

None of these calls would be half as impressive were it not for the crane's extremely long trachea, which extends the entire length of its neck and is coiled inside its chest, doubling as a perfect resonance chamber. Further signals of varying intensity and intonation include the stress call, the location

A pair of Wattled Cranes pick up speed for take-off. Of the four species that breed in Africa, they are the most threatened; since 1980, their numbers have dwindled to under eight thousand (Okavango Delta, Botswana).

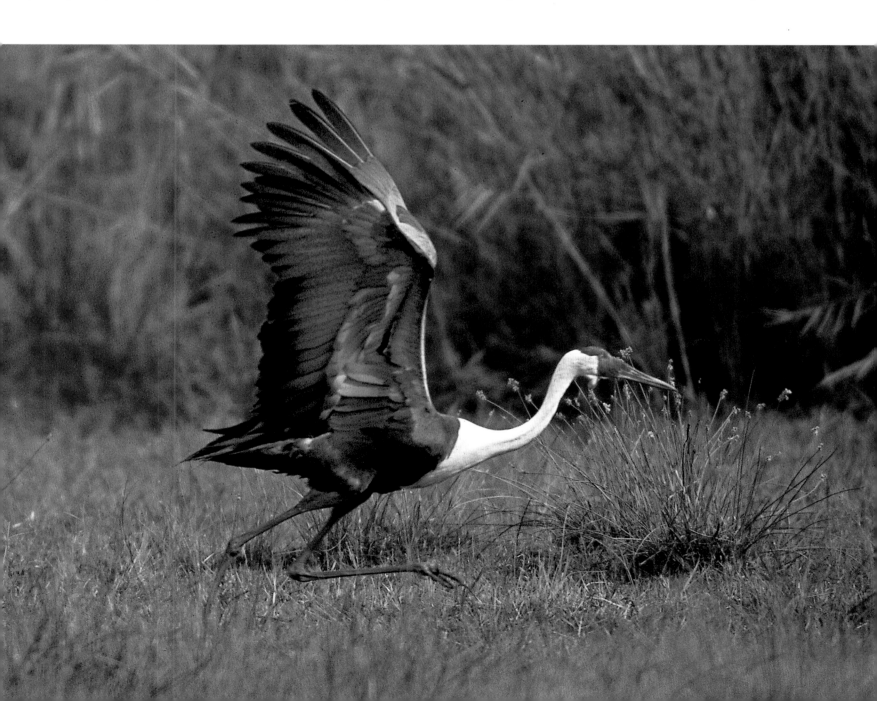

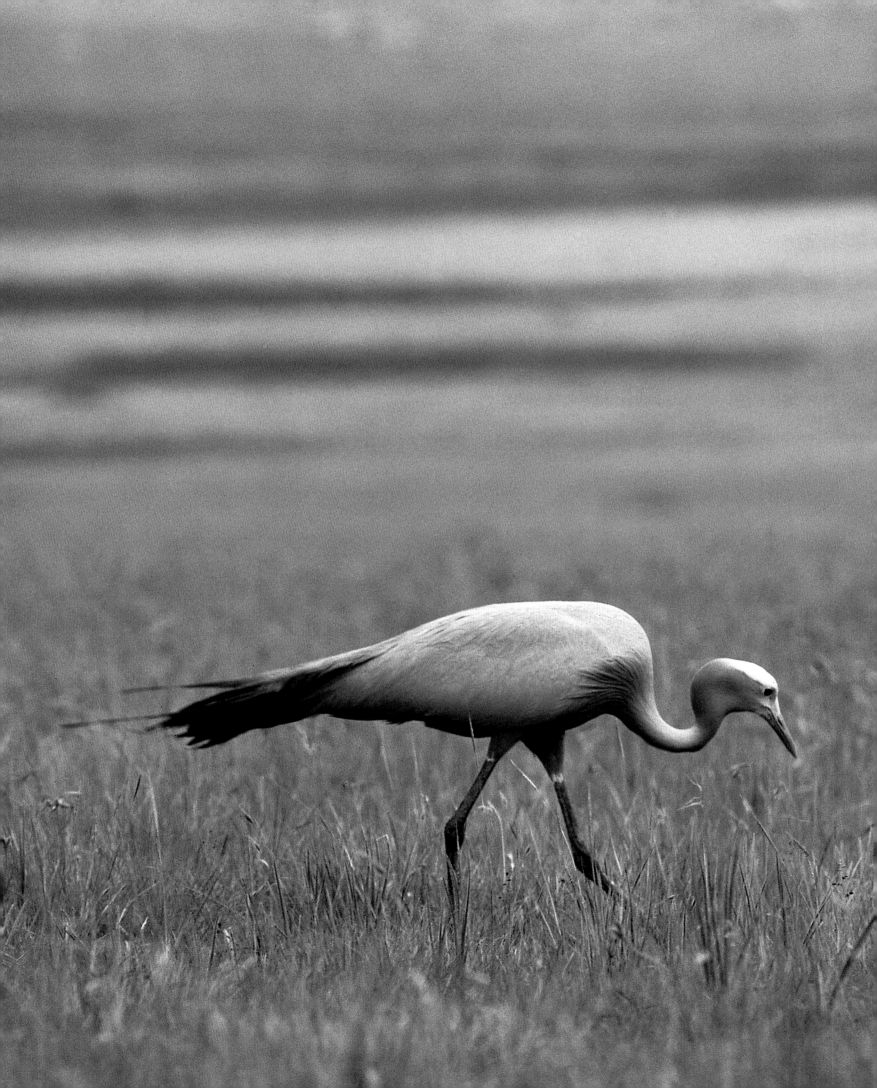

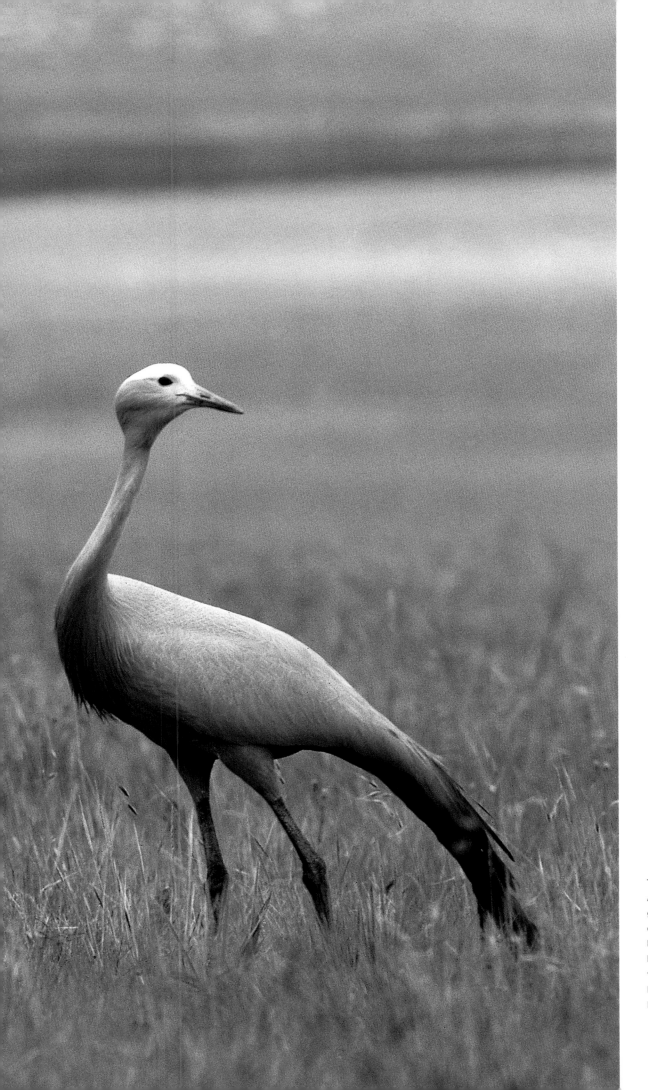

The wide-open grasslands of South Africa used to be a prime breeding ground for Blue Cranes, the only species of crane endemic to this country. However, many millions of hectares have been reforested over the past fifty years, taking away much of the Blue Crane's habitat (Steenkampsberg, Mpumalanga, South Africa).

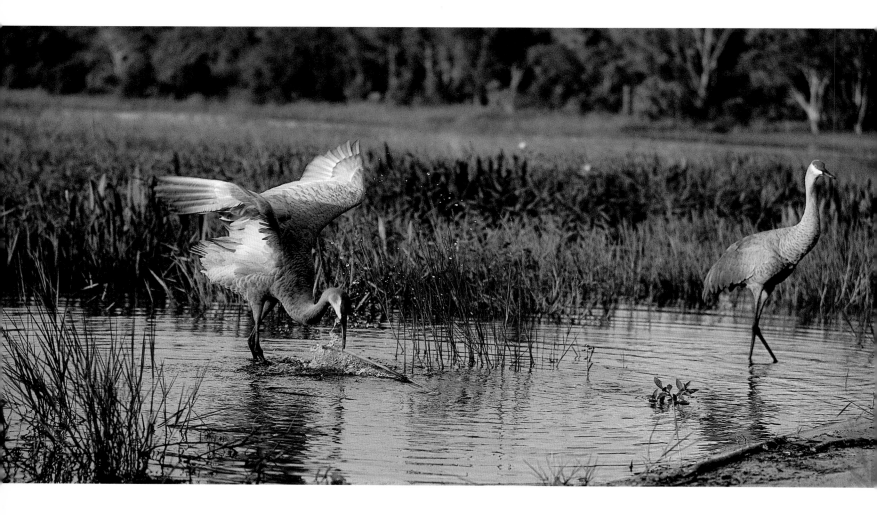

call, the contact call, the migration call (which helps in the birds' orientation), and the flight intention call (which is uttered with the neck stretched forward). Crane aficionados can even differentiate between the food-begging call, a range of pre-copulatory calls, and a multitude of different nesting calls.

Most of these calls can be heard, if somewhat drowned out by the voices of other cranes, in the staging areas outside the mating season. Where thousands of cranes gather, there is almost constant chatter. Only at night in the shallow waters upon which they sleep—be it at the coast, inland, on a river sandbank, on the shore area of a lake, on a flooded meadow, in a shallow fishpond, or even in wastewater lagoons—are the birds tranquil for a few hours. But the cranes are then all the louder when, early in the morning, they prepare to fly off to their feeding grounds. The first families and flocks leave

their sleeping areas long before sunrise. Occasionally, the whole mass of them will take off together, performing a deafening concert.

How long cranes stay in their nocturnal abode depends, apart from disturbances, on the weather. Where conditions remain stable, generations of cranes will return to the same place over decades. They are even prepared to fly over fifty kilometres twice a day to reach their feeding grounds. This entails a one-hour flight in the morning and again at dusk, but it also provides the young ones with an opportunity to train their muscles and learn to navigate.

Cranes on the Move
In the spring and autumn, birds are constantly arriving and taking off from the staging areas. Even though cranes stay longer in a region after the breeding period than before, families, or groups of

When Florida Sandhill Cranes are in the mood for courting, they will grab whatever object they can find and toss it into the air. In this case, one of the birds has scooped up a dead root from an aquatic plant; the bird's partner leaps into the air in response (right). Florida Cranes, as they are also known, do not migrate, but rather stay near the same habitats all year round. Outside of the breeding season, they sometimes form small flocks (near Lake Mary, Florida, USA).

FOLLOWING DOUBLE PAGE
In the autumn, large numbers of
Greater Sandhill Cranes that breed
in the Rocky Mountains migrate to
New Mexico. Tens of thousands spend
the winter in nature reserves, often
together with even greater numbers
of snow geese. During the night,
the water around their feet and legs
can freeze over (Bosque del Apache
NWR, New Mexico, USA).

families and unpaired birds, all have different
travelling arrangements. However, because these
travel plans are often heavily dependent on the
weather, a 'migratory traffic jam' can sometimes
occur. It may take days—sometimes as much as a
week or two—before the conditions are favourable
for a long-haul flight. In autumn, in the northern
hemisphere, favourable conditions mean high pres-
sure and northeasterly winds, whereas in spring,
the wind should be blowing from the south. When
many cranes have had to wait for a long time in
a highly frequented staging area before embarking
towards their wintering grounds, tens of thousands
of them will take to the sky all at once when the
weather improves.

If the high-pressure area extends across the entire
continent, the cranes can remain airborne for twenty-

four hours non-stop, covering a distance of up
to 2000 kilometres. This has been observed among
Eurasian Cranes travelling from the coast of the
Baltic Sea in Germany to southwestern France
and northern Spain, for example. When they have
tailwind, the cranes can increase their normal cruis-
ing speed of fifty to sixty kilometres per hour by
more than fifty percent. In such cases, the animals
will not interrupt their journey for sleep, even
though they would do so under less hectic circum-
stances—and this for good reason: it is harder for
the birds to recognise landmarks at night. By the
same token, the increasing density of human infra-
structure in the areas cranes fly over means that lit
villages, cities, and streets, as well as car head-
lights, offer them some navigational aids. In addition,
ornithologists believe that cranes, like other birds,

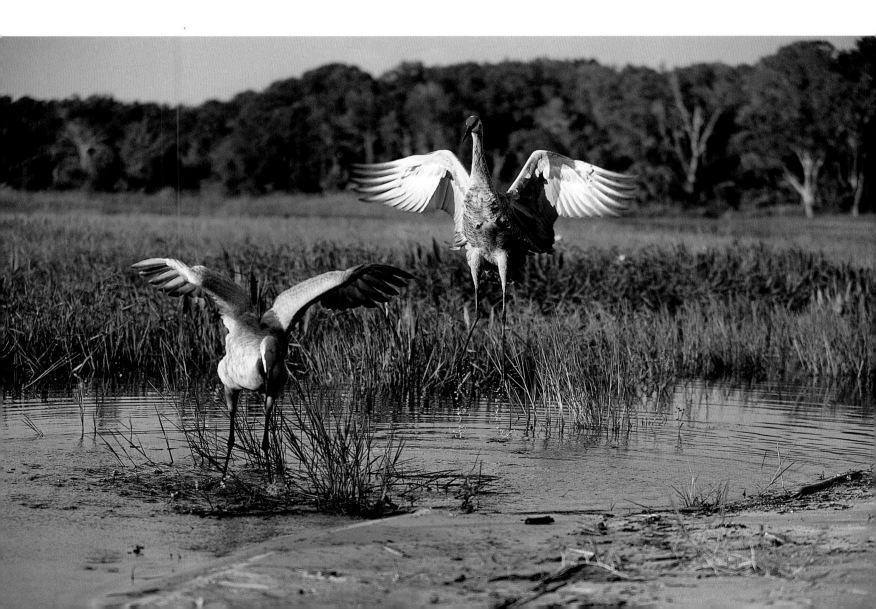

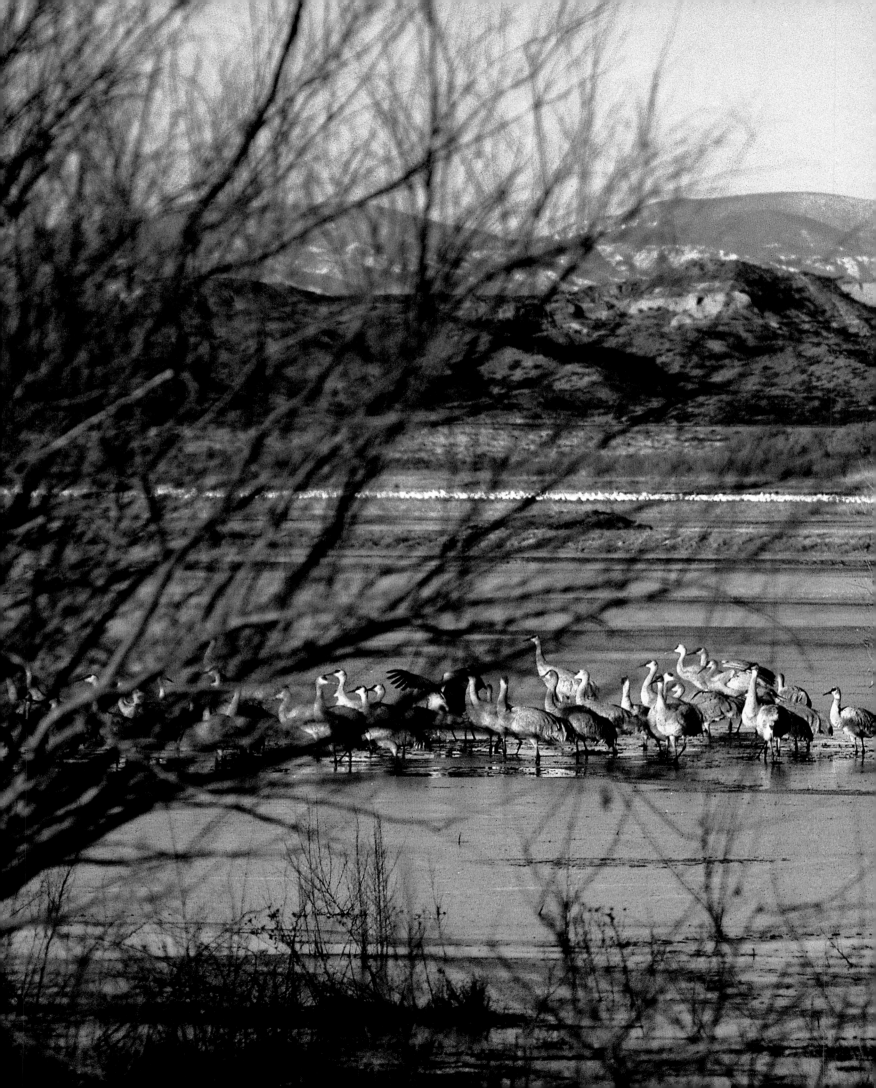

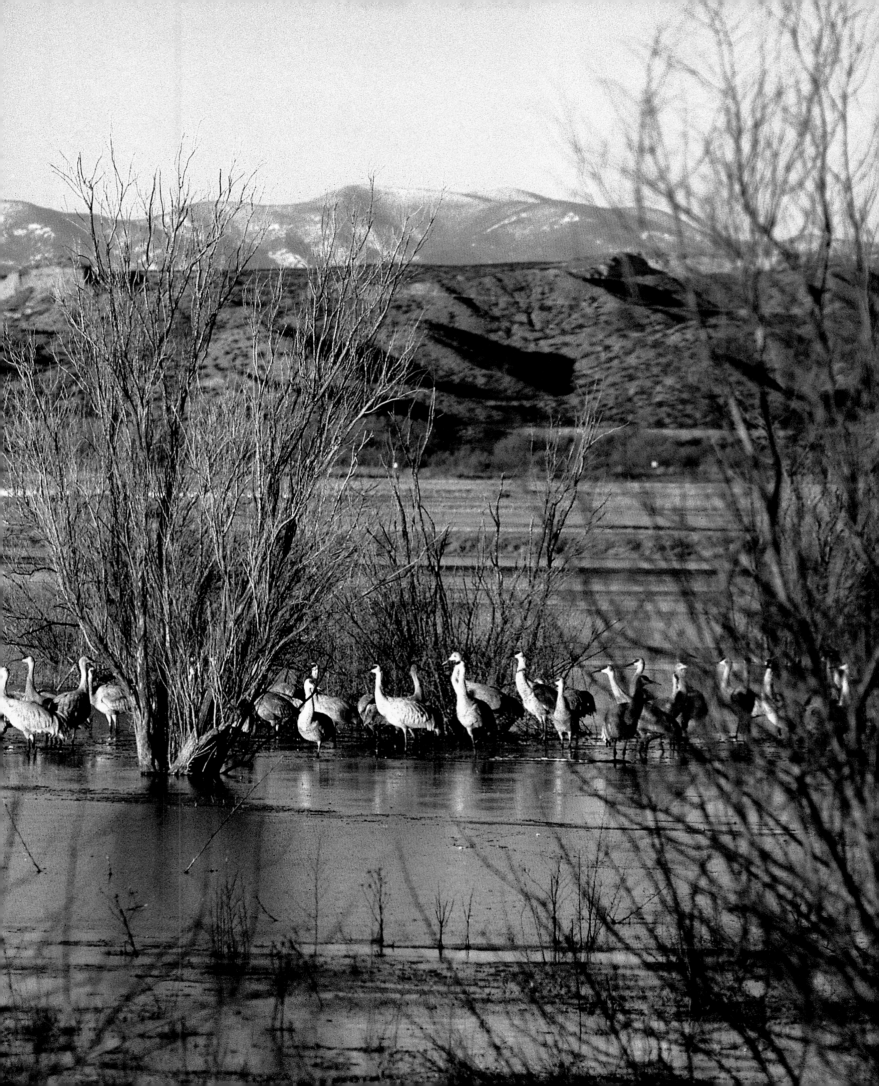

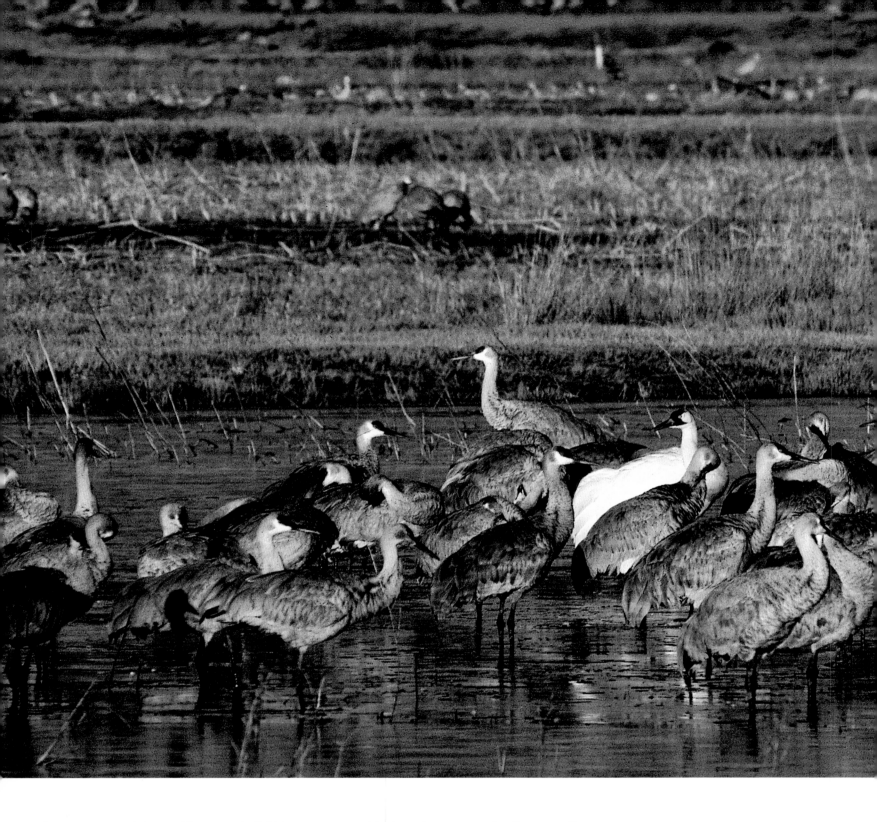

also use stars and the earth's magnetic field to orient themselves.

Whereas cranes' preferred flying altitude during the day lies between 300 and 500 metres, these long-distance migrators will increase their altitude considerably during the night. On clear nights, flocks of cranes have been observed, from aircraft, flying as high as 4000 metres. If the birds have to pass over mountains, they can easily increase their altitude to more than 8000 metres above sea level. Various accidents and emergency landings over the years have shown, however, that night flight can be dangerous for migratory birds, especially in the event of sudden fog. On 7 November 1998, for example, some 2000 Eurasian Cranes passed over the Vogelberg Mountains in the German state of Hesse, about 100 kilometres north of Frankfurt and fifty kilometres west of Fulda. Apparently, the birds mistook a low lying fog-bank, illuminated by the lights of the small town of Ulrichstein, for a stretch of

During their long journey, the grey-brown Sandhill Cranes will occasionally come across white Whooping Cranes, especially on the Platte River in Nebraska. These two birds, however, have arrived from a failed reintroduction programme in the Rocky Mountains, which is described in greater detail on page 142 (Bosque del Apache NWR, New Mexico, USA).

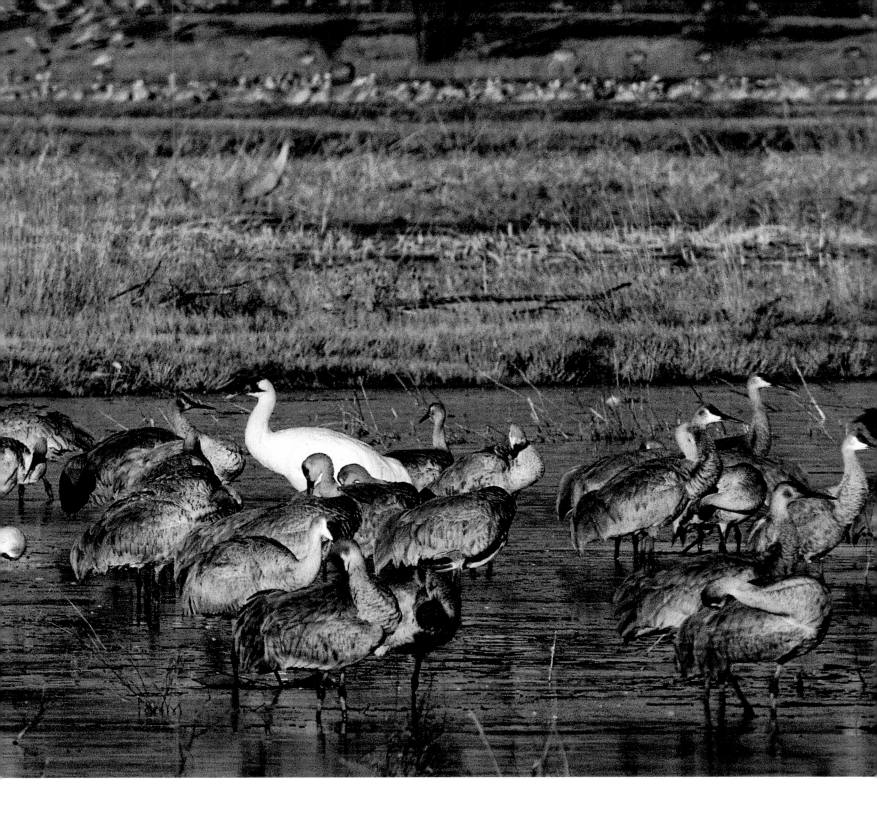

wetland—and attempted to land on it. Many in the flock ended up crashing into streets, the walls of houses, and overhead power lines. The inhabitants of the town believed they were witnessing a natural disaster (which they were), and had it not been for the fire brigade, which switched off street lamps and other powerful sources of light, things would have been worse. But with sixteen dead, seven severely injured, and hundreds of extremely confused cranes, things were bad enough.

Some cranes, like three of the six subspecies of the Sandhill Crane, the Siberian Crane, and the Red-crowned Crane, have to be extremely adaptable as they make their way from the deserted northern stretches of the Nordic taiga and tundra into densely populated southern areas. The birds pass over many countries with different ecological guidelines and hunting traditions. There are a great many other hazards and obstacles that need to be circumnavigated, too. Young birds would not be able

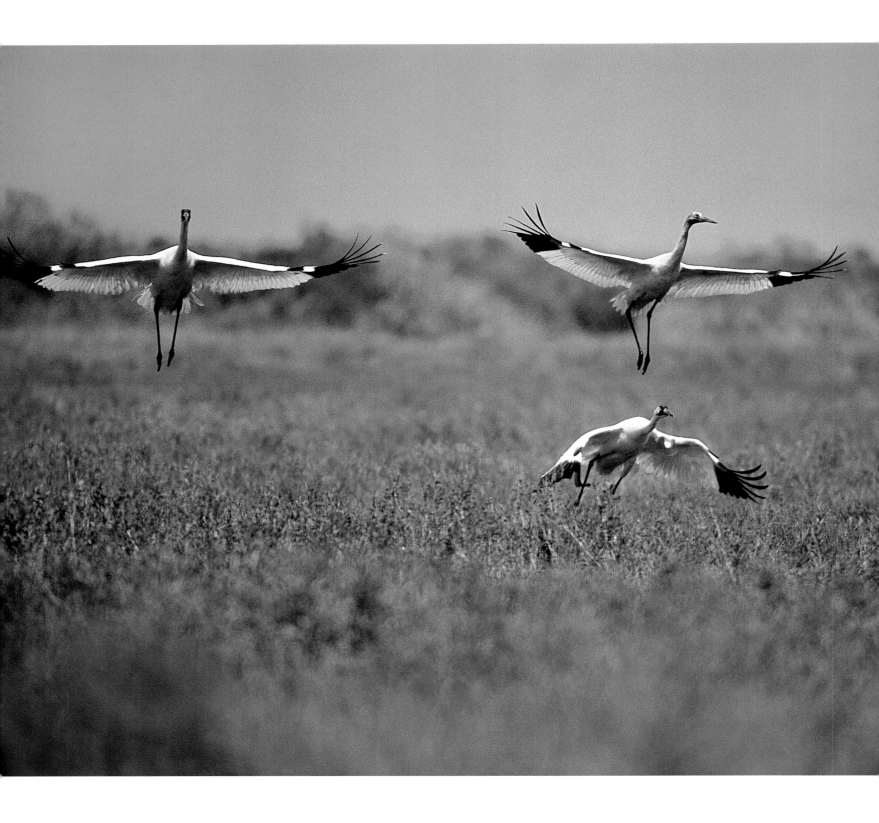

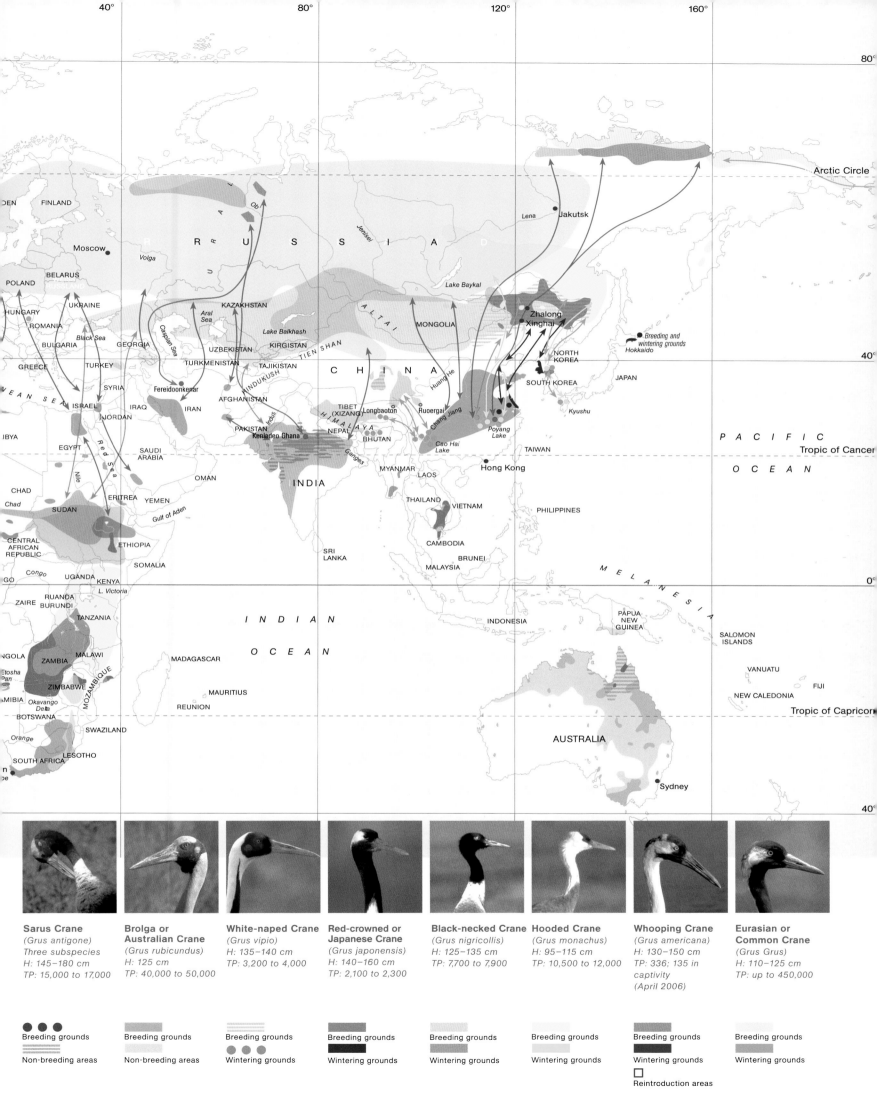

40° 80° 120° 160°

80°

Arctic Circle

FINLAND

Lena Jakutsk

Moscow

Volga Ob

R U S S I A

POLAND BELARUS RUSSLAND

HUNGARY UKRAINE

ROMANIA KAZAKHSTAN Jenissei Lake Baykal Breeding and wintering grounds

BULGARIA Black Sea Aral Sea ALTAI MONGOLIA Zhalong Hokkaido

GEORGIA Caspian Sea Lake Balkhash Xinghai

GREECE TURKEY UZBEKISTAN KIRGISTAN Huang He NORTH KOREA 40°

TURKMENISTAN TIEN SHAN C H I N A SOUTH KOREA JAPAN

SYRIA TAJIKISTAN HINDUKUSH Ruoergai Chang Jiang

ISRAEL AFGHANISTAN Tibet Longbaoton Kyushu

IBYA JORDAN IRAQ IRAN Fereidoonkenar (XIZANG) Poyang PACIFIC

EGYPT PAKISTAN HIMALAYA NEPAL BHUTAN Lake

SAUDI Kenladeo Ghana Cao Hai TAIWAN OCEAN

Red Sea ARABIA INDIA Ganges Lake Tropic of Cancer

CHAD Nile OMAN Hong Kong

Chad ERITREA YEMEN Gulf of Aden MYANMAR LAOS

SUDAN ETHIOPIA THAILAND VIETNAM PHILIPPINES

CENTRAL SOMALIA SRI CAMBODIA

AFRICAN LANKA BRUNEI M E L A N E S I A

REPUBLIC Congo UGANDA KENYA MALAYSIA 0°

GO RUANDA L. Victoria I N D I A N

ZAIRE BURUNDI INDONESIA PAPUA SALOMON

TANZANIA NEW ISLANDS

O C E A N GUINEA

NGOLA MALAWI MADAGASCAR VANUATU

ZAMBIA FIJI

ZIMBABWE MAURITIUS NEW CALEDONIA

AMIBIA Okavango MOZAMBIQUE REUNION Tropic of Capricor

Delta AUSTRALIA

BOTSWANA SWAZILAND

Orange LESOTHO

SOUTH AFRICA Sydney

40°

Sarus Crane	**Brolga or Australian Crane**	**White-naped Crane**	**Red-crowned or Japanese Crane**	**Black-necked Crane**	**Hooded Crane**	**Whooping Crane**	**Eurasian or Common Crane**
(Grus antigone)	*(Grus rubicundus)*	*(Grus vipio)*	*(Grus japonensis)*	*(Grus nigricollis)*	*(Grus monachus)*	*(Grus americana)*	*(Grus Grus)*
Three subspecies	*H: 125 cm*	*H: 135–140 cm*	*H: 140–160 cm*	*H: 125–135 cm*	*H: 95–115 cm*	*H: 130–150 cm*	*H: 110–125 cm*
H: 145–180 cm	*TP: 40,000 to 50,000*	*TP: 3,200 to 4,000*	*TP: 2,100 to 2,300*	*TP: 7,700 to 7,900*	*TP: 10,500 to 12,000*	*TP: 336; 135 in captivity (April 2006)*	*TP: up to 450,000*
TP: 15,000 to 17,000							

Breeding grounds	Breeding grounds	Breeding grounds	Breeding grounds	Breeding grounds	Breeding grounds	Breeding grounds	Breeding grounds
Non-breeding areas	Non-breeding areas	Wintering grounds	Wintering grounds	Wintering grounds	Wintering grounds	Wintering grounds	Wintering grounds
						Reintroduction areas	

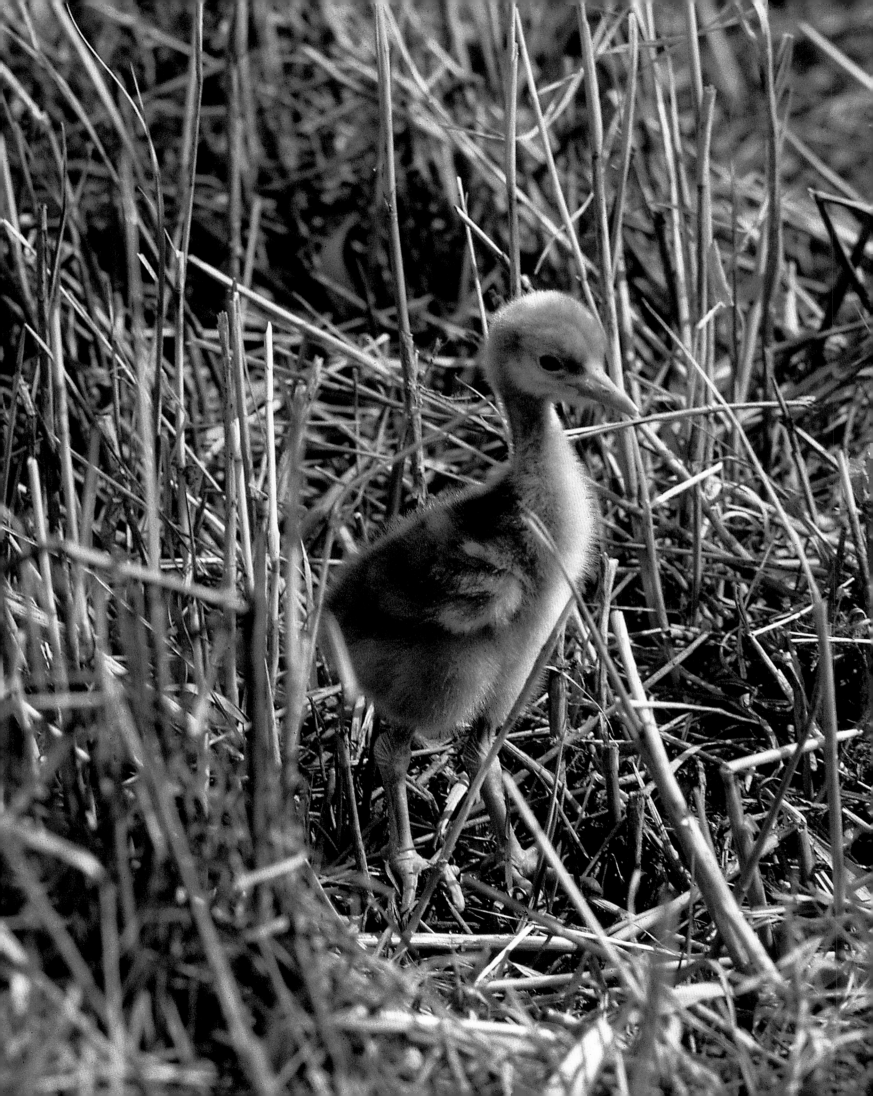

Similar, yet Different:
Each Species Has Its Special Features

The fifteen species of cranes may have a lot in common, but apart from their varied appearance, they also have very different behavioural patterns and preferences. The similarities are greatest when they are still chicks. The little ones' plumage ranges from grey to golden-brown, but the colour differences between species are only minor, so even experts have trouble distinguishing between them, barring other points of reference. The easiest way to determine the species to which a crane chick belongs is by examining its legs, feet, and beak. As with all other crane chicks that are only a few days old, the Red-crowned Crane shown on the opposite page has legs and feet that are quite large in relation to the rest of its small body, no matter how tall it tries to make itself. There is good reason for this: no later than three days after hatching, the chick will need to follow its parents on land and on water.

During their first few weeks of life, crane chicks develop species-specific patterns of behaviour, which may become more pronounced when they are fully grown. The behavioural blue-print is in their genes. For example, chicks of a certain species may be extremely aggressive towards their siblings, even killing them on occasion, whereas chicks of a different species may be tolerant of each other. This behaviour tends to extend into the birds' adult lives. For example, species that are aggressive when young, such as the American Whooping Crane, tend to live an isolated family life as adults, spending the entire year defending their territory— even against cranes of their own kind. In contrast, cranes that get along well with their siblings when they are young will, later in life and outside the breeding season, enjoy being in the company of large gatherings of their own kind. Every few decades, new discoveries and research findings prompt us

to revise our notions of family life among cranes. This will continue to be the case in the future.

Drawing, in part, on the author's personal experiences, the following short portraits will describe the behaviour of various species, their distribution, their overall numbers, and specific conservation programmes. Apart from the last five portraits, this section will follow the sequence chosen by Curt D. Meine and George W. Archibald in *The Cranes: Status Survey and Conservation Action Plan*, which was published by IUCN (The World Conservation Union) in 1996. Thus, we will begin, as most surveys do, with the two oldest species living today: the Crowned Cranes. However, the list ends with a species that is spread across three continents and will, if developments continue as they have since 1970, become even more numerous than the Sandhill Crane: the Eurasian Crane.

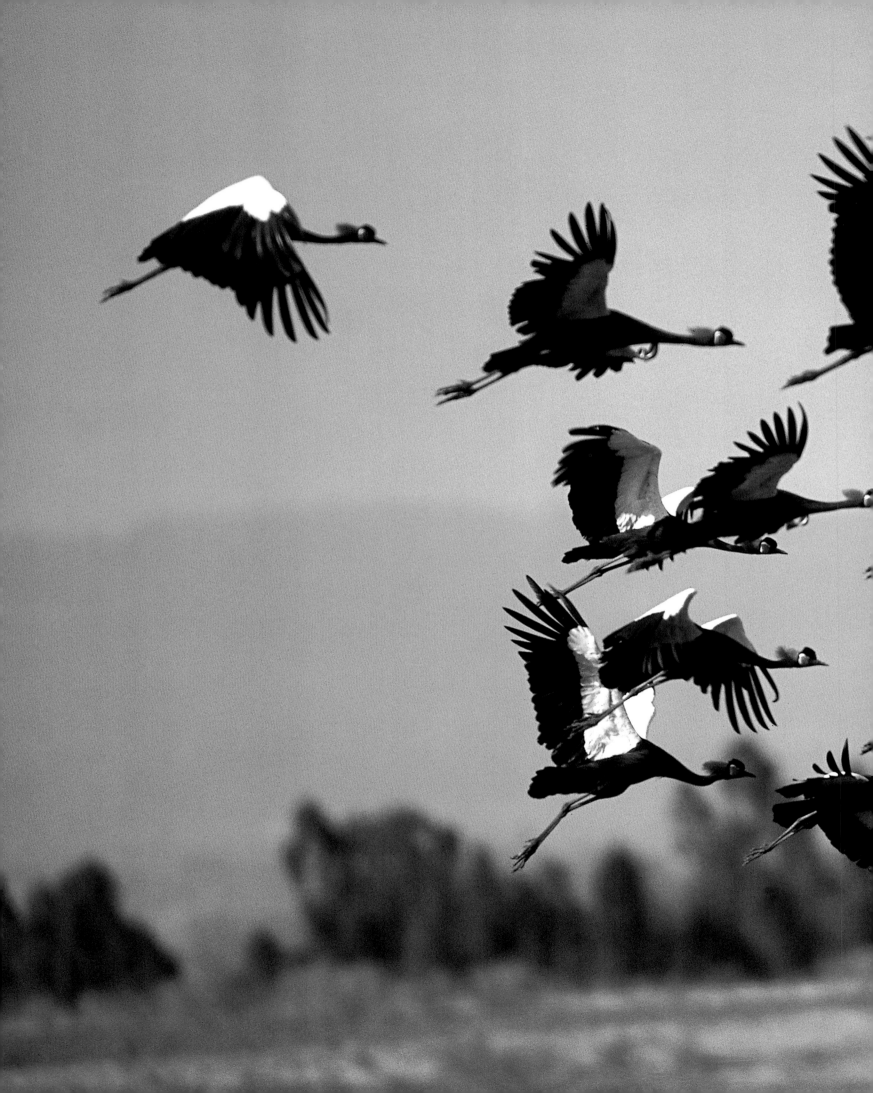

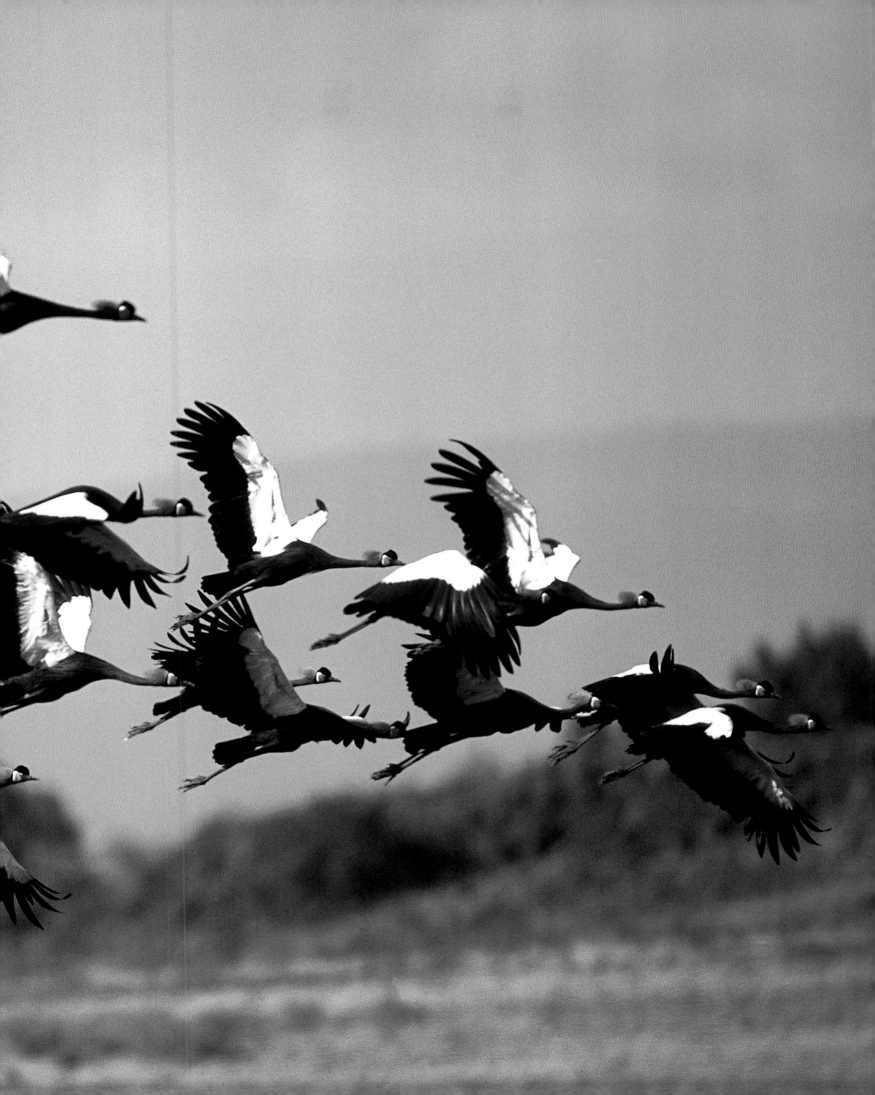

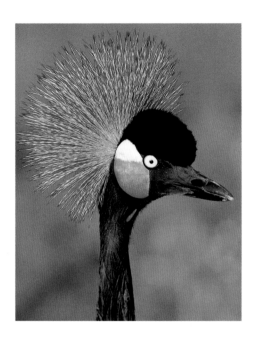

Black Crowned Crane *(Balearica pavonina)*: The Western Subspecies is Even More at Risk Than the Eastern Variety

'It won't even take half an hour by car before we see our first Black Crowned Cranes,' Yilma Dellelegn Abebe tells us after picking us up at midnight from the airport in Ethiopia's capital Addis Ababa. This announcement evokes keen anticipation within our small group of three travellers. As a long-standing member of the Ethiopian Wildlife and Natural History Society and head of Ornithopia, a tour operator specialising in ornithological tours through this northeast African nation, Yilma knows what he is talking about. Although we have come here in late January to study the wintering conditions of the Eurasian Crane, my companions and I are equally interested in the eastern subspecies of Balearica

pavonina, the Sudanese Crowned Crane *(Balearica pavonina pavonina)*.

The next morning we are not disappointed. Only twenty-five kilometres south of Addis Ababa we encounter a group of twenty-two birds on a harvested field near the Endode floodplain. Their plumage is mainly dark in colour, and they have gold-yellow crowns and brilliant red cheeks. The birds ignore the small number of nearby herdsmen, but when we approach, they raise their heads, so we think it best to keep our distance. It takes a while for these black 'peacock cranes', as these birds were once known, to get used to us strangers, but eventually we are able to get within about one hundred metres without them showing any signs of agitation. Their calmness in the presence of the local farmers suggests to us that they have no reason to fear these people.

Fifteen years earlier, while on a visit to the northern tip of Cameroon near the border to Chad, I was able to get a good look at several dozen Western Black Crowned Cranes *(Balearica pavonina ceciliae)*. They have disappeared from there now and, apart from isolated pairs, can no longer be found anywhere in western Africa. Today, this second subspecies of the Black Crowned Crane is considered to be threatened with extinction. Of a population that, only 50 years ago, was estimated at 100,000 and, with the exception of forests and desert regions, used to be common throughout western Africa, only an estimated 15,000 Western Crowned Cranes exist today, spread across an area roughly the size of Europe. Although the Sudanese Crowned Crane is twice to three times as populous, even these birds are clearly on the decline. (Sudanese Crowned Cranes occur primarily in Sudan and Ethiopia, with minor populations in the north of Uganda, Kenya, and southeastern Chad.) Some

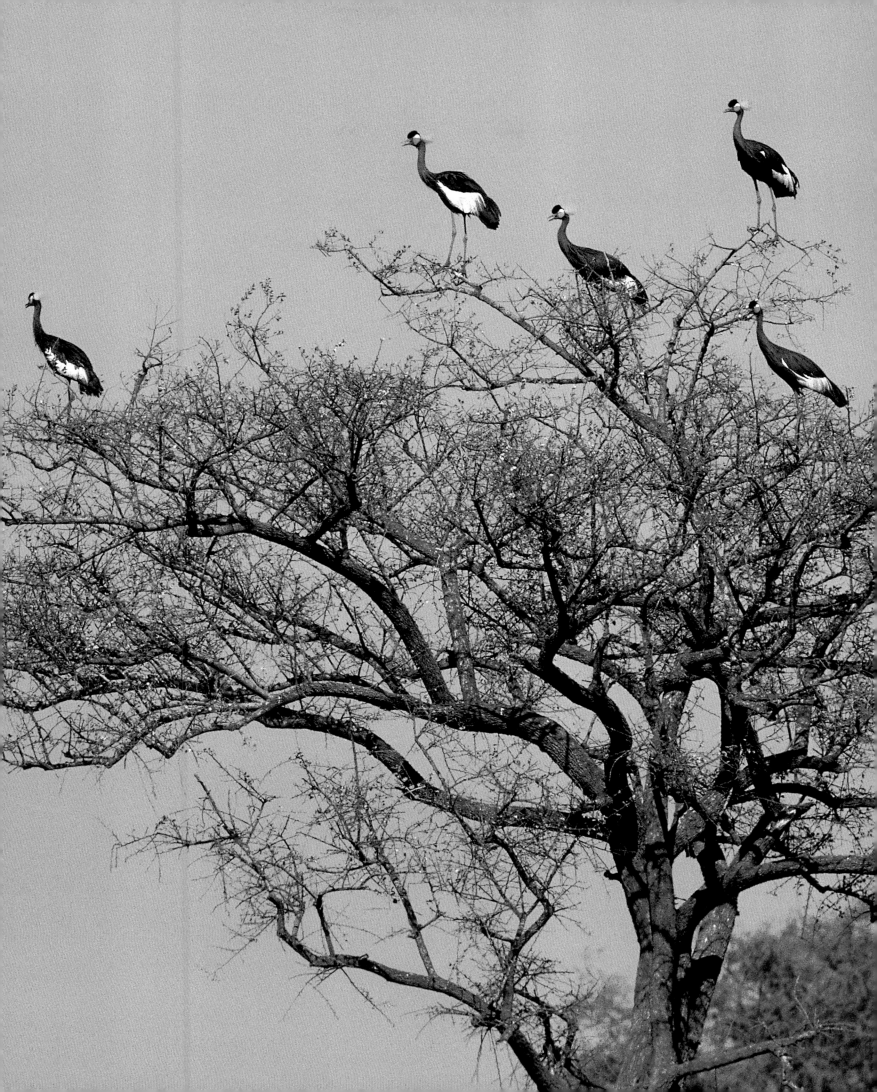

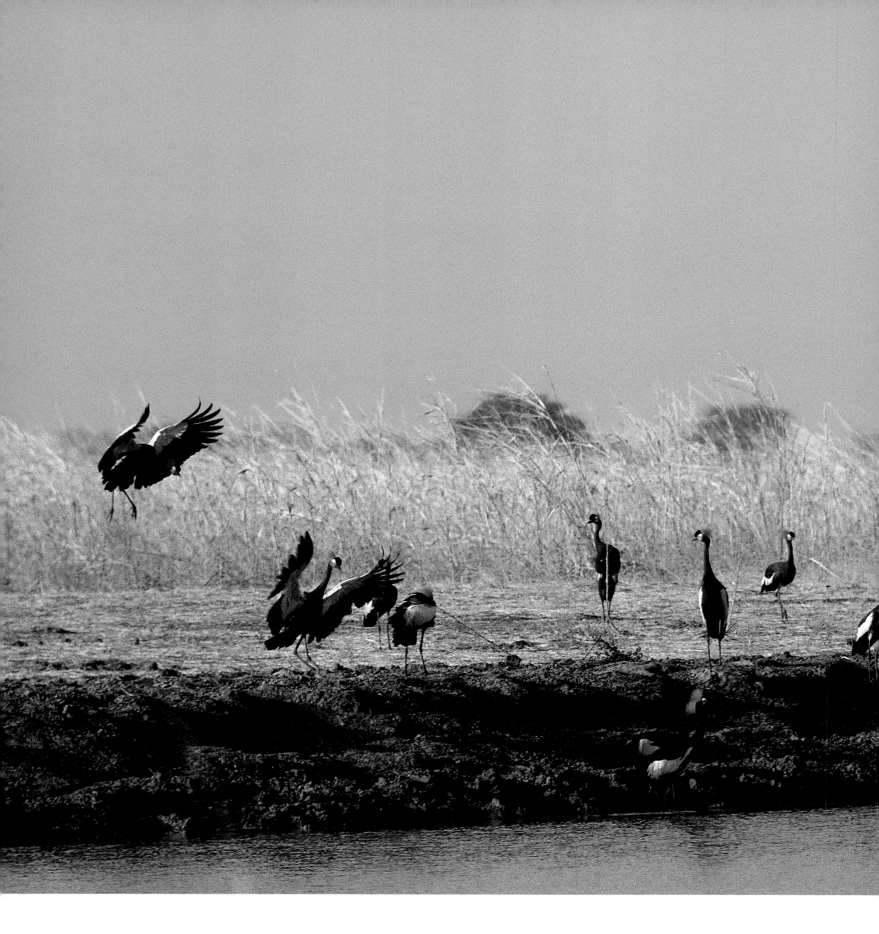

A flock of West African Crowned Cranes lands by a lake in the savannah of northern Cameroon. Like other cranes, they gather outside the breed-ing season at midday to quench their thirst (Waza National Park, Cameroon, near the Chad border).

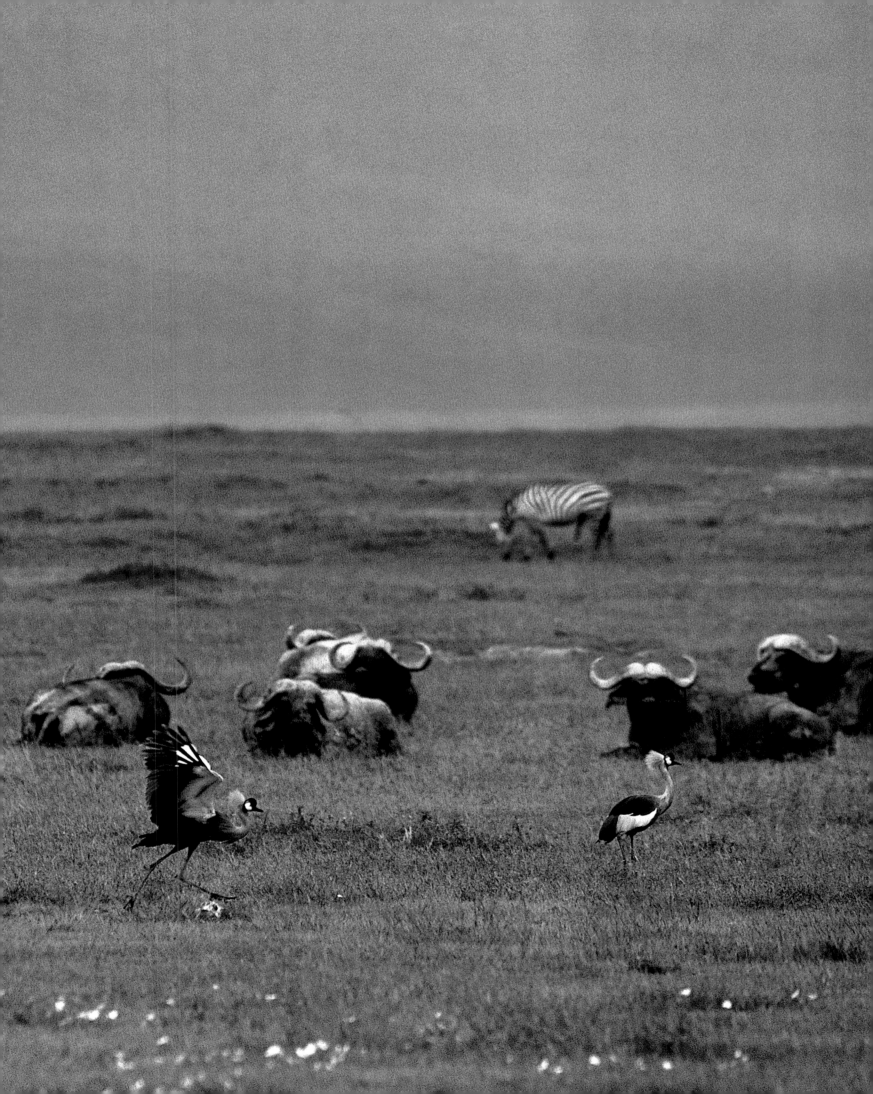

Demoiselle Crane *(Anthropoides virgo)*: Small, Elegant, and Undemanding

It is hard to believe that the smallest of all cranes can be so loud! The whole sky seems to be filled with their trumpeting calls before we can even see the birds. We are sitting near a reservoir located at the edge of the Little Rann of Kutch, a seasonally flooded semi-arid salt desert in the northwestern Indian state of Gujarat, and are waiting for the return of the Demoiselle Cranes. These birds announce their imminent arrival from afar and from great heights, thus providing a prelude to an amazing spectacle of nature that takes place here and at other, usually man-made aquatic locations every morning between mid-November and early March.

The first flock, with dangling legs and angled wings, is just about to land, and we can already hear the next group approaching. For the next hour and a half, the reservoir becomes a kind of airport, with heavy bird traffic arriving from all directions. In the end, more than 4000 Demoiselle Cranes and about fifty Eurasian Cranes are crowded on the sandbank. After landing, most of them take a drink before preening their feathers and then resting, either by sitting down on the sand or standing on one leg. All of them have flown from fields that are within a thirty kilometre radius; some might even have come from a greater distance to rest here for a few hours. Earlier, the birds had taken off from the reservoir at daybreak and will do so again in the afternoon. In the evening, they will return once more to spend the night roosting in the shallow water.

Even amidst a large flock, each Demoiselle Crane seems delicate and elegant. This was also my impression a few years ago when I was able to study a pair close-up on their breeding grounds in the Xianghai Nature Reserve in the northeastern Chinese province of Jilin. The birds have two white feather plumes on their black heads, their eyes are reddish-brown and shiny, and the black apron of feathers that hangs from their chests contrasts with their silver-grey plumage. The elongated tertial feathers that cover the tail when their wings are folded give the birds' roughly ninety-centimetre-long bodies a sweeping, finishing flourish.

Even though they are smaller than Eurasian Cranes, Demoiselles are easily mistaken for them in poor light, especially since both species fly in the same formations. Lined up in an aerodynamically favourable V-pattern, the Demoiselles are capable of quickly bridging the long distances between their breeding grounds, which are mainly located in the steppe regions between the Black Sea and Manchuria, and their wintering grounds in Africa (i.e. Sudan, Ethiopia, and Chad) and in many parts of India. In certain years, if the monsoon has established favourable

BOTTOM

This Demoiselle Crane is about to settle on its clutch of eggs, which are well camouflaged in a hollow in the grass (Xianghai Nature Reserve, Jilin Province, China).

FOLLOWING DOUBLE PAGE

With angled wings and hanging legs, these Demoiselle Cranes descend from great heights to land by a stretch of water (Little Rann of Kutch, Gujarat, India).

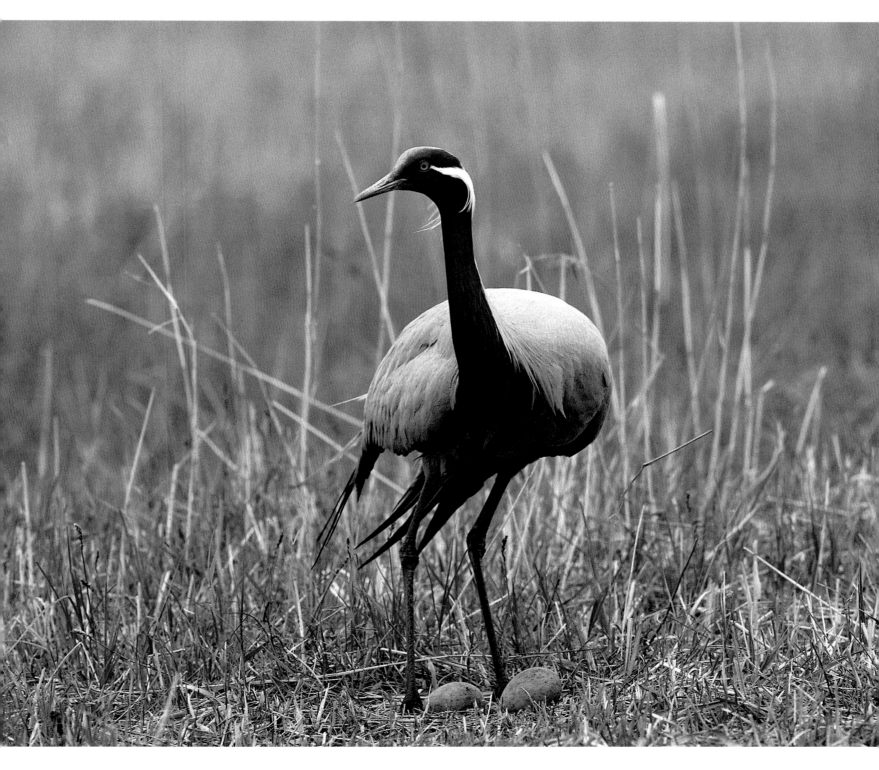

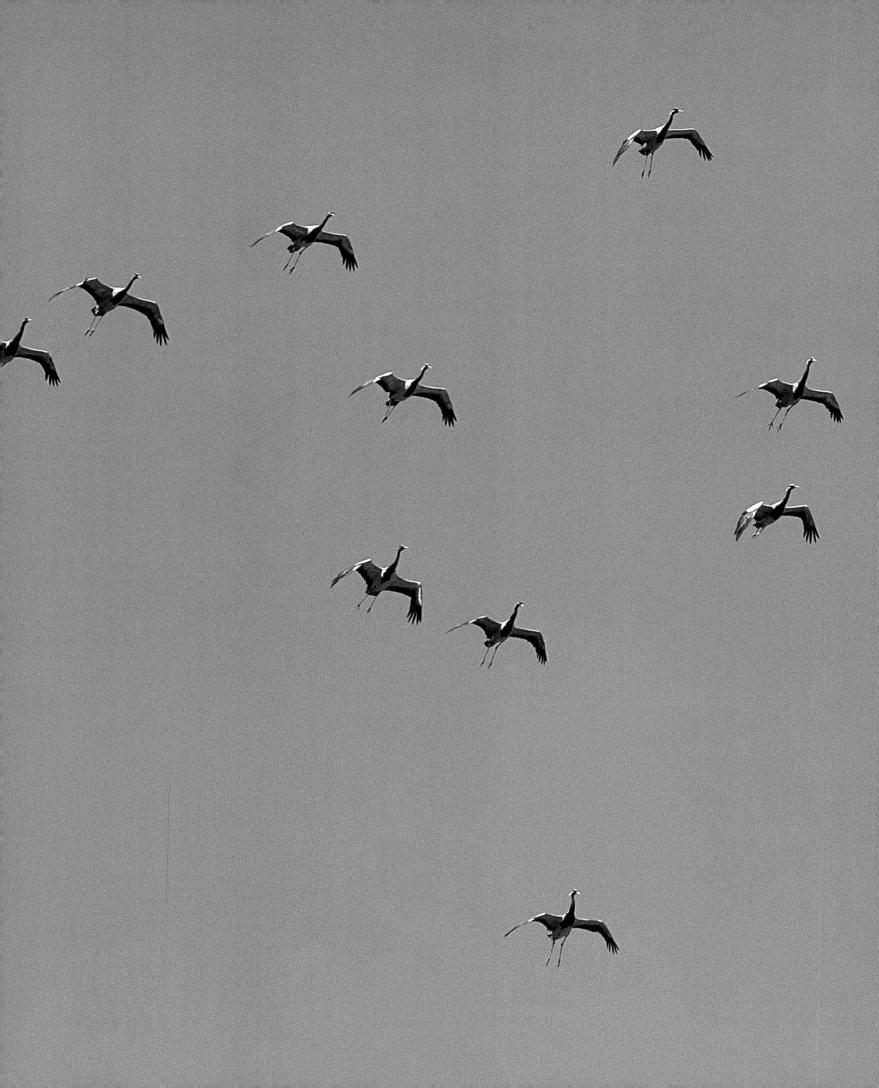

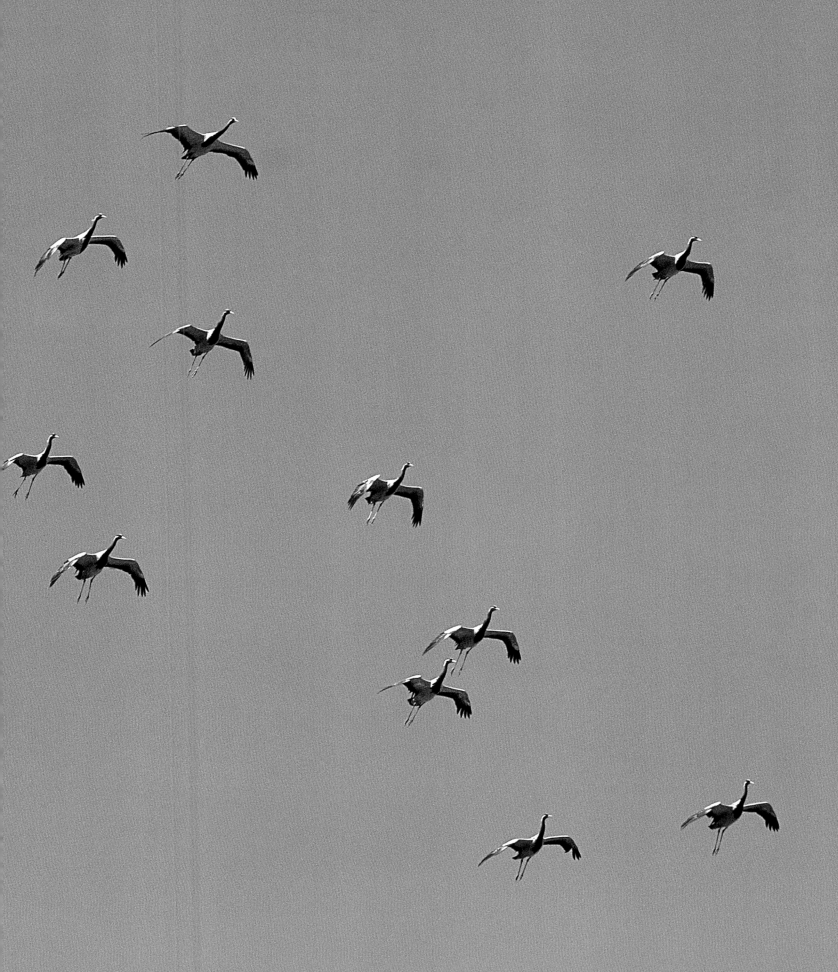

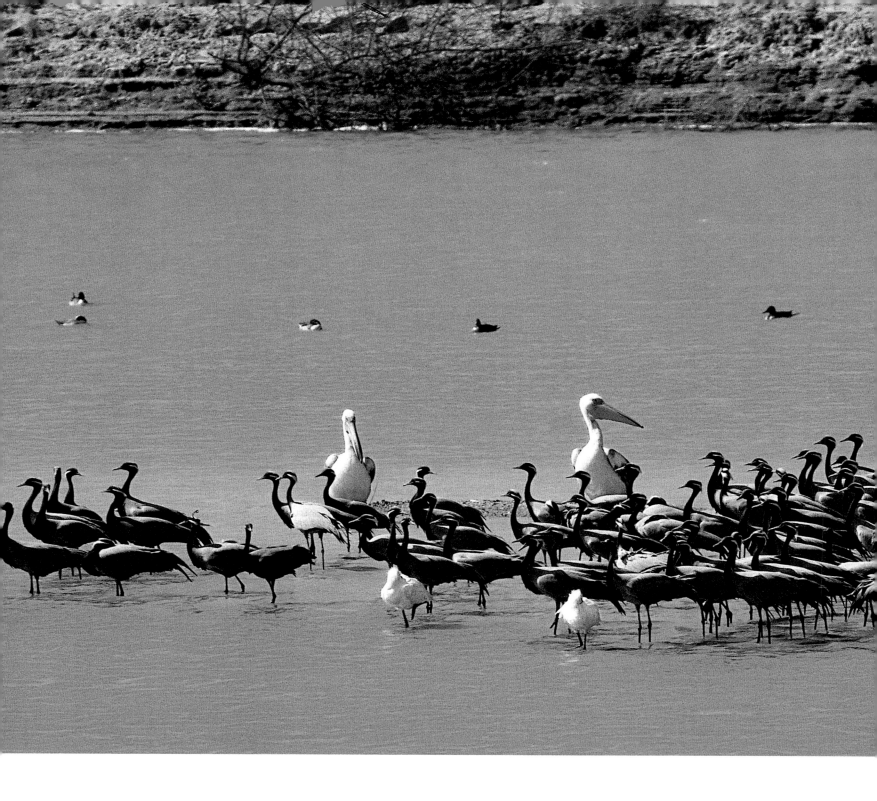

conditions, more than half of the total population of 200,000 to 300,000 Demoiselle Cranes will fly to Gujarat to winter. (For information about a special staging area for Demoiselle Cranes in the Thar Desert in neighbouring Rajasthan, see page 216.)

Right up into the nineteenth century, large numbers of Demoiselle Cranes went to breed in southeastern Europe; in the eighteenth century, they even migrated to Spain. A small population of breeding Demoiselle Cranes became extinct in northwest Africa as late as the twentieth century, and thirty to fifty breeding cranes are thought to have survived in Turkey. The species no longer occurs in Bulgaria or Rumania, and only a small number of these birds remain in the Ukraine. However, even in their core habitats in the steppes of the Kalmuk Republic, in Kazakhstan, in Mongolia, and in northeast China, the species is declining. In some regions these animals are trying to adapt to the man-made changes to their environment. But where the steppes are overrun with domestic livestock, there is little left for cranes to eat, or their clutches are trampled down and destroyed.

Reservoirs are particularly attractive to many birds when the water level is low. Demoiselle Cranes can be seen here together with pelicans and spoonbills (Little Rann of Kutch, Gujarat, India).

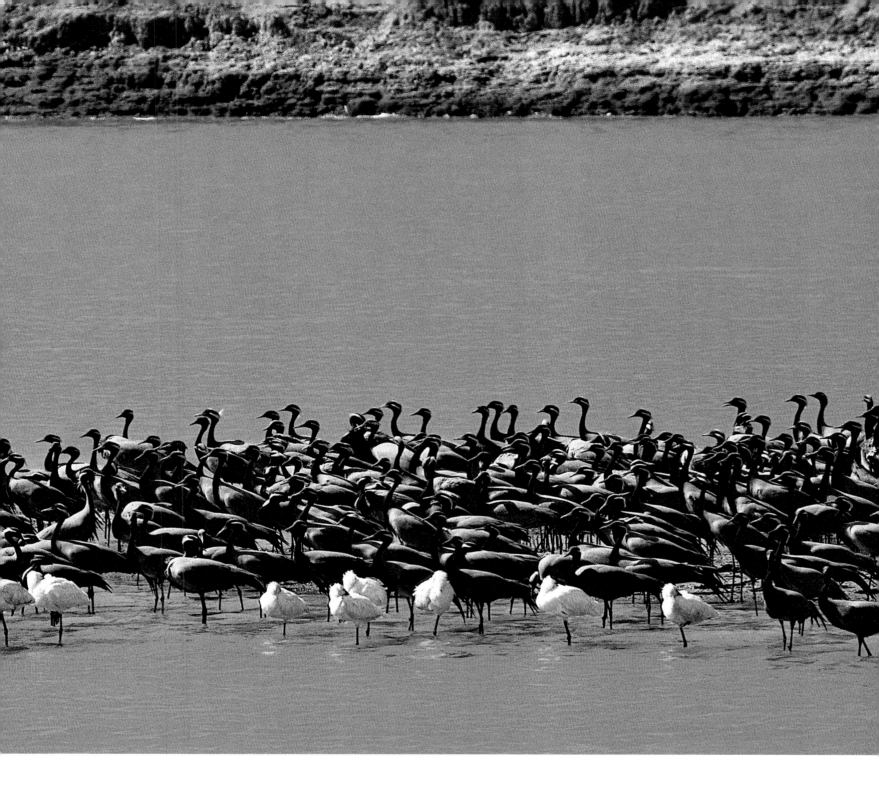

In locations where the steppes have been converted into arable land, the Demoiselles breed in cornfields, but usually without much success. As is the case with the Blue Cranes in South Africa, only a well-managed environment protection programme will lead to an improvement in breeding outcome. Moreover, the birds' safety along their migration routes must also be ensured. Each year, thousands of Demoiselle Cranes are shot or captured in Afghanistan, Pakistan, and the Sudan. But they are also hunted and their eggs are stolen from their nests in some areas of the countries where they breed. Were it not for all of this, Demoiselle Cranes should be able to thrive, since they are undemanding and do not need much to survive. They incubate their appealingly coloured eggs on the bare ground, and as long as there is water within a kilometre of their nesting grounds, they are content. Their incubation period is only about four weeks, and the young cranes fledge in less than two months. One hundred years ago, there were likely more than one million Demoiselles on three different continents.

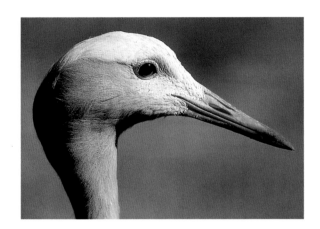

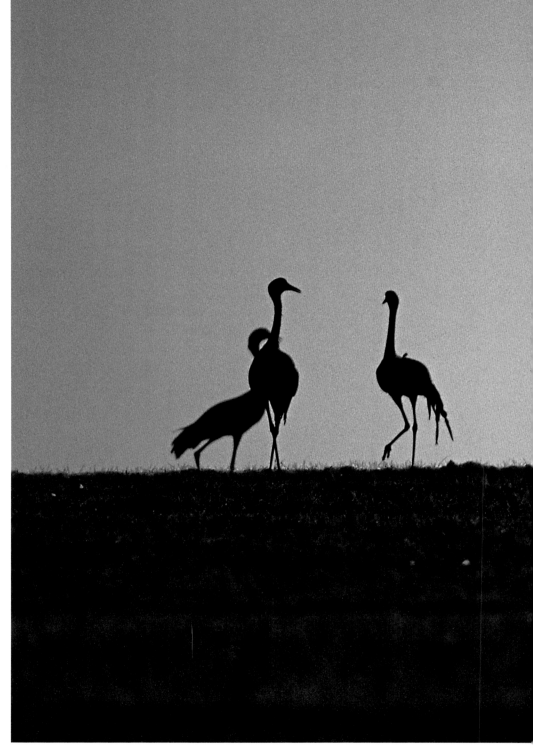

Blue Crane (Anthropoides paradisea):
The Blues Adapt to Agriculture

One hundred kilometres east of Cape Town, South Africa's national bird is experiencing a major come-back and seems, at least for the time being, to have escaped the threat of extinction. Until about 1990, the Blue Crane's chances of survival had been rapidly declining. Of the population of more than 50,000 Blue Cranes that had inhabited the area be-tween Transvaal in the north and Cape Agulhas in the south in 1960, only between 15,000 and 20,000 were left thirty years later. Wide-scale reforestation of grassland with fast-growing non-indigenous coni-fers and eucalyptus trees for timber production, and the transformation of grazing lands and fynbos regions into maize and wheat fields have caused rapid and decisive changes to the habitats of the South African population of Blue Cranes. (Fynbos regions are stretches of land in the Western Cape that originally extended over 70,000 square kilome-tres and still harbour a particularly rich diversity of plant life.) The birds have reacted by abandoning their breeding grounds, resulting in fewer offspring.

The fact that the number of Blue Cranes had risen to 25,000 as of 2006 is due to their adaptability and the success of conservation measures specifically tailored to their needs. Thus, if you visit Overberg for a few days at the end of May (i.e. during the South African autumn) as we did, and you are driv-ing through the wide-open landscape north of the imaginary line separating the Atlantic and Indian Oceans, you can hardly miss these beautiful bluish-grey birds. Everywhere, we can see groups of up to thirty animals or pairs with one or two fledged

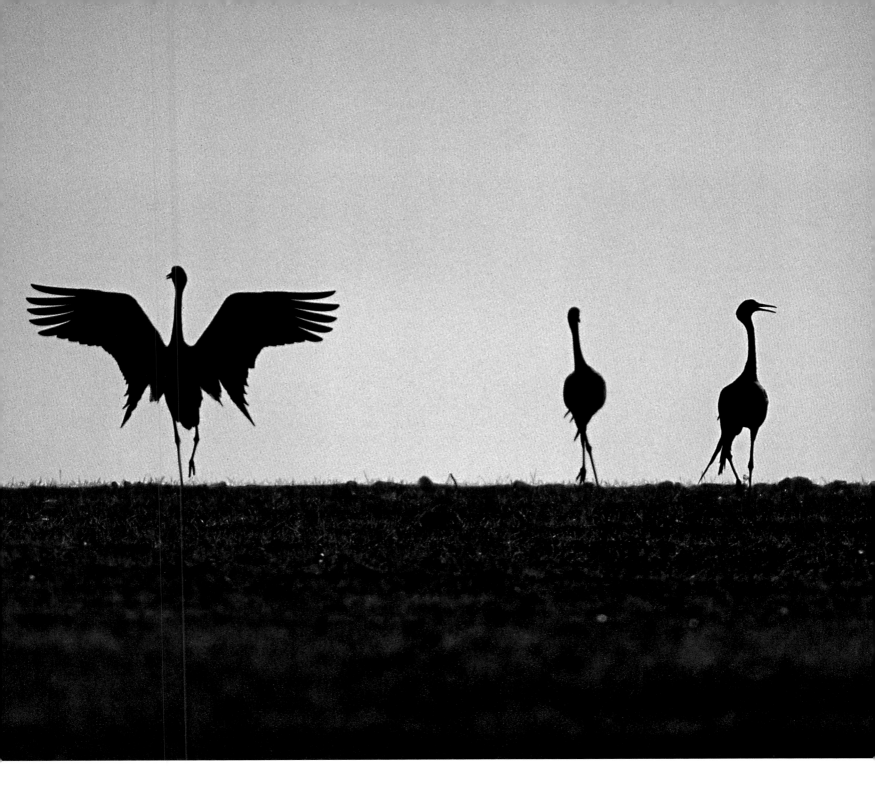

youngsters searching for food on the fields. And, regularly, we see some of the birds flapping their wings and jumping into the air. When they do this, you can see the feathers that earned them the attribute *paradisea* in their Latin name: the long tertials that reach to the ground. Many of the cranes are standing near dams, the water reservoirs dug by farmers every few kilometres. These are not only used for drinking, but also as roosting areas. Later, in the winter, the flocks can grow in size, numbering more than 300 birds. Although they are not migratory birds, these groups travel widely throughout the region.

The abundance of water is not the only reason why the Blue Cranes, which adorn every South African five-cent coin, occur in such large numbers in this region of the Western Cape. Indeed, like their closest relatives, the Demoiselle Cranes, they are not nearly as dependent on water as the other crane species. Blue Cranes usually breed on dry land, and, in spite of their elaborate camouflage (or, rather, because of it), they are exposed to a great number

of dangers. The many young ones here in Overberg, distinguishable from their parents by shorter secondary feathers and the absence of a white crown, are proof that Blue Cranes breed successfully in this agricultural environment. And this is mainly due to the efforts of the Overberg Crane Group, a section of the South African Crane Working Group, which, under the auspices of the national nature conservation organisation Endangered Wildlife Trust, has been working on behalf of all three species of South African cranes since 1995.

Right from the start, the project workers in Overberg and neighbouring Swartland focused their attention on the Blue Cranes. The conservationists realised that they could only make progress if they cooperated with the farmers. No one knows this better than Wicus Leeuwner, the chairman of the Overberg Crane Group, himself a farmer—and a successful photographer to boot. He has even named his property Blue Crane Farm. Wicus and his team have managed to convince many farmers and their workers to join the alliance. Since Blue Cranes have been laying their eggs in cornfields and on sheep pastures with increasing frequency, the task has not been to keep the location of the nests a secret, as is usually the case. On the contrary, the people who work the fields with machinery or shepherd the sheep need to know where the birds, huddled close to the ground, are nesting. This is the only way that farmers and workers can avoid damaging the nests. Because thousands of people are now enthusiastic about promoting Overberg as Blue Crane Land, and because particularly vigilant farm workers are sometimes even given small rewards, the number of Blue Cranes is growing and its population is even spreading out geogra-

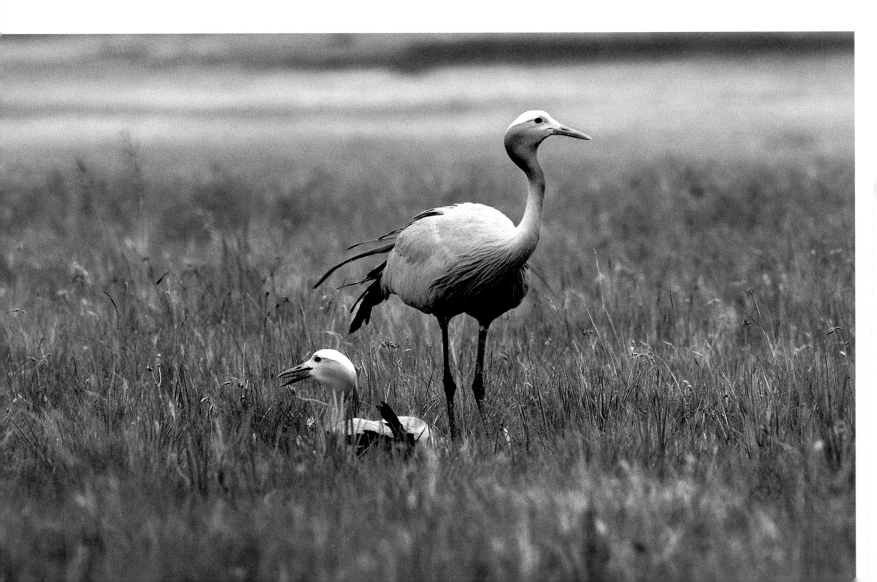

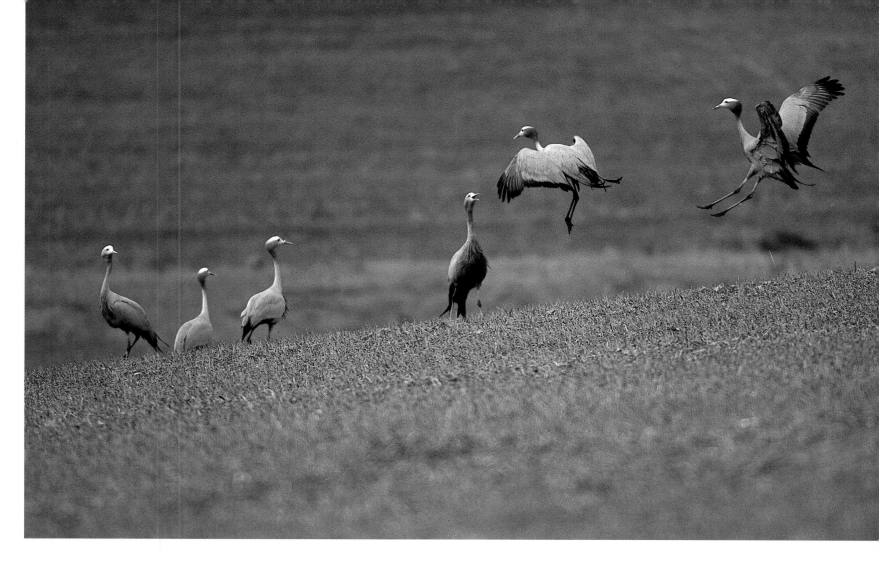

phically. In six other provinces, similar groups have
been formed, such as the Karoo Blue Crane Educa-
tion Programme, the KwaZulu-Natal Crane Foun-
dation, the Highlands Crane Group, and the Kwande
Crane Conservation Programme.

But these 'Stanley Cranes', as these 100-centi-
metre tall birds often used to be called in the past,
require more of humans than simply having their
nests treated with care. When the chicks hatch after
a thirty to thirty-three day incubation period, they
initially require vegetation rich in insects and seed,
not a monoculture drenched in chemicals. Only
a variety of crops, like those found on the many
thousand-hectare farms of Overberg, in conjunction
with an intact natural environment, can provide
what the young birds need. And when the cranes
nest in the vicinity of housing settlements, it is
important that dogs not be allowed to roam freely.
This is because young Blue Cranes do not fledge
until they are three to five months old, making them
easy prey for land-based predators. On the huge

fields, at least, the parent birds usually have mat-
ters under control—another reason for their success
in breeding. However, coexistence with agriculture
also has its dangers: some Blue Cranes get their
legs caught up in left-over bale twine, which can be
fatal. And in other areas of the country, cranes are
still being killed with poisoned corn. The positive
developments in Overberg must not make us blind
to the fact that Blue Cranes have been driven out
of many of their former habitats in the north of
South Africa. And the small, isolated population of
sixty to seventy birds in Namibia's Etosha Pan, which
together with a few other birds in the Swaziland
border area are the only Blue Cranes to exist out-
side of the South African Republic, cannot thrive
because of the lack of adequate habitats.

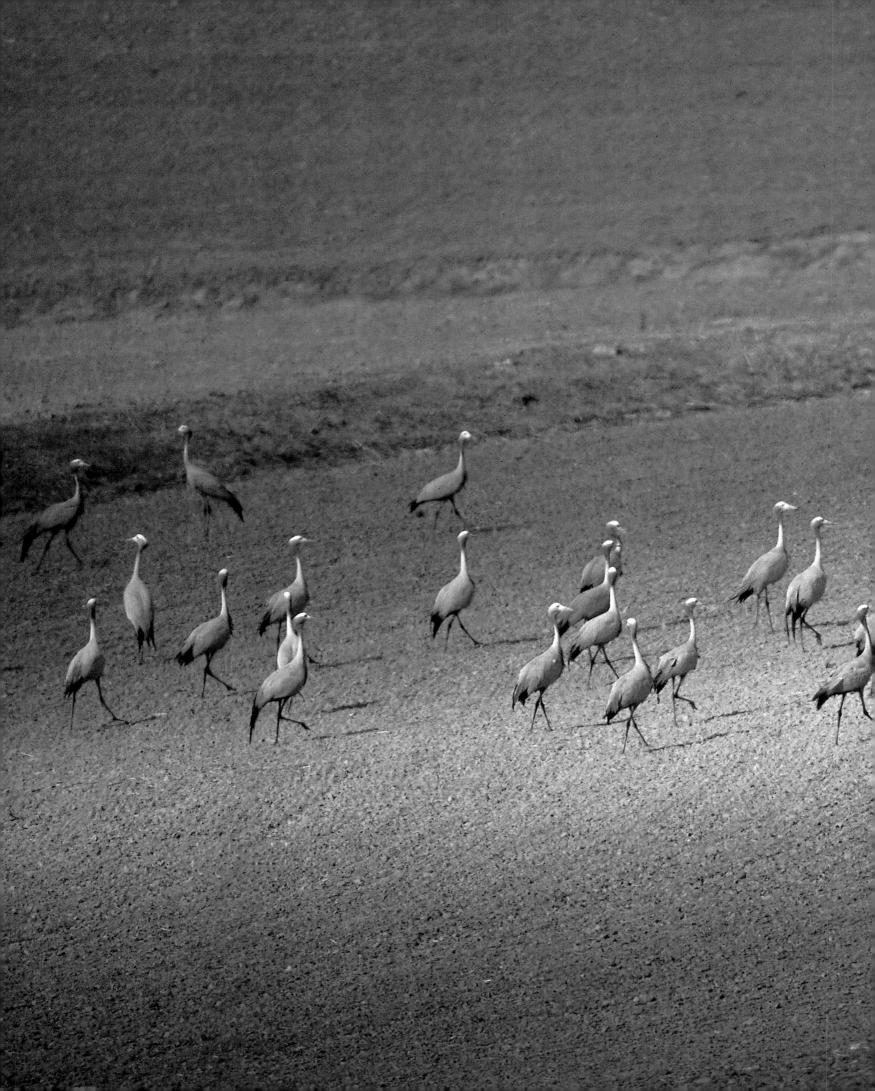

The lakes are still frozen over when these Siberian Cranes begin to explore their breeding grounds on the tundra near the Arctic Ocean. They have little more than three months before they have to return south with their chicks (Kytalyk Nature Reserve, Allaikha Ulus [district], Yakutia, Russia).

FOLLOWING DOUBLE PAGE
Two tiny white dots in the seemingly endless tundra landscape—seen from a helicopter, these are the first indication that a pair of Siberian Cranes have established their territory here (Kytalyk Nature Reserve, Allaikha Ulus [district], Yakutia, Russia).

the only food they can find in the treeless, shrubby tundra during the first weeks are berries left over from the previous autumn. Should a careless lemming cross their path, the cranes will not ignore him either. Later on, if the vegetarian menu is still too skimpy, they will eat, in addition to small mammals and insects, the occasional fish or amphibian. If spring and summer start late, breeding may not take place at all that year.

'Kytalyk' is the Yakutian name for the Siberian Crane, and it is also the name given to the 1.6 million hectare nature reserve the Yakutian government established in 1997 with help from WWF. The sanctuary lies south of the East Siberian Sea, between the Indigirka and Kolyma Rivers. About 800 of the approximately 3000 Siberian Cranes

that constitute this eastern population breed exclusively in northern Yakutia, and they also winter exclusively in China in the watershed of the Yangtze River, the 'father of all rivers'. Very little was known about this eastern population until Chinese naturalists discovered the Siberian Crane's wintering grounds in the Poyang Lake basin in 1980. Until then, all crane experts believed that there were only a few hundred Siberian Cranes left: a central population of around 200 birds which, in 1965, were wintering in what is now Keoladeo National Park in Rajasthan, India, and a western population of a few dozen birds migrating between the marshlands east of the Urals and the southern tip of the Caspian Sea in Iran. Today, not a single Siberian Crane winters in Keoladeo National Park; the central population,

which once had its breeding grounds on the lower reaches of the Ob River and the Kunovat River basin, appears to be extinct—wiped out by hunters in Russia, Kazakhstan, Uzbekistan, Turkmenistan, and, above all, Afghanistan and Pakistan. These are the countries the cranes had to cross over on their 5000 kilometre journey to northern India. The western population, which used to breed 600 kilometres further south, has also been decimated. In the winter of 2005/2006, a grand total of two Siberian Cranes were counted in Iran. A captive-raised Siberian Crane named Suna was released in the vicinity of these two unpaired, lone birds. Suna bonded with one of the birds, and in the spring, she left with him on their migratory journey.

Apart from intensive measures to protect Yakutian breeding grounds and especially the Chinese wintering areas and the important stop-over sites along the migration route, a massive project has recently been launched. Its aim is to repopulate the former breeding grounds of the Siberian Crane east of the Urals with a self-sufficient population that will either use the old migratory routes and destinations or find new, secure flyways and wintering grounds. The United Nations Environment Programme (UNEP), with support from the Global Environment Facility (GEF), has pledged 10 million US dollars, and participating countries and organisations have agreed to contribute 12 million US dollars to establish a network of wetlands and favourable migratory corridors in Asia for Siberian Cranes and other migratory waterbirds. The project, under the auspices of the International Crane Foundation, has a time-frame of more than a decade, and Bonn's UNEP office, which oversees the Convention on the Conservation of Migratory Species of Wild Animals (CMS), has reached a so-called 'Memorandum of Understanding' with the eleven countries along the migration

route. In the autumn of 2006, and emulating, in part, the American Whooping Crane project, young Siberian Cranes raised in captivity, but without direct human contact, are to be guided from West Siberia to the wintering grounds or staging areas with the help of light aircraft. Crane conservationists hope that the captive-bred birds will join their wild counterparts. In recent year, Siberian Cranes bred at the Oka Biosphere Reserve have been reintroduced to the wild at staging areas used by the last female members of their species still living in the wild, as well as by Eurasian Cranes.

It is hoped that the birds will return on their own and that their migratory instincts will guide them independently in the following winters—and, of course, that they will find partners and breed within a few years. One of the most important components of this ambitious plan is to raise awareness among the people who live along the migratory routes and to monitor this corridor. There is a lot of work to do.

The Siberian Crane's main wintering grounds on the lower reaches of the Yangtze River were not discovered until 1980. The Chinese authorities subsequently designated some of the lakes and flood areas as sanctuaries, but the growing human population is nevertheless making life difficult for the countless birds, including the four species of cranes that winter in the region. (Poyang Nature Reserve, Jiangxi Province, China).

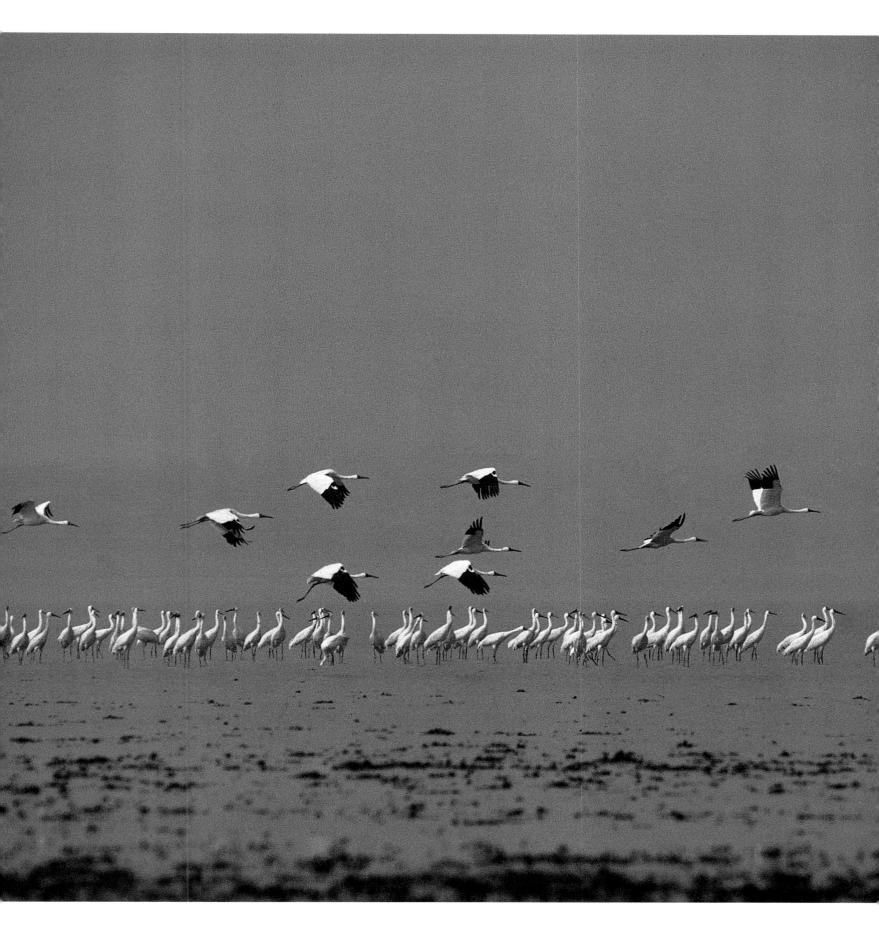

Sandhill Crane *(Grus canadensis)*: Widely Distributed in Six Subspecies

The difference could not be greater. It is the end of March, and only two days ago, as we travelled at a leisurely pace through the nature reserves of Wisconsin, we were able to watch several pairs of Greater Sandhill Cranes *(Grus canadensis tabida)* on their breeding grounds. Whilst performing their courtship rituals with their broad array of postures, the birds made sure that no other crane would enter or fly across their territory. Today, just before dawn, and almost a thousand kilometres further southwest, we are sitting in a so-called viewing blind set up by the Platte River Trust in Nebraska. Just 200 metres in front of us, several thousand Sandhill Cranes are standing side by side on the riverbed. Here, unlike on the breeding grounds, there is no hint that the birds could be bothered by territorial boundaries. They have spent the night on sandbars and in the shallow water and are now preparing to depart, shaking their plumage, flapping their wings, and striding about restlessly, their deep, hoarse calls increasing in frequency.

Even before the first rays of light reach the poplars on the river bank, the prolonged departure begins, the flocks heading for meadows, pastures, and harvested maize fields within a thirty kilometre radius. Even though flocks and family units of these grey and brown birds are constantly taking off, more than half an hour passes before the river bed is deserted, apart from about two dozen stragglers. In the evening they will all return. However, in several days' time, the whole congregation will be gone, the birds' V-formations heading for the breeding grounds in the north.

For as long as people can remember, Sandhill Cranes (and some Whooping Cranes) have used the Platte River as a staging area each spring for several weeks. Conservationists are always having to fight to ensure that this increasingly strained river system, so important to the cranes, will not be completely drained of its water. Here, on this 60 kilometre stretch of river between the towns of Grand Island and Kearney, not far from Highway 80, the world's largest gathering of cranes takes place every year between late February and early April. Three of the six subspecies of Sandhill Cranes are migratory, and these three subspecies congregate here in close quarters. 'Try to identify the three types,' my American crane friends whisper to me while we are in our hideout by the Platte River, adding, with a smile, that even they would be hard-pressed to distinguish between them. But if identifying these different subspecies is possible anywhere in the wild, then this would be the place.

Of the more than 400,000 cranes that stop off here each spring, the Lesser Sandhill Cranes *(Grus canadensis canadensis)* account for about ninety percent. The Little Browns—as they are sometimes called to differentiate them from the others—have a decidedly brownish plumage, and at ninety centimetres

This pair of Greater Sandhill Cranes are keeping their territory occupied in autumn, even though they have not produced any offspring. In doing so, they defend their territories against members of their own species until departing. After returning from their wintering grounds, the cranes will try to reoccupy this patch of land as quickly as possible (Necedah NWR, Wisconsin, USA).

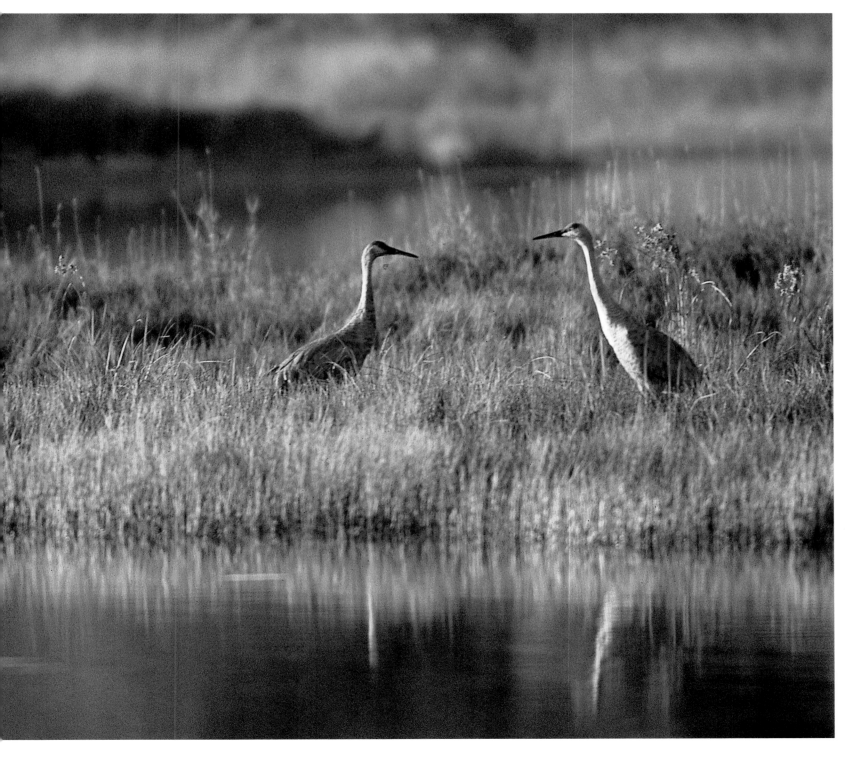

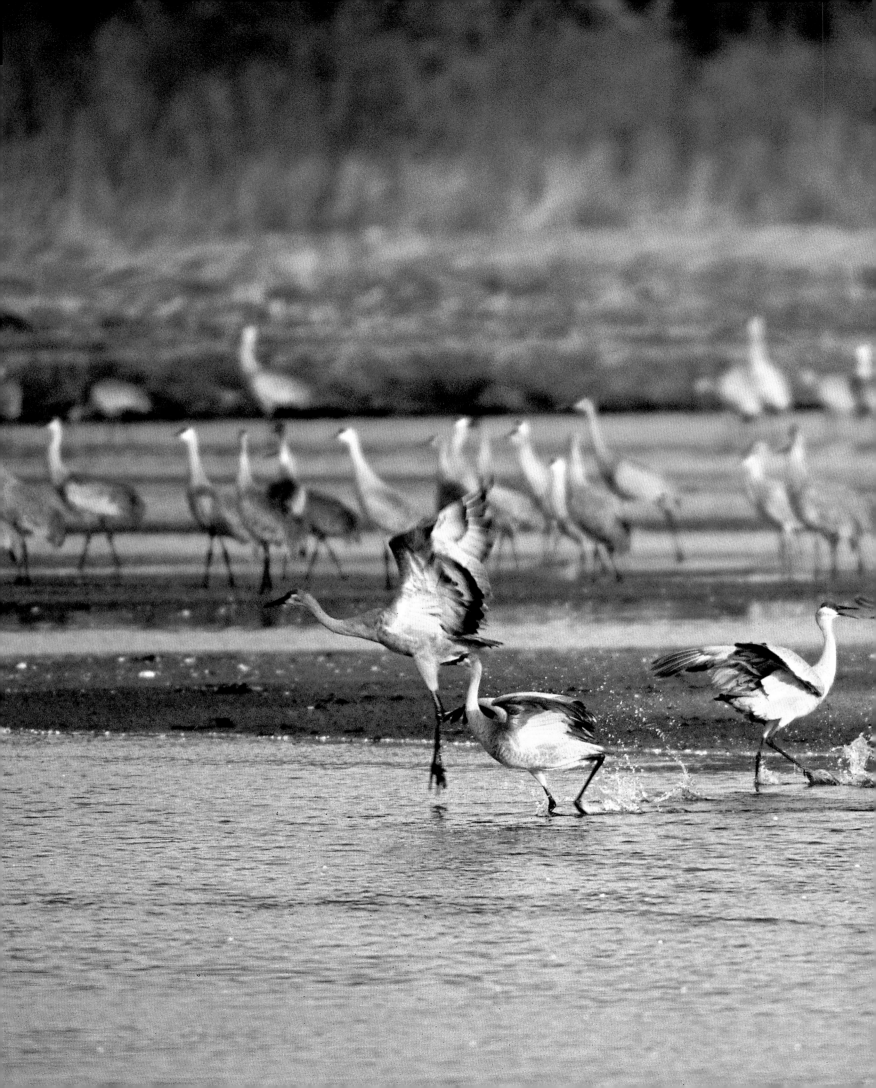

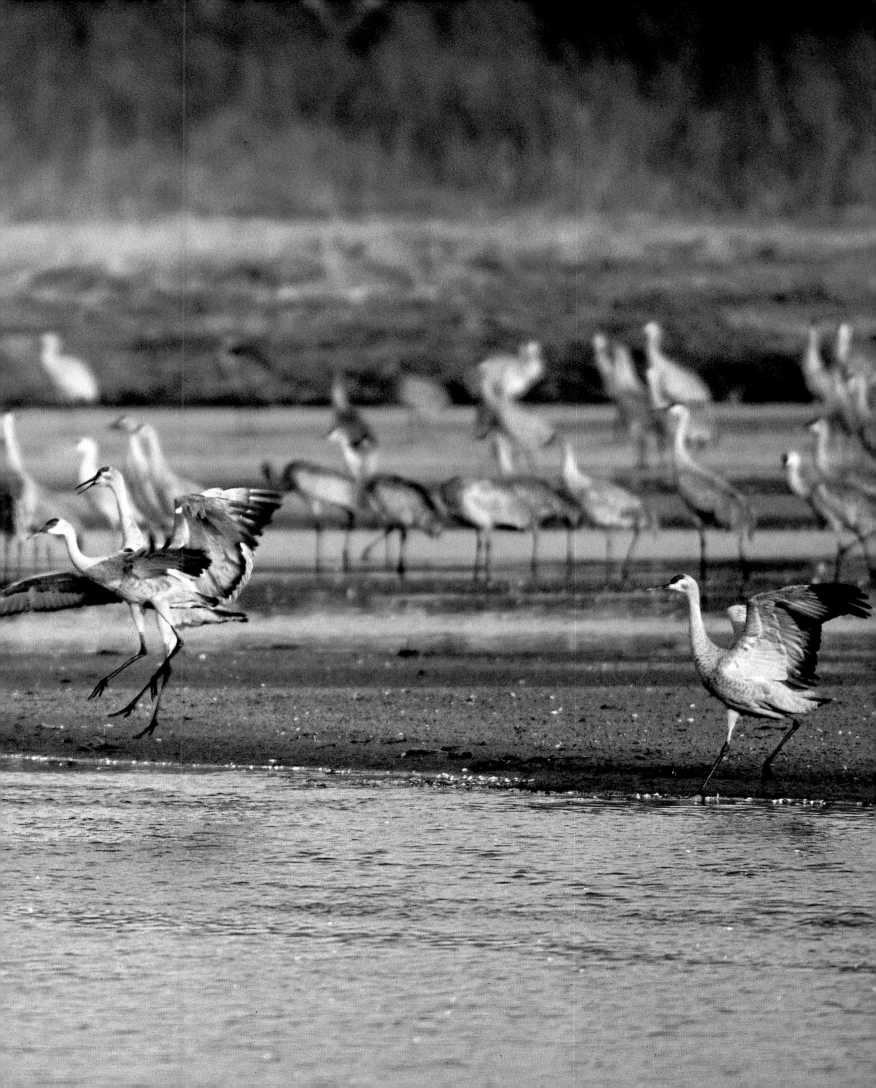

in height, they are twenty centimetres shorter than the more grey-coloured Greater Sandhills. The Canadian Sandhill *(Grus canadensis rowani)* is larger than the Lesser Sandhill, but smaller than the Greater Sandhill. It is a hybrid of the latter two, and some zoologists do not recognise it as an independent subspecies. Since some Canadian Sandhills resemble the Lesser Sandhills, while others look more like the Greater Sandhills, they are difficult to spot. And since they do not worry about keeping separate from the other species—no matter whether they are 'en route', on their wintering grounds in the US, or on their breeding grounds (mainly in central and northwestern Canada)—there are no exact data about their geographic distribution or their numbers. Their breeding grounds lie roughly between those of the Greater Sandhills (northern United States and southern Canada) and those of the Lesser Sandhills (the Canadian Arctic, Alaska, and Siberia). The International Crane Foundation estimates that there were 450,000 Lesser Sandhill Cranes in 2006. Those that migrate twice each year between the Lena Delta in Siberia and the north of Mexico and south of New Mexico and Texas do not have a lot of time to breed and raise their young. Only three months after hatching, when the birds leave the tundra to embark on their 8000-kilometre-long journey, they still look like large chicks. All the nourishment they can find under the midnight sun is initially channelled into strengthening their flight muscles. The 65,000 to 75,000 Greater Sandhill Cranes have an easier task, since they do not have to travel as far. They are divided into four populations: two western ones, based mainly in the Rocky Mountains, winter in California, New Mexico, and Texas; a central, prairie population winters in Texas; and an eastern Great Lake population winters primarily in central Florida. Thanks to intensive conservation measures, their numbers have increased considerably in the northern United States over the past fifty years. And although they are no longer regarded as endangered, they are not hunted, unlike the Lesser Sandhill Cranes (see pages 218–221). There are three non-migratory subspecies of Sandhill Crane: the Florida Sandhill Crane *(Grus cana-*

densis pratensis), which is similar in size to the Greater Sandhill and has a stable population of about 4000 birds spread between central Florida and southern Georgia. The second is the smaller Mississippi Sandhill Crane *(Grus canadensis pulla)*, whose population consists of 130 birds which live primarily in the specially created 6000-hectare Mississippi Sandhill Crane National Wildlife Refuge. This is the most endangered subspecies, and attempts are being made to boost its numbers by means of reintroduction programmes. Finally, there is the Cuban Sandhill Crane *(Grus canadensis nesiotes)*, whose population of about 300 birds has been stable

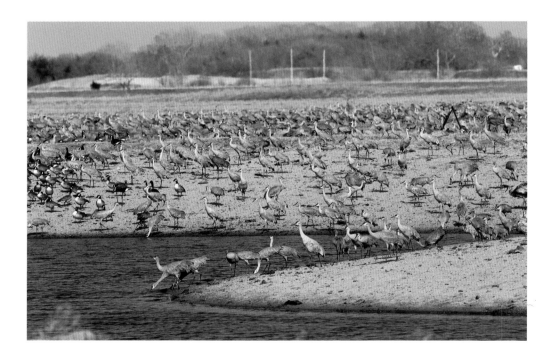

for many years thanks to conservation measures mainly on the Isle of Pines, but also in some areas of the main island and on several small islands of the Cuban archipelago.

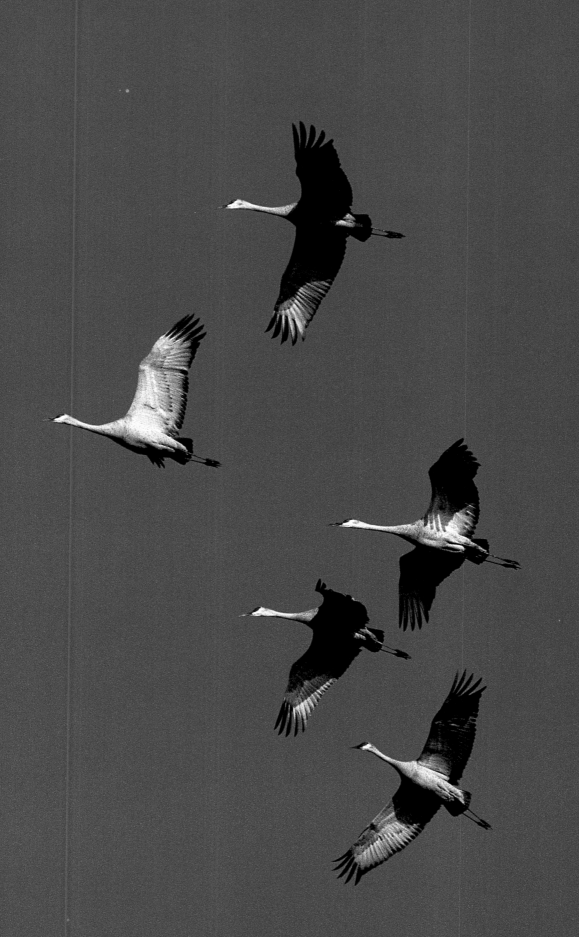

Sarus Crane (*Grus antigone*): Rice-paddies Are Not Safe Places in Which to Breed

The surroundings could not be more appropriate for the largest of all cranes. The two adult birds look extremely elegant with their silver-grey plumage, the almost white tertials covering their tails, the shiny red skin on their heads and necks, and their pink-coloured legs. After a few minutes, we make a pleasant discovery: the particularly large male (about 180 centimetres tall) and the slightly smaller female are escorting two, roughly four-week-old, brown-coloured youngsters through the high grass. This is what we were secretly hoping to see, now, in mid-November. Sarus Cranes breed during the monsoon period and remain with their offspring for more than a year; the young ones can fly after about three months. While dining on insects they glean from the ground or off the reeds, all four family members wander about between two distant temples, as though this were the only fitting setting for them. And indeed, for these Sarus Cranes, the sacred Buddhist shrines are a part of the daily

scenery. They are wild birds living in the 100 hectare Lumbini Crane Sanctuary, right next to one of Nepal's main pilgrimage destinations. If all people were Buddhist monks, Sarus Cranes—and all other animals—could lead their lives undisturbed by humans. But since this is not the case, the population of this largest of all flying birds has suffered severe setbacks on the Indian subcontinent. In 2001, the bird protection organisation Birdlife International estimated that the number of Sarus Cranes today is, at best, ten percent—and probably closer to five, and maybe only two and a half percent—of the number that existed in 1850.

Rajendra Suwal has accompanied us from Kathmandu to what is thought to be Buddha's birthplace in order to show us the area with the greatest number of Sarus Cranes in Nepal. About 100 cranes live in this 150 square kilometre region located five hours southwest of the Nepalese capital by car. These birds probably represent more than half the Sarus population in the whole country. Each year, some fifteen pairs breed in this area, which is largely dominated by corn and paddy fields; two particular pairs regularly breed inside the sanctuary. The young biologist Suwal is proud that he and his co-workers, whose project is supported by the International Crane Foundation, have managed over the space of several years to convince a large number of farmers to let the cranes roam freely on their fields. It is even more of an achievement if we consider that many inhabitants of this fertile region emigrated from nearby India and are not Buddhists. But the Hindus here also take care of their cranes: one day, near a village, as I am aiming my camera's long zoom lens at a pair of Sarus Cranes and their already fledged young one, several villagers come running up to me with worried expressions on their faces, because they fear that I am about to shoot the birds.

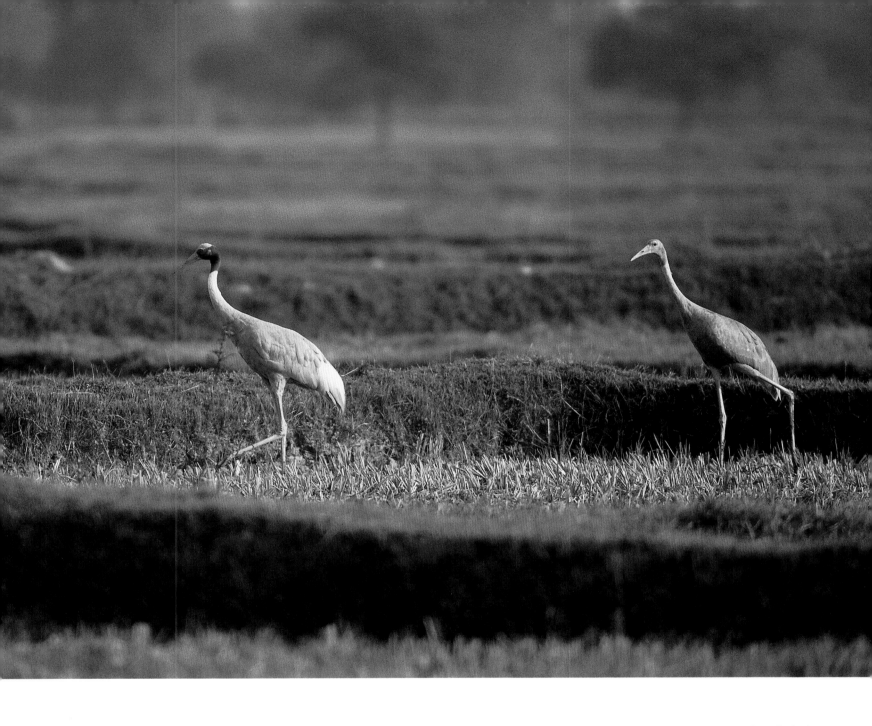

This young Sarus Crane appears to be larger than its parents. This is because the already fledged youngster has relatively long legs in comparison to its body, which is still developing. The parents will look after it for about a year (in the vicinity of Lumbini, near Bhairawa, Nepal).

Incidentally, the name Sarus is derived from a Sanskrit term meaning 'belonging to the water'. How Carl von Linné hit upon the Greek heroine Antigone when he gave the crane its scientific name remains his secret. However, his choice of terms did give rise to the name commonly used in Germany at one time: 'Antigone Crane'. Because of the bright band on the bird's neck beneath the area of red skin, the crane also used to be called 'Halsband-Kranich', or 'Collared Crane' in German.

Along with Assam, in India, Nepal is the most northerly habitat of *Grus antigone antigone*, the Indian Sarus Crane. It is the largest of three subspecies, can grow to weigh more than eight kilograms, and was once common throughout many regions of

northern India, including what is now Bangladesh and Pakistan. It is thought that only about 8000 to 10,000 of them exist today. Their southern habitats extend into the eastern regions of the state of Maharashtra near the town of Chandrapur in the central area of the subcontinent. Larger numbers of the Indian Sarus Crane, though their populations have declined strongly over the past twenty years, can be found in Rajasthan and Gujarat. About one-third of the total population is to be found in Uttar Pradesh.

Because natural wetlands are becoming increasingly rare, pairs tend to choose rice paddies for breeding during the monsoon season. Sarus Cranes build large nests on the ground, and because they

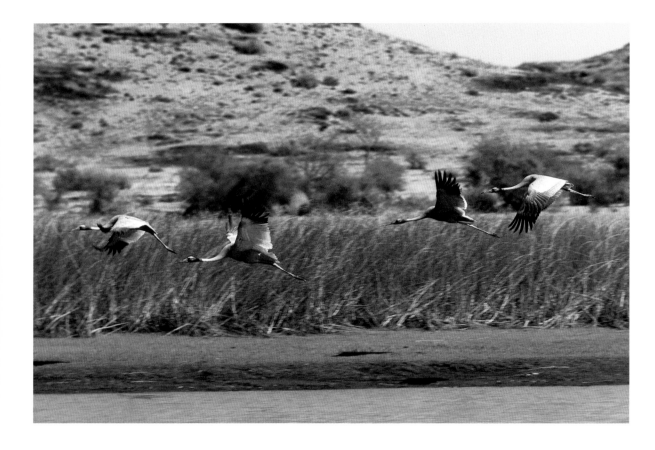

LEFT
Outside the breeding season, Sarus Cranes tend to form small groups that travel back and forth between suitable loafing sites. These large birds look impressive in flight, as well (near Rajkot, Gujarat, India).

trample down all vegetation in the vicinity of their nests, farmers are not particularly fond of them. Nevertheless, since many people who live on the land regard these birds as sacred, they will not kill them. But they do often plunder or destroy the nests. Moreover, Sarus Cranes frequently die from the poison that farmers have spread out for rodents: since these birds are omnivores, they use their long bills to eat mice and young rats that have eaten the poison, which often proves fatal. Thanks, in large part, to Gopi Sundar, Indian conservationists have launched a number of initiatives to protect the species in recent years.

The Eastern, or Burmese, Sarus Crane *(Grus antigone sharpii)* is smaller and has darker plumage than the Indian Sarus Crane. The population is estimated to be no larger than 1000 birds, and these are considered highly endangered. The Burmese Sarus Crane's habitat used to stretch as far as Yunan in China, but nowadays, during the breading season, it only inhabits small areas within Myanmar, Laos, and Cambodia. Outside the breeding season,

several hundred birds fly to Tram Chim National Park, located in the Mekong delta region in Vietnam. Like other cranes, the Eastern Sarus likes to eat the grass tubers of the genus *Eleocharis* that grow there.

The third subspecies, the Australian Sarus Crane *(Grus antigone gilli)*, was only recognised as an independent species by ornithologists in 1966. These birds, of which only about 5000 are left, are a little smaller and lighter in colour than the Eastern Sarus Cranes. Before they were discovered and categorised as an independent subspecies, ornithologists thought, for a time, that they were Australian Brolgas. Later, they were erroneously taken to be Eastern Sarus Cranes. The members of *Grus antigone gilli* inhabit the northern region of the continent, and their preferred diet, when they are not eating arable crops, are the tubers of wetland grasses.

RIGHT
Sarus Cranes have to bend down low to eat and drink since the largest members of their species can reach up to 180 centimetres in height when standing upright. They are, in fact, considerably taller than any other birds capable of flight (Keoladeo Ghana National Park, Rajasthan, India).

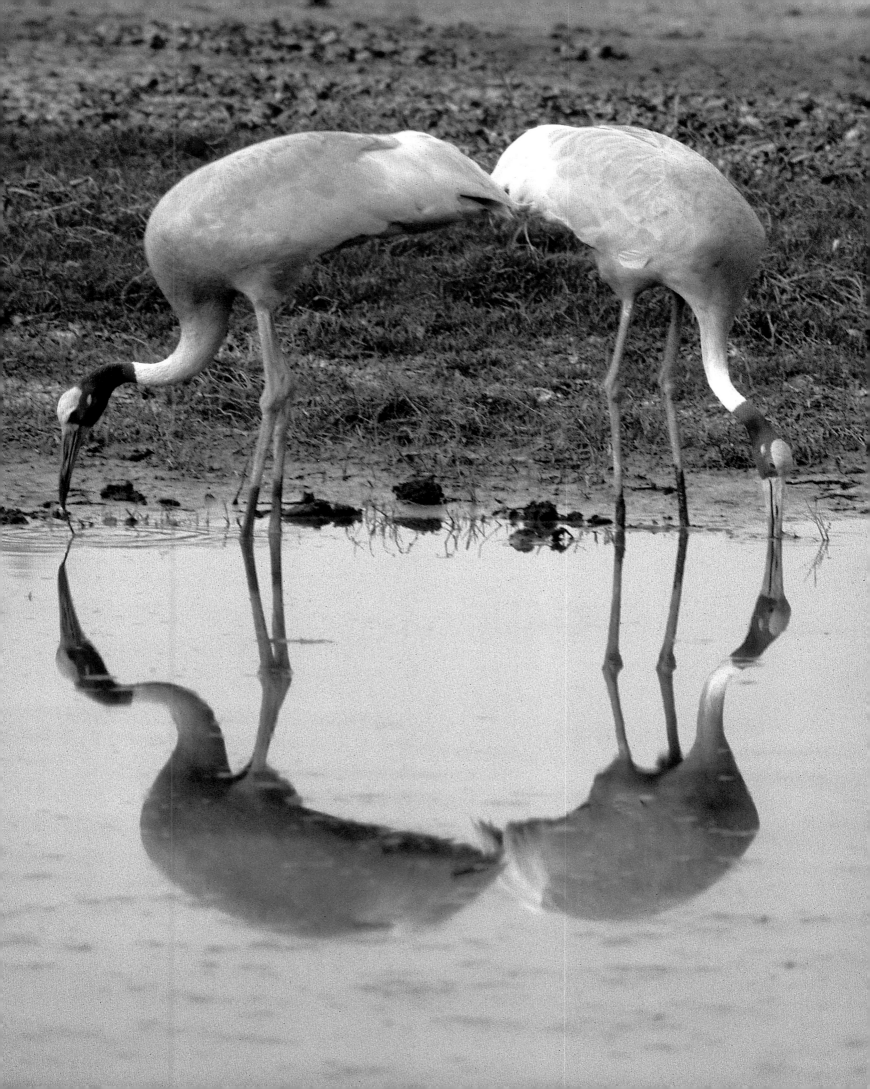

Australian Crane, or Brolga (Grus rubicundus): For a Long Time, Their Population Was Thought to be Larger

Even as the fifth large passenger jet roars by eighty metres over our heads as it approaches the runway, we cannot help but flinch. The ten Brolgas before us, however, are not perturbed by the noise in the least, nor does the turbulence created by the plane's engines seem to bother them. They are standing on a mowed field in a nature reserve in Queensland, 500 metres from the Pacific coast and barely 200 metres away from the airport of Townsville. As is the case every year, several flocks spend some weeks in this area during the dry season, roaming between the brackish waters of the Great Barrier Reef and the runway. They have everything they need here: during the daytime, they feed on the grain, rice, and soybeans that the environmental authority has planted especially for them and other birds, and at night they have a safe abode in the shallow coastal lagoons, where they can also find plenty of snails, crabs, and all sorts of other small animals. Here, people leave them alone, and they have long since become accustomed to the low-flying aircraft. My friends with international experience had told me that this was where I should go if I wanted to be sure to see the Brolgas, as the Australians call them (see p. 180), close up.

And, indeed, you have to get quite close to the Brolgas to be able to distinguish them from the Australian Sarus Crane, the smallest member of the Sarus species. True, the Brolgas, which grow to a maximum height of 125 centimetres, are about twenty centimetres smaller than the Australian Sarus on the average. But a well-grown Brolga male is hardly shorter than a female Sarus Crane. The two species' colouring is also similar. The Brolga's pearl-grey plumage is somewhat lighter, and its body—at least when its wings are folded—is darker since its secondary feathers are not as light as those of the Sarus Crane. The Brolga's legs are also dark, whereas the Sarus Crane has red legs. However, the best way to distinguish between the two species is to look at their heads: the Brolga's naked red skin does not extend as far down the neck as it does with the Sarus; and the round grey feathered patches on each side of the Brolga's head and its grey forehead are more pronounced. Finally, unlike the Sarus Crane, the Brolga has a little red pouch of skin on its throat. The Brolga's call is also deeper. But the many fine distinctions tend to get watered down when members of these two species pair together, which is not uncommon. When this happens, one of the two partners will have to make compromises. Brolgas, for example, build their nests on open wetlands, whereas Sarus Cranes prefer areas between trees and bushes. In both cases, however, the nest must be surrounded by water. Breeding always takes place during the rainy season, and incubation lasts between four and five weeks, depending on the number of disturbances. After

RIGHT
Brolgas can exchange nesting duties in less than a minute—at least, some pairs go about this in a very business-like manner. Here, relieved of duty, one crane has already taken up position over the eggs as the other strides off (Serendip, Victoria, Australia).

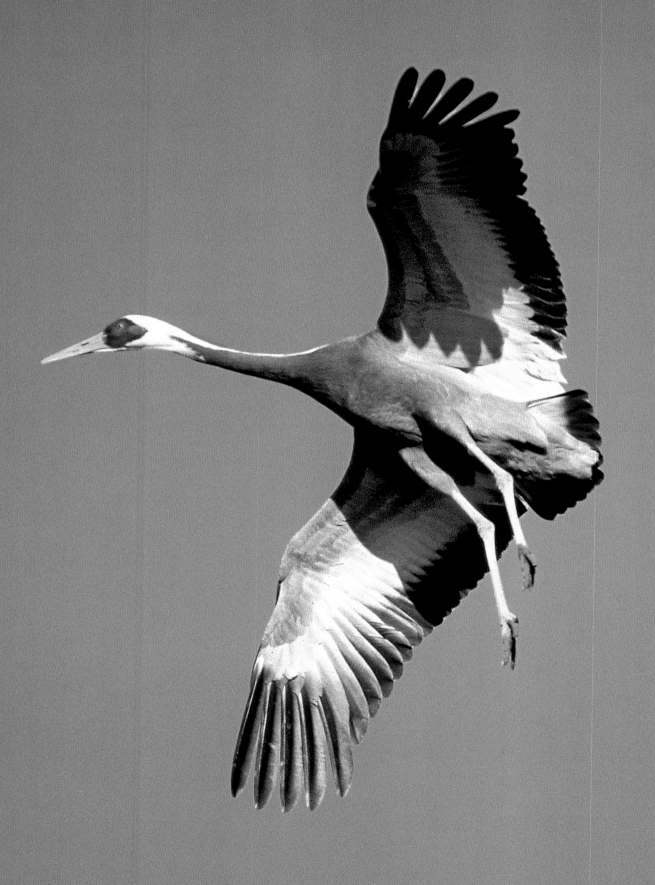

The same applies to their breeding grounds, which extend from the area south of Lake Baikal, across Mongolia, the area around the Amur and Ussuri Rivers, and southern Manchuria into the province of Jilin. Twice yearly, White-naped Cranes fly long distances between their wintering grounds and their summer habitats, though this achievement does not represent a record within the family of cranes. When they arrive at their breeding grounds in late March—or in April if these are further north—the pairs like to keep their distance to others. The nests are built at least a kilometre apart. This is the only way to ensure that the families do not have to compete for the broad range of plants and animals upon which they feed. Because of human encroachment, many suitable wetland areas have shrunk so dramatically that they can only sustain one pair of White-naped Cranes and their offspring. Finding four or five pairs in a single reed-covered area, as on Lake Chanka, is a rare occurrence.

Even if the conditions in spring seem favourable—i.e. the birds build a well-camouflaged nest in high vegetation, the female lays two eggs, and both partners incubate—it is still no guarantee that the young ones will survive. Often, farmers and shepherds burn down reed and grass plains in the spring to enhance the growth of fresh plants. Many nests are destroyed in the process, and frequently chicks die in the flames. In Inner Mongolia (China) and in Mongolia, where experts believe the majority of the White-naped Cranes' breeding grounds to be located, the increasing number of livestock is detrimental to the fields, and thus also to the cranes. For this reason, the authorities have, in recent years, established a number of protected areas for which the White-naped Crane is the flagship species. The 103,000 hectare Dagurian Nature Reserve on the Uldza River in the Mongolian province of Dornod—which was, for a time, supported financially by the World Wide Fund for Nature/World Wildlife Fund (WWF)—is part of a Mongolian-Chinese nature sanctuary and is home to the largest breeding population of *Grus vipio*.

TOP
With wings spread wide and necks outstretched, the two White-naped Cranes seen here strike up a unison call. This ceremony can last several minutes, with brief pauses, and often inspires others in the flock to do likewise (Arasaki, near Izumi on the island of Kyushu, Japan).

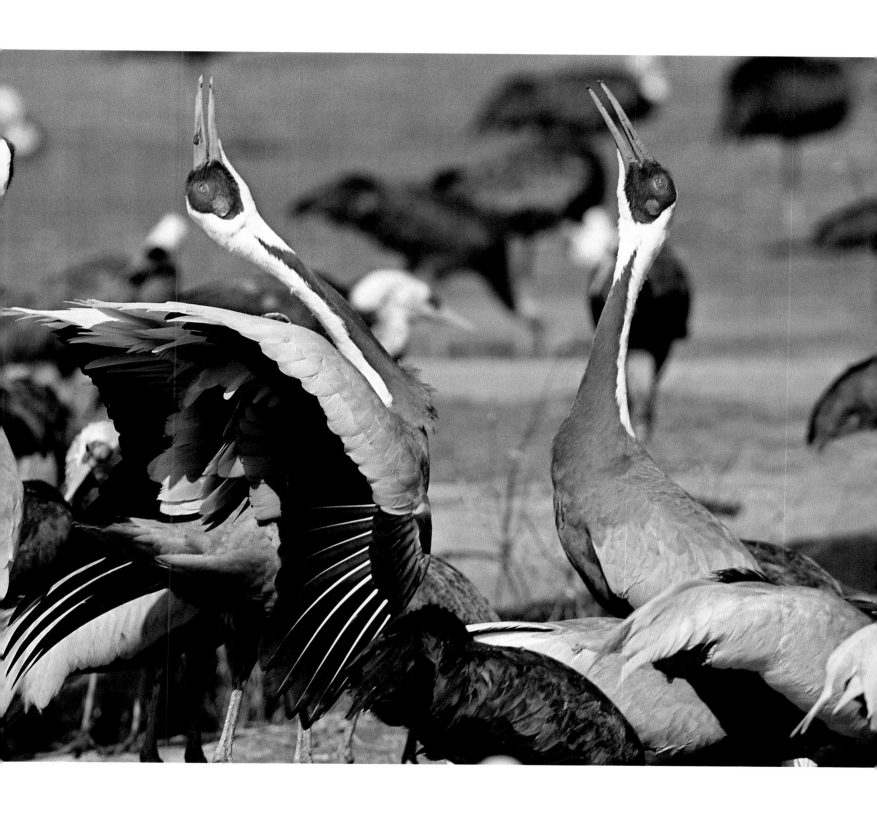

During the breeding season, White-naped Cranes only expose their clutch of eggs when exchanging incubation duties or rotating the eggs. Here, the bird taking over incubating duties rearranges the eggs while its partner probes with its bill in the water (Zhalong Nature Reserve, Heilongjiang, China).

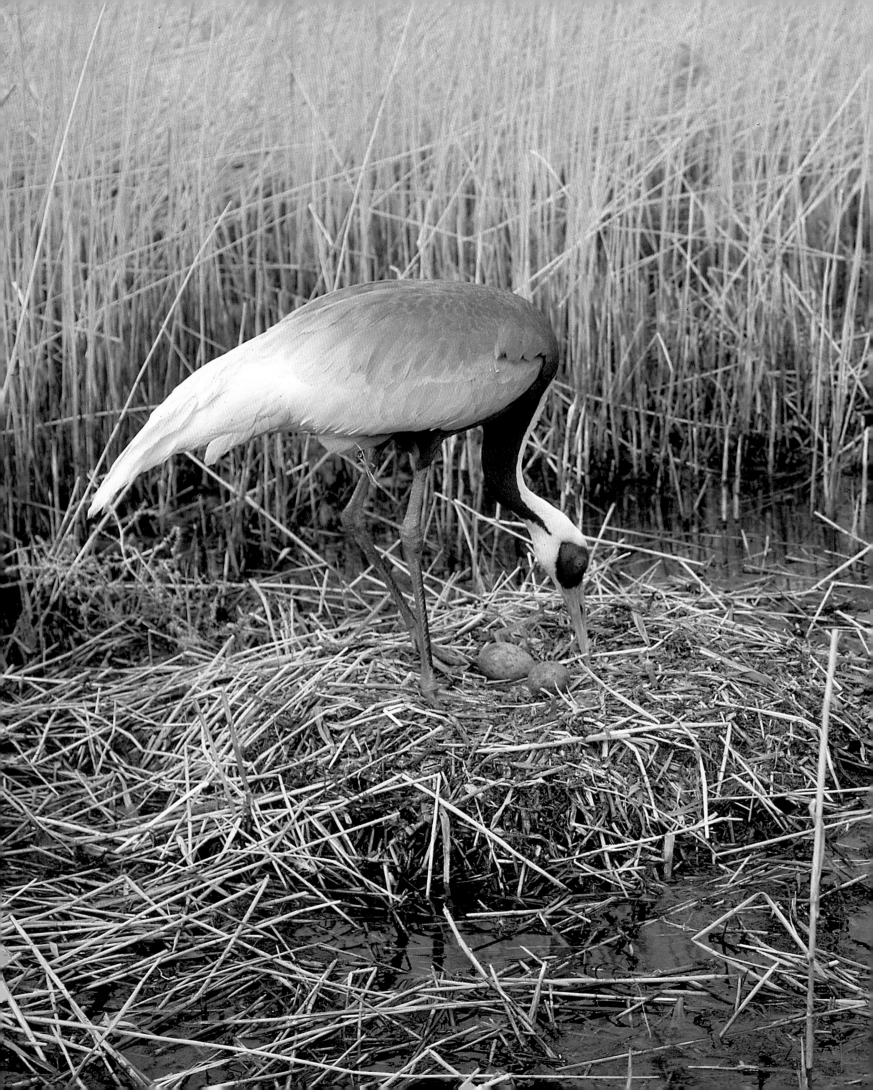

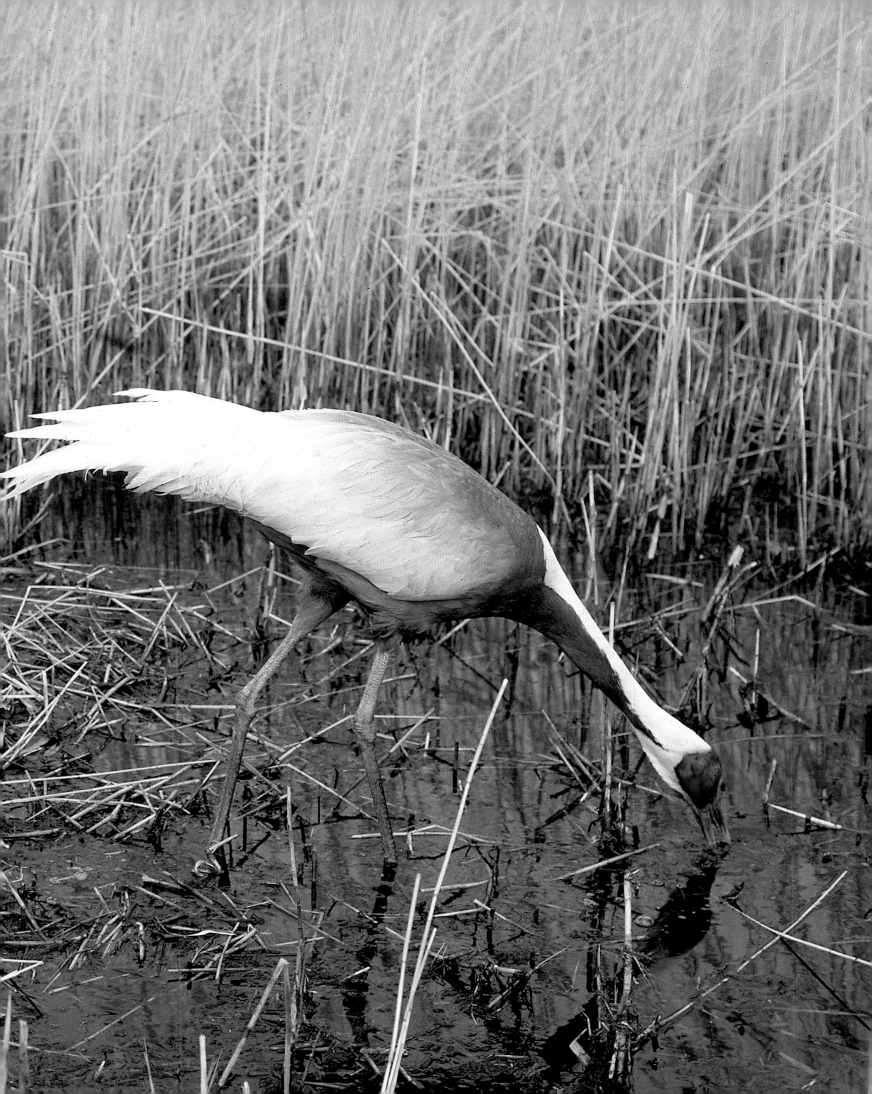

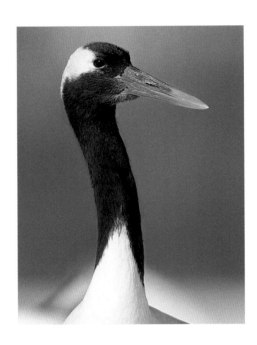

Red-crowned Crane *(Grus japonensis)*:
Prospering in Japan, but Declining
in China and Russia

It is a wild bird like any other, and yet it shows
no signs of shyness. Over the last several days, we
have grown accustomed to the trust shown us by
the eighty Red-crowned Cranes that gather every
day at noon on this snow-covered feeding ground in
Akan. But this one bird appears to be particularly
tame. With its partly black-feathered neck and face
and its shiny red forehead and crown, this 140-cen-
timetre-tall crane is a real beauty. It strides towards
us in a regal fashion, coming within ten metres,
and stares at us for several minutes before return-
ing to its fellow cranes. As is the case every win-
ter morning, dozens of photographers with long
zoom lenses have taken up position behind the low
barrier to the field. As soon as a crane lands or

takes off in front of them—and especially when
two birds start fighting or several birds jump into the
air, flapping their wings and causing a stir within the
congregation—the shutters of the photographers'
cameras go off in a burst of clicking and clattering
sounds. It seems like a perfectly choreographed
production when these birds with their white primary
and black secondary feathers perform their spec-
tacular dances, encouraging even more cranes to
join the dance and surpass them with increasingly
outlandish movements. Their stature, appearance,
and rich repertoire of gestures have earned these
birds the reputation of being the 'top dancers' in the
family of cranes. The snow-covered backdrop lends
the whole spectacle a theatre-like atmosphere, and
the actors all play their roles perfectly.

Some 60,000 people come to Akan every year to
visit the cranes. None of the birds seems bothered
by the comings and goings of the many people
from the nearby Akan International Crane Centre.
The birds seem to realise that nobody wishes them
any harm. In the morning, they had quickly eaten
up the maize that had been scattered onto the field
for their benefit, and now they are waiting for the
next shipment. At exactly two o'clock, their minder
appears with a bucket and distributes herring-sized
fish. The cranes have to be fast now, because sever-
al sea eagles have been waiting for the fish man,
too. The cranes have one advantage over the eagles,
though: they are not shy and will allow him to get
very close. In contrast, the sea eagles keep their
distance before swooping down like a bolt of light-
ing and grabbing a fish.

The feeding of Red-crowned Cranes at four main
and several secondary feeding stations in the vicinity
of the Kushiro Swamps, fifty to 100 kilometres from
the port city of Kushiro, represents one of the suc-
cess stories of crane conservation. At the beginning

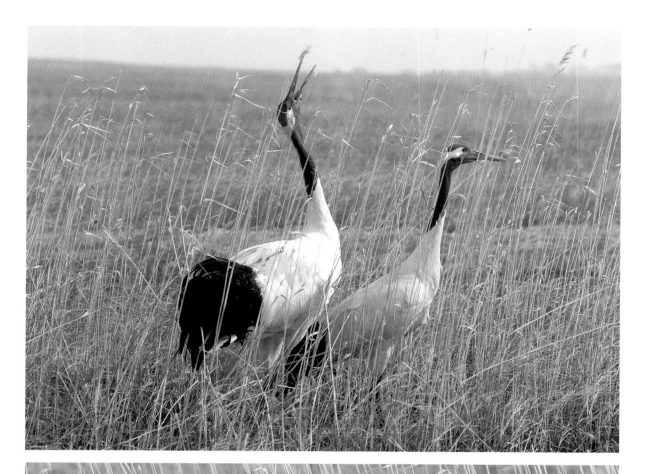

The two Red-crowned Cranes shown here use the few reeds that have not been mowed down during the winter to build their nest and breed. They strengthen their pair bonds with regular unison calls (top). Once they have left the nest, it is not easy for the chicks to follow their parents through the vegetation, especially when the chicks have to wander across the stubble of reeds (bottom). But the adult birds have a lot of patience with their offspring and are quite doting (Zhalong Nature Reserve, Heilongjiang Province, China).

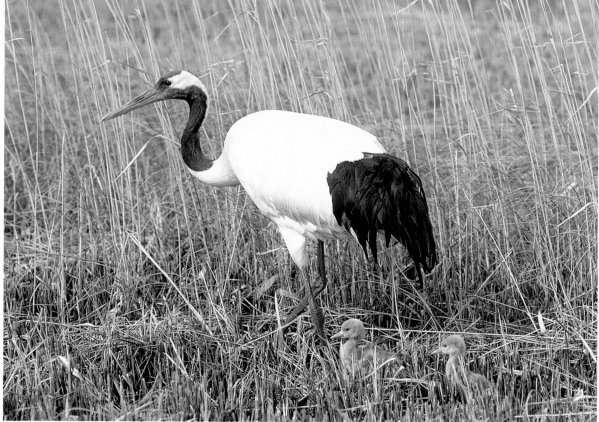

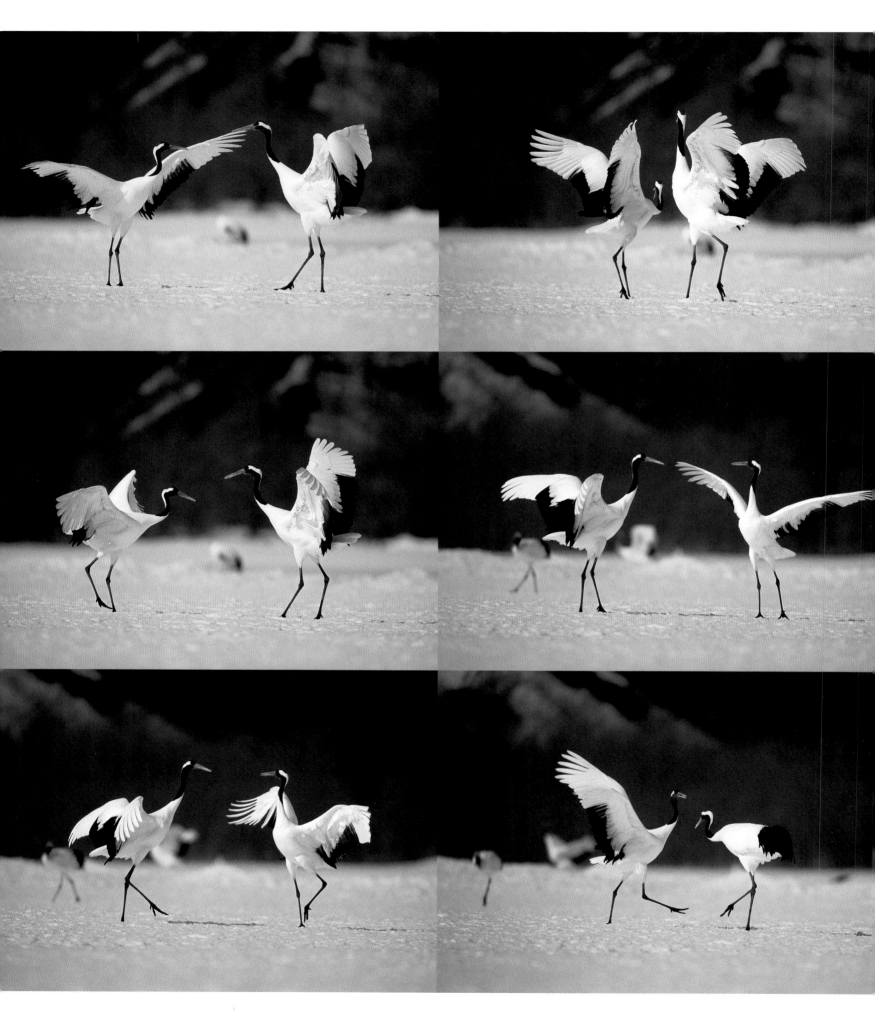

of the twentieth century, these impressive cranes were thought to have been wiped out in Japan, which many Japanese regarded as a disgrace, since the *tancho* ('the red-headed one') is revered and considered a symbol of good luck and prosperity in this country. In 1952, during a particularly severe winter, and much to the surprise of many of the country folk, thirty-three Red-crowned Cranes gathered near a marsh region in Kushiro (which used to be larger), trying in vain to find food on the snow-covered fields. Farmers and school children fed the cranes rice and corn, not only securing their survival, but also sparking the amazing re-emergence of the Japanese Crane. (This is the bird's scientific name and, until quite recently, was also the term used in English.) The residual population of Red-crowned Cranes, which had survived for decades unnoticed in what, at the time, were unpopulated regions of Hokkaido, has now grown to more than 1000 birds, thanks to extensive conservation measures. (When they were first counted in 1972, there were only fifty-three birds. In January 2006, the count was 1101, of which 122 were young cranes. And in the summer of 2005, the Wild Bird Society of Japan counted 308 breeding pairs). The Red-crowned Cranes stay on Hokkaido all year round, but the size of their territory is constantly shrinking. In the winter, when the birds spend the nights on shallow rivers that have not frozen over, they are completely dependent on the help of humans. Only about 1200 to 1400 Red-crowned Cranes live on the eastern Asian mainland. Their breeding grounds in Russia are on Lake Khanka and the Amur and Ussuri Rivers. In China, they breed in the provinces of Heilongjiang and Jilin, as well as in the autonomous region of Inner Mongolia; within that region, Dali Nuo Er/Dalainor is their most westerly breeding outpost. Almost everywhere, the birds' habitats have been restricted to a few sanctuaries, and they face the same problems as those confronting the White-naped Cranes, as described in the previous section. These 'birds of white jade' ('hsien-ho' in Chinese and 'ussuriskii zhuravl', in Russian) are also dependant on nature reserves to be able to winter, since their traditional wintering

On the snow-covered fields of northern Japan where the Red-crowned Cranes are fed, it never takes long before at least two of these large, white birds engage in a dance performance, watched by the many visitors. These 'messengers from heaven' perform a large variety of figures and movements. But quite often this display of curtsying, jumping, and flapping wings turns into a wild chase (Akan, Hokkaido, Japan).

grounds have been occupied and undergone intense development by humans. As a result, most of the Red-crowned Cranes on the mainland fly to the 40,000 hectare Yancheng Nature Reserve in the province of Jiangsu, 300 kilometres north of Shanghai in the Yangtze delta region. Smaller flocks spend the winter in North Korea or in the demilitarised zone between North and South Korea, the latter representing a relatively temporary abode. Small groups or families try to find suitable staging areas on the Chinese coast. Being omnivores, they are not so fussy about food, but they need water to roost in and peace and quiet from humans, since these cranes are not nearly as tame, and are more easily stressed, than their brothers and sisters on Hokkaido; also, people outside of northern Japan are a great deal less sympathetic towards the birds. Chinese conservation authorities are trying to breed Red-crowned Cranes in semi-natural conditions in

the Zhalong Reserve in Heilongjiang—and this with some success. However, as long as the birds' few remaining natural habitats are not effectively protected from drainage and agricultural development, as well as from poaching, programmes to reintroduce cranes to the wild will be doomed to failure and the number of Red-crowned Cranes on the mainland will decrease still further. Even now, they are second on the list of the most endangered species of crane.

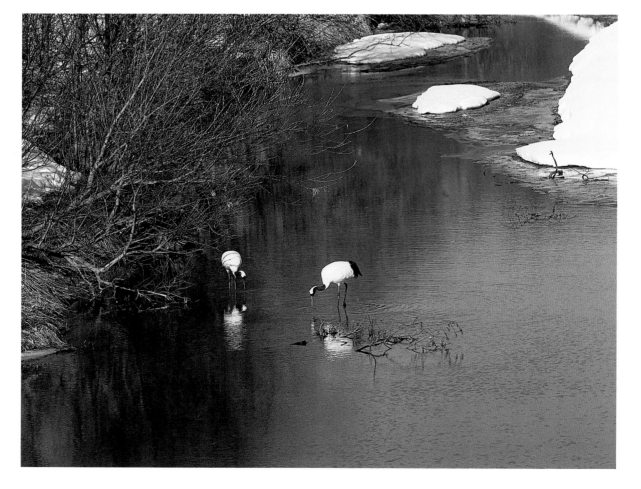

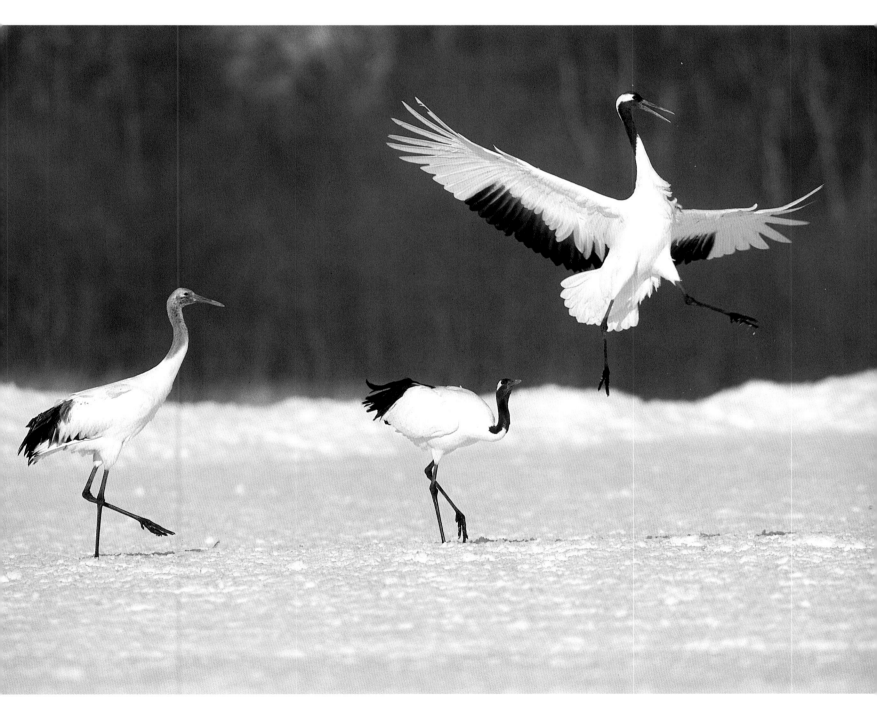

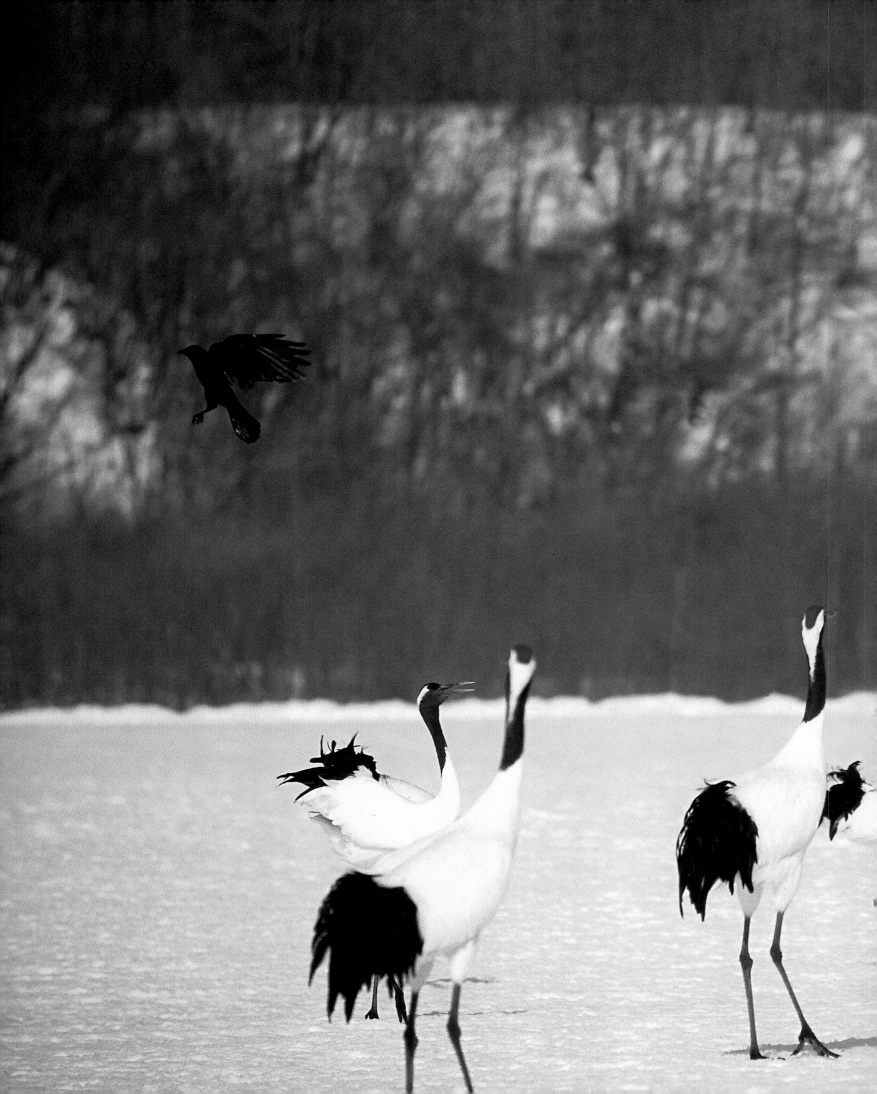

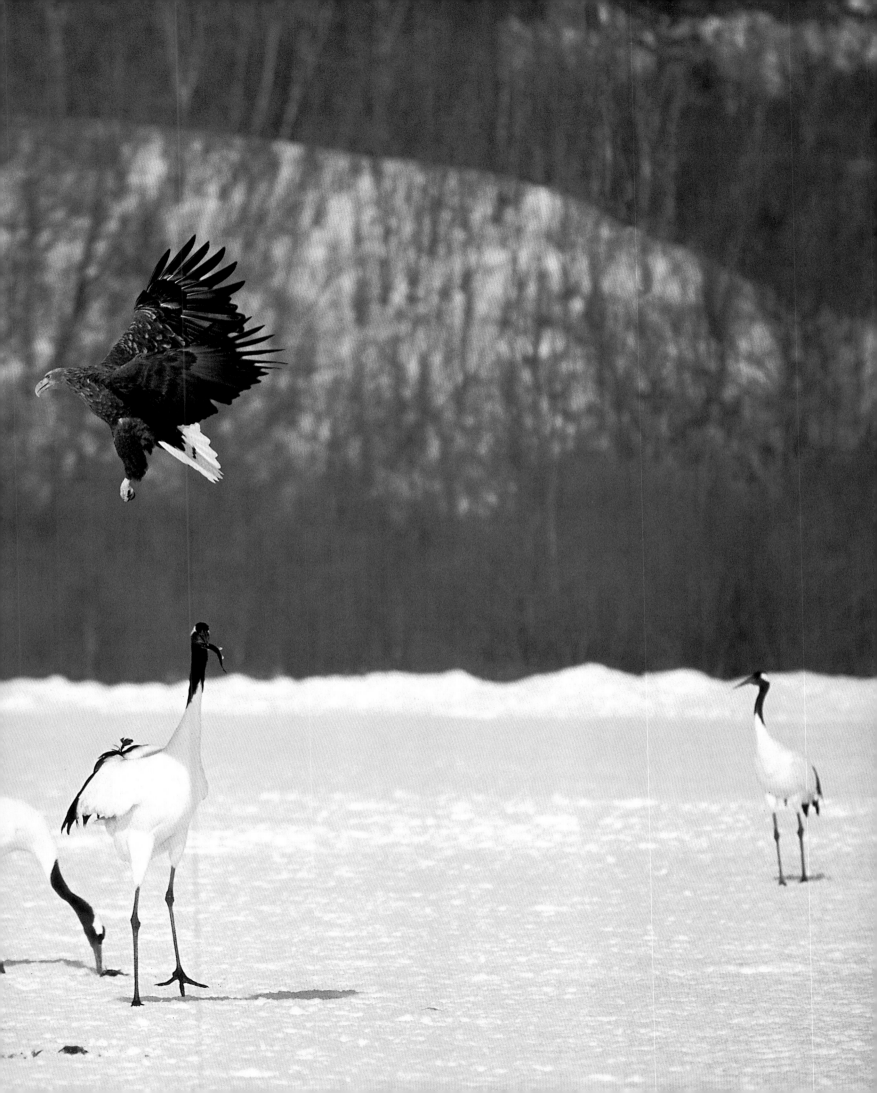

Black-necked Crane (*Grus nigricollis*): Some Chicks Hatch in 5000-Metre-High Mountain Valleys

The two Black-necked Cranes are engaging in long, uninterrupted unison calls. With their heads stretched skywards, the two birds parade through the water, side by side, as though they were engaged in some kind of competition. And they are alone at that, in this 4200-metre-high river valley in Long-baotan in the northwest Chinese province of Qing-hai, near the Tibetan border. Apart from the photo-grapher, in his little camouflage tent, the only ones watching are some yaks and sheep on a nearby field. A 5500 metre mountain range completes the scene with an impressive backdrop. Here, some distance from the shore, the birds built their high nest at the beginning of May, constructing it from rotting aquatic plants they extracted with their bills from the bottom of the shallow branch of a river. The first egg was laid on May 8th, the second on the 10th. Now, almost five weeks later, the birds seem more agitated than usual as they exchange incubation duties: the chick in the first egg has pecked a hole in the shell and will hatch within the next twenty-four hours. In a few days' time, the two young ones will be swimming after their parents as they stride through the cold water, feeding their chicks insects, small fish, crabs, snails, and tadpoles. Only when the young ones are almost grown up will they also eat tubers and seeds.

Four other pairs are breeding in this valley, which is twenty-five kilometres long and up to three kilo-metres wide; their nests are between two and four kilometres apart. (Forty years ago, fifteen pairs are said to have been breeding in Longbaotan.) The species' other breeding grounds are similar: every year, about half of the 7000 Black-necked Cranes breed within a vast area that extends from the

PREVIOUS DOUBLE PAGE
The Red-crowned Cranes know that the White-tailed Eagle will not harm them: he is after the fish that have been scattered about the cranes' feeding area. The crow, on the other hand, is well advised to flee from the bird of prey, though the latter likely only views him as a bothersome competitor (Akan, Hokkaido, Japan).

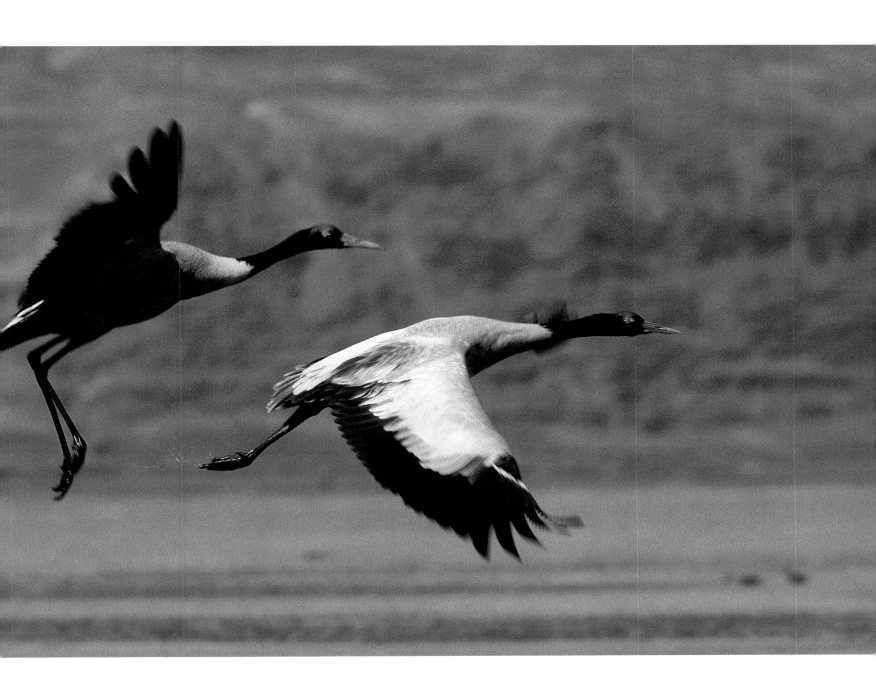

The Black-necked Crane is not only black around its head and neck. Its primary and secondary feathers also have a deep dark colour. Especially when the birds are in flight, these dark areas contrast nicely with their grey and brown plumage (Cao Hai, near Weining, Guizhou Province, China).

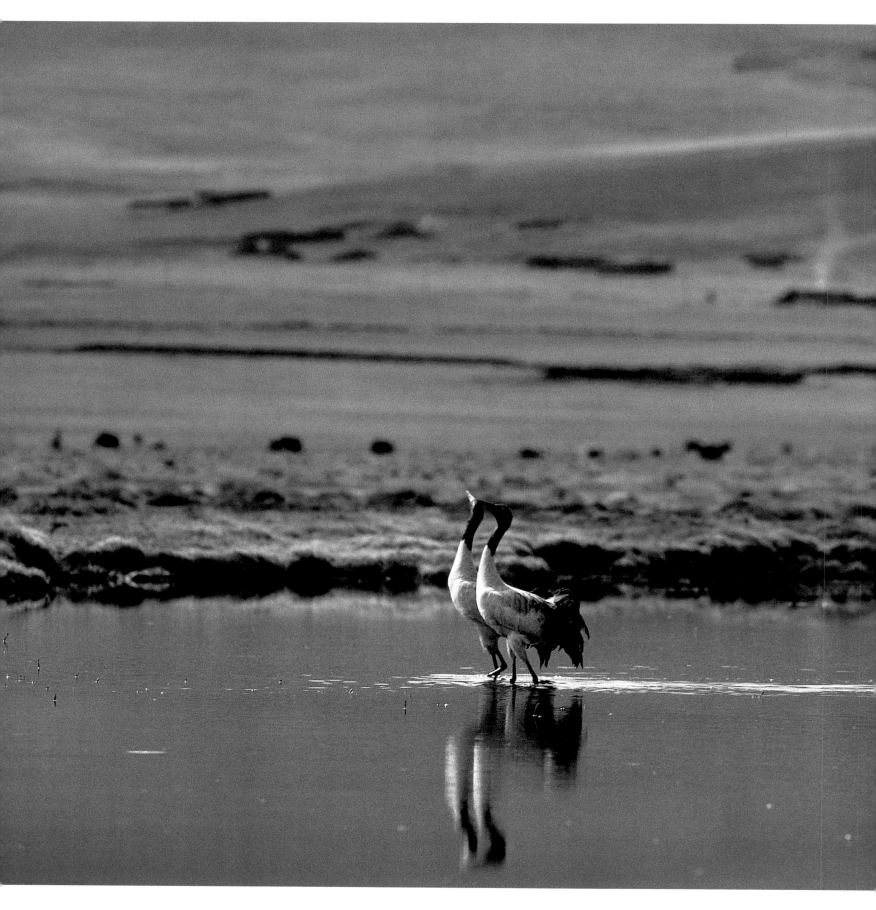

northern corner of the province of Sichuan over large regions in the east and north of the province of Qinghai and right into central Tibet. Some birds even breed at an altitude of 5000 metres.

Given such inaccessible breeding grounds, it is hardly surprising that the species *Grus nigricollis* was not discovered by science until the Russian naturalist Nikolai Mikhaylovich Przhevalsky happened upon them in northeastern Tibet in 1876. And since, for decades, it was not possible to travel through northern China and there was little contact with foreign conservationists until about 1995, very little was known about Black-necked Cranes or their numbers, until about twenty years ago. Not until around 1995, when the results of a long-term joint study by Chinese conservationists and the International Crane Foundation were published, did a sense of relief emerge: until then it was thought that only about 1000 Black-neckeds still existed, including the twenty birds in Ladakh, in northern India—the only breeding ground of this species outside of China and Tibet.

I would love to know whether the pair I am observing now, as they utter their calls and are answered by another pair far away, were among the 800 wintering Black-necked Cranes I came close to more than a year ago when I was on the 2200-metre-high Cao Hai, about 1000 kilometres further southeast in the province of Guizhou. Or did this pair spend the winter in the Napahai Nature Reserve in the northwest of the province of Yunnan, 700 kilometres south of here? They may also have been further east in Yunnan, near the province of Guizhou. Or they might have met up with the group of Black-neckeds that breeds in one of the river valleys of southern Tibet. Or was this pair part of the flock of about 400 Black-necked Cranes that fly from Tibet to Bhutan each autumn to winter in the mountain valley of Phobjikha or in two other valleys? But, most likely, in the autumn, the cranes of Longbaotan join the others of their kind that come from the high altitude marsh regions of Ruoergai in northern Sichuan— regions which are threatened by peat extraction— and fly with them to Yunnan, or to the nature reserve around the lake at Cao Hai, where they congregate

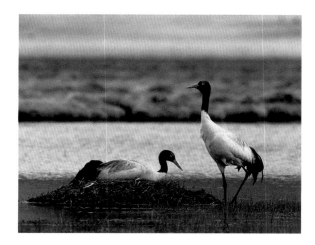

with many other wintering birds, including several hundred Eurasian Cranes.

One would think that Black-necked Cranes, living in such a vast area and accustomed to difficult conditions and a rough climate, would be pretty good at surviving. But the living conditions for this species are also changing rapidly. Through the massive influx of Han Chinese into Tibet, more and more settlers are populating and developing the valleys. The agricultural practices are also changing: instead of planting barley and oats in the autumn and leaving the smaller fields untended, the new farmers are ploughing the small fields and planting so-called catch crops. This means that the cranes are no longer able to glean leftover grains from the harvest, as they were able to do when the Tibetans did most of the farming in this area. In other regions of

During the breeding season, in a mountain valley 4000 metres above sea level, a pair of Black-necked Cranes take time for an elaborate ritual marking their exchange of incubation duties. This involves marching through the water side by side, stretching out their necks, and trumpeting a unison call, which is then reciprocated by echoes ricocheting off the mountain walls (left). But soon afterwards, they are peacefully united at the nest, as the above photograph shows (Longbaotan, near Yushu, Qinghai Province, China).

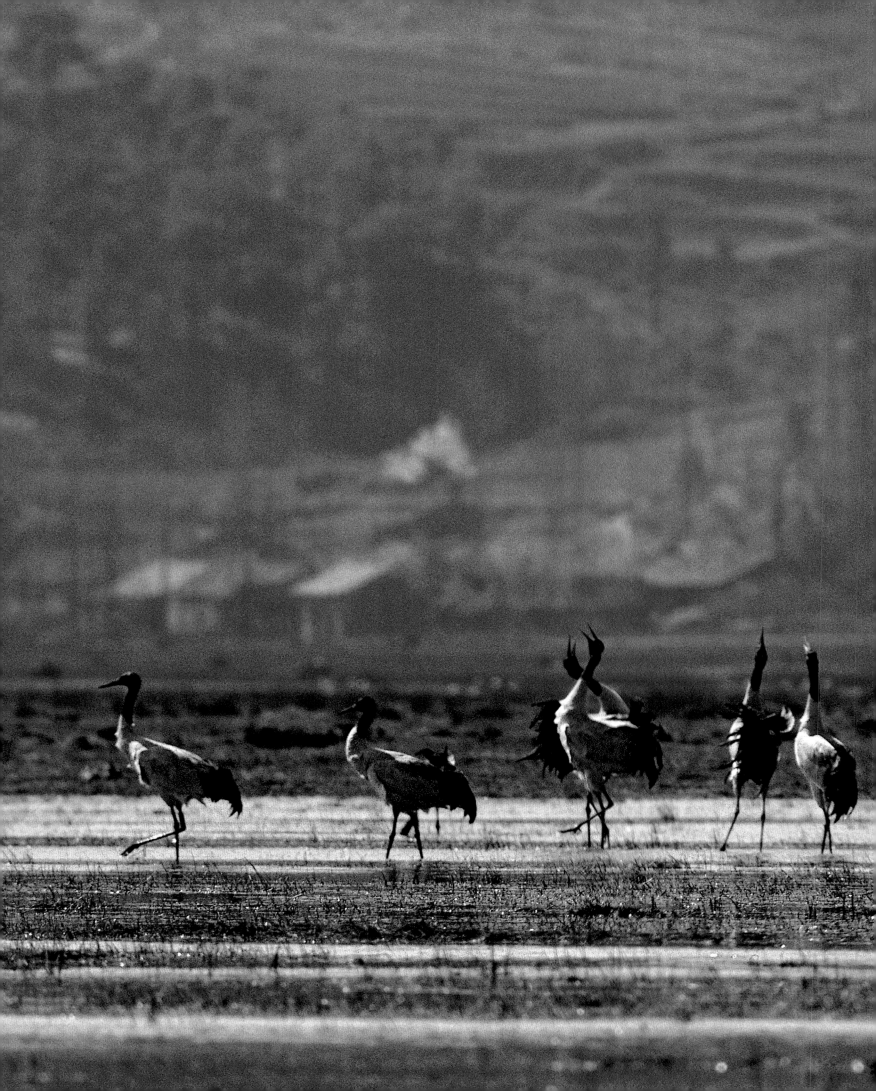

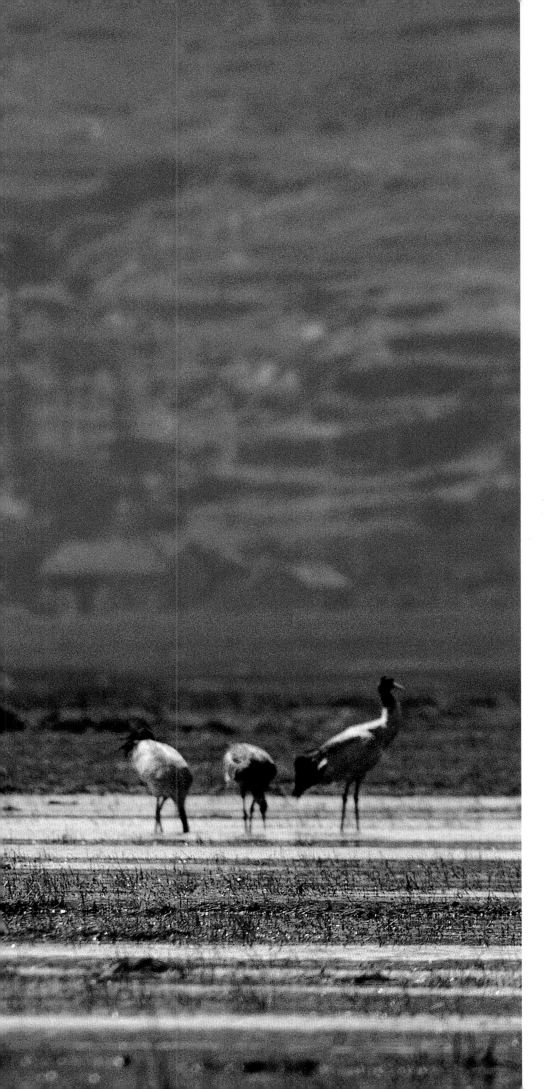

China, privatisation in agriculture has led to a huge increase in the number of cattle left to graze on high pastures. The many hooves destroy the cover of vegetation, allowing snow and rain to erode the soil. The constant disturbances prevent the cranes from breeding, and roaming sheep dogs pose a real danger for young cranes that cannot yet fly. And in the wintering areas, too, human population growth is taking its toll on nature.

In Cao Hai, one of the most important wintering grounds, as well as in Yunnan, the International Crane Foundation has devised a programme together with Chinese environmental authorities combining crane conservation with measures to fight poverty. The programme encompasses local development projects, enhanced education, raising awareness, and sustainable crane tourism. For several years now, people and cranes in Cao Hai have been profiting from the US Trickle Up Program, which involves helping people in rural communities to help themselves by giving them advice and small interest-free loans.

Shortly before the Black-necked Cranes leave their wintering grounds in southwest China in early April to head north, their calls increase in number and become more intense. Their pre-migratory restlessness also prompts them to short excursions and wing-flapping leaps (Cao Hai, near Weining, Guizhou Province, China).

Hooded Crane (Grus monachus):
From the Siberian Taiga to the Rice Fields of Japan

For five whole days, Yuri Shibnev and his cousin Andrej have been wandering all over the high-moor bogs of the eastern Siberian taiga in the vicinity of the Bikin River, a tributary of the Ussuri. But now they spot a Hooded Crane sneaking away between small larches and dwarf birches, its head held down low. This is when they realise that they have finally discovered a breeding ground of these elusive slate-grey birds. Soon they are standing on uneven peat marsh, looking at a nest mound made of damp moss, sedge, small twigs, and reeds. Inside are two longish, oval, green-brown eggs with dark brown speckles. Nowhere to be seen, the parents are probably hiding somewhere between the low trees and shrubs. The two experienced nature experts

memorise the location, which is not an easy task given the sheer expanse of the Bikin marshes. A few rotting spruces about 200 metres away will have to suffice as markers for orientation. Subsequently, the two men start on their three hour return trip across the still frozen marshland to the banks of the Bikin River, where their motorboat is moored. Half a day later, they are back in their home town of Verhni Pereval.

A week later, on May 8th, they escort me to the nest, passing over marshes sodden from the melted snow where normally only wild animals pass by. We are wearing rubber boots that reach up over our knees. Before setting out into this wilderness, I travelled 10,000 kilometres via Moscow and Khabarovsk accompanied by the Russian biologists Natasha and Konstantin, until we arrived at the home of Yuri's aging parents in Verhni Pereval on the Bikin River in Primorsky Krai. (Yuri Shibnev is one of Russia's best nature photographers, and his father, Boris, has a nationwide reputation as a nature conservationist.) It takes several days before we have set up the observation tent in the right place and have moved it closer to the nest, bit by bit. We have been very careful not to disturb the birds, and, of course, we obtained prior permission from the nature authorities. In the end, I am sitting so close to the nest that I can tell the male and female apart just by looking at the size of the red patch on their foreheads. But this particular pair is easy to tell apart anyway: when one bird relieves the other of its incubating duties, which always takes place some distance from the nest, their difference in height is quite apparent: the male is about one-fifth larger than the female. With an average size of ninety-five to 110 centimetres, Hooded Cranes are among the smaller representatives of their kind. Their name is derived from the colours of their plumage: together with its

In the autumn, this family of Hooded Cranes flew thousands of miles from northeastern Russia via China and Korea to spend the winter in southern Japan. Several times a day, they fly back and forth between their feeding grounds, their roosting areas on the flooded fields, and the surrounding countryside (Arasaki, near Izumi on the island of Kyushu, Japan).

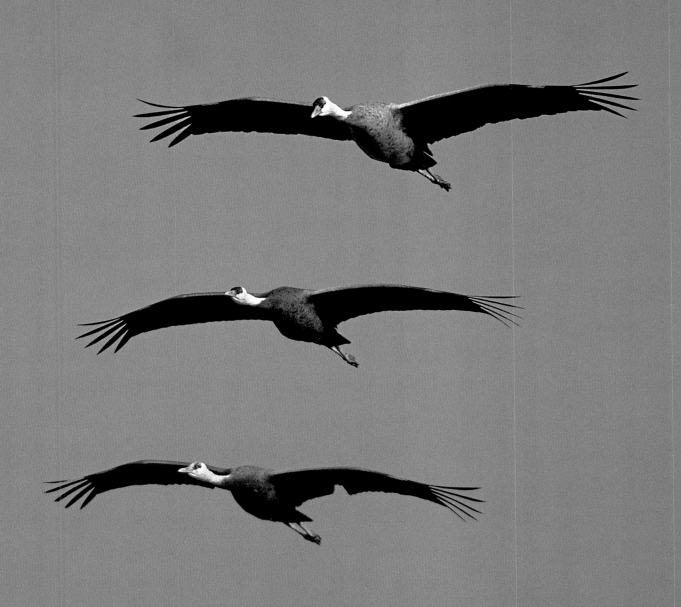

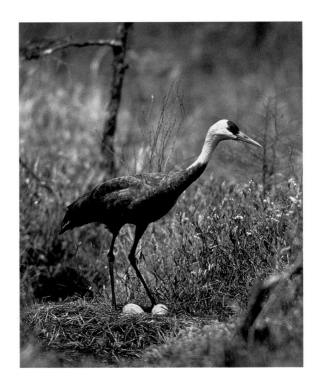

LEFT
The Hooded Crane's two eggs are clearly
visible, but in the several square kilometre
taiga marsh between the Amur and Ussuri
Rivers in eastern Siberia, the nest is difficult
to spot (Bikin River watershed, Primorskij
District, Russia).

dark-grey body, the Hooded Crane's white neck
and white head with a red cap are reminiscent of a
monk's habit. It was not until 1974 that Russian nat-
uralist Yuri Pukinski was able to discover a Hooded
Crane nest and scientifically document his find-
ings. The birds' breeding grounds, which have by no
means been comprehensively studied or demar-
cated, extend across a vast area of eastern Siberia,
with a central area north of the Amur and Ussuri
Rivers stretching into the endless Yakutian taiga.
There, Hooded Cranes and Eurasian Cranes meet
up, and there is frequent and fruitful cross-pairing
between the two. Their offspring appear in the
wintering grounds as Hooded Cranes with light
grey feathers. There are a few breeding grounds in
northeastern China: in 2003, a pair of Hooded
Cranes bred successfully in the Xiaoxing'an Moun-
tains in the Manchurian province of Heilongjiang.
Bachelor flocks fly as far as the Ob in western
Siberia.

During the breeding and rearing period, which
lasts from mid-April till the end of July, pairs within a
breeding range will usually keep a distance of sev-
eral kilometres between families. This is important,
if only because each pair needs the undisputed

territory to be able to feed its young. Food is often
in short supply, especially when the birds return
from their wintering grounds. At that time, the per-
mafrost of the mari (as the high-moor bogs in the
mountainous valleys of Siberia are called) is often
still covered with snow, and the animals have to
make do with the previous year's bog blueberries
and cranberries. Only later, when the chicks have
to be fed, do they also find insects, amphibians,
small fish, and mammals. But on the whole, Hooded
Cranes tend to have a more predominantly vege-
tarian diet than most other species of cranes.
Hooded Cranes are able to raise two chicks, since
their young ones grow up in harmony with one
another, unlike the offspring of other crane species.
Only when the chicks have fledged do the families
join up with larger groups and migrate with them
to the south in September. Similar to the Eurasian
Cranes in Europe, though somewhat less faithfully,
the Hooded Cranes use two migratory corridors:
birds that breed east and north of Lake Baikal,
or spend the summer there without breeding, fly to
their wintering grounds on the Yangtze via eastern
Mongolia and China. This western population is
estimated at 1400 birds. More than 9000 Hooded
Cranes fly south over eastern Russia and China,
cross Korea (where about 200 of them stay), and
finish their journey in the west of the southern Japa-
nese island of Kyushu at the end of October or the
beginning of November. Once they have arrived
there, their behaviour suddenly changes.
During migration, Hooded Cranes are shy and
keep well away from humans. But once they have
landed on the rice fields of Arasaki a quarter of
an hour's drive from Izumi, they start to behave
like chickens. Crowded together in groups, they will
come as close as twenty metres to visitors. And,
from behind the low barrier, crane enthusiasts can

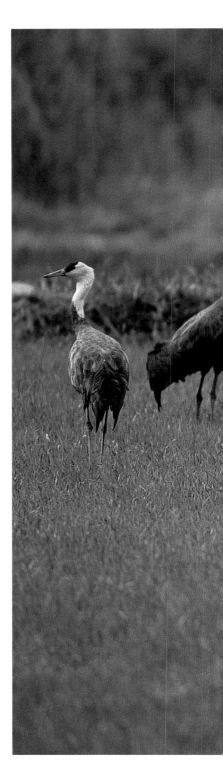

BOTTOM

If the ratio of old to young Hooded Cranes were always seven to two, as it is in this photograph, then it is likely that the population of *Grus monachus* would continue to increase, as it has done in recent years. However, there are years when the older birds only bring a few young ones with them to Japan (near Izumi, Kyushu, Japan).

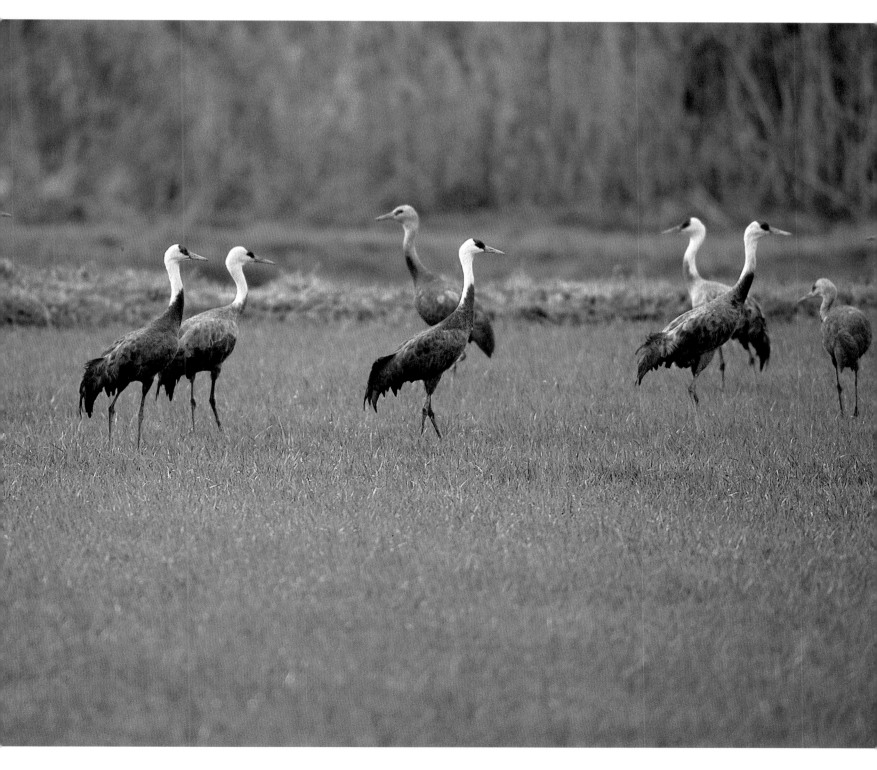

watch as Hooded Cranes, hundreds of White-naped Cranes, pintails, and crows compete to devour the corn that is strewn each day on the fields that have been leased especially for the cranes. Later in the day, small groups of Hooded Cranes will roam the surrounding fields in search of food, but even then they are not nearly as shy as on their breeding grounds and during migration. This trusting behaviour lasts until the beginning of March. In the last few weeks before their departure, the birds are not just fed corn, but also fresh sardines. Once they have tanked enough energy, they embark on the long flight northwards. Thanks to their fat reserves, they have little trouble getting through the first lean days in their breeding grounds and can soon start to lay eggs. The figures prove that Hooded Cranes are fond of Izumi: in the winter of 2005/2006, 10,027 of them wintered there. Thirty years earlier, only about 3000 came, and fifty years earlier a grand total of 259 appeared. As Izumi has become more popular with Hooded Cranes, the number of birds spending time on the earlier wintering grounds—for example on the Japanese main island of Honshu— has decreased. However, ornithologists believe that the growing numbers in Izumi also reflect a slight growth in the population as a whole. And the reason for this, the ornithologists believe, is that there are plenty of successful breeding pairs: in the last few years, thirteen to fifteen percent of the wintering population of Hooded Cranes has been young birds—more than is the case with most other crane species.

FOLLOWING DOUBLE PAGE
In the hustle and bustle of the feeding ground, conflicts such as the one between these two Hooded Cranes (right) are almost inevitable (Arasaki, near Izumi on the island of Kyushu, Japan).

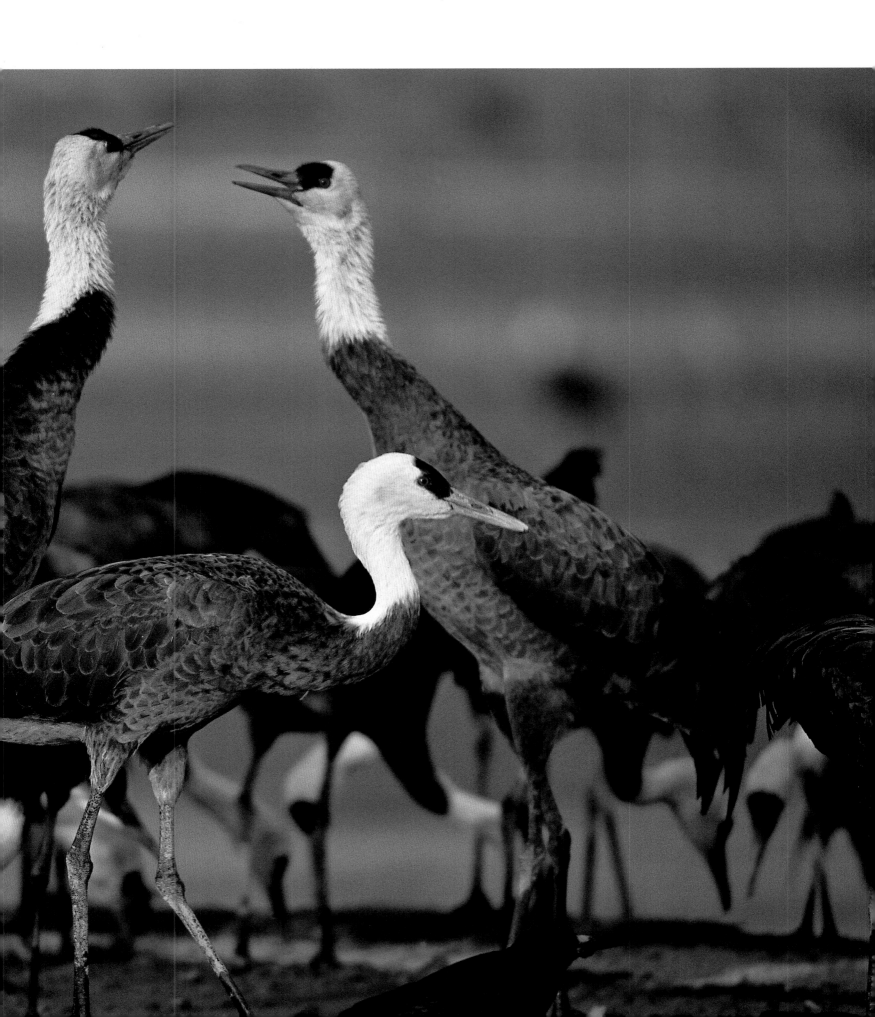

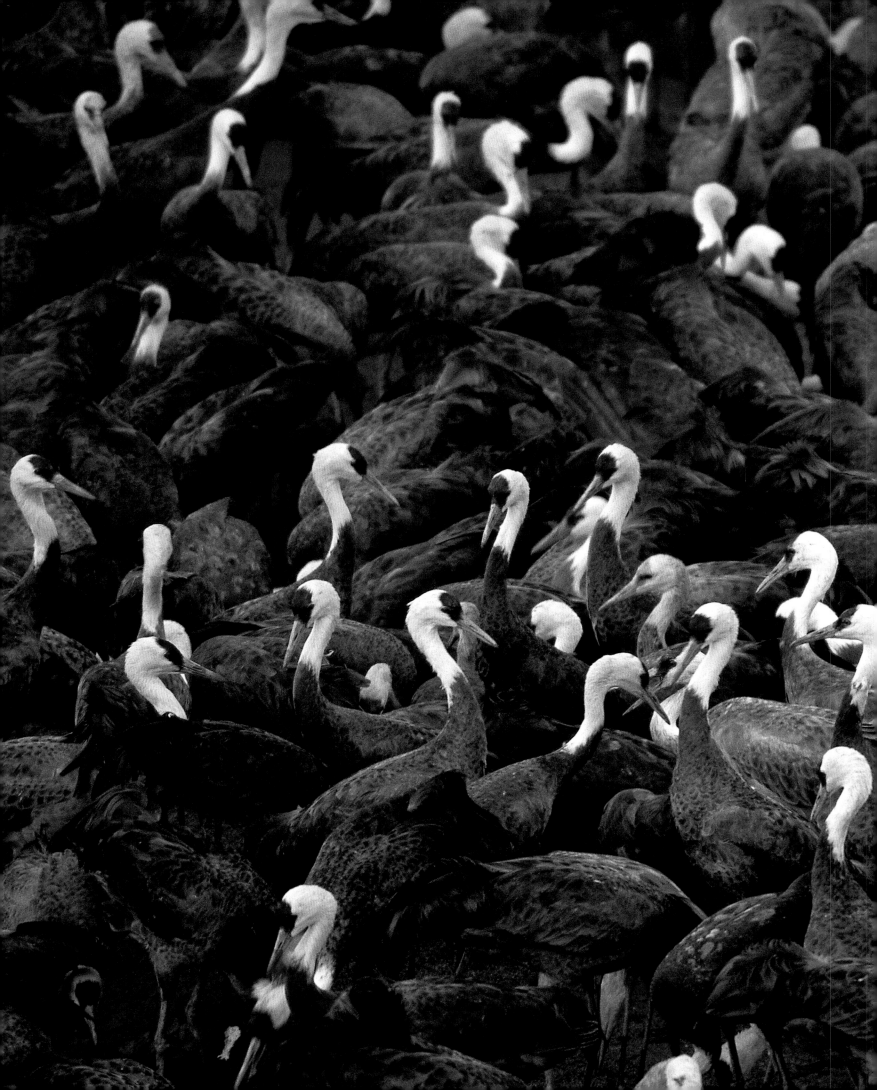

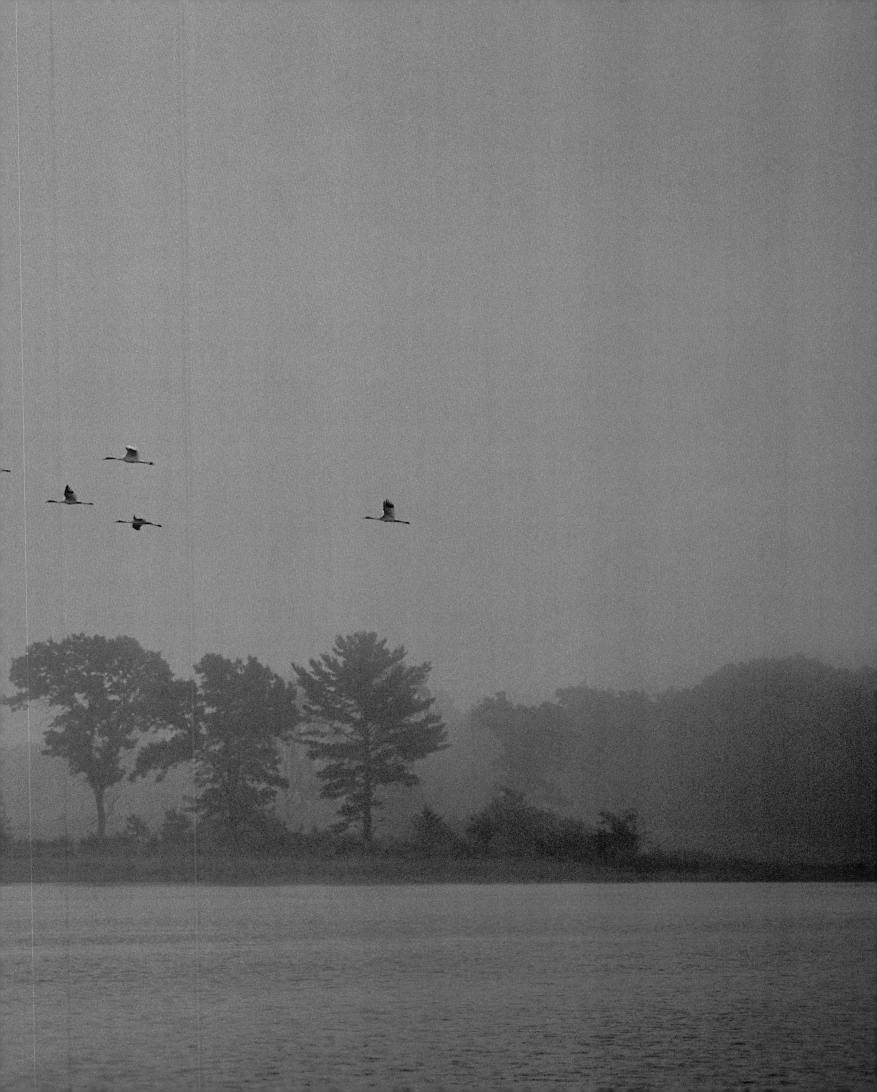

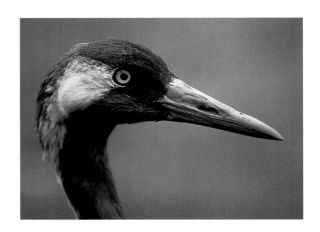

Eurasian Crane *(Grus grus)*: There Are More of Them Each Year

Every spring I ask myself, with some apprehension, the same question: will they return and reoccupy their usual breeding ground in the former peat bog and nearby alder marsh only about 800 metres from our house in the southeast of Schleswig-Holstein? For the past ten years, the Eurasian Cranes have not disappointed me. During five of these ten years, they successfully reared young ones; in four of these years, they even raised twins. The conditions for breeding could not be better: shallow waters, sufficient foliage for cover, tranquillity, nearby meadows and, behind them, cornfields. And since other suitable habitats have become scarce in our region, they have all the more reason to keep returning in the future. I do not know whether they are always the same birds; there are no distinguishing features in their plumage, and they have not been marked in any way.

Sometimes the two large, silver-grey birds can be seen as early as February, searching for food in the cow dung left over from the previous autumn and in the soil beneath the short grass, and engaging in unison calls. Other years, they arrive as late as mid-March. But they are always there before the V-formations of their brothers and sisters, bound for Scandinavia and Eastern Europe, pass high above our beautiful border region between the Duchy of Lauenburg District and the state of Mecklenburg–West Pomerania. When these flocks pass by, it is not only 'my' pair that answers their calls. Five to seven other pairs within a kilometre and a half of our home also trumpet their duets into the spring air. But by this time, our local pairs are already incubating. When the Eurasian Cranes in northern Sweden lay their eggs, the northern German ones are already chaperoning their chicks through the alder marshes, beech

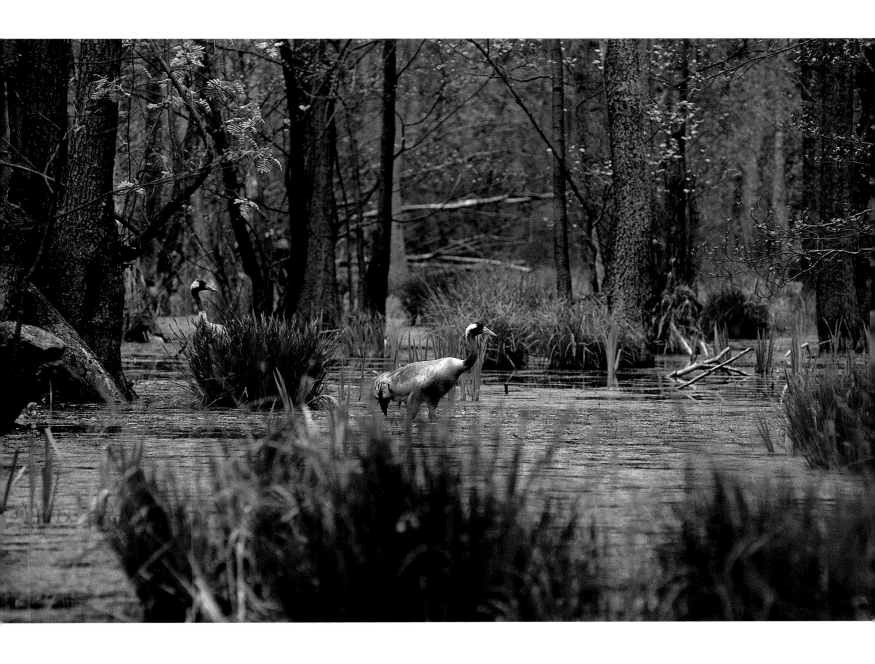

FOLLOWING DOUBLE PAGE

No matter what their flight formation, at which height, or in which light they pass over the observer: Eurasian Cranes always leave a lasting impression, especially when their hoarse trumpet calls ring out simultaneously (near Linum, Brandenburg, Germany).

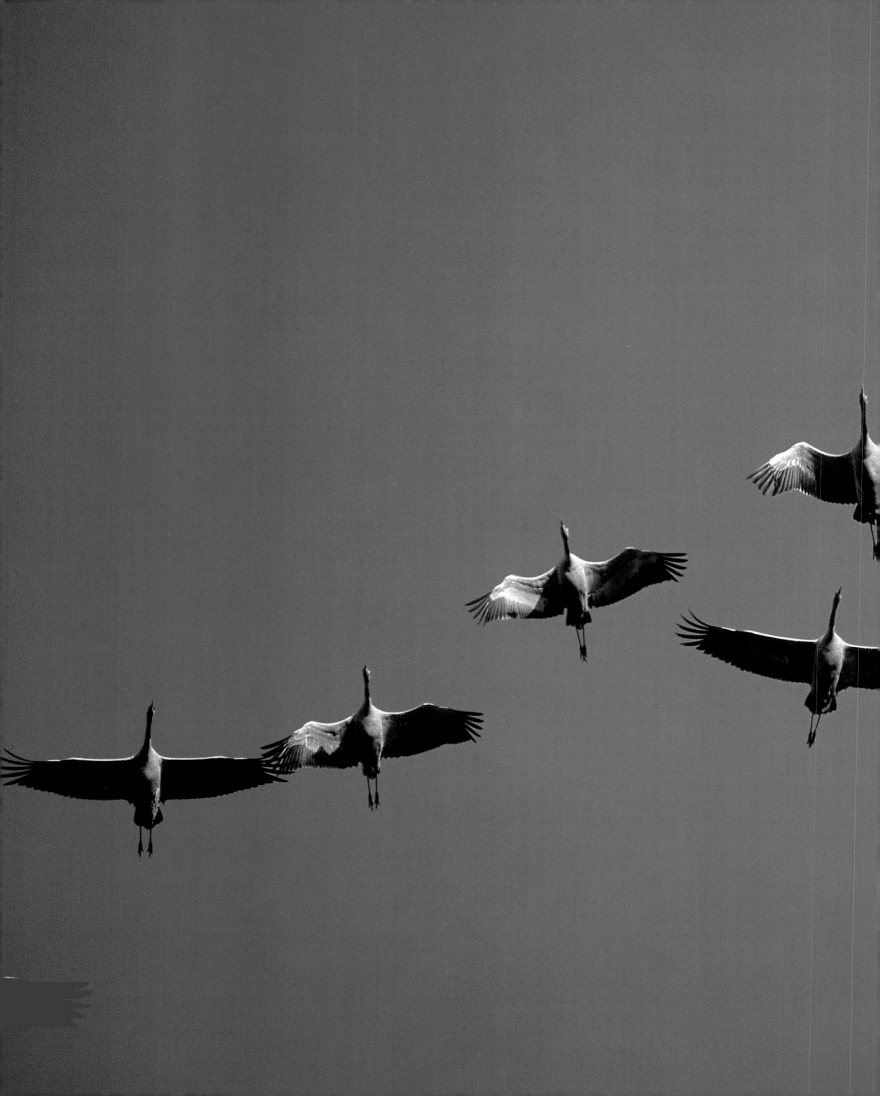

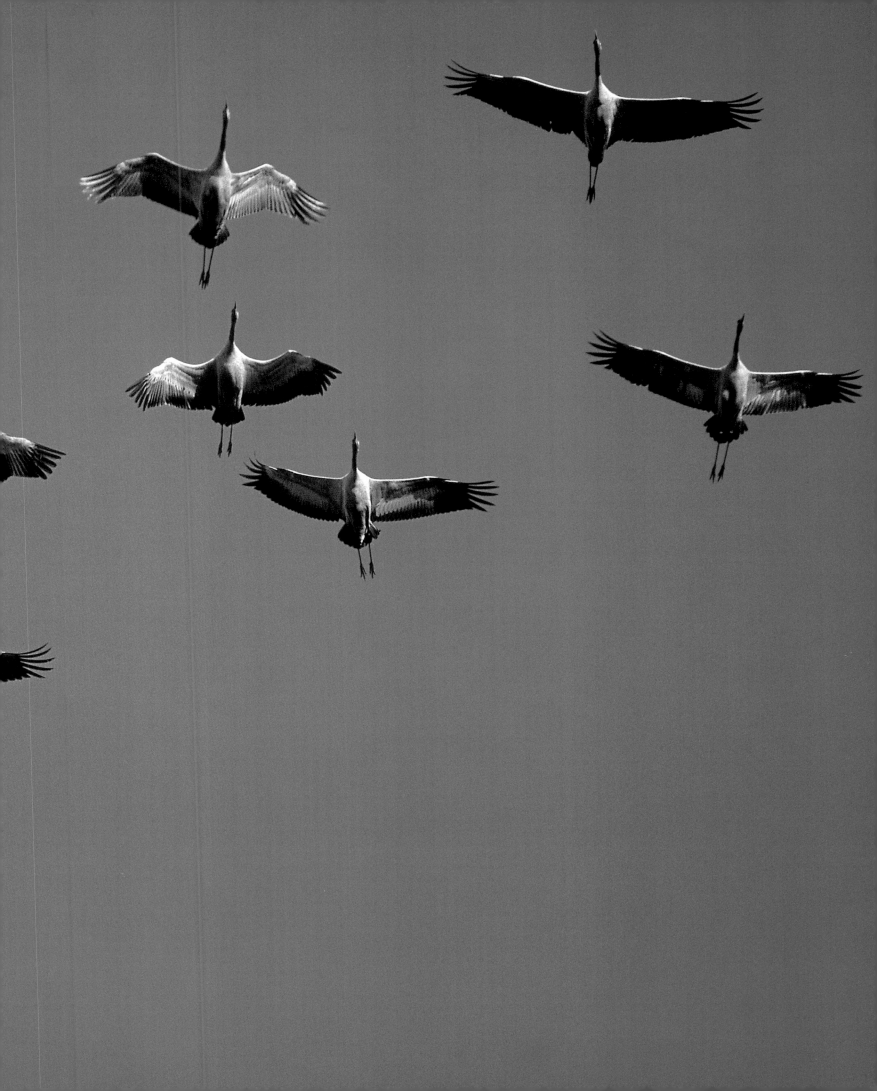

woods, and moors. If the early spring is particularly mild, some females will already lay their eggs during the first two weeks of March.

Northern Germany has only been blessed with such a vibrant crane presence since about 1980. Until then, the most westerly outpost of *Grus grus* ended in Schleswig-Holstein and Lower Saxony near the border to East Germany. Around 1970, hardly more than two dozen pairs were breeding in these two West German states. There were a lot more in Mecklenburg-West Pomerania and in Brandenburg across the border, but not nearly as many as there are today. Even German crane conservationists were surprised when they heard the new figure at their annual conference in 2004: one scientist had surveyed all of the crane habitats in Germany and estimated the number of birds to be more than 5000. Based on this, the crane experts at the conference agreed that there must be at least 4000 breeding pairs. (In 2006, Crane Protection Germany raised this estimate to 5400.) And there was more good news: the cranes were (and are) expanding their territories towards the west and the south. The location of the first breeding area in Bavaria is being kept secret, and, following territorial expansion into the western part of Lower Saxony, a breeding pair has turned up in North Rhine-Westphalia. In the Netherlands and eastern France, two or three pairs have appeared in the past few years, and about twenty cranes now stay in England all year round. The Eurasian Crane is reoccupying territory it vacated more than a century ago. The expansion of its breeding areas is also proceeding in a southeasterly direction. Each spring, between twenty-five and thirty pairs settle in the Czech Republic; in Hungary some cranes have also started to breed. Looking further north, the number of breeding pairs in Poland, in the three Baltic States of Estonia, Latvia, and Lithuania, in parts of northwest Russia, and in Finland has also increased. In Sweden, there are 20,000 breeding pairs, meaning that a total of approximately 60,000 cranes gather there in late summer. And there are now some sixty-five breeding pairs in Denmark.

Just how well the Eurasian Crane is faring in Western Europe can be seen by looking at the number of cranes migrating south and southwest from northern and central Europe. Hundreds of crane enthusiasts document the birds' movements each year along the two main migratory routes. In 1970, about 50,000 cranes flew along the West European route from the German Baltic Sea coast, following various routes to the Rhine, then heading due southwest over eastern France to the south of France and on to Spain and Portugal. In 2005, the number of these birds had risen to 160,000. And whereas in 1970 about 30,000 birds took the so-called Baltic-Hungarian route, that number had risen to 100,000 by autumn 2005. If one includes stray flocks, the number of Eurasian Cranes in Western Europe is about 300,000. According to the International Crane Foundation, there are as many as 450,000 Eurasian Cranes in the world today, if one takes into account the other population whose territory extends into northeast China.

As the Eurasian Crane population has grown, it has found additional breeding grounds and staging areas (many of these places are listed in the chapter 'Visitor Destinations'). The increase in average winter temperatures has prompted cranes in Europe to shorten their journeys to the wintering grounds. In some years, as many as 70,000 Eurasian Cranes do not bother to cross the Pyrenees, preferring instead to spend the winter in France. Aside from the milder weather, this is only possible because of

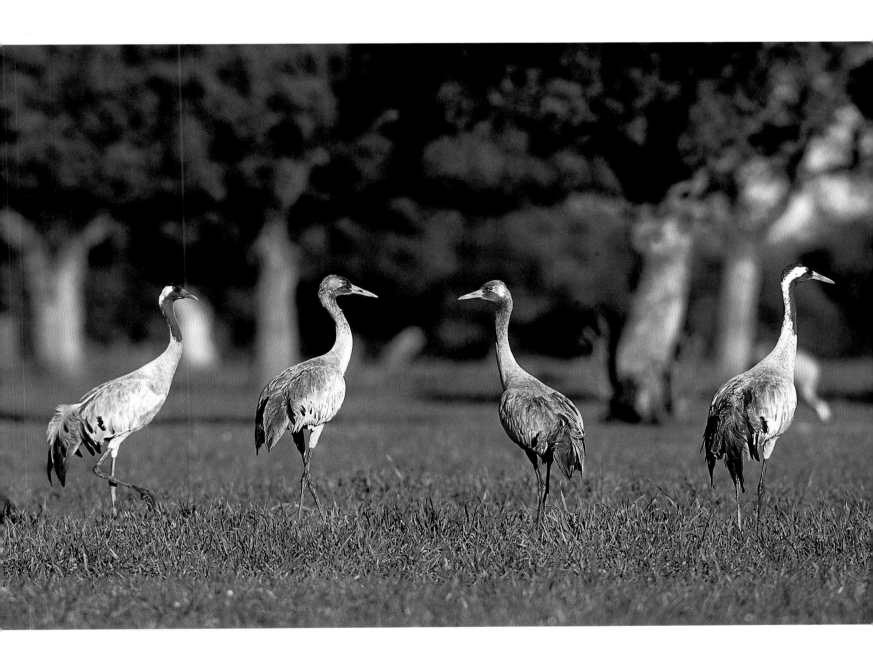

A classic family picture: two Eurasian Cranes with their young ones in the middle stroll through the *dehesas*, the oak forests of the Extremadura in southwestern Spain (near Obando in the vicinity of the Orellana reservoir, Extremadura, Spain).

intensive maize production, since the cranes' main diet consists of harvest leftovers. (The problems caused by this are described on pages 210–218). In Hungary, too, cranes are staying longer into the autumn than they used to. Nowadays, the expanded wintering territories of the Eurasian Crane extend across parts of France, Spain, Morocco, Tunisia, Israel, Ethiopia, Sudan, Turkey, and India, and as far afield as southwest China. For the Eurasian Cranes to flourish, the protection and maintenance of their staging areas, where tens of thousands of them sometimes congregate, is at least as important as the conservation of their breeding grounds. Encroaching on, or even destroying, just a few of these areas can cost many cranes their lives. And because cranes that breed in one area tend to spend their winter holidays together, the loss of such flocks can lead to the desolation of large breeding areas in subsequent years.

Even when walking among the broad trunks of ancient cork and holm oaks, the Eurasian Crane cuts an impressive figure. Increasingly large areas of these centuries-old mast forests—a defining feature of southwestern Spain, both in terms of the environment and culture—are being cleared to make way for EU subsidised farmland (near Obando, Extremadura, Spain).

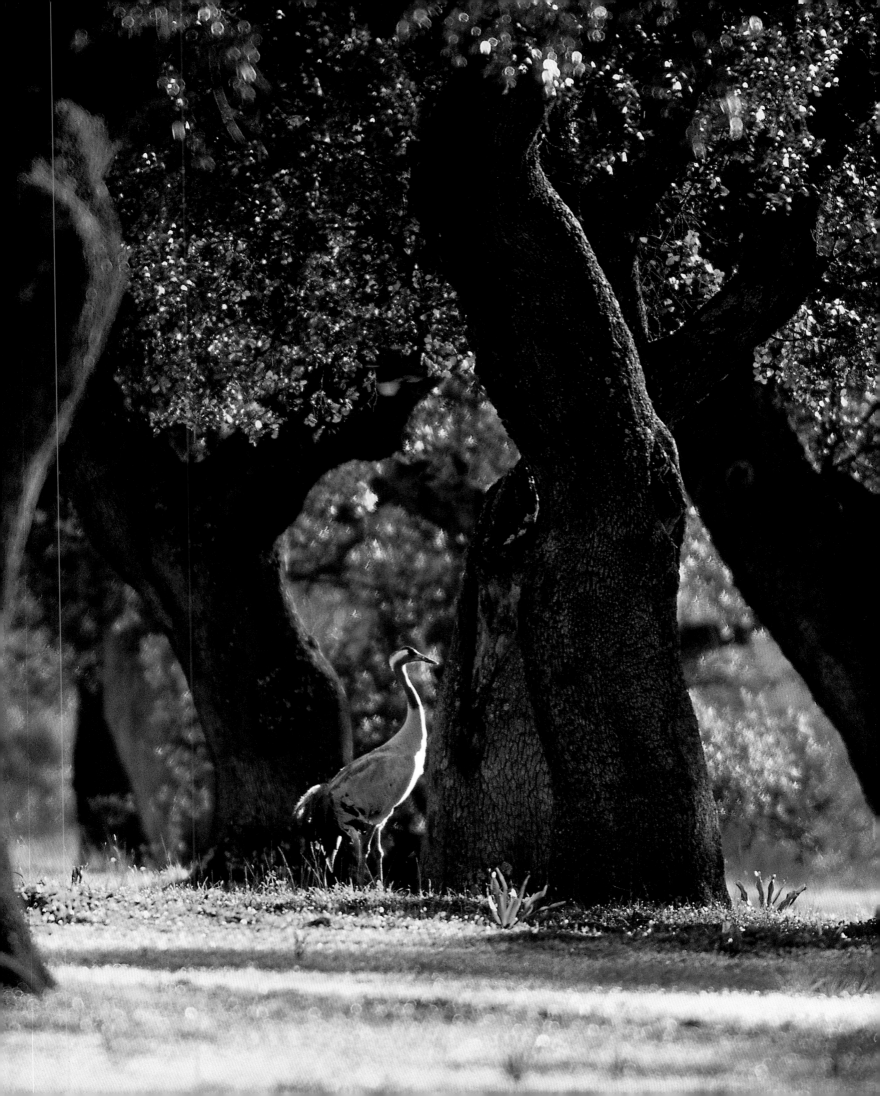

RIGHT
At their wintering grounds, Eurasian
Cranes meet many other types of
birds they would not otherwise come
across. This pelican, in the Hula Valley
in Israel, is one of 300 species of
birds that gather here. Exhausted
or wounded cranes have to watch
out for birds of prey such as Golden,
Imperial, Steppe, and Sea Eagles
(Agmon Park, Hula Valley, Israel).

FOLLOWING DOUBLE PAGES
An autumnal morning at the roosting
area of a flock of Eurasian Cranes,
shortly before sunrise (p. 158–159).
A few minutes after this photograph
was taken, the birds ended their nightly
sojourn and early-morning feather
preening, taking off in small groups
to the surrounding fields (near Grüne-
walde, Brandenburg, Germany).

Long before sunrise, these Eurasian
Cranes have left the wetland roosting
areas in their Ethiopian wintering
grounds (p. 160–161) and are passing
over the mighty canopy of an old, free-
standing tree (close to Lake Cheffe
near Debre Zeyit, south of Addis
Ababa, Ethiopia).

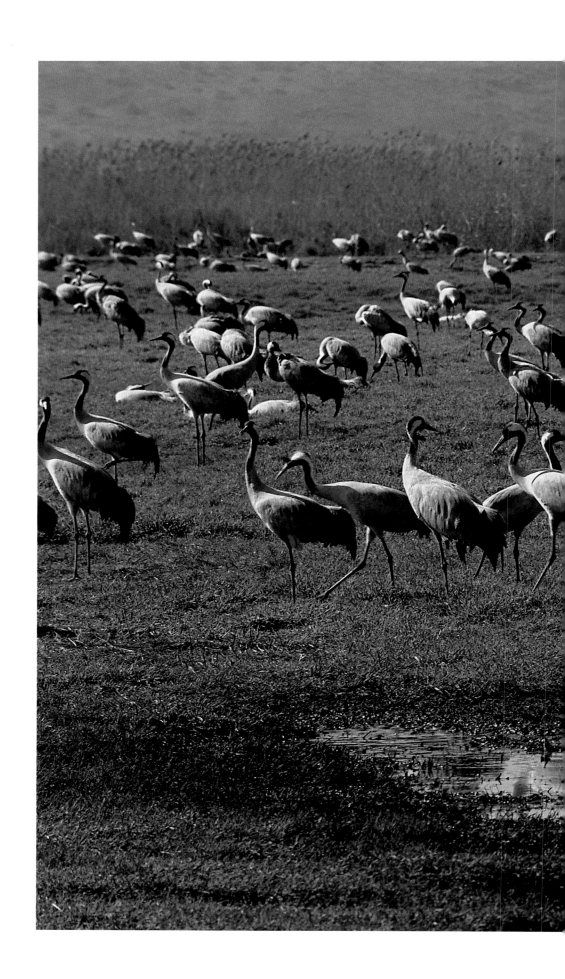

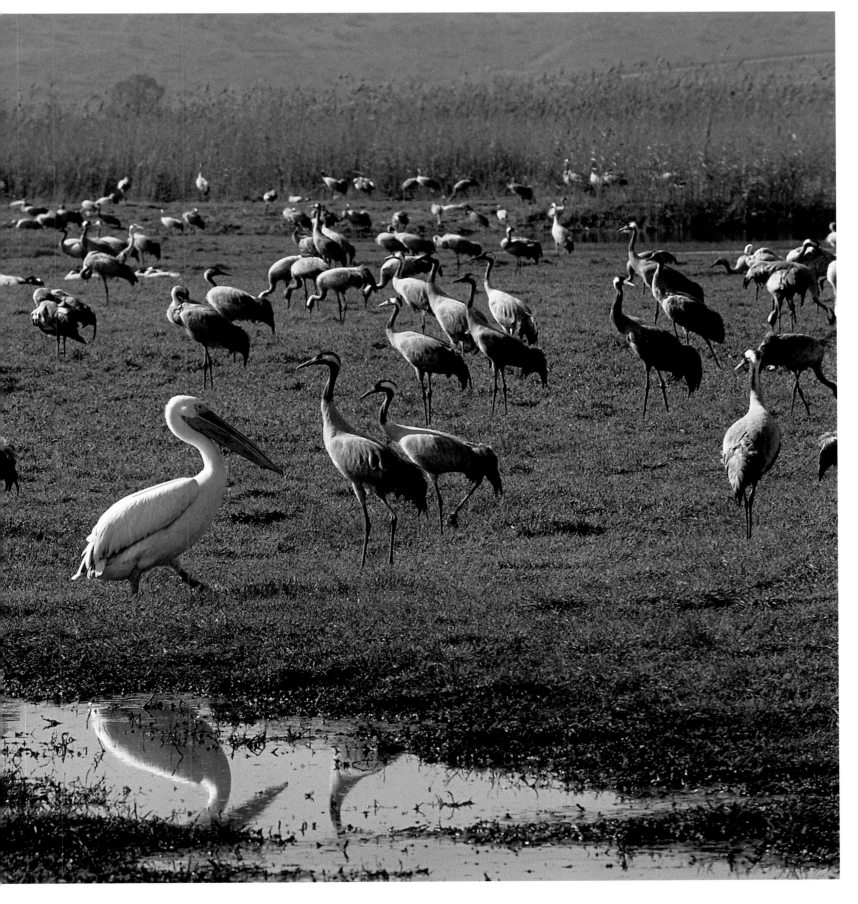

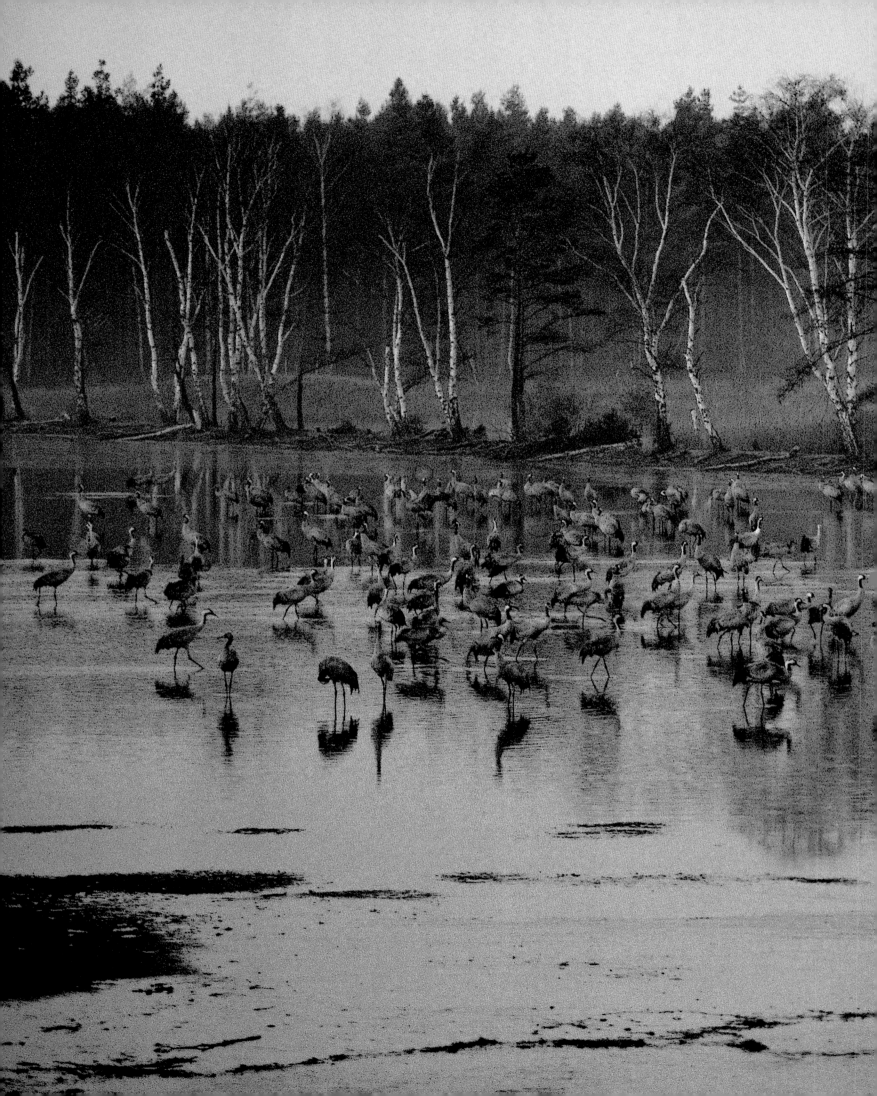

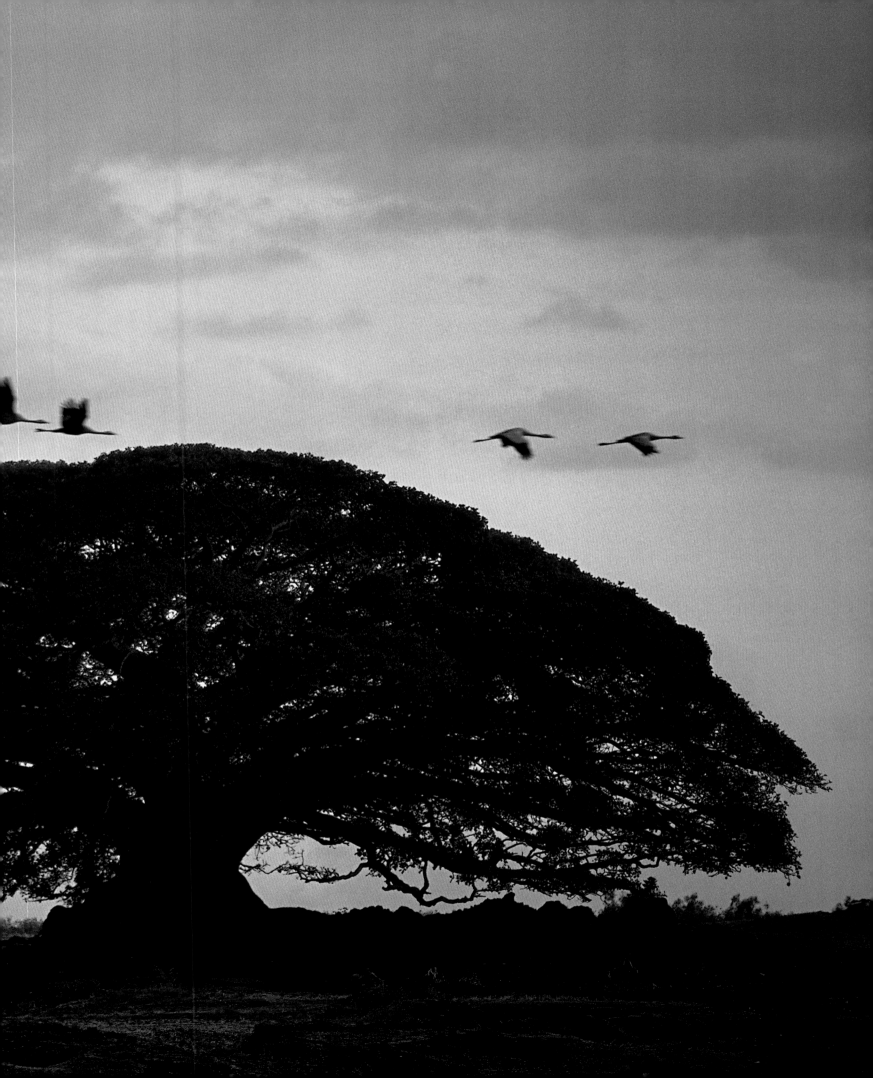

Beautiful limestone reliefs on the walls of ancient Egyptian grave chambers *(mastabas)* depict domesticated or captured European and Demoiselle Cranes with their keepers. The 'crane wall' in the burial chamber of Ty in Sakkara is particularly well preserved (beginning of the Fifth Dynasty, about 2400 BC).

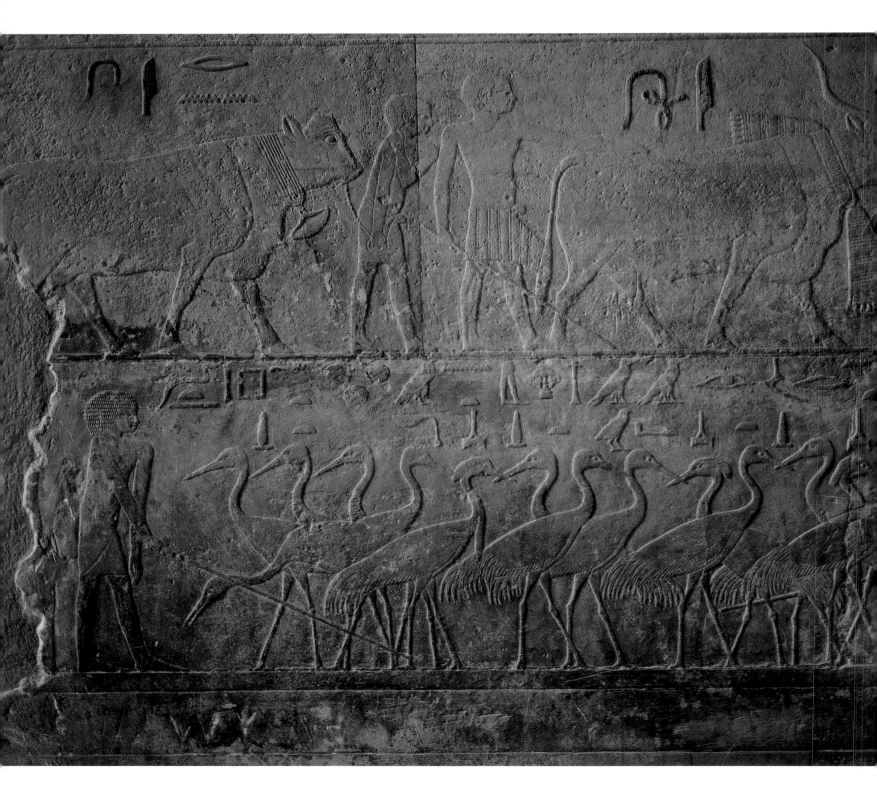

Unique Among Birds as Icons
of Art and Culture

Cranes have been a source of fascination, stirring people's curiosity and imagination, since the earliest times, as is evidenced by numerous works of art and literature from different periods, cultures, and countries. The interest in these especially charismatic birds has remained undiminished to the present day. In fact, it is probably stronger than ever before considering the many modern depictions of cranes—their frequent use in advertisements and as marketing tools, as well as an increasing number of films and books (including the present volume). This chapter will only be able to highlight a few examples of the important role played by cranes in mythology, religion, art, and literature, as well as in people's everyday lives from antiquity to the present day. In the process, it will be impossible to avoid citing occasionally from my earlier book *Kraniche – Vögel des Glücks* (Cranes – Birds of Happiness), in which the topic is treated more extensively. A complete cultural history of the crane would undoubtedly be as extensive and exciting as a natural history of this elegant bird. Whichever approach is chosen, however, both types of history must be continually updated, since new facts emerge each year.

Even though many historical artefacts detailing the relationship between humans and cranes were lost before the advent of modern conservation techniques, there are still astonishingly early clues as to humans' high regard for, and many uses of, these birds, which populated the earth long before *Homo sapiens* arrived on the scene. For example, in 1999 archaeologists working in the Yellow River Valley in China unearthed a still-playable flute carved approximately 9000 years ago from the wing bone of a crane. But whereas this can be considered a 'secondary use' of the animal, a large number of reliefs chipped or carved in stone approximately 4500 years ago in Egypt show how people at the time kept herds of cranes for sacrificial purposes, or as a source of meat.

Particularly famous and well-preserved are the images of cranes in the underground burial chambers *(mastabas)* of Ty, a wealthy country nobleman in the town of Saqqara, a few kilometres to the south of Cairo's outlying districts. These reliefs were created around 2400 BC at the beginning of the Fifth Dynasty and provide valuable insights into the background and everyday life of a rich landowner of the time. On several walls of the extensive underground complex, which belongs to one of ancient Egypt's most important necropoles, the visitor can see reliefs in which people are depicted together with cranes. Interestingly, the stonemasons distinguished precisely between Eurasian and Demoiselle Cranes. To this very day, both species fly along the Nile as they migrate from their breeding grounds in Eastern Europe to their winter homes in Ethiopia and Sudan.

Only partly preserved and no longer in colour: a guard holds a crane.

In earlier times, large flocks of cranes undoubtedly also spent the winter on the fertile banks of the Nile, where they were caught and tamed. Already in use back then, clap nets were set up in areas where the birds would sleep. Pictures indicate that cranes were kept and fed like other fowl, at times together with geese and ducks. The practice of force-feeding was also used to fatten the birds. It is unlikely that cranes, especially those born in the wild, were as comfortable with people as some depictions make them out to be. However, the ancient Egyptians may also have bred the animals in captivity, raising their offspring as domestic fowl.

As Food and Medicine

Lovers of good food have consistently claimed that crane meat is especially savoury. The Roman poet Horace (65-8 BC) described the bird as 'agreeable prey', and his contemporary Apicius, who had a reputation as a gourmet, recommended crane meat, but suggested that the cook remove its many tendons first. Even the prominent natural scientist Konrad Lorenz (1903–1989) was said to have spoken approvingly of the taste of crane meat after testing a sample.

Old recipe books extol the curative power of certain parts of the crane's anatomy or of broth made from its meat. For example, in the German edition of his treatise on birds published in 1557 and originally written in Latin, Conrad Gessner writes: 'Cranes are useful, when eaten, to people afflicted with colic. Broth of this bird makes for a strong voice and enhances masculinity. The head, eyes, and stomach of this bird are dried and powdered with everything in them; this helps against fistulas, cancer, and all sorts of swellings. From the marrow of this bird's shin bone, a salve for the eyes can be made.' Prior to this, recommendations for obtaining medicines from cranes were made by scholars of traditional Chinese medicine, as well as by the Roman author Pliny the Elder (23–79 AD) and the Abbess Hildegard of Bingen (1098–1179).

In ancient Egypt, cranes not only enriched the bill of fare and were likely used to produce medications. As can be seen on the walls of the tombs, they also served as sacrificial animals, according to the maxim: what tastes good to people will also please the gods. It is possible that cranes were among the many offerings placed in the magnificent graves along with the dead. Moreover, items painted on the walls were also meant to ensure that the deceased, in the sealed burial chambers, would have an environment similar to the one they knew from this life.

The well-preserved depictions in various tombs in Saqqara are not the only examples of cranes in art from this period. The Egyptian Museum in Cairo boasts part of an especially beautiful limestone relief from a *mastaba* in Meidum showing three cranes and dating from the Third Dynasty (between 2660 and 2590 BC). Unlike the falcon or ibis, there is no firm evidence that the crane had mythological or religious significance in ancient Egypt, although it is suspected that this may have been the case. Interestingly, however, cranes frequently appear not only in tombs, but also in some temple complexes, such as those in the ancient capital of Thebes—known today as the tourist destination Luxor. Whether they served there as illustrations of everyday life, and thus purely as wall decoration, or were religious symbols, cannot be answered with any degree of certainty.

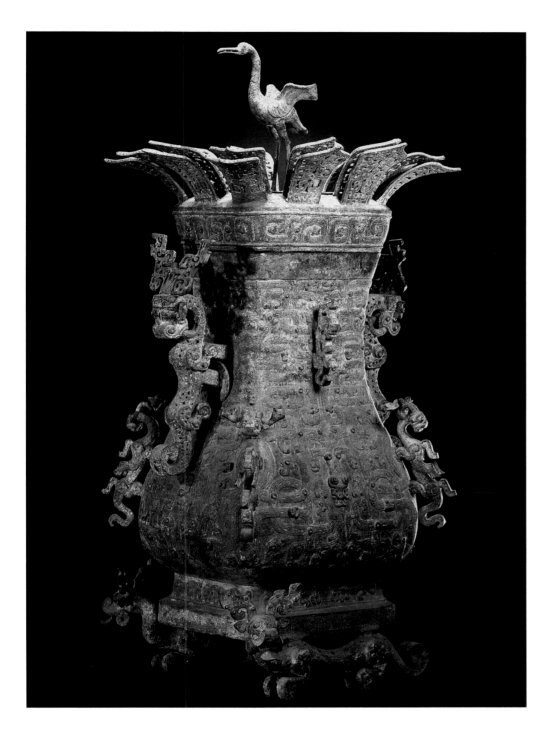

In the Company of Nymphs and Dancers

Although Egypt and Greece belong to two different continents, they are not far from each other, and in antiquity they had, at times, political relations that were not always beneficial to Egypt. But culturally they inspired one another. As Assyrians, Hittites, and Sumerians in Asia Minor and the Middle East had done before, Egyptian and Greek scholars studied bird migration and, especially, the flight formations of cranes. The peoples in and around Mesopotamia are thought to have drawn inspiration for their cuneiform script—and, later, the Greeks for several letters in their alphabet—from the flying patterns of cranes.

Ancient Greek art was also influenced by these elegant birds, and one often finds cranes depicted together with humans on vases, bowls, and perfume vials dating back as early as the fifth and fourth centuries BC. This artistic development followed a path similar to that seen in Egypt: in Greece, too, cranes were kept as pets and courtyard animals— but for aesthetic enjoyment rather than as a source of nutrition. Numerous clay and alabaster vases from this period depict Demoiselle Cranes, mostly in the company of women. The birds also appear together with nymphs and female dancers as engraved or raised figures on precious and semi-precious stones. This suggests that members of the species *Anthropoides virgo* were common in Greece during this period—as, indeed, they were throughout southern Europe, even residing throughout the year in some regions. These delicate, attractive creatures are often portrayed in a manner that implies they were nurtured, or even worshipped, by the people around them. Even nowadays one finds them in grand Asian gardens or even in backyards, where they are kept, usually illegally, as vigilant pets.

This richly ornamented bronze vessel from the Spring and Autumn Period (770 till 476 BC), excavated in the Chinese province of Henan in 1923, is crowned by a crane.

Everywhere in and around the palaces
and temples of the former 'Forbidden
City' in Beijing are stone or metal
cranes. The birds are also depicted
on walls. Today, the Palace Museum
attracts hundreds of thousands of
visitors each year.

Companions of the Gods

Painters and potters in Greece probably studied cranes long before the earliest preserved artefacts were made. Indeed, cranes had already accompanied the gods Apollo and Hermes, and stood at the side of Eros, the god of love, as well as Artemis, the goddess of hunting and chastity—not to forget Demeter, or 'mother earth'. So it was nigh impossible for early poets and philosophers not to focus attention on these birds that crossed the Peloponnese twice a year. In the eighth century BC, Homer refers at the beginning of the third book of the Iliad to a story that must have already existed at the time and was passed down and transformed through the ages, but is still known today as 'The War Between the Pygmies and the Cranes': 'When the companies were thus arrayed, each under its own captain, the Trojans advanced as a flight of wild fowl or cranes that scream overhead when rain and winter drive them over the flowing waters of Oceanus to bring death and destruction on the Pygmies.' These lines have been subject to diverse interpretations and been linked to many a legend. 'Geranos', the Greek term for crane, is even derived from such a legend: the Greek goddess Hera is said to have transformed Gerana, a leader worshipped by the pygmies, into a crane. (Different versions of this story exist.) In his drama *Helena*, the Greek poet Euripides (486–406 BC) has the choir of Greek female slaves held in Egypt sing the following: 'You feathered birds with necks outstretched, gliding above among the racing clouds—fly on towards the Pleiades to Orion, lord of the night.'

A further Greek legend in which cranes play a special role, and which may even be based on a true story, is particularly well-known in the German-speaking world. In his ballad *The Cranes of Ibycus*, Friedrich Schiller (1759–1805) crafted some impressive verses concerning the fate of the popular sixth-century BC singer and lyricist Ibycus, who is killed by two robbers while on his way to the chariot races and musical competitions in Corinth. At that moment, a flock of cranes, 'screeching fearfully', passes overhead and the dying man calls out to them: 'By you, ye cranes, that soar on high, if not another

In ancient China the crane was regarded as the 'emperor's bird' and adorned the rulers' residences, either as a life-like depiction or, occasionally, as an artistic abstraction. This bronze crane by the Palace Museum is probably the world's most photographed bird.

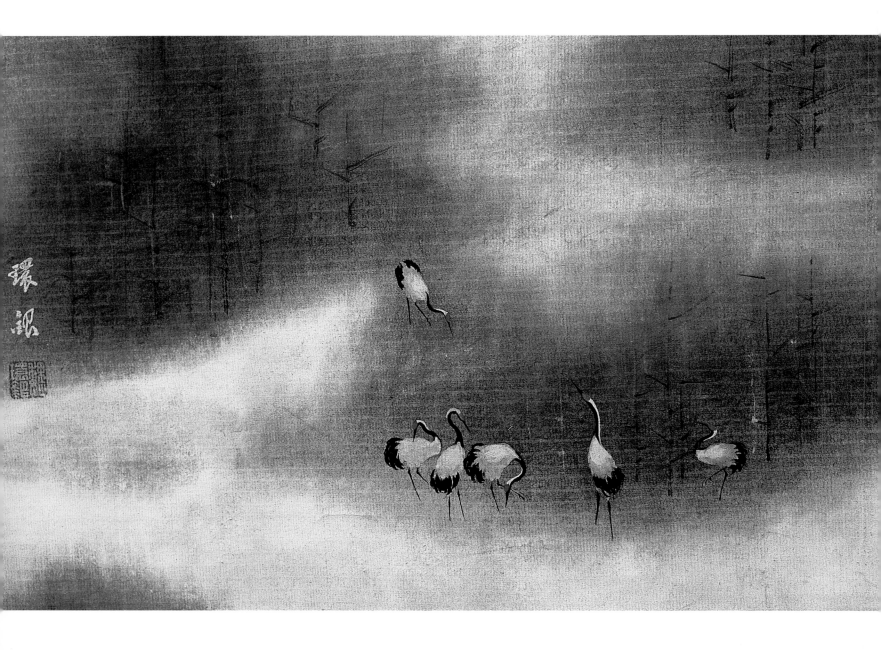

Up to this day, cranes have remained
a popular motif among Chinese artists
for their scroll paintings. Here is a
very delicate depiction of Red-crowned
Cranes in typical pose.

voice is heard, be born to heaven my murder cry!' Later, when the killers arrive at the aforementioned contest in the theatre, they see 'overhead a dusky flight of cranes approaching hastily'. One of the murderers shouts: 'See there, see there, Timotheus! Behold the cranes of Ibycus!' Thus the killers reveal themselves and are punished for their crime.

The Bird With the Stone

Far closer to nature, Hesiod wrote the following around 700 BC: 'Beware the time when you hear the voice of the crane, which year for year, high above the clouds, cries sharply, for this signals that it is time for rain.' Or: 'Note that as soon as you hear the voice of the crane, which yearly cries from on high announcing the winter rain, he sends you a warning to plant your fields.' And the Greek historian and storyteller Herodotus (ca. 485–425 BC) noted in his second book *The Histories* that the migration of the cranes coincided with the annual floods of the Nile. The Roman poet Vergil (70–19 BC) also regarded cranes as weather forecasters: 'When the high-flying crane seeks refuge in a valley, a storm is brewing.'

The philosopher Aristotle (384–322 BC), who studied nature extensively, disputed a fable conjured up by his sixth-century BC compatriot Aesop in which the poet also ascribes great cleverness to cranes. As the story goes, when cranes rest, one of them is always on guard duty, holding a stone in its raised foot. Should this crane begin to fall asleep, the stone falls onto the other foot, thus reawakening the guard. This story, Aristotle declared, was simply a myth, as anyone familiar with cranes can confirm. It was nonetheless later taken up by Roman authors such as Pliny the Elder, mentioned above, and Aelianus Tacticus (170–235 AD), who spun the tale further. Since this time, *Grus vigilans*, the 'crane with the stone', has been immortalised by painters, carvers, stonemasons, sculptors, poets, and on coats of arms—right through the Middle Ages and up to the present day.

Another tale from the realm of myth, and one that was popular in a number of European countries, was that cranes swallowed stones before embarking on their long journey between their breeding grounds and wintering habitats. The birds would then, should the winds require it, regurgitate the stones in flight and cast them off like excess ballast. If the birds were travelling by night, or so the story goes, the sound of the stones' impact would reveal whether the cranes were flying over land or over water. This tale has also been depicted frequently in paintings.

A detail of the crane-adorned wooden ceiling in the three-storey imperial Chang Yin Ge Theatre from 1776, which today is a part of the Palace Museum in Beijing.

来绮道附十通
主逢来山童波
飞青沈菌柱上
参天云鹤逊其
下翔鹤戏其身
来风忽堂举约
棹见家幼状
杂飞所出乃在
翔阳俗中心院
苍关布乐盖
天陛日由坐东
幹熊夕没画枝
顾伴纡阳当
回日使东驰
人堂不陽百戚
威北赦映惠於
香六翔排窝
陵紫盛辉姚
同松奇凯迟堂
非洞翔翔九天
上韩罗透讨
游东凯扶杂
暖石鏡的水涯
北恆玄夭佑南
翔陶丹丘

北建
粉仙
图

Many a restaurant in China has crane
motifs on its walls; on the opposite
page is a restaurant in the northern
Chinese town of Qiqihar, depicting
Red-crowned Cranes. The photograph
above is of a Beijing hotel restaurant,
showing a detail of a 60-square-metre
painting with beautiful calligraphy by
the well-known contemporary artist
Huang Yong Yu. It depicts Black-necked
Cranes and is entitled *The Journey
to Paradise*.

All in gold with a deep blue background: the crane at the foot of a pine tree, in front of a temple, faced by another crane on a branch opposite. This relief belongs to a series of fine pieces of goldwork exhibited in the Palace Museum in Beijing.

Highly Revered in the Courts of Rulers

Nowhere else has the crane been so consistently adopted over the millennia as a symbol for good as in China—whether as a heavenly messenger or as a trademark on packets of cigarettes or on bottles of beer. Although seven species of cranes regularly appear in this large Asian country, all tributes, illustrations, and descriptions pertain to the white Red-crowned Crane. Yet black, yellow, and blue cranes also appear in Chinese mythology. A treatise on cranes dating back to the sixth century BC equates the crane with the philosophical concept of yang, which, in contrast to ying, represents light and happiness. The 'immortal crane' is seen both by Laozi (in Taoism, which he founded) and by Buddha (who regards the crane as a 'godly bird') as an important arbiter between the 'now' and the 'hereafter'. The red-crowned birds with the snow-white plumage and the black secondary and tertiary feathers were seen as messengers from heaven and as the flying 'horses' of the Gods; they were called 'heaven's crane' *(t'ien-ho)* and 'crane of the blessed' *(s'ien-ho)*. When a Taoist priest died, he would be transformed into a crane and lifted into the heavenly kingdom. In this way, the crane became a symbol for immortality.

As it says in the commentary to the Shi Jing, the Confucian Book of Songs from the third century BC, 'The crane has a long life of a thousand years.' Emperors and princes held cranes at court, hoping that some of the birds' godliness and longevity would be passed on to them. Hosts of servants had to ensure the well-being of these animals, which enjoyed the very highest status. It is said that Prince Yi, who ruled over the state of Wei during the Spring and Autumn Period (770–476 BC), bestowed on his cranes the ranks of 'high officials and generals' and that they accompanied him on his travels, chauffeured in coaches and sedan chairs. Artisans, and sometimes even the rulers themselves, variously depicted the birds on scroll paintings, carpets, and silk curtains, also making models of them out of bronze, gold, silver, porcelain, stone, clay, or wood. Years ago, archaeologists exploring Qin Shi Huang's monumental tomb in Lintong, near the old imperial

福を招く「和室」の演出
Hanging Scrolls and Folding Screens
幸せを呼び込もうと
建物の中に飾った瑞鳥ツル。

The crane depicted as the 'heavenly bird' bearing the souls of the dead into paradise: a classic painting from ancient Japan. The motif is Chinese in origin, but has been modified many times over in the 'Land of the Rising Sun'. The old scroll painting is featured on a poster in the Crane Museum in the southern Japanese town of Izumi and has additionally been embellished with two dancing cranes in the top right-hand corner.

city of Xian, discovered that China's 'First Emperor' had thirteen large bronze cranes in his artefact chamber, dating from 220 BC. They were there to accompany him in the afterlife, along with ceramic soldiers and a multitude of dead animals including, apparently, giant pandas, tigers, and 500 horses.

In the former 'Forbidden City' in Beijing (the Emperor's palace built between 1406 and 1420, now the Palace Museum), scores of crane statues, ceiling paintings, carved figures, as well as precious jewellery, silk embroidered capes, and embroidered rank insignia on uniforms of Mandarins and court officials from the Ming and Qing dynasties (1368–1911) all bear witness to the diversity of representations, and thus the significance that cranes had in China. In the Summer Palace (Yi He Yuan) on the outskirts of Beijing, the visitor will also frequently come across representations of cranes.

Often, cranes were depicted alongside tortoises and mountain pines, two other symbols of longevity and steadfastness. Laozi is rumoured to have said to Confucius, 'The crane does not bathe every day, but still stays white. Its call is not as pleasing as that of the nightingale, but it rings of honesty and justice'. And, in the aforementioned Book of Songs, it is written: 'When a crane, standing by a pond, cries out, its voice reaches heaven'.

The Patriarch Among the Birds

Considering the importance of cranes in religion and mythology, it is not surprising that poets and writers focused early attention on these 'patriarchs among the birds'. There are many fairy tales and legends in which humans are transformed into cranes or vice versa. Usually love and (un)happiness are vital ingredients in these stories. In an ode to his loved one, Ying, the famous Tang Dynasty poet Bai Juyi (618–907) writes: 'May we become cranes and fly through the heavens, wing upon wing'. Time and again, cranes have been used to signify liberation from earthly constraints, as symbols of the unshakeable unity of two people, and of everlasting

happiness. Thus, one of the most beautiful lyric poems in recent German literature, Bertolt Brecht's *Die Liebenden* (The Lovers) from *Aufstieg und Fall der Stadt Mahagonny* (Rise and Fall of the City of Mahagonny) was inspired by Chinese poetry: 'See there two cranes veer by one with another, / The clouds they pierce have been their lot together / Since from their nest and by their lot escorted / From one life to a new life they departed / At equal speed with equal miles below them / And at each other's side alone we see them: / That so the crane and cloud may share the lovely, / The lonely sky their passage heightens briefly; / That neither one may tarry back nor either / Mark but the ceaseless

Cranes shown in the open, snow-covered landscape in front of Mount Fuji—this famous picture by Katsushika Hokusai (1760–1849) with the title *36 Views of Mount Fuji* has been copied and interpreted widely in Japan.

lolling of the other / Upon the wind that goads them imprecisely / As on their bed of wind they lie more closely. / What though the wind into the void should lead them /.../ In one another lost, they find their power.'

'May your life be as long and as happy as that of a crane!' Even today, this is a common toast expressed on birthdays in China, Japan, and Korea. At the turn of the year, lavishly styled cards depicting cranes are sent to friends and relatives. In Japan, many brides wear kimonos with cranes printed or embroidered on cloth or silk. (In 2004, Hanae Mori, one of Japan's great international haute couture fashion designers, presented a farewell collection

Shown below is a detail of the fifteen-metre-long painting *A Thousand Cranes* from the seventeenth century. One of Japan's national art treasures, it was created by the artist Sotatsu together with numerous calligraphers.

of very elegant dresses and capes decorated with traditional and modern crane motifs.) Here, too, the 'honourable Mr. Crane' *(O tsuru sama)* is a guarantor of longevity and happiness—for he is a constant companion of Fukurokuju, one of the seven gods of fortune in Japanese Buddhism. And on special occasions, a classic ballad called *Tsurukame* is often played, a piece in which a crane and a tortoise play the leading roles.

In fact, Japanese society has maintained a 'crane cult' that is based more closely on historic and religious influences than is the case in China, where the fine line between reverence and kitsch or commercial hype is crossed more frequently. (And this even though the crane cult originated in China, only making its way to Japan, via Korea, in the sixth century together with Buddhism and the Buddhist artistic heritage.) It took centuries for a homegrown Japanese style to emerge in the depiction of cranes. Even now, in Japanese museums, visitors can see old scroll paintings or vases made by Chinese artists. However, from the eleventh century onwards, at the latest, an independent 'art of cranes' emerged in Japan. This was not only apparent in typical Japanese lacquer paintings. The fifteen-meter-long work *A Thousand Cranes* painted by Sotatsu in 1611 is one of the classics of Japanese art and has provided inspiration to artists ever since. In this masterpiece, the gold and silver cranes dancing on the coast are juxtaposed with the verses of 36 poets, the calligraphic presentation done in various sizes and shades.

Every day, in addition to flowers, the visitors to the Memorial Cenotaph commemorating the victims of the atomic bomb attack on Hiroshima also leave folded paper cranes.

Numerous examples of creative Japanese origami art are to be found at the Hiroshima Peace Park. Paper cranes attached to chains and wreathes are particularly popular and are often placed with poems and letters attached to them.

Symbol of Life and Champion of the Good

A thousand cranes also appear in the realm of origami, which is the art of folding paper into figures and making creative packaging. As long ago as 1798, a book with the title *How to Fold a Thousand Cranes* appeared in Kyoto. A single paper crane, better still a bouquet of folded cranes, has always been considered a good-luck charm and—based on the idea that cranes live to be a thousand years old—a guarantor of longevity. If someone is ill, visitors bring that person origami cranes as a get-well gesture, rather than flowers. In some Japanese households, one finds bundles of paper cranes by the entrance, placed there to ward off evil. Even today, thousands of people, especially school children, visiting Hiroshima's Peace Memorial Park lay large numbers of paper cranes at the foot of the Peace Memorial commemorating the victims of the American atomic bomb attack on 6 August 1945 and its horrific aftermath. The visitors also pay their respects to one victim in particular: Sadako Sasaki, who, suffering badly from radiation sickness, started folding cranes in hospital, ten years after the bomb was dropped. She wanted to fold a thousand cranes because, according to legend, doing so is a means of overcoming death. Sadako only managed to fold 600 before she died. Children from over 3000 schools in Japan folded millions of cranes to collect money for building a cone-shaped monument, crowned by a girl with a paper crane in her hand. The monument is a constant reminder of the fate of Sadako Sasaki and countless other victims. Since then, the 'chain of a thousand cranes' has served as a symbol of peace, as has the 'crane bell', also located in the Peace Memorial Park.

The crane had yet another meaning in Japan at the end of the Second World War. 'With the voice of the crane', the Japanese emperor advised parliament to accept capitulation. Even today, one does not contradict *tsuru no hitokoe*, the 'unique call of the crane', because it denotes authority. In other Asian countries, cranes have been held in equally high esteem. Together with the spread of Confucianism, Taoism, and Buddhism, in which cranes, among other animals, appear time and again, these 'messengers of heaven' not only crossed borders while migrating, but as symbols and cult objects. The attachment of Koreans to the Red-crowned Crane, can be seen even today. A major reason for their fondness for this bird is that 400 to 600 cranes winter in North and South Korea each year—quite a few of them in the Demilitarised Zone (DMZ). However, although cranes have great symbolic significance in Korea even today, people in both the North and South continue to infringe upon the birds' wintering grounds.

The depictions of cranes in some of the monasteries in Bhutan were inspired partly by religious beliefs (that were not necessarily imported from China), but also served educational and decorative purposes. The images are creative representations of white cranes and Black-necked Cranes. At one time, the latter may even have had breeding grounds in this mountainous region. Nowadays, several hundred fly over from Tibet each November to spend the winter in two specific valleys. When asked about the meaning of these pictures on their walls, the monks from the various monasteries were unable to provide an answer. Some indicated that they regarded cranes as a special type of bird—one that serves as man's companion throughout his life and thus needs to be honoured and protected. Depicting them in paintings was a way to do this.

In the past, however, monks not only made paintings of the birds, but also endowed them with an aura of myth. According to an Indonesian legend, which is said to have originated on Sulawesi, one of the Greater Sunda islands, a crane standing on a rock in the sea was the first living being after the world was created. The rock perspired as the crane was born, and out of this sweat, the goddess Lumimuut came into being. The crane told her about a 'primeval land' from which she was to fetch two handfuls of earth. She did this and, upon her return, poured the soil over the rock, which gave rise to all other forms of life.

In India there are paintings in which the Sarus Crane is depicted as the companion of Vishnu, who is one of the main gods next to Shiva and Krishna. With its height of more than 170 centimetres, the Sarus

Crane's commanding appearance undoubtedly contributed to its status as a sacred animal. But whatever the reason for this veneration, the status afforded cranes in India ensured for many centuries that they were not hunted—and even tolerated when they came to feed on a farmer's land. In the vicinity of Buddha's birthplace in Lumbini in south-western Nepal, Sarus Cranes are still regarded as special birds by the rural population. In fact, the people there have established a refuge area for the species *Grus antigone* between the temples, many of which were only built in recent years. These animals—which in the other areas they inhabit are threatened by the expansion of human settlements—apparently also used to be exempt from being hunted. This can be deduced from old paintings, which show humans going after all sorts of birds with nets and weapons, but leaving the Sarus Cranes unharmed.

World-class Dancers

The Brolga, a close relative of the Sarus Crane, was held in high esteem in its homeland Australia; according to an Aboriginal legend, the crane had once, itself, been an Aborigine. This story is rooted in the Brolga's passion for dancing. The legend says that an evil magician enveloped the beautiful dancer Buralga in a cloud of dust. The magician was angry because she had rejected his advances. Buralga could only free herself from the cloud by becoming a crane. Since then, her feathered descendants have been particularly avid and tenacious dancers, and these dances serve to remind us of the beautiful girl's fate. Another legend has the Brolga bringing fire to humanity. One day, the crane flew so close to the sun that a twig it was carrying in its beak caught fire, whereupon the bird returned to the ground and lit a pile of wood.

The flapping and jumping dances performed by the cranes—to stimulate their partner, as a group exercise, out of excitement, or as a threat display—have inspired people around the world to emulate them. Crane dances, as they are still presented on special occasions by school children wearing colourful costumes in the northeastern Chinese town of Qiqihar, were already being performed in China around 500 BC. The Ainu tribe on the northern Japanese island of Hokkaido used the Red-crowned Crane as a role model for its figure dances, the bird being renowned for the agility of its movements. Various indigenous tribes in North America were inspired by Sandhill and Whooping Cranes. In Africa, the Zulus and other tribes studied the 'choreographies' of Grey Crowned Cranes and Blue Cranes; in Chad, Black Crowned Cranes served as role models; in Europe, the Eurasian Crane inspired beautiful dance figures among a number of different peoples.

From the ancient world, the crane dance of Delos deserves special mention. Theseus is said to have first performed it on the island together with the seven virgins and seven youths he had saved from the Minotaur on Crete. Theseus may well have been inspired by the crane dances on neighbouring

Catching birds, especially cranes, has been popular in Afghanistan for many centuries. This picture (in the National Museum in New Delhi, India) was created by the artist Bhag in the sixteenth century BC. It depicts two Sarus Cranes in the company of pelicans, storks, herons, and other birds, being watched by a catcher who has spread out his net.

مضبوط می سازند بعد از آن چوب برابر بند دست را در میان
طناب پیچیده می برازند طناب همان طور پیچیده و کاو اک می ایشد بیلد ورا کرا

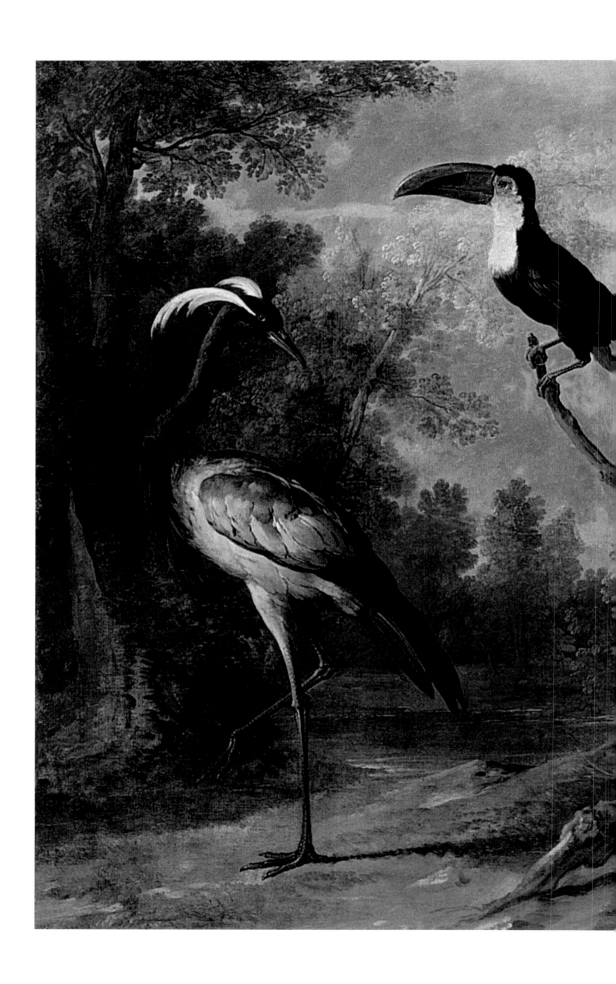

The French painter Jean-Baptiste
Oudry (1686–1755) studied his feath-
ered subjects very closely in aviaries
and parks before 'enhancing them'
through his art, as he put it. He parti-
cularly liked painting cranes. This
130 x 160 cm oil painting from 1745
entitled *Toucan, Demoiselle Crane,
and Crowned Crane* is now owned
by the State Art Museum in Schwerin,
Germany.

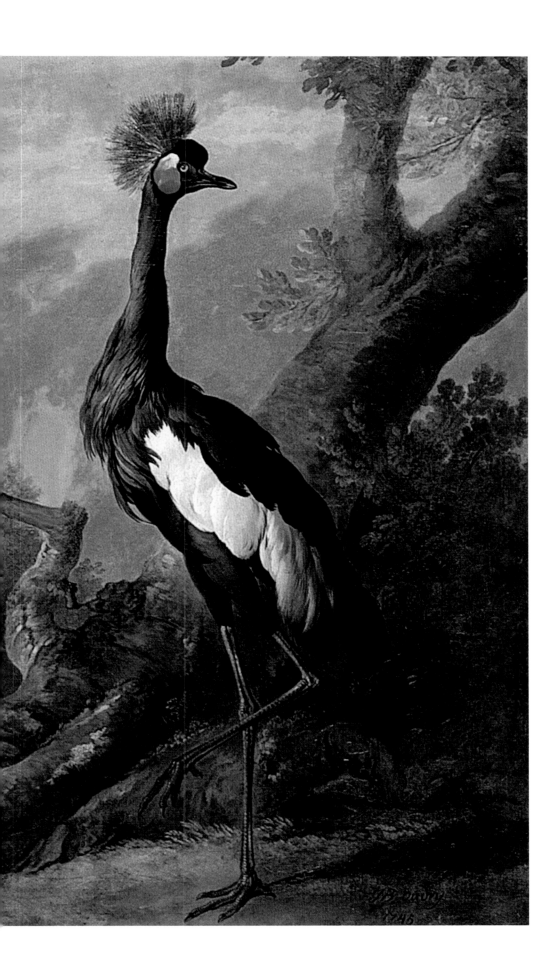

In the fourth guest room in Sanssouci Palace in Potsdam, the so-called Voltaire room, ornate wood carvings—all with a nature theme—adorn the walls. Particularly impressive is this crane with a bent neck, which, like the splendid palace itself, was created in the mid-eighteenth century.

In the aviary for wading birds in
the Vienna Zoo (Tierpark Schönbrunn),
Annie Eisenmenger created this mosaic
of Francis of Assisi in 1955. No less
than three species of cranes are in
attendance before the holy saint.

islands, which were part of the ritual of sun worship. Even today, people in some Nordic countries greet the onset of spring by performing crane dances. One of the dances that used to be performed at the French royal court before becoming a popular ballroom dance in neighbouring countries during the Baroque period, was the *crue*. The name is very similar to the French word for crane: *grue*. This dance begins with nine steps—equal to the number of strides the crane usually makes before it takes off in flight.

Highly Esteemed by Artists

Towards the end of the Middle Ages and during the first centuries of the modern period, the crane became a very popular symbol in many European nations. This probably had less to do with the birds' dwindling numbers (as a result of intensive hunting), but rather with their increasing popularity as a motif among famous artists. The use of cranes imported from other continents as decorative elements for the pleasure grounds and aviaries of kings and princes undoubtedly played a role in this development. Thus, the artists who created the beautiful mosaics in the anteroom of the Church of San Marco in Venice between 1215 and 1218 did not include a Eurasian Crane among the group of birds waiting to board Noah's ark, even though this species was indigenous to Italy at that time. Rather, they chose to depict Asian White-naped Cranes. Crowned Cranes and Demoiselle Cranes were particularly popular because of their beautiful plumage. Whilst Lucas Cranach the Younger (1515–1586) and Matthäus Merian (1593–1650) incorporated Eurasian Cranes into biblical themes, Hans Hoffmann painted a Crowned Crane as early as 1584. In his woodcuts of a triumphal arch for Emperor Maximilian I, Albrecht Dürer (1471–1528) depicts a crane using a motif typical of the time: as *Grus vigilans*, the watchful 'crane with the stone'. This is how the bird appeared on the insignia of bishops and rulers, but also on the coats of arms of families, towns, and communities—as a symbol of open-mindedness, wisdom, and care for others. In the sixteenth and seventeenth centuries, printers used the crane

as a seal of quality, until the supposedly even wiser owl replaced it as the symbol of the guild. Despite this, the crane has not been lost to the world of literature. Since 1983, the Darmstadt-based Deutscher Literaturfonds has awarded an annual Kranichsteiner Prize. It is named after Castle Kranichstein (literally: 'Crane Stone') near Darmstadt; on the palace roof stands a golden crane holding a stone in one foot. The prize, apart from a financial award, is a bronze crane designed by the Darmstadt sculptor Gotthelf Schlotter, creator of many a crane sculpture.

Cranes are also featured in many works of art from the seventeenth and eighteenth centuries, when landscapes and still-lifes were predominant in painting. Of the Dutch and Flemish artists, Melchior de Hondecoeter (1636–1695), member of a family dynasty of well-known artists, was particularly fond of, and particularly apt at, incorporating Crowned Cranes into his bird paintings. The French artist Jean-Baptiste Oudry (1686–1755), famous for his portrayals of animals and hunting scenes, portraits and landscapes, as well as for his many designs for Gobelin tapestries and porcelain, depicted many species of cranes and other 'valuable birds, like precious jewels on a brocade pillow', as described in a catalogue to an exhibition in the Schwerin State Museum, which owns many of the artist's works. Oudry, a master of the art of bird representation, used imaginative backgrounds to enhance his animals—'rendre valeurs aux animeaux', as he put it. Almost at the same time, another Frenchman, the scientist and private scholar Georges-Louis Leclerc, Comte de Buffon (1707–1788), presented his colourfully illustrated *Histoire naturelle*, with nine species of cranes categorised as *Ardea* (herons), the genus classification for cranes common at the time. In terms of accuracy, the artist Oudry, using both living and dead birds as models, far surpassed the scientist Buffon, despite Oudry's somewhat overly imaginative depiction of nature. Finally, between 1827 and 1838 in his work *Birds of America*, the American John James Audobon (1785–1851) created true-to-life depictions of cranes, which were already of great value back then.

FOLLOWING PAGES
Wilhelm von Kaulbach (1805–1874), the court artist of Bavarian King Ludwig I, illustrated Goethe's *Reineke Fuchs* ('Reynard the Fox'), depicting the crane as a Samaritan and doctor who removes a sharp piece of bone from the wolf's throat.

Und es kam ihm ein spitziges Bein die Quer' in den Kragen;

Aengstlich stellt' er sich an, es war ihm übel gerathen.

Boten auf Boten sendet' er fort die Aerzte zu rufen;

Niemand vermochte zu helfen, wiewohl er große Belohnung

Allen geboten. Da meldete sich am Ende der Kranich,

Mit dem rothen Barett auf dem Haupt. Ihm flehte der Kranke:

Doctor, helft mir geschwind von diesen Nöthen! ich geb' euch,

Bringt ihr den Knochen heraus, so viel ihr immer begehret.

 Also glaubte der Kranich den Worten und steckte den Schnabel

Mit dem Haupt in den Rachen des Wolfes und holte den Knochen.

Weh mir! heulte der Wolf: du thust mir Schaden! Es schmerzet!

Laß es nicht wieder geschehn! Für heute sey es vergeben.

Wär' es ein andrer, ich hätte das nicht geduldig gelitten.

Gebt euch zufrieden, versetzte der Kranich: ihr seyd nun genesen;

Gebt mir den Lohn, ich hab' ihn verdient, ich hab' euch geholfen.

Höret den Gecken! sagte der Wolf: ich habe das Uebel,

Er verlangt die Belohnung, und hat die Gnade vergessen,

Die ich ihm eben erwies. Hab' ich ihm Schnabel und Schädel,

Many famous artists have illustrated the fables of Jean de la Fontaine (1621–1695), in which cranes crop up frequently. Another world-famous fable is *Reynard the Fox* by Johann Wolfgang von Goethe (1749–1832). No less than Wilhelm von Kaulbach (1805–1874), court painter to King Ludwig I of Bavaria and head of the Munich Academy, illustrated the well-known 1848 Munich edition. A classic scene from this work shows how a crane removes a bone stuck in the fox's throat—and is then conned out of his promised reward.

Immortalised in Many Poems

Goethe frequently refers to cranes in his works. In the first part of *Faust* in the scene 'Outside the Town Gate', Faust says, 'Alas! To wings that lift the spirit light / No earthly wing will ever be a fellow / Yet 'tis inborn in everyone, each fancies / His feeling presses upward and along / When over us lost amid the blue expanses / The lark sings down his showering song / When over rough heights of firs and larches / The outspread eagles soaring roam / And over lakes and over marshes / The crane strives onward toward his home.' And in *The Sorrows of the Young Werther*, the protagonist sees a crane 'soaring above my head, inspiring me with the desire to be transported to the shores of the immeasurable waters.'

Of the many poets who feature cranes in their works, only a few—some with examples of verses—shall be mentioned here. Schiller and Brecht have already been acknowledged. In the anguish of love, the Hungarian poet Bálint Balassi (1554–1594) devotes seven lines *To the Cranes*. Ewald Christian von Kleist (1715–1759) mentions the impressive bird in the title of his rhyming fable *Der gelähmte Kranich* (The Injured Crane), as does Nikolaus Lenau (1802–1850) in his poem *Der Kranich* (The Crane). Detlev von Liliencron (1844–1909) has the following rhyme in his poem *Märztag* (Day in March): 'Cranes that plough the air up high / in screeching flock from afar do fly.' The Russian poet Sergei Yesenin (1895–1925), who often mentions cranes in his works, describes them as follows: 'The golden shadows on autumn woods / He liked to talk his birch-tree tongue / The cranes that solemnly fly over / have no regrets, their fate still young … I am alone. All round is silence / The cranes are scattered, long since gone / I yearn for my youth's rich endowment / But nothing reached my heart for long.' The poem *Der Große Lübbesee* (The Great Lake Lübbe) by Günter Eich (1907–1972) also ends in a melancholy vein: 'Windless September day / Golden joy flying away / Silently on a crane's wings'. And on the dark side, Ingeborg Bachmann (1926–1973)—though more likely inspired by a heron—writes in

A bronze crane by sculptor Karlheinz Goedtke (1915–1995) stands guard over the small artificial pond in the spacious courtyard of the Duchy of Lauenburg District administrative offices in Ratzeburg. The district has the highest number of breeding Eurasian Cranes in the German state of Schleswig-Holstein.

her poem *Große Landschaft bei Wien* (Large Landscape Near Vienna): 'Where the crane in the reeds of the shallow water / Ends the bow of its renditions / Louder even than a wave / Crashing in, the piped hour beckons.' Wilhelm Busch's (1832–1998) reverence to the large bird in *Der kluge Kranich* (The Wise Crane), and Eugen Roth's (1895–1976) rendition in *Tierleben für jung und alt* (Animal Stories for Young and Old) are cheerful by comparison. Roth describes the crane as 'often very amusing, but reliable as a messenger'.

The list of writers who have included, or referred to, cranes in their novels and novellas, is also long. It includes—to name just a few, and excluding the ancient authors mentioned above—the Italian Giovanni Bocaccio (1313–1375) in *The Decameron*, the Russians Aleksandr Sergeyevitsh Pushkin (1799–1837) and Anton Chekhov (1860–1904), the Germans Theodor Fontane (1819–1898), Ehm Welk (1884–1966), and Ernst Wiechert (1887–1950), and the Kyrgyz writer Chingiz Aitmatov (born 1928) with his novel *Early Cranes*. And, finally, in 1957 the Russian Mikhail Kalatozov gave to his unforgettable movie from that year the title *The Cranes are Flying*.

In the realm of natural history, our knowledge of cranes has been advanced by the Hohenstaufen Emperor Frederick II of Prussia (1194–1250) with his book *De arte venandi cum avibus* (The Art of Hunting With Birds), the Swede Bengt Berg (1885–1967) with *To Africa With the Migratory Birds*, and the American Aldo Leopold (1887–1948) with 'Marshland Elegy' from his book *A Sand County Almanac*, which, translated into many languages, has become a cult book within ecological circles since it was first published in 1949. More recently, a first comprehensive portrayal of all crane species was compiled by Lawrence Walkinshaw (1904–1993), a dentist from Michigan. His *Cranes of the World*, based on his own observations, appeared in 1973. Ten years later, his fellow American Paul A. Johnsgard used the same title for his own new book.

A golden 'crane with a stone' stands above the pediment of Jagdschloss Kranichstein, the sixteenth century hunting lodge near Darmstadt. *Grus vigilans* had an important symbolic and heraldic status in Europe between the fifteenth and eighteenth centuries. Since then, many families and towns have placed the crane on their coats of arms as a symbol of vigilance, reliability, wisdom, and care.

Chief of the Birds

In the New World, interest in the Whooping Crane and Sandhill Crane goes back a long time. Many indigenous American tribes respected and worshipped the crane as the 'chief of the birds' or as 'the one who has the say'. Countless legends, passed on orally from generation to generation, emphasise the crane's importance and tell of its feats. 'Grandfather Crane' helped people on the run cross rivers and gorges by stretching out his long neck and legs to form a bridge. People of the Cree tribe liked to tell their children the tale of how the crane helped the rabbit reach the moon, and how the crane was rewarded with a red crown for its head. When Crow and Cheyenne warriors went into battle, they would blow on whistles that had been carved out of the wing and leg bones of cranes. Crane feathers sometimes complemented eagle feathers as headdress. The warriors hoped that this would encourage the

Cranes have also provided inspiration for wrought-iron craftsmen, who especially like to embellish doors and gates with these elegant birds. And where would they be more aptly placed than in front of the entrance to the International Crane Foundation in Baraboo, where this wrought-iron ensemble welcomes visitors?

'messengers of the great Manitou' to help them—
and to carry their souls to heaven should they nev-
ertheless die in battle.

The indigenous peoples of North America believed
that cranes departed in autumn to search for the
previous spring, which the birds would bring back
with them each time they returned from the south.
They also believed that when these large birds
departed in the autumn, they took smaller birds with
them inside their plumage—birds that did not have
the stamina to fly so far on their own. They reached
this conclusion because young cranes make high-
pitched squealing noises during flight, which sound
like the calls of songbirds. Some tribes called these
invisible passengers 'birds on the back of cranes'.
Natural historians writing at the end of the nine-
teenth century attached so much credence to this
idea that they seriously discussed the matter in
specialist journals.

Native Americans in the southern regions of North
America also regarded cranes as unique. Tecumseh,
the famous Shawnee chief, appealed to the 'power
of the cranes' in his attempt to unite mid-western
and south-eastern tribes against the encroaching
white settlers. But crane power did not help him.
The mystical powers attributed to cranes can also
be seen in their depictions on totem poles. And
in some areas of Mexico, where cranes spend the
winter and are thought, at one time, to have bred,
cranes were regarded as 'birds of wisdom'. The
Aztecs are said to have called themselves 'crane
people'.

The crane as protector: in this 1982
painting by Jerry Ingram entitled *Per-
sonal Medicine*, a Crow Indian warrior
bears ermine fur, horse hairs, and
grass on his shield. But most promi-
nently depicted are the head and neck
of a Whooping Crane, adorned with
eagle and crow feathers.

The Frankfurt-based Russian artist and crane researcher Sergei W. Winter saws, carves, grinds, and sands down roots, branches, and trunks to create animal figures. His favourite theme is cranes, of which he has crafted numerous sculptures.

In the past, when much of their behaviour was still a mystery, cranes must have fascinated humans even more than they do today. This is supported by historical documentation from all countries in which cranes once existed or still exist. Africa—which is home to six species if one includes those that migrate there for the winter—is no exception. On this continent, where in certain regions magic and witch doctors still play an important role in people's lives, most animals are assigned a certain status in relation to humans. It is hardly surprising that the Crowned Crane, with its impressive plumage and headdress, is seen as the 'top bird'. Incidentally, according to one legend, these cranes are said to have been given their crown by a king who would have died of thirst in the desert had he not been saved by a group these birds. The South African Zulus saw the 'king of the birds' as a guard of their fields, who made sure that each bird got its ration, but that there was enough left over for the farmers. Today, of course, people living on and from the land will begrudge the crane even a single grain. Indeed, owners of small plots will try to keep their fields 'crane free'—which is understandable, considering

the difficult situation faced by many farmers in this region. Resentment also plays a role in a tale that originated in Chad: a female Crowned Crane wins the favour of a tribal chieftain, but, in doing so, incurs the wrath of the female rhesus monkey. The story about the battle between the cranes and the pygmies has already been mentioned on page 167.

Cranes made of scrap metal have become a popular South African export. These modern works of art are a source of income for their creators, and some of the profits are channelled into the country's crane protection programmes.

Very Popular in Advertising

Considering that cranes have fascinated poets, scholars, storytellers, and naturalists for millennia, it is hardly surprising that these birds were discovered by advertisers. Today, cranes are presented to the public in many variations and for many purposes. A prominent example: at least six airlines bear the crane, in different designs, on the tail unit of their planes. Of these, Lufthansa has done so for longer than any other company. In fact, Lufthansa is so readily identified with its symbol—a stylised crane with an ornamental heron's feather on its head— that the airline is often referred to in the press as 'the crane line', or simply 'the crane'. Lufthansa employees even refer to the airline as 'our crane'. So it is good to know that Lufthansa's identification with the crane has, for many decades, prompted the company to support conservation efforts and activities within, and well beyond, the borders of Germany.

The crane is also experiencing a renaissance as an icon in South Africa. As the national bird, the Blue Crane is making the most headway, but the

Uganda has a Crowned Crane as a symbol on its national flag.

Grey Crowned Crane is hot on its heels. Many hotels, restaurants, and companies like to promote themselves using both of these attractive species. The Wattled Crane, while being the largest of the three and anything but ugly, lags somewhat behind. Although it is perhaps not much consolation, the Wattled Crane is frequently featured on signs related to nature conservation, especially in areas where only small numbers of this species exist.

Bertolt Brecht, *The Rise and Fall of the City of Mahagonny*, translated by W.H. Auden and Chester Kallman (Boston: David R. Godine, Publisher) 1976, pp. 71–72.

The Markaryd municipality in Sweden has chosen a crane and two post horns as a symbol for its emblem.

LEFT

South Africans call the strelitzia, which is indigenous to their country, the 'crane flower' (also known as 'bird of paradise') because its exotic petal arrangements resemble the head of a crane.

RIGHT

Lufthansa has hardly made any changes to its emblem since the airline was founded in 1926; the crane with a stylised feather on its head has always been a worthy companion.

Shanghai Airlines (above) and the
Polish airline LOT (middle)—along with
Uganda Airlines and Xiamen Airlines—
have always trusted in the stylised
cranes adorning their planes.

For decades, Japan Airlines sported
a classic, Far Eastern crane motif,
but JAL replaced it recently with a
modern design.

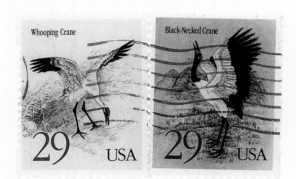

The beauty of cranes has always prompted stamp designers and postal services to feature these birds as national messengers to be sent around the globe—even if the only cranes to be found within some of these countries' borders are the ones living in zoos. Examples of this include the stamp from Singapore showing African Crowned Cranes and the stamp from Haiti featuring a North American Whooping Crane. With only a few exceptions, the stamps shown here are part of a collection belonging to the International Crane Foundation.

POSTES CANADA POSTAGE
WHOOPING CRANE
GRUE BLANCHE
5¢

TIMBRE TAXE
Grue cendrée
POSTES
REPUBLIQUE ISLAMIQUE DE MAURITANIE
0F50

REPUBLIQUE DU MALI
150F
POSTES 1994
La Grue couronnée Balearica pavonina
O.M. DIALLO
IMPRESSOR S.A.

CROWN BIRD
REPUBLIC OF
NIGERIA
1/3
MAURICE FIEVET

PAKISTAN
Rs.3
SIBERIAN CRANE
Grus leucogeranus

ANTHROPOIDES VIRGO
COCORUL MIC
2L
MOLDOVA

Postes
0,60$
CAPEX'87
Balearica pavonina
1987
0.80 RIEL
R.P.KAMPUCHEA

SVERIGE 1 KR

日本郵便
50 NIPPON
タンチョウ・北海道

ประเทศไทย
POSTAGE
2
THAILAND
Sarus Crane

South Africa
R1
Wattled Crane 1998

GOURDES
5
AVION
GRUS AMERICANA
WHOOPING CRANE
REPUBLIQUE D'HAITI

BALEARICA PAVONINA
singapore
5¢

المملكة المغربية
البريد
2,00
POSTES
Anthropoides virgo (Demoiselle de Numidie)
ROYAUME DU MAROC
L. DELLOZ

대한민국 우표
재두루미
REPUBLIC OF KOREA
20

NIPPON 62

62 NIPPON

日本郵便 RAMSAR

197

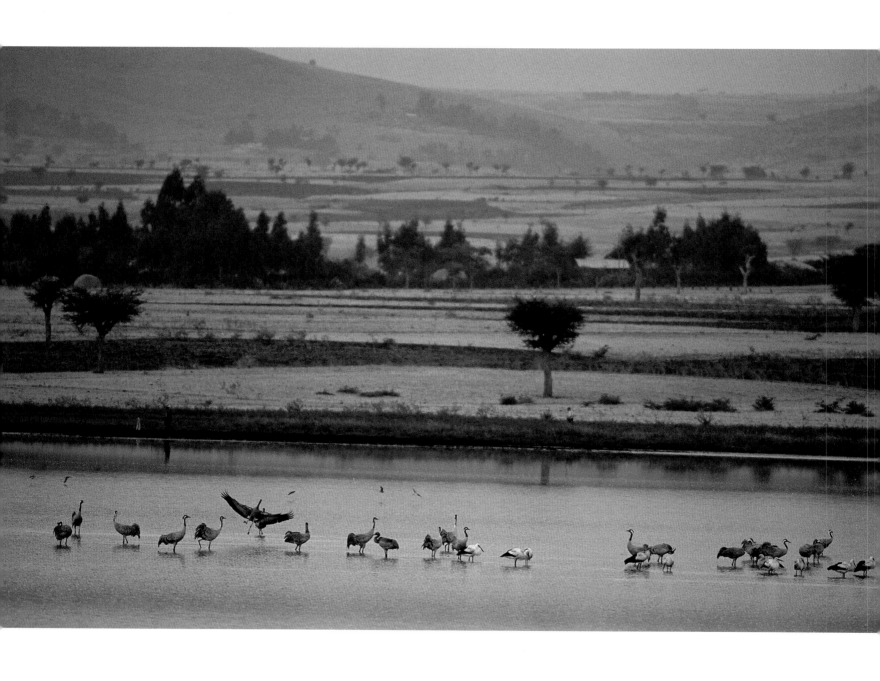

Symbols of International Conservation

Flagship Species for Diverse Ecological Communities and Biotopes

All cranes depend, for the greater part of their lives, on water. Some types—such as the Siberian Crane, the American Whooping Crane, and, to a lesser extent, the African Wattled Crane—need wetlands for breeding, feeding, and sleeping. In fact, one could say that they require water twenty-four hours a day, 365 days a year. Brief exceptions, however, prove the rule. The other eight *Grus* species (the Sandhill, Sarus, Brolga, White-naped, Red-crowned, Black-necked, Hooded, and Eurasian Cranes) and the two *Balearica* species (the Grey Crowned and the Black Crowned Cranes) often spend their days on fields, grasslands, and steppes, especially outside of the breeding season. And many like to spend time at artificial feeding stations. The two *Anthropoides* species (the Demoiselle and Blue Cranes) like to do so as well, when such stations are made available to them, but they will even lay their eggs on dry land. However, when it comes to drinking (often in conjunction with a lunch break) and sleeping, even these cranes need wetlands. Water is the source of all life—every human, animal, and plant depends on it—but it is unevenly distributed around the globe. According to a UN survey conducted in 2004, more than a billion people do not have enough water to drink, and an even greater number lack clean water. So it is easy to imagine the situation faced by many animals that require water not only for drinking and cleaning, but also for other behaviours essential to their survival. Indeed, water can serve as a source of nourishment, provide protection from land-based predators, and function as the place for reproduction. Cranes are representative of an untold number of species that have similar requirements for survival, but are not as conspicuous or mobile as the elegant birds.

Every conservationist knows that wild animals and plants can only exist if humans leave sufficient natural space for their needs and—in light of the threats humans pose to nature—actively support conservation efforts. Thus, it becomes clear how protecting cranes also has far-reaching and positive effects on a wide variety of interdependent ecological communities that rely on water, as well. As a result, this highly visible animal has become an extremely important biological indicator for the condition of wetlands: wherever habitats are left intact or re-established, it is not only plants dependent on constant wetness or moisture that benefit, but also a myriad of micro-organisms and a colourful array of insects, amphibians, reptiles, crabs, shellfish, snails, fish, mammals, and birds. In this way, cranes can be said to be guarantors for the biological diversity of their habitats. Since many species of cranes are capable of re-populating breeding areas from which they had withdrawn because of ecological damage (or, rather, been driven out of by humans), the creation of new areas—or the reflooding of marshes, swampland, wetlands, and shallow lakes and the adjoining feeding grounds—can lead not only to cranes returning (provided a neighbouring area is overpopulated and the cranes are not disturbed too much), but also to a return of other species. Even if only relatively small 'islands of life' are created where cranes spend a short amount of time during the year, these are habitats for diverse animal and plant life that will subsequently attract other species—that is, if humans allow this to happen, or even support the process.

Sometimes during the wintering season, more than 10,000 Eurasian Cranes sleep on the shallow waters of Lake Cheffe, fifty kilometres south of Addis Ababa, along with white storks, pelicans, and spoonbills. At dawn they are often shooed away by farmers cracking whips. This does more harm than good, since the cranes then depart even sooner to feed on crops within a radius of fifty kilometres.

Intensive Cooperation

Almost all cranes lead a very international life. They do not care about national boundaries. The only thing that matters to them is whether an area is adequate to their needs—i.e., whether it is suitable for breeding, as a temporary habitat during regional migration, as a path along their migratory routes, as a resting place, or as an area for wintering. For some time now, conservationists who focus on cranes have stopped referring to them as being 'at home' in, or 'belonging' to, certain countries. Even if the birds only cross a single border, they still are citizens of the world and, therefore, part of global nature. But as fond of travel as these birds are, many cranes do not just pass over, or dwell in the territory of, two countries. Quite often, it is half a dozen or more.

Wherever cranes happen to be—whether for breeding, resting, or wintering—there are now people who care about the well-being of these 'birds of happiness'. Until about 1975, there were only a few local ornithologists and small groups of enthusiasts who cared about the fate of these long-legged, feathery creatures and wanted to find out more about how they lived. In the last thirty years,

however, a huge international network of crane experts and conservationists has come into being. Many of them, with a pinch of self-mockery, describe their passion for these birds as 'crane mania' and they call themselves crane maniacs, or 'craniacs', who are constantly infecting others with the 'crane virus', thus ensuring that the movement gains momentum. Some men and women who initially stood on the sidelines as observers have since become patrons of crane protection.

Thanks to internet and e-mail, newly acquired knowledge about cranes, as well as information about their numbers, their stop-overs during migration, and current threats and accidents, can be disseminated across a specialised electronic 'crane network' in no time at all. This means that it does not take long to organise an international protest, should cranes need our support. It has been demonstrated on several occasions that local politicians will take note when people point out to them that the cranes in their countries are not a domestic affair, but rather part of an international natural heritage. Thus, the representatives of Scandinavia, Poland, and Germany—countries in which cranes breed and are a protected species—expect France

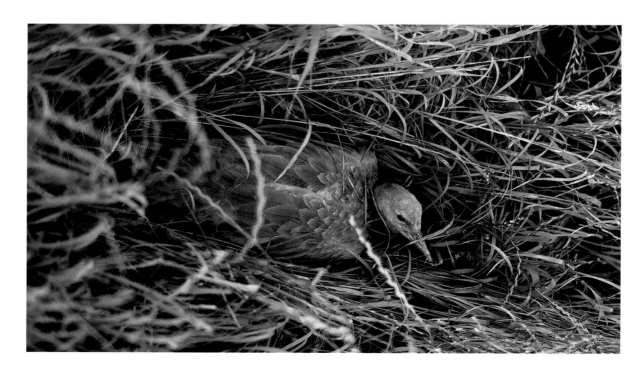

A young crane huddles in the high grass, making it difficult for the ringers to locate him.

and Spain, where Eurasian Cranes winter, to afford the animals protection as well. And when the government of the Russian-Siberian republic of Sakha, in which almost all of the world's Siberian Cranes breed, is concerned about the preservation of these animals' wintering grounds in China, then a diplomatic appeal will be directed at the respective Chinese ministry. If that does not work, governments may even discuss the matter directly.

A major coordinating role in this cross-continental exchange between the world's crane experts and conservationists is played by the International Crane Foundation, situated in Baraboo, in the US state of Wisconsin. Since ICF was founded in 1973, it has developed into an organisation that is highly respected throughout the world. (ICF will be treated in more detail in the section 'The Crane Diplomats of Baraboo'). The existence of such a network of crane conservationists is extremely important, because the living circumstances of cranes are in a state of constant flux, and people who feel a responsibility for these animals must be prepared to act swiftly. The task might entail finding an alternative for a

stop-over area that is no longer suitable, or preventing building development on a winter staging ground. It might involve campaigning against the construction of a wind farm, or against the use of searchlights for advertising purposes along a major migration route. Or it might mean ensuring sufficient water levels in areas used by cranes for roosting, or even drawing upon one's own resources to flood and maintain a dried-out former biotope. The challenges are similar all over the world. It is easier to find solutions for areas that are relatively intact and where few people live, than for areas where many humans live and work. The success of every conservation effort depends on good public relations—and because these attractive creatures generate a lot of goodwill, cranes are, thankfully, good PR material.

As it happens, cranes are also cooperative protégés. For all their adherence to behavioural traditions, which determine their lives within their families and communities, they learn fast and are incredibly adaptable. Sometimes they might even be described as opportunists. Only this can explain the fact that, within a few years, tens of thousands of birds can completely alter their flying routes, redirecting their migratory paths through Europe, Asia, and Africa by several hundred, if not several thousand, kilometres. Often such changes are made in response to agricultural developments or to large-scale changes in water management along flying routes and in staging areas. And this is when fast action is required, even if this means simply providing information to people in areas where cranes turn up, for the first time, to rest, winter, or extend their breeding grounds. This, in fact, is another area in which the intensive networking and communication among crane conservationists comes in handy. Without this network, marking individual cranes by attaching coloured rings to their legs or fitting them with lightweight transmitters, would not make much sense. During the last twenty years, the deployment of this technology on a worldwide scale has led to enormous growth in our knowledge about these birds, as well as great progress in international conservation efforts.

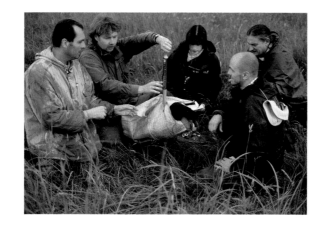

As soon as the young crane has been found, the team of ringers, led by Günter Nowald, gets down to the task of weighing and measuring the bird. Since everyone on the team knows exactly what to do, it rarely takes more than ten minutes before the young crane can be released.

Coloured Rings and Satellites Help in the Study of Cranes

The operation seems like a top-secret police raid. In the early afternoon, five figures, clad in camouflage-type clothing, steal their way through a mixed forest southeast of Stralsund on the Baltic Sea coast, in Mecklenburg-West Pomerania, Germany. The figures are heading for the edge of a meadow, but before they reach it, two of them separate from the others and prowl off in different directions, parallel to the edge of the wood—taking cover behind trees along the way. While two of those who remained behind hide behind a large oak, their leader stealthily approaches the periphery, frequently looking through his binoculars, making sure that the subjects, standing 150 meters ahead in the knee-high grass, are unaware of his presence. Again and again, he has to freeze whenever one of the long necks pokes up out of the sea of grass. Finally, the leader takes up position behind a tree on the edge of the meadow, sets up the scope that has been fixed to his belt, directs it at the green expanse, and turns his walkie-talkie on. Whispering into the device, he tells the 'prowlers' to give him their position: 'Can you see the cranes? How far away from them are you?' Thomas Fichtner has managed to sneak up within fifty metres of the pair and their young male without being detected; Andreas Pschorn has been unable to get closer than 100 meters without risking being seen.

For more than half an hour, the two prowlers have been inching their way towards the feeding family of cranes, approaching them from opposite sides. 'Okay, I can hear them clearly from here. We'll start on the count of three!' Günter Nowald quietly does the countdown, whilst monitoring the birds through his scope. Finally, Thomas and Andreas leap from their hide-outs and sprint towards the cranes from opposite directions. Anja Kluge and Ehrhardt Hohl, the two who have stayed behind in the woods, are listening to the exchange and now also dash towards the clearing. Once they reach the meadow, they rush towards the place where Thomas and Andreas, directed by Günter Nowald via walkie-talkie, are systematically combing through the tall

grass. Nowald knows roughly where the junior crane, still too young to fly, remained after its brief attempt to flee. The young crane's parents, shocked by the sudden ambush, have taken to the air and, after circling twice, flown off. While doing so, they made rasping and growling calls to their young one, urging it to hide.

Everything has to be done quickly now. But these people are professionals. Since 1994, between mid-June and the beginning of August, Günter Nowald (head of the Crane Information Centre in Groß Mohrdorf in Mecklenburg-West Pomerania) and his team outwit twenty to thirty young cranes, as well as some older ones that are incapable of flight because they are moulting, to put coloured rings on their legs. They also attach small transmitters, weighing no more than sixty-five grams, to the backs of particularly well-built specimens. With these tools, the conservationists gather information about the distribution, life-span, feeding and breeding habits, territorial behaviour, pair loyalty, migratory routes, and wintering habitats of *Grus grus*, the Common Crane of northern Eurasia, also known as the Eurasian Crane.

There are plenty of places where Günter Nowald and his team can operate. Each spring, ornithologists, forest wardens, and hunters give useful hints about breeding places and breeding rates in eastern Mecklenburg and West Pomerania. In fact, it was a phone call from the local forest warden that informed Nowald and his team of the presence of the crane family they have just cornered. The two older birds and their roughly eight-week-old son have been spending most of their time on the aforementioned meadow, just as the parents had done in previous years. Because of heavy rains, the grass has not yet been cut, Nowald was told. Because of this, finding the youthful crane is not a simple task. At the moment, it is hiding, its motionless body pressed firmly to the ground, neck outstretched, its grey and brown plumage camouflaging its presence. But patience pays off: after systematically scouring the area for about five minutes, Thomas finds the young crane, lying only a metre in front of him. As is usually the case in these situations, the bird is

not where he thought it would be. Distances become distorted when viewed through binoculars or a spotting scope. Frequently, the search team has to give up after about half an hour because the young bird, or even a pair of them, cannot be found. The 'ringers', as people who ring birds are called, do not want to expose the young ones to the anguish of being separated from their parents for longer than this.

Fortunately, once the animal has been captured, the actual task of naming it, noting down its characteristics, and ringing it does not take that long. Everyone on the team has a clearly defined task, and they work quickly. In this case, four hands grab the young bird and place it, its back facing downwards, onto a length of tarpaulin. Günter Nowald slips a dark-coloured hood over its head and beak. The crane immediately calms down, at least physically. Nowald's helpers wrap the tarpaulin around the bird and weigh the package: 3952 grams, without the sheet—an impressive number. The young bird's well-developed primary feathers indicate that it will fledge in about two weeks' time. By then, the bird ringers would not stand a chance of capturing it. A situation like this has happened to the team only recently: after six hours of preparations, the young bird escaped with its parents, leaving the ringers gazing up at the sky in surprise. They had misjudged the age of their target. Sometimes the young crane turns out to weigh less than two kilograms. In that case, the rings are not fitted, and the whole operation is called off. Similarly, birds weighing less than three kilograms cannot be fitted with a transmitter. The ideal crane, from the

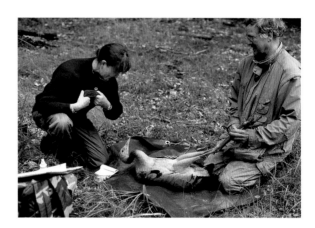

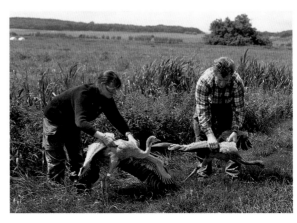

catcher's point of view, is eight to nine weeks of age and will be able to fly within a few days. When chicks from a replacement clutch (i.e., from a second nesting attempt) hatch as late as June, a catch-and-catalogue operation can even be successful in mid-August.

But back to our young crane, where all parameters are favourable. Günter Nowald attaches a thin aluminium band from the Hiddensee Ornithological Institute to the tarsus of its left leg. The band is inscribed with two letters and three numbers. Now the bird is officially registered. Three octagonal clip-rings, made of synthetic material, are subsequently attached to the tibia of each leg. It takes quite an effort to make the rings—designed especially for cranes by the Radolfzell Ornithological Institute—click together audibly. The rings come in six different colours and are fitted in different combinations. The people fitting them have to ensure that the same colours are not placed next to each other.

Since the rings are used throughout Europe, the Europe Crane Working Group has agreed on country-specific codes: the top ring on the left leg indicates the county. In the case of Germany, the ring is blue. Because the German states of Mecklenburg-West Pomerania (starting in 1989) and Brandenburg (since 1994) regularly ring cranes according to the European guidelines, there is also a sub-categorisation. Brandenburg cranes carry a blue-red-blue, or a blue-blue-red, coding on their left leg, whereas cranes from Mecklenburg-West Pomerania are coded blue-black-blue. On the crane's right leg, the colour combination can be chosen freely, as this is the so-called 'individual code'.

As far as naming each crane is concerned, the bird ringers have to be creative: in Mecklenburg-West Pomerania alone, a total of 314 cranes had to be 'christened' between 1994 and 2005. About half of these also had a transmitter fitted to them. Using a black elastic band, Günter Nowald attaches the transmitter and antennae (worth 230 euros) to the bird's back, just behind the base of its wings. The ringers decide to name the young crane Thunder, because of the approaching storm. While Nowald is working, he talks about his two 'celebrity' cases.

On 17 July 2003, he and his group detained two young brothers southeast of Rostock. Since they weighed 4600 and 4350 grams, respectively, which is quite a lot, they were classified as males (at this age, identifying a crane's sex accurately is only possible by taking a blood sample). The heavier of the two was given the individual colour coding red-blue-green, and the lighter one got black-red-yellow. Since the latter colours are reminiscent of the German flag, one of the team's members quickly thought up appropriate names: Joschka, named after the (then) German Foreign Minister and Green party politician Joschka Fischer, and Schröder, named after the Chancellor of Germany at the time, Gerhard Schröder.

That autumn, both young cranes flew with their parents to the Landes region of Gascony in south-west France, where they spent the winter. Just before the onset of spring in 2004, ring coding and transmitter signals revealed that Joschka and Schröder had separated: on March 16th, Joschka was detected west of Stralsund in Germany amongst a group of cranes on a field in Hohendorf, near Groß Mohrdorf; at the same time (on March 16th and 17th) Schröder was sighted with fellow cranes in the French Champagne region. Only at the end of August 2004 did Schröder reappear, this time on a harvested corn field between Rostock and Stralsund; he subsequently spent the night in Lagoon Area National Park in Western Pomerania, on the island of Kirr. A month later, on September 30th, Joschka also reappeared. He spent the day with Schröder and a flock of companions near Pruchten in the National Park region. In December 2005, both cranes were seen in the Extremadura region, and in May 2006, Joschka—and his mate— were observed near Joschka's birthplace.

But now we return to Thunder, who is ready for release. After attaching the equipment, it takes Günter Nowald less than fifteen minutes to measure the young crane's wings, legs, and—once the bird is released from the hood—its beak. Before its

As a graduate student, Li Fengshan, present-day coordinator of ICF's China programme, closely examined the life of cranes in China and Tibet. This photo shows him in June 1988 in Longbaotan, listening to the eggs of a pair of Black-necked Cranes to detect whether the chicks are making little chirping sounds to announce their imminent hatching.

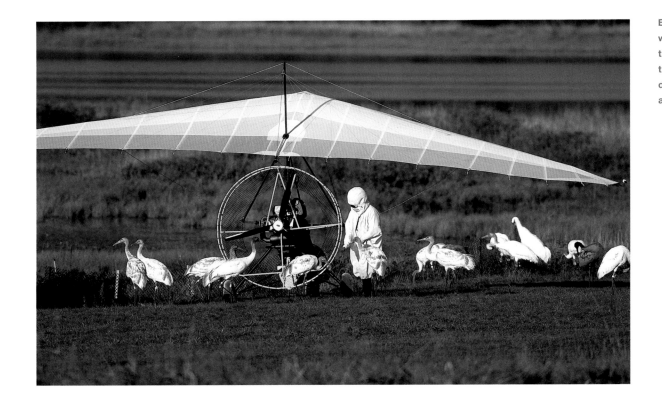

surprise at being able to see again translates into panic, prompting the bird to attack with its sharp beak, it is helped onto its feet. The crane's first steps are a bit wobbly, but then it makes a dash for it, heading straight for the edge of the woods. It will later be found, between the oaks and the alders, by its parents. Sadly, however, the researchers some-times get their rings and transmitters back after only a few days or weeks. When the signals are sent from the same place over a length of time, the researchers can only assume the worst. For it usual-ly means that their bird is dead, killed by a fox or a marten, or crashed into an overhead power line soon after fledging. One of the many discoveries of marking birds in this manner is that at least twenty-two percent of young cranes die between the ages of six weeks and six months. The death toll amongst chicks younger than six weeks is probably even greater.

That even fully-grown cranes can be captured for registration has been demonstrated by the crew led by Eberhard Henne, former environmental minister of Brandenburg. Out of a total of 420 cranes, the former veterinary surgeon and current head of the Schorfheide-Chorin Biosphere Reserve caught an impressive total of fifty adults between 1994 and 2005 and was able to include them in the European coordinates network. Most of the adult birds were caught during the summer months while they were moulting and unable to fly for several weeks. But you can only truly appreciate what an accomplish-ment this is if you know how shy these birds are during the moulting period—and how fast they run and effectively they can hide. Apart from cap-turing techniques involving running, Eberhard Henne and his team use a variety of tricks—all of which have to be approved by the local environmental authority on a case-by-case basis. For example, the team sets up soft funnel-shaped, mobile nets near the cranes' roosting areas. Or they spike a corn cob with a sleep-inducing drug to temporarily sedate a pair of non-child-rearing cranes. Adult cranes, ringed within their own territory, can later reveal a great deal about territorial and partnership attachments. Using these methods, Henne and his colleagues discovered that the much-extolled

RIGHT

Weather permitting, the young Whooping Cranes follow their motorised leader for ten to twenty minutes each morning for several weeks, training their flight muscles before the convoy finally leaves Wisconsin for Florida.

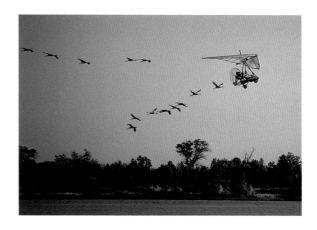

life-long monogamy of pairs is not quite what it was made out to be. Blood samples can also help determine identity and gender. These are analysed at the Berlin Institute for Zoo and Wildlife Research. The samples are then frozen for later DNA analysis and possible evaluation by young zoologists or students of veterinary medicine writing their doctoral thesis.

A thirst for new knowledge is also required when, during the migratory season, throngs of cranes, standing side-by-side on fields or in their roosting areas are scanned through spotting scopes to identify their ring coding and, with the help of the internationally accessible ID registry, to find out when and where the animal was ringed, and whether a file already exists concerning its movements. Identifying and evaluating the individual location signals regularly sent by the transmitters—which have a lifespan of up to four years—is a still more arduous task. Crane specialists deploy different types of transmitters. Some broadcast over short distances to a receiver with a direction-finding antenna, while others emit electronic impulses that are picked up by a satellite and then beamed back down to the receiver. The crane researchers gather most of their data during the migration and wintering periods. In Spain, the air force even occasionally helps out with a reconnaissance plane. From the air, signals from cranes on the ground can be tracked over a distance of up to fifty kilometres, and airborne cranes can be located up to 200 kilometres away. In contrast, ground-based receivers have a maximum range of only about five kilometres. Incidentally, for years now, Spanish researchers have been helping crane ringers in Mecklenburg-West Pomerania, whilst Germans and Scandinavians join their French and Spanish colleagues during the winter as they search for 'their' cranes.

Apart from the technical equipment, one needs quite a bit of experience to interpret information from the transmitted signals accurately. Where are the cranes exactly? How long do they remain in one place? Which direction are they flying in? What distance do they cover in one day? Since all of these questions involve large areas and long dis-

tances, satellites are a great help. At the same time, telemetric calculations using direction-finding antennae are useful for determining local flying patterns and habitats, the use of space within breeding and staging areas, or the partnership behaviour of pairs. A new method is also being used to study crane genealogy: individual birds can be identified using sonographic equipment, which electromagnetically records voice and calling patterns, and can create printouts of these calls. Bernd Weßling from northern Germany has been experimenting with this method for a number of years now all over the world. Using these 'acoustic fingerprints', researchers can recognise individual birds and determine the identity of their partners in situations where observation and visual differentiation based on external characteristics prove difficult. This approach also opens up hitherto unforeseen possibilities when it comes to analysing and comparing the calls of the fifteen different species of cranes.

But back to the classical methods: if it were not for the fact that so many cranes across all continents

BOTTOM

Many prominent organisations have joined forces for the million-dollar project to reintroduce Whooping Cranes to the eastern United States. It could take many years to be successful.

Canada/U.S. Whooping Crane Recovery Team
Friends of Necedah National Wildlife Refuge
International Crane Foundation ,
National Fish & Wildlife Foundation
Natural Resources Foundation of Wisconsin
Operation Migration Inc.
U.S. Fish & Wildlife Service
USGS National Wildlife Health Center
USGS Patuxent Wildlife Research Center
Wisconsin Department of Natural Resources

had been ringed and fitted with transmitters, not only would researchers know a lot less, but many of the recent protection measures would not have come into being. Each year, the maps of the differ-ent species' migratory movements become more colourful and comprehensive, but also more con-fusing. On the one hand, the research shows how stubbornly most birds stick to their traditional routes and staging grounds. On the other hand, it shows that there are always the odd ones who, either reluctantly, or prompted by a new partner, seek out new and far away breeding or wintering grounds. Take Eurasian Cranes, for example: some will choose the western migratory route one year and the eastern route the next. These are often Finnish or Baltic birds that, one year, will fly, with a stop-over in Germany, to wintering grounds in France or Spain, but the next year to North Africa, with a stop-over in Hungary. At the same time, there are cranes that breed in Finland and Eastern Europe that sometimes prefer the Baltic-Hungarian route, but other times fly via the Ukraine and Black Sea to Israel, occasionally even continuing on as far as

Ethiopia. Most cranes that stop over in Hungary will fly on to Greece and proceed from there to southern Italy and Tunisia. However, occasionally, a crane will instead fly southeast from Hungary, across western Turkey, to the Near East—as one crane, which had been ringed in the southeast of Estonia, demonstrated by turning up and being identified in Israel the following winter.

Two female Eurasian Cranes, which were fitted with transmitters in the Hula Valley in northern Israel, also transmitted some interesting travel data to a satellite in 1999 and 2000. After the first of these birds, named Carolina, arrived in the Hula Valley on 1 December 1998 and was ringed on 12 March 1999, she flew via Lebanon, Syria, Turkey, the Black Sea, and the Ukraine to the vicinity of Arkhangelsk in northwestern Russia, about 1000 kilometres northeast of Moscow. After four lengthy stop-overs, including a five-week stint north of the Black Sea, she arrived at the breeding grounds seventy-two days after leaving the Hula Valley. During these seventy-two days, she only embarked on longer flights (totalling 4616 kilometres) on sixteen days.

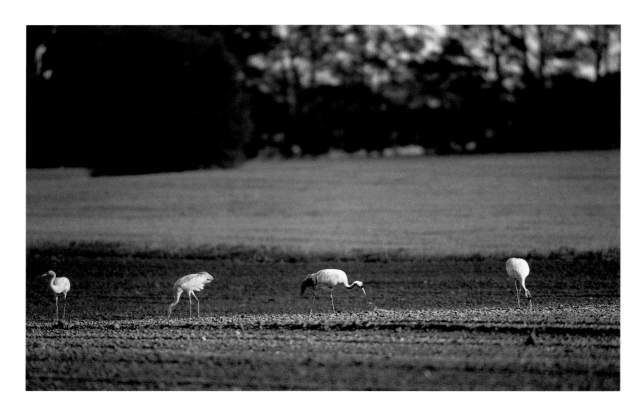

A pair of Eurasian Cranes and their two young ones are searching for food on a freshly-planted cornfield in Mecklenburg-West Pomerania.

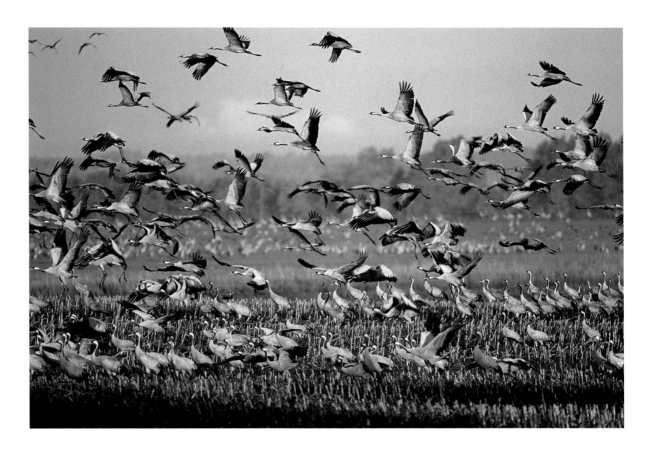

Eurasian Cranes near their staging grounds on the Baltic coast in Mecklenburg-West Pomerania, Germany swoop down on a maize field specifically planted by conservationists to 'distract' the birds and prevent them feeding on regular crops.

She stayed in the breeding grounds from May 24th until August 14th—too short a period to reproduce. So she arrived back in the Hula Valley in November, without a chick, after a return journey lasting seventy-five days. On the southbound-leg of her trip, she had flown as far as 1000 kilometres further east than she had done in the spring, crossing the Caucasus and, at some point, the border region between Turkey, Iran, and Iraq.

Drora, the other female crane, 'only' flew 3950 kilometres and reached her breeding grounds south of Arkhangelsk after just six weeks, putting in fewer pauses than Carolina. After 154 days, Drora had reared two young ones with her unmarked mate and, forty-two days later, had safely chaperoned them back to the wintering grounds in Israel, taking much the same route she had followed in the spring. Drora's return to Russia in the spring of 2000 was also tracked by satellite, but then the transmission stopped abruptly, presumably because the batteries had run dry.

Thanks to ringing and the transmission tracking, the travel adventures of other types of cranes have also been documented. As recently as 1996, Russian and Iranian scientists used satellite tracking to locate the near-dormant breeding grounds of the decimated—'extinct' would be the wrong word—western population of the Siberian Crane, east of the Urals. Thanks to the support of the Wild Bird Society of Japan, the International Crane Foundation in Baraboo, the office of the Bonn Convention on the Conservation of Migratory Wild Animals, and a number of corporations, a single bird was tempted into a net with the help of two tame Siberian Cranes and marked in January 1996 on its Iranian wintering grounds, southeast of the Caspian Sea.

On March 6th, the crane embarked on its journey along the south and the west coasts of the Caspian Sea, stopping off in Azerbaijan and the Volga delta, and finally arriving on May 1st north of Tobolsk in the Russian district of Tumenskaya, about

250 kilometres to the south of the area where the Irtysh River joins the Ob.

A good seven weeks later, crane experts Yuri Markin and Alexander Sorokin flew by helicopter across the marshes, lakes, rivers, and woodlands of the area and discovered three pairs of cranes, one of them with a young bird, as well as a single older bird. Although they did not spot the crane with the transmitter, it had helped them locate these elusive breeding grounds. The same year, a young Siberian Crane that had been ringed about 600 kilometres to the north of Kunovat in 1995 confirmed a long-held assumption in the international crane community: in February 1996, the crane was spotted in Keoladeo National Park, near Bharatpur in Rajasthan, India, thus proving that the declining central population of *Grus leucogeranus* breeds in Kunovat and spends the wintering season to the west of Agra, not far from the world-famous Taj Mahal.

In the last twenty years, many other long migration routes have been traced, thanks to ringing and transmission tracking. Apart from locating new breeding and wintering grounds, many en-route 'stepping stones'—the staging grounds—have also been discovered. Thus, researchers now know that the majority of Demoiselle Cranes that breed in Mongolia and parts of China have their wintering grounds in the Indian states of Gujarat and Rajasthan. Hooded and White-naped Cranes that breed in the eastern Siberian region of Russia migrate to Korea and to the southern Japanese island of Kyushu. After several years of painstaking research, Chinese and Japanese ornithologists were able to show that there is a 'crane connection' between Manchuria and Japan. A White-naped Crane that was ringed on its wintering grounds near Izumi, on Kyushu, in 1984, three years later accompanied its mate to the Zhalong National Reserve in the northeastern Chinese province of Heilongjiang, where the two birds reared a young crane that was then also ringed. The new arrival, whose left leg was fitted with a red plastic ring bearing the number sixty-one, spent the 1987/88 winter season in the company of the older, yellow-ringed bird.

Red-crowned Cranes born in the area near the Amur and Ussuri migrate to southeast China. Some Black-necked Cranes breeding in Tibet winter in Bhutan, whilst others of their species, breeding in the provinces of Qinghai and Sichuan, fly 1000 kilometres within China to Guizhou and Yunnan. Thanks to bird ringing and satellite technology, other riddles concerning the domestic routes of Brolgas in Australia, Blue, Crowned, and Wattled Cranes in Africa, and Sandhill and Whooping Cranes in America, have also been solved. And some of the large-scale reintroduction programmes for certain species would not have been possible without visual and telemetric aids.

Agriculture, Wind Power, Overhead Power Lines, and Hot Air Balloons

The fact that a few species of cranes have increased in number over the past decades, even if only regionally, can be attributed largely to agriculture. Sandhill, Eurasian, and Blue Cranes are good examples of this. If farmers were simply to let the birds roam their fields, most other species, in whatever country, would also be experiencing an up-turn. But then the harvest yield in many places would be dismal. As early on as the Byzantine Empire, farmers in what is now Turkey and Italy discovered that 'it is better to cultivate on rock than on fields and hills where cranes are one's neighbours.' Calling them 'soil peckers', 'seed pirates', and 'harvest terminators', the Greeks went after them with nets, slings, and lime twigs, as did others after them. Well into the nineteenth century, landowners employed field guards to chase away cranes, wild geese, pigeons, and other hungry birds. And schoolchildren were recruited to march out onto the fields and bang pot lids to stop the cranes from landing. In the eighteenth century, King Frederick William I of Prussia declared cranes fair game 'due to the great damage' they would cause, and for a while a reward was paid for each bird killed.

Indeed, farmers have always feared gatherings of cranes—and this up to the present day. Flocks that gather around dams or on sandbanks in

The gathering grounds of Eurasian Cranes—which have inspired this signpost in the Extremadura—have little to do with Siberia. More than 50,000 wintering cranes draw bird-lovers from around Europe to southwestern Spain, giving rise to a second tourist season during the winter months.

BOTTOM

Wintering Eurasian Cranes feel very much at home in the *dehesas* of the Extremadura region in southwestern Spain, as well as in southern Portugal. Increasingly, however, the region's typical mast forests of cork and holm oaks are being cleared to make way for corn and maize fields and olive plantations, subsidised by the European Union.

semi-drained rivers to spend the night can swarm out during the day, scouring fields within a radius of fifty kilometres, leading to desperation among farmers. Maize has also become an increasingly popular crop, especially in Europe, and this has resulted in a marked growth in the population of the Eurasian Crane. These adaptable animals have actually changed their migratory routes to take advantage of this development and have subsequently found new wintering habitats. As many as 150,000 Eurasian Cranes currently take the 'West European migration route', descending on fields in parts of Sweden, western Finland, the Baltic states, Germany, France, Spain, and Portugal, thus engendering frustration and conflicts between farmers and crane conservationists. In Central and Eastern Europe, a further 100,000 of these large grey birds, taking the 'Baltic-Hungarian route', temporarily descend on areas in the Baltic states, Poland, Slovakia, Hungary, Greece,

and southern Italy/Sicily, before the majority of them arrive to winter in Tunisia or Algeria. Still further east, some 50,000 Eurasian Cranes migrate from Russia, Belarus, and the Ukraine to the Middle East via the Black Sea and Turkey. They stop over in Israel before flying on to Egypt or the Sudan. Wherever they land, they 'refuel'.

And outside of Europe, too, not everyone is happy about cranes. Each year, farmers in the United States and Canada insist on compensation for ruined crops—or demand the culling of Greater and Lesser Sandhill Cranes. In twelve US states and two Canadian provinces, Lesser Sandhill Cranes are legal game all through the autumn period, although the hunt is restricted by certain rules. In this manner, more than 25,000 are killed each year, representing around five percent of the subspecies of *Grus canadensis canadensis*. In Japan, farmers on the island of Kyushu are up in arms about Hooded and White-

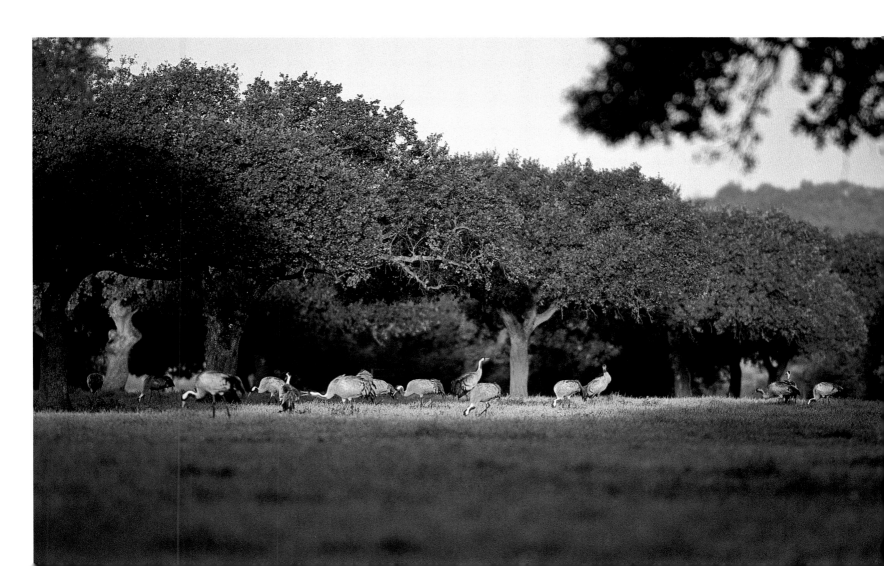

naped Cranes that transgress from the feeding areas onto their small patches of land. South African grain growers complain about the hundreds of Blue and Grey Crowned Cranes that descend on their newly-planted fields during the winter. And in the past, some farmers have taken the law into their own hands, illegally poisoning the birds. Such measures are mainly aimed at Egyptian and Spur-winged Geese, or sometimes even guinea fowl, but, in the process, the perpetrators hazard the possibility that large numbers of cranes will suffer a painful death. Poison that is improperly, and thus illegally, deployed to kill rodents has caused the death of many cranes and is a problem, even today, in Germany.

In the past, conservationists would occasionally voice the opinion that cranes are part of the cycle of nature and should therefore be accepted by farmers in much the same way as the seasons. However, this argument is no longer tenable. Today, no bona fide conservationist will deny the damage done by flocks of cranes feeding for any length of time on newly-planted fields. In most countries where large numbers of cranes have staging grounds or stay for the winter, there are study groups made up of farmers and conservationists that seek to

find mutually acceptable solutions. One method is to divert the birds from freshly sown fields by luring them to alternative feeding areas. Although this method is not always feasible or entirely effective, it has increasingly helped relieve tensions in badly affected areas. This being said, some biologists warn that, should cranes be fed in much the same way as chickens are fed in a farmyard, they might lose their natural ability to fend for themselves in the wild. In any event, it is not financially possible to feed tens, or even hundreds of thousands of cranes, each of which requires approximately 350 grams of grain per day for most of the year, especially during migration and their stay in the wintering areas.

For years now, conservationists and farmers in many countries have been discussing and testing various concepts that will benefit the cranes, as well as badly hit farmers. The first step is always to establish whether the damage attributed to cranes has actually been caused by them. Once this has been proved, the damage has to be assessed in an objective fashion. This neutral stocktaking might be limited to a single field, or it might involve determining the overall quality of an entire staging ground, including the numbers of cranes, their length of

Greater Sandhill Cranes wintering in Florida even manage to get along with the local livestock.

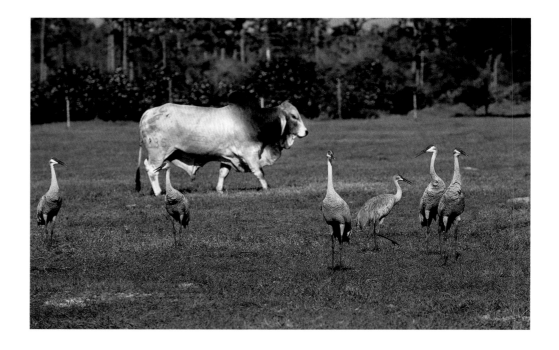

In many wildlife refuges in the United States, maize and corn are specially grown for the benefit of cranes, wild geese, and wild ducks. These fields are then harvested gradually during the winter so that the birds will always find enough to eat. The Sandhill Cranes in Bosque del Apache National Wildlife Refuge in New Mexico have long since grown accustomed to the tractor with its cutting machinery and follow close behind it.

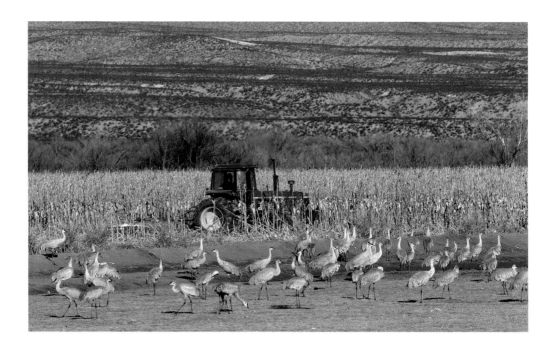

stay, the types of crops involved, and the size and attractiveness of fields in the surrounding area. Crane experts can quickly gain an overview and, in conjunction with farmers, devise a plan that will typically consist of a number of measures, such as temporarily driving specific flocks away from sensitive areas; deploying feed on fields that are far from road traffic; purchasing still-growing or harvested crops and making them available to the cranes; and, of course, compensatory payments. Sometimes environmental authorities or private organisations (or a joint-venture of the two), will buy or lease land where large numbers of cranes go to feed— usually in the vicinity of wetlands traditionally used by cranes as sleeping areas. There are examples of this in France, Germany, Sweden, Israel, the US, and Japan. Such land is used either to grow crops specifically suited to cranes, or to regularly distribute feed.

Whereas in the mid-1930s only about thirty breeding pairs of the Greater Sandhill Crane existed in the US state of Wisconsin, today there are more than 12,000 of these birds. Harmless chemical agents are being tested there as a way to deter cranes from eating newly planted seeds. In other places, and with differing degrees of success, scarecrows,

bird deterrent kites, warning shots, auditory frightening devices, wardens with dogs, and motorised vehicles are being deployed. However, while efforts are being made to prevent cranes from helping with the harvest, one must always be careful not to drive these birds from every source of nourishment, thus threatening their survival. The further that cranes have to fly, the more energy they expend— and the more they will eventually eat. Put another way: if cranes are left to their own devices, they are likely to cause less agricultural damage. Quite aside from this, however, farmers should always be aware of and, if need be, reminded from time to time, that cranes are not a pest, but rather fellow living creatures with great cultural and ecological value. They must know that societies have a right to insist on their conservation and are obliged to afford protection to cranes from neighbouring countries. Restraint and cooperation are therefore prerequisites when it comes to managing the behaviour of these animals. And, in exceptional cases, there must be ways to financially compensate a farmer whose heart goes out to hungry cranes.

There are places in a number of countries where, at certain times of the year, cranes are regularly fed

outside the breeding season. Initially, the idea was to keep them away from fields where corn and potatoes were being grown, thus preventing or reducing damage to crops. However, over the years, most of these crane feeding programmes have additionally, if not primarily, become tourist attractions (see the last chapter of this book for more details). Some of these feeding grounds have now been around for more than fifty years, and the experiences gathered there have led to new standards for managing these birds.

One of these places is Lake Hornborga in Västergötland, Sweden, which, together with its information centre Naturum Trandansen ('Crane Dance Nature Centre'), is visited by tens of thousands of people during the spring. During certain days in April, as many as 10,000 cranes come to enjoy the barley scattered there for them. During recent years, the cranes' numbers have also increased in the autumn, with as many as 7000 birds per day feeding at Lake Hornborga in late September.

In Germany, the organisation Crane Protection Germany ('Arbeitsgemeinschaft Kranichschutz Deutschland') has acquired ten hectares of land near its Crane Information Centre. Parts of this land are used for cultivating maize to feed the large numbers of cranes that use the Western Pomerania Lagoon Area National Park as a staging ground, especially in the autumn. Other parts of the property are exchanged with land owned by a local farmer so that maize can be cultivated in other nearby locations, as well. In the vicinity, a public observation platform has been erected so that visitors can watch the birds as they feed.

In France, there is the Ferme aux Grues ('Crane Village') at the Lac du Der-Chantecoq in the Champagne region, a few kilometres southwest of St. Dizier. It is one of the two main staging grounds in eastern France, and it is increasingly turning into a wintering area for cranes. Conservationists and the local tourist authority ensure that maize is planted and that visitors can observe the cranes feeding without causing the animals any stress.

The Hula Valley in northern Israel has become the main gathering point for more than 30,000 Eurasian Cranes. Twenty-eight kibbutzim cultivate the 8000 hectares of fertile land in this valley on the edge of the Golan Heights, and an uncontrolled influx of these peanut- and grain-eating birds would spell disaster. For this reason, the Jewish National Fund (JNF), the Society for the Protection of Nature in Israel (SPNI), and the kibbutzim have joined

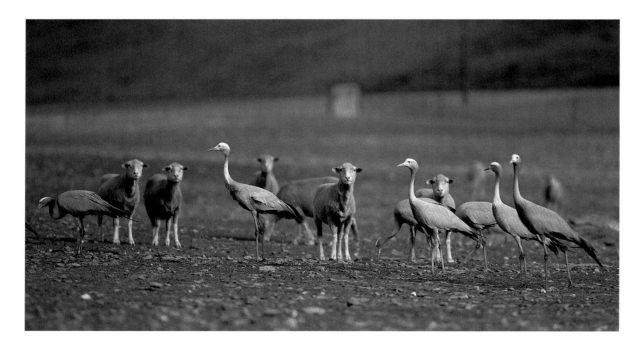

It is not unusual to see sheep and Blue Cranes standing together on the fields of Overberg in the South African Cape Province.

Crane conservation and agriculture go hand in hand in many regions of South Africa: here, Vicki Hudson from the 'Overberg Crane Group' is exchanging information with a farmer's wife, who is checking on her flock of sheep.

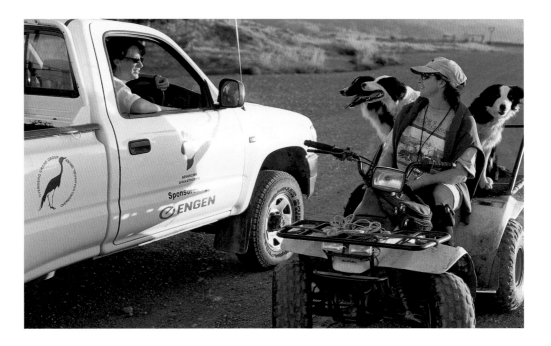

efforts in an exemplary project: starting in mid-December, when the leftovers from the harvest start to rot on the fields and the cranes will no longer eat them, a fertiliser sprayer is used to spread out three tons of maize twice daily (once early in the morning and once at midday) onto two fields comprising around seventy-five hectares. The fields are next to an artificial shallow lake. The cranes are so taken with this that 10,000 to 13,000 of them winter in the Hula Valley and stay until the northbound migration gets underway in mid-March. Even before this, however, the cranes that had moved on to Northeast Africa in December return to enjoy the benefits of the feast. The annual feeding expenses amount to approximately 100,000 euros, but the costs of the damage that would be incurred by the birds, were they not fed, would be far higher. Moreover, the 12,000 visitors who come here every year help to cover the expense.

In several of the 500 National Wildlife Refuges (NWR) in the United States, there are active crane feeding programmes. The NWR administrations, which in some places permit regulated agricultural activity and hunting, see to it that large areas are planted with maize and other crops to still the hunger of wild geese, wild ducks, and cranes. In the winter,

more than 50,000 Sandhill Cranes gather in the southern wildlife refuges. The crops are either planted by the authorities themselves or by contracted farmers, helping prevent damage outside the wildlife reserves, where cranes spend the nights on wetlands that are also maintained for them.

The fifty-year-old tradition of winter crane feeding in Japan has the same objective—albeit with slightly different methods. The 12,000 Hooded and White-naped Cranes that come from Russia and China to spend the winter on Kyushu, the southernmost of Japan's four main islands, are fed thousands of kilograms of grain each day within a relatively small area near Izumi. As of February, they are also fed a few hundred kilograms of fish to get them fit for the several thousand kilometre long journey back to their breeding grounds. During the wintering season, the local environmental department, together with the regional tourist board, leases rice fields from farmers and floods these fields to create safe sleeping havens for the cranes. On Hokkaido, the most northerly of the main Japanese islands, more than 1000 Red-crowned Cranes depend entirely on their daily rations for wintertime survival. During the day, they scoop up the grain and fish from the snow-covered fields, and at night they sleep on

shallow rivers that do not freeze over, despite
temperatures as low as minus twenty-five degrees
centigrade. In this instance, the *tanchos*, as this
endangered species is known in Japanese, are
not being fed to prevent damage to agriculture, but
simply to help them survive (see the section on
Red-crowned Cranes).

Another method of helping cranes, and one that
is not so easily emulated, makes newspaper head-
lines in India each year. Citizens and tourists in the
village of Khichan, in Rajasthan, can witness this
spectacle from early December to early March:
every morning between 6000 and 7000 wild cranes
descend on the little 60 x 100 metre fenced-in
square that lies between the village houses. It all
began in 1982 when someone threw a handful of
grain to some cranes that were commuting between
the nearby Thar Desert and the village's watering
place. Since then, more and more Demoiselle Cranes
have come to Khichan each winter. Every day, the
inhabitants, many of whom are members of the
Jain religious community and will never harm ani-
mals, let alone kill them, feed about 2000 kilos of
corn, which they pay for out of their own pockets,
to 'their' cranes. The animals stand jam-packed in
front of the feeding station, more densely than even
chickens would, and they do not seem at all per-
turbed by the people standing nearby. The specta-
cle also ensures that the cranes stay away from
the villagers' fields. When the cranes finally take off
for their breeding grounds in the faraway, lonely
steppes of Mongolia just before the onset of spring,
they are strong enough to fly right over the Hima-
layan Mountains. Fortunately these 'chicken cranes'
have never fallen victim to a serious infectious
disease.

Whenever flying flocks of cranes descend, or even
simply follow their set routes, they face one primary
danger: overhead power cables. Every year, hun-
dreds, if not thousands, of cranes die in the increas-
ingly dense-knit web of cables that criss-cross
the planet. In particularly critical areas, such as in
the approach path to a wetland roosting area, dozens
of cranes can die within the space of three winter
months. During the last few years, for example, the

regular winter death toll amongst Eurasian Cranes
along a less than one hundred metre stretch of land
twenty kilometres south of Addis Ababa in Ethiopia
has been in excess of fifty. Lacking flying experi-
ence, a large number of young birds die within the
first few months after fledging. It is the cables that
prove to be deadly obstacles for these large birds,
especially in the dark or when there is fog or heavy
rain. Many a crane has simply been swept into
the power lines by a strong gust of wind. It is usually
the collision that kills them, rather than an elec-
tric shock. If a crane survives the impact, however,
it often has a broken wing or neck and quickly

Every winter for more than fifty years,
Sueharo Matano (on the left) has fed
and cared for the cranes in Arasaki near
Izumi on the southern Japanese island
of Kyushu. Satoshi Nishida (on the
right) has also worked for many years
to help the cranes.

Thousands of Hooded and White-
naped Cranes gather in Arasaki every
morning and await the arrival of the
small truck from which two helpers
distribute grain. Before the birds embark
on their journey to their Siberian breed-
ing grounds, they are also fed fish.

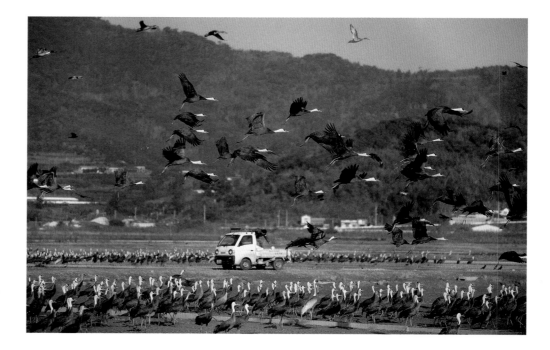

falls victim to a fox or stray dog. Quite frequently, cranes that have broken a leg can keep themselves alive for a while. It is easy to recognise these hapless birds in flight by their hanging leg or, on the ground, by their pitiful limp. However, cranes with a damaged leg are usually not able to run sufficiently fast to gain enough momentum for take-off, and thus become easy prey for land-based predators. For some time now, in many countries, conservationists and electricity companies have made efforts to reduce the hazards in critical areas. Quite often, it is enough to simply mark the cables with coloured signs or balls that move in the wind, enabling cranes to recognise the obstacle from afar. In some areas frequented by cranes, overhead cables have been replaced by subterranean power lines, but this tends to be expensive. Just as important as redirecting existing cables is the study of flying habits among cranes (and other large birds), and taking these into account when planning new power lines. Quite a few projects have been scrapped, or modified, to help the animals.

The wind farms that have been sprouting up everywhere during the past decade are another problem. Often, migrating cranes are confused by them and take alternative routes that sap the birds' energy

or prevent them from reaching suitable staging grounds. Added to this, the blades, which nowadays have a circumference of more than 100 metres, are like gigantic knives. Because the blades create considerable turbulence whilst turning, an increasing number of large birds get drawn into them and are bludgeoned to death or hurled, injured, to the ground. A growing number of wind park projects, but also single units (which do not make very such sense in terms of energy yield anyway) have been scrapped because of opposition by nature and animal conservationists, the latter drawing attention to the negative effects on breeding grounds and the migratory and staging requirements of cranes. Pilots of hot air balloons who ignore minimum altitude regulations and no-go areas are also an increasing concern, as they are liable to induce panic among entire flocks of cranes congregating on roosting, staging, or feeding grounds, prompting the birds to flee. If the culprits—who, according to staging ground wardens, sometimes actually seem to enjoy the havoc they wreak—are reported, they usually try to excuse their behaviour by placing the blame on unfavourable winds or a depleted gas tank. However, professional balloonists, who represent the majority, respect the cranes and keep their distance. Private airplane pilots tend to be more vigilant, because if caught breaking the rules, they are liable to lose their license. Also, unless a plane is actually circling over a gathering of cranes, it is only visible to the birds for a brief moment.

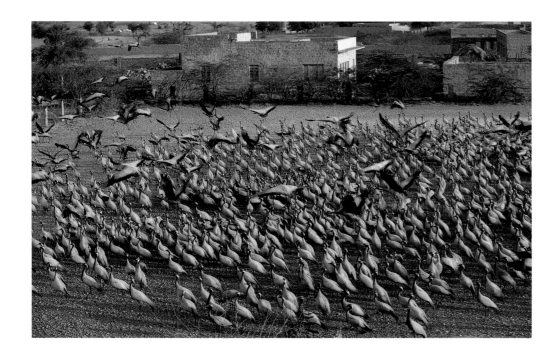

Hunting, Trading, and Capture

Today, in most countries where cranes are to be found—whether they are there to breed or are migrating—it is practically inconceivable that they would be shot at or captured. This was not always the case. For a long time, cranes were generally regarded as prized hunting trophies or as a pest to be driven from the fields. In falconry—hunting with trained birds of prey—it was considered a particular thrill to unleash a gyrfalcon, a peregrine falcon, or even a golden eagle to bring down a crane. As early as the thirteenth century, Emperor Frederick II singled out cranes as prized targets for his falcons, as described in his famous book on hawking, entitled *De arte venandi cum avibus*. Even in nineteenth century Europe, cranes were regarded as animals to be hunted, and in some countries rewards were paid for killing them. Not that it was any different on other continents. Even in Japan and China—where cranes were considered holy and, for long periods, afforded a special status by decree of the emperor—they were hunted and eaten at times. In particular, cranes were seen as fair game in places where they appeared in large numbers, or when they were migrating or spending time on their wintering grounds. Certain species were also revered as rare trophies to be preserved and stuffed, including the American Whooping Crane and the African Grey Crowned Crane.

It was not until the second half of the twentieth century, by which time the number of cranes had fallen dramatically, that the concept of ecological conservation gained sufficient currency to secure the birds legal protection against being hunted in Europe. Cranes also enjoy protected status today in many Asian and African nations, though this is not always a guarantee for their complete safety. Even in Europe, and right up to the present day, an unknown number of cranes are shot illegally. In some areas of Pakistan and Afghanistan, capturing cranes during the migration season is part of ancient tribal traditions; every autumn, hundreds, if not thousands, of Eurasian and Demoiselle Cranes fall victim to special capturing techniques involving the use of the 'soya' (thin ropes with balls attached that are hurled at the birds) and decoy cranes

In China, cranes raised and kept by humans are displayed not only in zoos and parks, but also sometimes at events—here the occasion is an international crane conference in Qiqihar.

The owner of this chateau in the vicinity of the French town of Rambouillet near Paris is in legal possession of this pair of Siberian Cranes, and he allows visitors to his réserve sauvage take a closer look at them.

(imitating their calls during darkness to attract their victims). Firearms are also used to kill the birds. The almost total extinction of the western population of the Siberian Crane is mainly due to hunting in these countries, primarily in Afghanistan. However, the greatest number of casualties today are the result of cranes being shot by hunters in North America. And this happens quite legally. Each autumn, more than 25,000 Lesser Sandhill Cranes *(Grus canadensis canadensis)* are killed in twelve western and central US states, as well as in two Canadian provinces and in nine Mexican states.

In Arizona, Colorado, Idaho, Kansas, Montana, New Mexico, North Dakota, Oklahoma, South Dakota, Texas, Utah, and Wyoming, which inevitably converge with the flyways of the 'Little Browns' at some point, the hunt is regulated by a quota and license system. The US Fish and Wildlife Service establishes quotas based on early-autumn projections for population growth, so that the numbers shot are less than the projected increase. Thus the overall number of Lesser Sandhill Cranes has

increased over the past quarter of a century, despite hunting. Nonetheless, many non-hunters who care about nature conservation find it strange that—just beyond the nature reserves, in which maize is planted for cranes and where the animals spend the nights—metal or wooden decoys are used to attract the birds, while the hunters lie in wait for them, camouflaged and ready to fire. Sandhill Cranes are also hunted regionally in the remote northeast of Russia.

For thousands of years now, cranes have been valued for their aesthetic qualities, and not just in zoos. It has once again become fashionable for wealthy owners of large estates and parks to 'decorate' their properties with exotic birds. It is hardly surprising that cranes have a particular attraction for them. The fact is, however, that most species of cranes are listed in Appendix I or II of the 1973 Washington Convention on International Trade in Endangered Species of Wild Fauna and Flora, otherwise known as CITES. This means that cranes cannot legally be sold, bought, swapped, or given as presents, unless an official exception is made to

this rule and the proper documents are at hand. An exception might, under certain circumstances, be made if one can prove that a particular crane was born of a 'lineage' that has spent several generations in the care of humans. In such an instance, this animal might become a tradable 'object'. Although cranes can quite easily be reared in captivity, it takes decades, at best, until it is possible to clearly demonstrate a genealogical lineage based on breeding. And even then, an enthusiast would not simply be allowed to buy and keep an endangered species of crane. He would need impeccable references, as well as facilities guaranteeing that the animal would live in an environment adequate to its needs.

Given all this, it was almost inevitable that a black market for these handsome birds would emerge; the more beautiful and rare a specimen, the higher the price. If, indeed, a pair is required, tens of thousands of euros may swap hands. The most sought after species of crane, and the ones most commonly kept in captivity, are African Grey Crowned Cranes. Crane conservationists assume that, today, there are probably more of these birds in captivity outside of Africa than in the wild. The criminal machinations begin at the breeding grounds, where one or two young Grey or Black Crowned Cranes are removed from their nest. Next, a middleman obtains false papers from a department manned by corrupt officials. After further intermediate stops, birds and certificates end up in the hands of a dealer outside of Africa. This dealer may have a large animal 'storage facility', maybe even a breeding unit, in which false tracks are laid and certificates of origin forged. Thus, according to CITES, Tanzania alone exported at least 4854 Crowned Cranes between 1992 and 2002. Of these, 2692 were Black Crowned Cranes, a species that does not even exist in Tanzania, which is the habitat of the Grey Crowned Crane. This says everything. But that is not the end of it: between 1998 and 2003, sixty-three Wattled Cranes were exported, a highly endangered species. Indeed, this number represents almost a quarter of the population of *Bugeranus carunculatus* living in Tanzania. Quite apart from the sheer population drain and loss of genetic diversity, the figure does not even include those cranes that died before being exported and the ones that failed to survive the journey to their destination. Experts believe that the death rate during transport runs as high as fifty percent.

Apart from Grey and Black Crowned Cranes, Blue Cranes are en vogue in South Africa, whilst Demoiselle Cranes are popular as pets and status symbols in Asia. They are beautiful and do not require quite as much space as the other species. It is estimated that several thousand of each of the two *Anthropoides* species of cranes are kept illegally in captivity.

In addition to the privately owned birds, a large number of cranes, including all fifteen species, are kept in public zoos and bird parks. Particularly the latter have greatly increased in number during the last twenty years. Although many of these

Jao Camp, a wilderness safari camp in the Okavango Delta in Botswana is a good place to see Wattled Cranes in the company of lechwes (left). The presence of Grey Crowned Cranes, Blue Cranes, and Wattled Cranes has ensured that Wakkerstroom and the surrounding area have become a Mecca for crane enthusiasts from South Africa and beyond.

Samson Phakathi and his speaking crane puppets (a Crowned Crane on the left, a Wattled Crane on the right) are very popular with schoolchildren from around the Balele Mountains near Wakkerstroom in KwaZulu-Natal, South Africa. As part of the South African Crane Working Group's environmental education programme, he takes his mobile stage to village schools, demonstrating the need for crane conservation. He also provides biology lessons on the side.

establishments successfully breed captive cranes and use them to promote conservation, the offspring usually also end up simply being put on public display. There is a case to be made for the argument that these birds, bred in captivity, help undermine the trade with wild cranes, but only if the original parents and birds acquired to regenerate the stock have not been bought from dubious suppliers and legalised with false documents. Breeding endangered cranes to help restore their numbers in nature is a task for which only very specialised institutions are equipped: it involves reducing human contact to a minimum and using professional methods to help the cranes adapt successfully to the wild. There will be more on this topic in the sections dealing with the Siberian Crane and the Whooping Crane.

The Crane Diplomats of Baraboo

This is a rare moment: George Archibald and Jim Harris, sitting on a wall in front of George's farmhouse, surrounded by colourful flowers, are enjoying the late-summer midday sun. The idyll is rounded off by the presence of a young crane that has only

just fledged. Trustingly, the crane approaches the men, while his brother, almost as trusting, prefers to stay a few metres away. The two youngsters, which have already been ringed, hatched from their eggs on a small patch of wetland created by a beaver's dam only about 200 metres from where the men are sitting. It is the third time that a pair of Greater Sandhill Cranes has successfully bred its young here. It must be George's affinity to cranes that prompts the young ones to approach him and collect their ration of worms and grain. Nonetheless, they and their parents will depart for the south in the autumn, and they will be normal wild cranes. While George, who is vice chairman of the board of directors of the International Crane Foundation (ICF), and Jim, its director, are clearly enjoying the fact that the two grey-and-brown birds feel so relaxed in their presence, they are discussing current international crane issues and organisational matters concerning ICF. Although they live near each other in the northern US state of Wisconsin and work in close collaboration, they sometimes do not see each other for months. George has just returned from a lengthy trip to Southeast Asia and

Iran and will soon depart for Africa to take part in a regional conference about cranes, before travelling to various countries to discuss wetland preservation projects at the federal government level. In three weeks, Jim will also embark on a lengthy journey, visiting China to monitor the progress of two projects aimed at protecting cranes, whilst at the same time helping the impoverished rural population. During an extended lunch break, Jim has driven twenty minutes from ICF's headquarters, located on the other side of Baraboo, to George and his wife Kyoko's farm to discuss urgent matters in a relaxed atmosphere.

The two men have known each other for twenty years, and their passion for cranes has cemented a friendship that is mutually beneficial—just as was the case with George, originally from Canada, and Ron Sauey. Graduate students at Cornell University in Ithaca, New York, George and Ron met in the early 1970s while completing their doctoral theses on the subject of cranes. The two students' mutual realisation that most species of cranes were globally threatened by humans, and that very little was known about these birds or the nature of the threat, spurred them to take action. In 1973 George and Ron set up an aviary on the horse ranch belonging to the Sauey family, not far from Baraboo. Thus, the privately funded International Crane Foundation was born. The two young zoologists and crane enthusiasts had a vision that certain cranes should be bred in captivity here, thus creating a gene pool for threatened species; that the foundation should

devise conservation programmes for the wetlands and savannahs on which cranes depend; and that the global public should be alerted to the problems faced by these important birds. Today, ICF summarises its five main tasks as 'education and training', 'research', 'ecosystem protection and restoration', 'captive breeding', and 'reintroduction into the wild'.

Initially, eggs from Eurasian Cranes, obtained from Sweden, as well as those from Sandhill Cranes, were used to develop working methods; both species were not threatened at the time, and they are still not today. The number of aviaries increased, whilst George and Ron, the latter of whom wrote his doctoral thesis on Siberian Cranes wintering in India, made contact with crane enthusiasts around the world. From month to month, the international network continued to grow. And domestically, both in the United States and in Canada, crane preservation was put on the public agenda. The first Regional Crane Workshop was held in the US in 1975, followed by another in Japan in 1980, and an international crane convention, under the auspices of Indian Prime Minister Indira Ghandi, was held in Rajasthan in 1983. The same year, the Crane Foundation, which now had several full-time staff and many voluntary helpers, moved to a new location a few kilometres away and established its headquarters on sixty hectares of land, a compound comprising viewing enclosures and breeding stations. A few months before the next big international crane conference in Qiqihar in northern China, in

January 1987, ICF co-founder Ron Sauey suddenly died, aged thirty-eight—a huge loss to the worldwide community of crane conservationists. Today, the large library on the ICF premises, the construction of which was supported by Sauey's parents, is named after him.

Apart from the library, many other facilities have been built since ICF was founded, including a large number of enclosures and free ranges, research facilities, a visitor centre with theatre and gift shop, an education centre (opened in June 2006) with an exhibition space and gallery, and living quarters for scientists and crane conservationists from around the world. The facility was enlarged to ninety-two hectares to encompass a natural prairie range and wetlands. Today, 120 cranes, representing all fifteen species, live on the ICF compound. The cranes reproduce by natural pairing and breeding, or by means of artificial insemination and incubator breeding. The roughly forty employees working at ICF perform a wide variety of tasks. These include feeding the birds daily, providing them with veterinary attention, caring for and breeding chicks, cleaning and repairing the aviaries, leading tours and supplying information to visitors (from mid-April till the end of October), training conservationists from around

the world, and initiating and supervising national and international protection measures with the help of cutting-edge communications technology.

Jim Harris has been with ICF since 1984. For many years, he served as vice president responsible for the entire foundation programme, but with a special focus on China and Russia. On 1 November 2000 he took over the post of president from George Archibald—a position he held until 2006 when he returned to his former position as vice president. Jim still oversees a number of projects in Russia and China to this day. George, in turn, is a highly gifted speaker and motivator who, as vice chairman of the board of directors, now travels around the country and the world even more than he used to. He promotes conservation measures (both on policy and practical levels), acts as a link for crane conservationists around the globe, and devises convincing strategies to obtain funding and support. And he gives particularly generous financial backers special tours around the hot spots of crane activity. In the time-honoured tradition of American fundraising, ICF has been able to expand thanks to the support of many other foundations, the help of 7000 regular contributors, and 25,000 annual visitors. In the same way, George Archibald's activities as

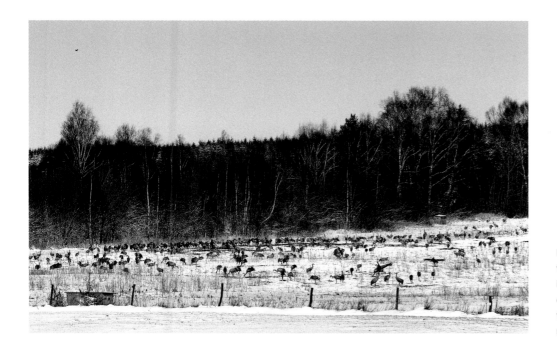

In April, when the cranes arrive at their staging grounds at Lake Hornborga in Sweden, the ground is often still covered in snow, or it may snow while they are there. These hardy birds do not mind as long as they are fed.

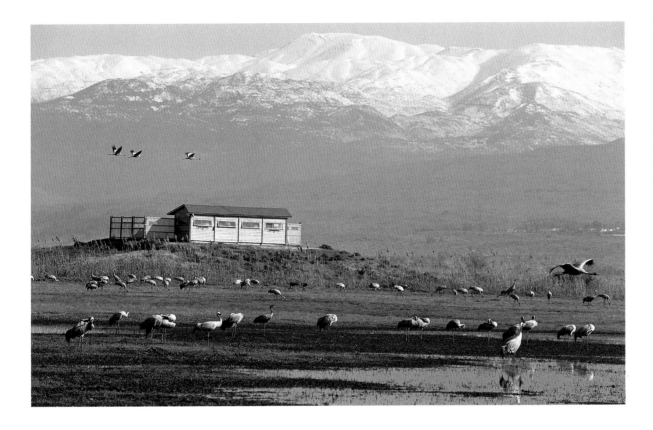

The Hula Valley in northern Israel, framed by the snow-topped Golan Heights, is home to more than 30,000 Eurasian Cranes between November and March. Many remain in the valley for the entire winter, whilst others rest here before flying on to Africa or on their return journey to their breeding grounds. In the 500 hectare Agmon Park, visitors can comfortably observe the cranes from huts.

ambassador on behalf of cranes are also sponsored by a foundation. When he is on his farm, e-mail and internet connects him with hundreds of conservationists—and with ICF headquarters, where Jim is also in touch with an equal number of people around the world.

'World Center for the Study and Preservation of Cranes' is the subtitle of the Centre's quarterly information magazine *The ICF Bugle*. Anyone listening in on George Archibald and Jim Harris's midday discussion would recognise immediately that the magazine's claim is in no way exaggerated: their topics range from Wisconsin to around the world. And the listener would also realise, if only because of Jim's winning laughter, which dots the exchange, how much joy and enthusiasm these two craniacs bring to their vocation. This is true of everyone on their international team, every member of which is an expert in his or her field. Without ICF, we would know a lot less about the fifteen species of cranes. And far fewer people would care about the cranes' lot or be prepared to help them. More

important still: without ICF, it is likely that not even half of the world's estimated 1.5 million cranes would be living in freedom. Because without the initiatives launched in Baraboo, there would be far fewer national and regional Crane Working Groups, whose members are dedicated to the survival of these 'birds of happiness'. These groups cooperate with each another in a variety of ways, reporting, for example, on their activities in regional newsletters (such as *China Crane News,* now in its tenth year).

Networks for Cranes

Of the interest groups from East and West Germany
that joined forces after the fall of the Berlin Wall in
1989, hardly any of them did so as rapidly as nature
conservationists from both sides of the border.
These groups defined their objectives and coordi-
nated their efforts even before political reunification
had become a reality. And, amongst these, the
northern German champions of cranes, situated
between the Elbe and Oder Rivers were the fastest
of all. In early 1990, the German World Wide Fund
for Nature (WWF) in Germany invited the parties
to a conference on the premises of the Duchy of
Lauenburg Foundation ('Stiftung Herzogtum Lauen-
burg') in Mölln, in the German state of Schleswig-
Holstein, not far from the Schaalsee, a lake through
which the impenetrable inner-German border had
run. For the first time ever, members of the Work-
ing Group for the Protection of Endangered Animals
at the Academy of Agricultural Sciences in the
German Democratic Republic met with crane con-
servationists from NABU (the West German Asso-
ciation for Nature Preservation) and WWF represen-
tatives. Free of ideological blinders, they were
able to discuss how best to join their efforts for the
future good of cranes. One year later, Crane Pro-
tection Germany was founded with the financial
backing of NABU, WWF, and the exclusive sponsor-
ship by Lufthansa. Since then, Crane Protection
Germany has represented a synthesis of East-West
know-how that has proved to be very effective.
(Even before the fall of the Wall, eastern Germany
had much larger breeding populations of Eura-
sian Cranes; the main congregating and staging
grounds were also located there, as is the case
even today).

In September of 1995, Crane Protection Germany
opened a Crane Information Centre, which has been
visited by more than 15,000 people a year ever
since (see next chapter). A 'Crane Week', a touring
exhibition of photographs, regular lectures, intensive
public relations activities, and, of course, fieldwork
in breeding and staging grounds have all ensured
that crane protection remains an important topic in
Germany. Every year, meetings are held in different
places during the migratory season; during these

meetings, between 100 and 200 volunteers from Crane Protection Germany share knowledge and experiences, and devise strategies for crane protection and hazard elimination.

This very harmonious merging of conservationists from former East and West Germany would probably not have gone as smoothly had many of the conservationists not already met and learnt to respect one another at conferences organised by the International Crane Foundation. Few East or West Germans were able to attend the far-away conventions held in India and China in 1983 and 1987; however, in between these meetings, in 1985, a European conference held in the Hungarian city of Orosháza, 200 kilometres southeast of Budapest near the Rumanian border, made it possible for a fair number of conservationists from East and West Germany to get to know each other and exchange experiences. For East German, Eastern European, Russian, and Chinese crane researchers and conservationists to be able to meet up with colleagues from the West, the conference needed to be held in a communist country, since experts from the

communist states could not obtain visas to travel to the West. For this reason, the follow-up conference, attended by a large German contingent (both East and West), was held in Tallinn, Estonia in 1989, shortly before the Iron Curtain fell.

When the delegates decided to hold their next conference in the German Democratic Republic, nobody could have known that, within weeks, the political situation would change so dramatically. For the crane conservationists from the former communist states, problems with visas and travel permits within Europe soon became a thing of the past. Nevertheless, following an interim meeting in Orellana la Vieja in Estremadura, Spain in 1994, the next major conference was still held in the eastern German town of Stralsund on the Baltic Sea in 1996—even though doing so was no longer a logistical necessity. The meeting was attended by representatives of the German federal and state governments. Further European conferences, which always included delegates from the far eastern part of Russia, China, Japan, and members of ICF, were held in Verdun and at the Lac du Der-Chante-

Black-necked and Eurasian Cranes wintering at Cao Hai in the Chinese province of Guizhou have grown accustomed to the villagers' pole-steered boats. Boatmen benefit from this very trusting and relaxed relationship with the birds because it allows them to take tourists close to the animals.

Seeing wild Sarus Cranes near temples is not uncommon in Buddha's birthplace of Lumbini in Nepal; a sanctuary has been established quite close to the holy site.

qoc in eastern France in November 2000, near Lake Hornborga in Västergötland, Sweden in April 2003, and in the autumn of 2006 in the Hortobágy National Park in Hungary.

In Europe, more than half a dozen working groups and networks are loosely coordinated within the European Crane Working Group, with its alternating national chairmanship, and the Crane Working Group of Eurasia, with its headquarters in Moscow. In France, for example, more than forty organisations and societies are joined together within the Réseau Grues France. National crane working groups in other parts of the world operate in much the same manner. These groups are usually made up of independent representatives, as well as of delegates from government and private institutions who share a concern for cranes. The North American group holds its North American Crane Workshop every couple of years. In addition, there is the Whooping Crane Conservation Association (WCCA), which has been active on this animal's behalf since 1961. The Northeast Asia Crane Site Network coordinates communications between official organi-

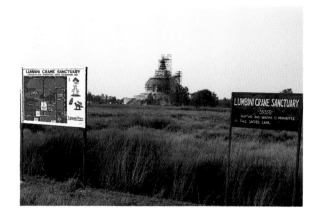

sations and independent crane experts from the Siberian part of Russia, as well as from China, North Korea, South Korea, Mongolia, and Japan. The Indian Crane and Wetlands Working Group focuses on the Sarus Crane and, much like the Southeast Asia Crane Working Group, also on wintering species. The South African Crane Working Group publishes the bi-annual *Crane Link* and exchanges experiences with other African crane conservationists. All of them are involved with the African Cranes,

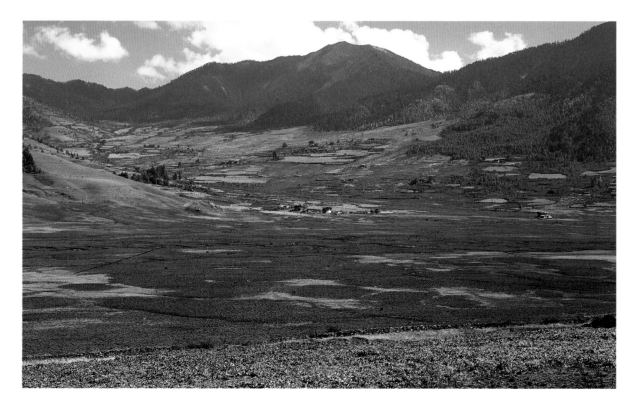

Each year, several hundred Black-necked Cranes spend the winter in the broad valley of Phobjikha in Bhutan. When they arrive from their high-altitude breeding grounds in Tibet in the autumn, or return north in the spring, they fly across the Himalayas.

Wetlands, and Communities Programme spearheaded by the International Crane Foundation and the Endangered Wildlife Trust (EWT), based in South Africa. In Australia there is also a circle of conservationists whose main concern centres on the well-being of Brolgas and Sarus Cranes.

The worldwide community of crane people has grown to such an extent that a global meeting, as in India and China in the 1980s, or even a continent-wide meeting with 100 delegates from twenty-four nations (as was the case with the African Crane and Wetlands Training Workshop near the Okavango Delta, in Maun, Botswana in 1993), is simply no longer feasible. This is why the regional conferences held roughly every three years are so very important. These are hosted by nations on an alternating basis for up to 150 participants. In a variety of proceedings, the many lectures, and thus the most current knowledge about cranes, are summarised. ICF delegates, who take part in, and contribute to, all of these international meetings, have the task of putting the results, experiences, and information exchanges into a global 'crane context'. In this way, the findings and conclusions, but also practical guidelines for dealing with everyday challenges, are made accessible to conservationists around the planet. The information flow is also enhanced by the occasional exchange of members among groups from different countries and continents—often with the aid of the 'crane airline' Lufthansa. Finally, ICF holds many very informative crane seminars for small groups—sometimes over the space of several weeks—in its headquarters in Baraboo.

When Red-crowned Cranes approach or leave their feeding grounds on the northern Japanese island of Hokkaido, they not infrequently pass very low over rooftops and people.

When Hooded and White-naped Cranes congregate at the 'feeding corridor' in Arasaki, visitors can approach to within a few metres without the birds showing any signs of being disturbed.

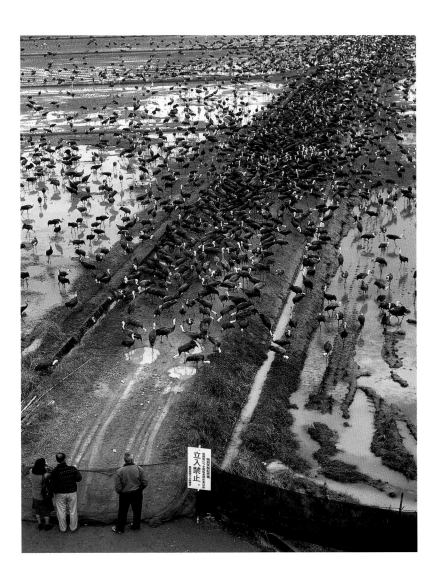

Cranes are a Boost to Tourism

Where cranes gather, humans will come to see them. The large birds are fascinating—not just for bird enthusiasts. The crane conservationists know this, as do tourist authorities, tourism managers, hotel and restaurant owners, and private landlords who rent out rooms. They use the 'birds of happiness' in full-page spreads in newspapers, encouraging people to visit the Baltic Sea coast in the autumn, for example, thus generating off-season business. The 11,000 cranes that perform their dances each April near Lake Hornborga in Sweden are easily outnumbered by the visitors arriving from far afield on a single Saturday or Sunday. There are many other places within Europe where

visitors get their money's worth when it comes to seeing the cranes gather, migrate, stage, or spend the winter. During the last few years, already existing restaurants, hotels, guest houses, and private landlords have responded to their guests' wishes, and some have expanded. New guest houses are opening up with names such as 'Crane Station', 'Crane Hotel', or 'The Resting Crane'.

Worldwide, crane tourism is growing year by year. In the United States, there are annual crane festivals near places where the birds spend a few weeks on a staging ground, or where they spend the winter. Large and well-equipped visitor centres attract crowds with crane exhibitions, as well as with shops and cafeterias run by environmental organisations

or even private entrepreneurs. In Izumi, on the southern Japanese island of Kyushu, there is a crane park near the fields where more than 12,000 Hooded and White-naped Cranes are fed during their winter sojourn. In this park, a huge, modern museum is dedicated solely to the biological and cultural aspects of these amazing creatures. This museum has set the standard for all such facilities—and not just those dealing with cranes. Whether in China, South Africa, India, Nepal, or Israel: people are working everywhere to bring humans and cranes closer together and, in doing so, to engender admiration of the animals and an understanding of their needs. Of course, commercial interests play their part, but as long as the protection of cranes is the main focus, there is no harm in this.

For nature lovers, one of the bonuses of being in a place where cranes congregate is that many other birds, as well as a variety of mammals, can also be seen. Often, the wintering grounds or the wetland staging and feeding areas are shared with flocks of birds that also thrive on water or on mudflats. In their wake, these animals attract birds of prey that encounter a rich bounty in the populations of geese, ducks, and rails. In short: these areas are a paradise for ornithologists.

This book names a number of places where tourists are sure to encounter cranes at certain times of the year, and where they can observe them and, usually, take photographs. In many of the places listed, the birds are fed regularly, which makes it easier to get close to them, but also conveys the wrong impression that they are naturally tame. Many venues also offer information and infrastructure, including extensive exhibitions, sign-posted trails and locations, tips on proper behaviour in crane territory, visitor platforms, photography outposts, and observation towers. Some flocks seem to feel particularly at home in national parks and nature reserves, where information about cranes is often embedded in general information about the locality.

The following list contains only brief descriptions of various locations and can in no way be regarded as comprehensive. A more detailed account would have turned this book into a travel guide. Those interested in cranes will have no trouble in finding their way to the places described here. The main rule when visiting staging and feeding grounds is to respect the birds and nature as a whole. Likewise, the people who live in the different regions listed must be respected. Not everyone in these places

In Florida, some of the Sandhill Cranes that stay all year, such as this pair, are so used to people that they will even approach a boat for food.

RIGHT
The Aransas National Wildlife Refuge in Texas is a vital wintering ground for Whooping Cranes that breed in Canada's Wood Buffalo National Park. In the winter of 2005/2006, more than 200 birds were counted there—the highest number in more than seventy years.

is always happy to see crane tourists. In particular, farmers can get angry and petulant, and rightly so, when strangers simply walk across their fields unannounced, and attempt—against all rules—to approach the cranes. Visiting breeding grounds requires particular caution, since cranes are far more sensitive to disturbances during this time than when they congregate outside the breeding season in staging areas. This is why the present volume does not list nesting areas where cranes raise their young, unless the place in question is a park in which semi-tame birds do not mind the presence of humans.

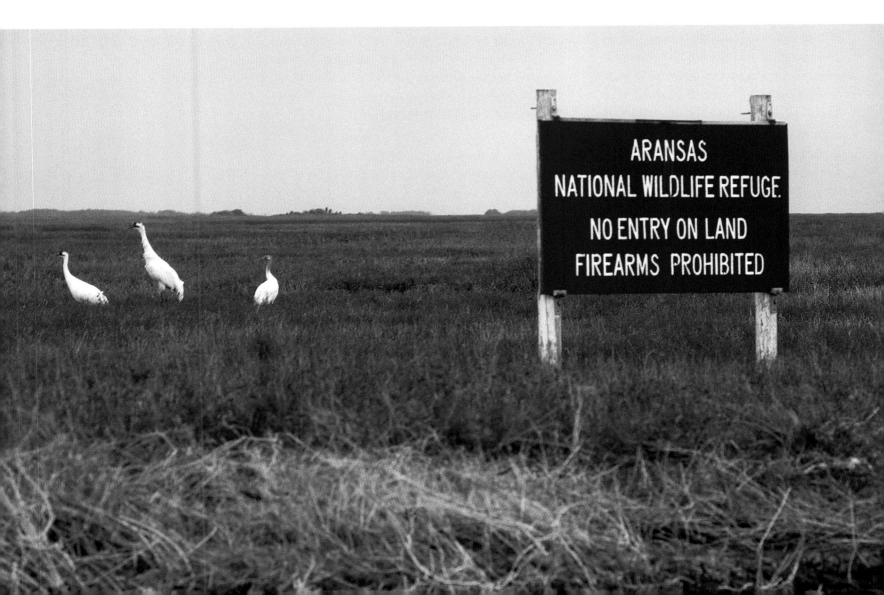

ARANSAS
NATIONAL WILDLIFE REFUGE.
NO ENTRY ON LAND
FIREARMS PROHIBITED

Visitor Destinations

Whether cranes actually come to these places and, if so, in what numbers, depends on the supply of food and whether there are roosting habitats nearby. There may be discrepancies in the periods quoted, depending on weather conditions. These are only rough guidelines.

Germany

(from mid-March till late April, as well as September and October)

1. In and around the West Pomeranian Lagoon Area National Park ('Nationalpark Vorpommersche Boddenlandschaft') in the Rügen-Bock region of Mecklenburg-West Pomerania. During the migratory season, 'crane rangers' lead groups of visitors to the various observation platforms and huts and provide authoritative information. With a ticket called the 'National Park Card—Watching Without Disturbing' ('Nationalpark Card—Beobachten, ohne zu stören'), which can be purchased from the Kur & Tourismus company in Zingst, or from the National Park station at Sundische Wiesen, it is possible to take part in a guided tour to the crane hot spot of Pramort in September (www.zingst.de).

For up to date information, contact the Crane Information Centre (NABU, WWF, Lufthansa) in 18445 Groß Mohrsdorf (Tel. +49 (0) 3 83 23-8 05 40; www.kraniche.de). The CIC has an exhibition and also shows films all year round. The Centre's feeding stations near Günz and Kranich-Utkiek in Hohendorf (Society for the Protection and Preservation of the Crane Grounds in the Rügen-Bock Region) facilitate close access to the cranes, particularly in autumn. Both places are near Groß Mohrdorf, about fourteen kilometres northwest of Stralsund.

2. In and around Müritz National Park ('Müritz-Nationalpark') near Waren in Mecklenburg-West Pomerania. The National Park Service offers a 'Crane Ticket' from September 1st till October 31st for a guided tour in small groups to two roosting habitats that are otherwise inaccessible. The tours start out in Federow and Schwarzenhof (www.nationalpark-service.de).

3. On the Langenhängener Seewiesen near Goldberg, about forty kilometres east of Schwerin in Mecklenburg-West Pomerania. Several thousand cranes sleep here and can be clearly observed from an observation platform (information can be obtained from: Förderverein Langenhägener Seewiesen e.V. in 19399 Langenhagen, Tel. +49 (0) 3 87 36/4 22 59).

4. Near Linum (Brandenburg) about forty kilometres northwest of central Berlin. Germany's largest inland staging and gathering area lies between Kremmen, Linum, Nauen/Rhinluch, and the Havel lakelands area of Luch. Most of the cranes spend the nights near Linum and during the day fly to meadows, pastures, and harvested fields. During the migration period, hundreds of birds can be seen on both sides of the A 24 motorway. Information can be obtained on the internet from the Landschaftsförderverein Oberes Rhinluch e.V. under www.oberes-rhinluch.de, and from the Rhinluch/Brandenburg State Environmental Office ('Landesumweltamt Brandenburg') in 16833 Linum, Tel. +49 (0) 3 39 22/5 05 00.

5. In the foothills of the Harz Mountains in Saxony-Anhalt, Lake Concordia (Concordia-See) near Nachterstedt has become an important staging area. So, too, has the Helme Reservoir (Helmestausee) near Kelbra at the southern edge of the Harz Mountains. October and November are particularly good times for observation.

6. Near the Oldenburger Wall in the district of Horst (Schleswig-Holstein) on the road from Neu-Horst to Lehmrade, six kilometres east of Mölln (heading towards Sterley). From here, as many as 600 cranes can be observed as they approach their roosting grounds. Cranes can also be seen on the Schaalsee, near Techin, sixty kilometres east of Hamburg.

7. In the Diepholzer Moorniederung, a fen in the state of Lower Saxony, about sixty kilometres northwest of Hanover. Diepholz, Sulingen, and Wagenfeld are good starting points for a visit to the observation tower on the east side of the Neustädter Moor and the road through the Rehdener Geestmoor, near Rehden, which the cranes cross on the way to their wetland roosting grounds (information can be obtained from BUND, which supervises the Diepholzer Moorniederung project: 49419 Wagenfeld-Ströhen, Tel. +49 (0) 57 74/3 71).

France

(from mid-October until March; however, during severe winters, the cranes will sometimes migrate further south)

1. At the Lac du Der-Chantecoq near St. Dizier, about eighty kilometres west of Nancy in the Champagne-Ardennes region (information about this large staging ground in eastern France can be obtained from the Ligue pour la Protection des Oiseaux Champagne-Ardenne (LPO) and their website: www.lpochampagne-ardenne.com). The Ferme aux Grues near St.-Rémy-en-Bouzement to the northwest of the lake is, among other places on the embankment, a good viewing point. Cranes can also be spotted forty kilometres southwest of here on the Lac du Temple and Lac d'Orient.

2. The damp lowlands of the Woëvre in the Lorraine comprise another staging ground during the autumn, when cranes coming from Germany rest on their southwesterly journey. Occasionally, the birds stay for several nights on the various large ponds near Billy les Mangiennes.

3. In the Réserve de chasse d'Arjuzanx in Aquitaine, about 100 kilometres south of Bordeaux, ten kilometres east of the Route Nationale 10 near Morcenx. Until 1983 this was an opencast mining district where brown coal was extracted. Each autumn, approximately 90,000 cranes search for food on the harvested maize fields surrounding the 2541 hectare nature reserve, where the cranes sleep on extended waterways. If the winter is mild and food plentiful, tens of thousands of cranes will remain here till spring rather than flying on to Spain. In the southern part of the nature reserve there is an observation tower that crane watchers can climb if they have permission from the *garde nature* in Mont de Marsan (Tel. +33 (0) 55 80/ 8 11 52). Not far away, to the northeast of Arjuzanx, there is the Parc Naturel des Landes de Gascogne. Another special kind of refuge is the military training area near Captieux, also to the northeast of Arjuzanx.

Spain
(from early November till mid-February)

1. Refugio Nacional de la Laguna de Gallocanta in Aragon, 250 kilometres northeast of Madrid, between the towns of Molina and Daroca, near national highway 211. Just after, or before, crossing the Pyrenees in November and February, respectively, large numbers of cranes can be seen resting on the fields surrounding a 1400 hectare saltwater lake near the villages of Bello and Tornos. The birds put in lengthy stops here and sleep on the shallow waters. If the weather is mild, many cranes will winter here.

2. In the Reserva Ornitológica de la Laguna de El Oso, 120 kilometres northwest of Madrid, twenty kilometres north of Avila. In this nature reserve (with an information centre) sponsored by SEO/Birdlife and local and regional authorities, thousands of cranes rest during their journey to the Extremadura.

3. By the Rosarito Dam on the Rio Tiétar near Candeleda, not far from national highway 501, about 180 kilometres west-southwest of Madrid. Cranes rest here during migration, some also staying the whole winter. During the day, the cranes search for food in the old oak mast forests of landed estates, which can only be accessed with the owners' permission, but you can get some good views from the roads as well.

4. In the Extremadura region, some 200 to 350 kilometres southwest of Madrid. This is where most of the northwestern European population of cranes spends the winter. For many years now, ADENEX (Asociatión para la Defensa de la Naturaleza y los Recursos de Extremadura) has been the main crane conservation organisation here. It is supported by Crane Protection Germany. The Spanish section of the German organisation EURONATUR is also active here.
Choosing the best place to observe the cranes depends on where the old oak mast forests are closest to the roads, as well as on the location of harvested maize fields. A good place to start is the Acueducto Gran Ruta hotel and restaurant on national highway 430 near Acedera, seventy kilometres east of Merida, where ADENEX has its offices on the Plaza de Santo Angel 1. The small town of Orellana la Vieja, to the south of Acedera, is also a good starting point. The nearby reservoirs and the areas to the north, especially those along highway 116 (which runs north off the national highway 430 near Obando), also offer plenty of good observation sites. In addition, there is a new crane information centre in this area. The centre is situated on the edge of a large nature park containing ancient cork and holm oaks. Although quite a few kilometres away, the park belongs to the town of Navalvillar de Peda.

Sweden
(mid-March till late April; first half of August till first half of October)

Around Lake Hornborga in Västergötland, about eighty kilometres northwest of Jönköping, on the road between Falköping and Skara. Since about 1970, thousands of visitors have come here every spring and autumn to observe the cranes. Most of the 23,000 Swedish crane pairs stage here for a few days before or after their journey to the breeding grounds in northern Sweden. For decades, the cranes were able to feed on what was left from the harvest on the extensive potato fields. In 1981, after farmers had stopped growing potatoes, the first feeding area was created for the cranes. Today the Lake Hornborga Nature Reserve attracts more than 200,000 visitors annually. Most of them choose the Naturum Trandansen ('Crane Dance Nature Centre') on the south side of the shallow lake as their starting point. This offers a panoramic view of the large flock, although individual birds can also be seen close-up. Photographers can hire little huts right in the middle of the crane territory, in which they have to remain from early morning till after dark. Visitors to the Hornborga

Naturum on the northeastern shore can witness the cranes' arrival at the lake and their departure to the feeding grounds. A growing number of cranes (more than 9000 on some days during the autumn) have their staging grounds at Lake Kvismaren to the northeast of Lake Hornborga. At Lake Tåkern to the west of Mjölby in Östergötland more than 3000 cranes can be observed in September.

Finland
(September till about the middle of October)

Especially along the Gulf of Bothnia on the country's west coast. This is a good place to watch the migrating flocks during September and the first days of October. The cranes sleep on the small islands, or skerries. Time-honoured staging grounds are found to the west of Vaasa and Pori. On clear autumn days, V-shaped flocks of cranes heading for Estonia are an impressive sight when viewed from Hanko on the southern tip of Finland.

Estonia
(mid-September till mid-October)

The nature reserve on Matsalu Bay, near Haapsalu, about 100 kilometres south of the capital, Tallinn, is the destination and staging area for more than 30,000 cranes and an excellent place to watch them, unless there is fog. Once ready to leave Estonia, the cranes choose one of three possible routes south: the Western European route (via the Rügen-Bock region to France and Spain), the Central European route (via Hungary and the Mediterranean to North Africa or Israel); or the Eastern European route (via the Ukraine and Turkey to the Middle East and East Africa).

Hungary
(mid-September till late November)

1. In Hortobágy National Park, west of Debrecen, in eastern Hungary, there are five protected roosting grounds, in which as many as 60,000 cranes stop over during the autumn. During the daytime, as well as during the cranes' morning and evening flights to the grazing grounds, there are plenty of accessible places from which to observe the birds. Information can be obtained from the national park authority in Debrecen, where Zsolt Vegvari is responsible for matters concerning cranes.

2. In Kardoskút Nature Reserve, near the town of Oroshára, about 200 kilometres southeast of Budapest, 10,000 to 20,000 cranes feed on the harvested maize fields surrounding Lake Natron, which extends over 100 hectares. The birds spend the nights on the lake. There is an observation platform from which visitors have a good overview of the feeding and roosting grounds.

Israel
(mid-October till mid-March)

An average of 120,000 people visit the Hula Valley, 170 kilometres north of Tel Aviv, in the winter alone. There, people can watch cranes, along with numerous other birds, as they stop over or winter in the area. Until mid-December, the Hula Valley's Agmon Park is a staging ground for more than 40,000 Eurasian Cranes. Initially these birds feed off the remains of the harvest on the peanut plantations belonging to the regional kibbutzim and farmers located in the valley. Later, the cranes are fed daily rations of maize. Up to 20,000 cranes stay the winter in the Hula Valley, whilst the others fly

on to East Africa. There is a large information centre which provides information about the history and management of Agmon Park, as well as about the nearby 400 hectare Hula Valley Nature Reserve. Sturdy nature trails allow visitors to take a tour near the fields and lakes of Agmon Park, which covers an area of 500 hectares. An observation building affords close-up views of cranes and other birds on the water. An observation wagon, drawn by a tractor straight through the crane habitat, is an ideal platform for photographers. A good base camp is the Pastoral Kfar Blum Hotel near Kefar Blum, which is only a few kilometres to the north of Agmon Park.

Ethiopia
(Eurasian Cranes can be seen from November till February; Black Crowned Cranes and Wattled Cranes are there all year)

1. There are several places in Ethiopia where Eurasian Cranes spend the winter. The most easily accessible are Lake Cheffe, ten kilometres from Debre Zeyit, and Cuba Dam, eight kilometres further on. Debre Zeyit is about fifty kilometres south of Addis Ababa. In total, 10,000 to 15,000 cranes choose these waters as a night-time abode and fly fifty kilometres each day to feed on fields, where they can also be clearly observed. There are a number of hotels in Debre Zeyit.

2. Just under twenty-five kilometres south of Addis Ababa is the Endoda Wetland, near Akaki. On this occasionally flooded plain, several thousand Eurasian Cranes spend their nights, depending on the water level. Visitors can also regularly observe Black Crowned Cranes there.

3. Boyo Wetland, 200 kilometres south of Addis Ababa. This large wetland area, near Fonka and Hosaina (a good place to stay overnight), is a breeding ground of Wattled Cranes and Black Crowned Cranes. Both species can be approached quite closely here, if one does not mind undertaking long treks through high grass and shallow waters. Outside of the breeding season, Wattled Cranes from the Bale Mountains (a national Park 200 kilometres southeast of Boyo) seem to favour this wetland for short periods.

Tanzania
(year round)

The Serengeti National Park and the Ngorongoro Crater are good places to watch Eastern Grey Crowned Cranes.

Botswana
(best from May till December)

A good place to see Wattled Cranes is the Okavango Delta. But to be certain to see these largest of African cranes, it is advisable to book a safari with Wilderness Safaris, though their prices are not terribly low (www.wilderness-safaris.co.za). Nevertheless, the company is to be highly recommended, and many of its camps lie in secluded areas only accessible by light aircraft. You are almost guaranteed to see Wattled Cranes (contact: Zingg Event Travel AG, Florastrasse 56, 8032 Zurich, Tel. +41 (0) 44 70 92 01 0; www.zinggsafaris.com).

South Africa
(Southern Grey Crowned Cranes, Blue Cranes, Wattled Cranes—throughout the year)

1. All three species are at home in KwaZulu-Natal around the Nottingham Road and Mooi River areas, on the N 3 between Durban and Harrismith. The cranes there are watched over by the KwaZulu-Natal Crane Foundation and the South African Crane Working Group (www.kzncrane.co.za). A good place to observe these birds—both in the wild and in aviaries—is the Hlatikulu Crane & Wetland Sanctuary at the foot of the Drakensberg Mountains, around fifty kilometres west of the Mooi River. Several hundred schoolchildren are brought here each year for practical lessons about biology and environmental conservation (Tel. +27 (0) 33 2 63 24 41).

2. Near Wakkerstroom in Mpumalanga, at the foot of the Balele Mountains on the border to KwaZulu-Natal, thirty kilometres east of Volksrust on the R 543. Here there is a crane reservation and an information centre with an adjoining feeding area run by BirdLife South Africa. All three species can be observed around Wakkerstroom—a Mecca for bird-lovers. The South African Crane Foundation is also active here (www.ewt.org.za).

3. Near Dullstroom in Mpumalanga, 200 kilometres east of Pretoria and thirty kilometres north of Belfast. There are plenty of places to stay here, and it is a good place to start exploring the beautiful Steenkampsberg region, beyond the main roads. There is a chance of happening across all three species of cranes, though they are becoming rarer here. The Verloren Valei reserve near Dullstroom is worth a visit. Here, too, the South African Crane Working Group is represented.

4. In Overberg in the Western Cape Province, 100 to 150 kilometres southeast of Cape Town. This is where the Blue Crane is most prevalent. It is impossible to miss them as you look across the fields in the area around Caledon, for example. A good place to stay is the Rouxwil Farm near Villiersdorp (www.rouxwil.co.za/contact.htm).

India
(Demoiselle Cranes, Eurasian Cranes, Sarus Cranes)

1. Gujarat: In this northwestern state, large gatherings of Demoiselle Cranes can sometimes be seen between November and February. The cranes congregate on several reservoirs and river sandbanks south of Rajkot and to the northwest of Ahmadabad. The best time to see these wintering birds is in the early morning, at midday, and in the evening. Since the water levels vary considerably, it is best to explore the area using a large-scale map or to ask the locals.

2. In Khichan in Rajasthan: Every morning between November and February up to 7000 Demoiselle Cranes descend on a little square to be fed. The small town is a few kilometres east of Phalodi and about 130 kilometres northwest of Jodhpur. During the day, the birds gather to drink around a large pond on the outskirts of town. They can also be seen in the desert or on nearby fields.

3. In the Keoladeo National Park in Rajasthan: this nature reserve near Bharatpur, which is known to bird lovers throughout the world, is situated 170 kilometres south of Delhi and fifty-five kilometres west of Agra. At one time, large populations of four crane species used

to winter here: Siberian Cranes from West Siberia, Demoiselle Cranes, Eurasian Cranes, and Sarus Cranes (which also spent the breeding season here). But since the turn of the century, Siberian Cranes have stayed away and the other types are also greatly reduced in number. Nevertheless, it is still worth a visit, especially between November and early March, when visitors are certain to see a few Sarus Cranes.

Nepal

In Lumbini in the southwest of the country near Bhairahawa on the Indian border, a good 250 kilometres west-southwest of Kathmandu. If visitors wish to see the Sarus Cranes in what is regarded as Buddha's birthplace, it is best to contact Rajendra Suwal, the project manager of the Lumbini Crane Sanctuary (e-mail: cranesnp@ccsl.com.np).

Bhutan

Between 300 and 400 Black-necked Cranes winter each year in the Phobjikha Valley, east of Punakha, in the western part of Central Bhutan. Since it is only possible to travel with a guide whilst in this country, it is probably a good idea to ask him to arrange for sleeping quarters in one of the farm guesthouses in the beautiful, wide Himalaya Valley. The guide will also help in getting a permit from the environmental department in Thimphu, which is required to visit the observation facility near the cranes' roosting grounds.

China

This is a very important country for cranes. China can boast eight species, of which six still breed there today. Suffice it to mention five areas: the Zhalong Nature Reserve, west of Qiqihar, in the northeastern Chinese and northern Manchurian province of Heilongjiang (breeding birds: Red-crowned and White-naped Cranes; visiting migratory birds: Eurasian and Siberian Cranes); the Xianghai Nature Reserve near Tongyu in the northeastern Chinese and southern Manchurian province of Jilin (breeding birds: Red-crowned, White-naped, and Demoiselle Cranes; visiting migratory birds: Eurasian, Hooded, and Siberian Cranes); Poyang Lake Nature Reserve near Wucheng, in the southeastern Chinese province of Jiangxi (main wintering area of Siberian Cranes from Yakutia; also wintering from November till February/March: Eurasian, Hooded, and White-naped Cranes); Cao Hai Nature Reserve near Weining, in the southwestern Chinese province Guizhou (wintering Black-necked and Eurasian Cranes, from October till the beginning of April; especially the Black-necked Cranes can be quite close to humans); Huize and Dashanbao are two lakes in the southwestern Chinese province of Yunnan, where Black-necked Cranes and Eurasian Cranes also congregate in the winter. Travel to the Chinese nature reserves and other places is possible only with a permit from the local provincial authorities; it takes time, and the trips should be well planned. Some reserves are the responsibility of the forestry department; in other cases the environmental department is in charge, and sometimes the jurisdictions vary.

Japan

1. On Hokkaido, the most northerly of the four main islands, more than 1000 Red-crowned Cranes live all year round. From early in the year until autumn, visitors can sometimes even observe breeding pairs from roads in the east of the island. But the main attraction, for the birds as well as for many visitors, is the snow-covered feeding grounds, where the Red-crowned Cranes regularly gather between November and February.
In Akan, about 100 kilometres northwest of the port of Kushiro, many birds (sometimes more than a hundred) descend on a single three hectare field. Here there is also a large information centre dedicated to Red-crowned Cranes, and visitors can find out where else to go to watch them. Visitors planning a trip to Kushiro can either take a plane or a ferry from Tokyo.

2. Arasaki, near Izumi, in the Kagoshima district of Kyushu, the main southern island, is the focal point for thousands of wintering Hooded Cranes and White-naped Cranes—as well as a few Demoiselle Cranes, Eurasian Cranes, Sandhill Cranes, and a Siberian Crane that occasionally arrive here by joining the migrating flocks of the first two species. Before seeing Izumi with your own eyes, it is hard to believe how close you can approach the flocks of cranes, and vice versa. Stay overnight in Izumi, or in the small guesthouse belonging to the main warden in Arasaki. You can get to Izumi by train, via Fuokoka, or fly to Kagoshima and take a bus from there. The taxi ride from Izumi to Arasaki takes ten minutes. The Crane Park with its large, modern Crane Museum on the outskirts of Izumi is definitely worth a visit.

Russia

This is another country highly frequented by cranes, but only two locations are to be highlighted here:

1. Muraviovka Park in the eastern Siberian Tambovka district (Amur Oblast), 650 kilometres west of Khabarovsk and sixty kilometres to the south of Blagoveshchensk. The park is ideally suited for observing Red-crowned and White-naped Cranes during the breeding season, as well as Hooded and Eurasian Cranes during the migration period. This 5000 hectare nature reserve, which was established in 1994 by the Russian biologist Sergei Smirenski with the help of Japanese sponsors and the International Crane Foundation has been leased from the government for a period of fifty years, and is also used to host meetings of Russian, Chinese, and US conservationist groups. There is also a facility for students to stay, including Russian orphans, who are brought here on holiday to learn about nature and ecological farming.
The accommodations are very basic.
Visitors are welcome from May till September.
Contact person: Elena Smirenski (e-mail: elena@savingcranes.org).

2. The Oka Biosphere State Nature Reserve, near Moscow, with its breeding and rearing facilities for cranes.

United States

North America has very many locations and reserves where cranes can be watched. Only a few are listed here, which either have particularly large populations of cranes or offer excellent access to them.

1. The International Crane Foundation (ICF) near Baraboo, about fifty kilometres from Madison, Wisconsin. This is the world's leading international crane information centre, and all fifteen species of the bird can be seen hilst touring the compound, which is set up like a zoo. But ICF also has much more to offer. In the research library, visitors can find just about everything that has ever been written about cranes. From early in the year until autumn, plenty of Greater Sandhill Cranes congregate in the vicinity of the ICF Centre. During the winter, the Centre is closed to visitors (address: E 11376 Shady Lane Road, P.O. Box 447, Baraboo, WI 53913-0447, USA, www.savingcranes.org).

2. The Platte River along Interstate Highway 80, between Grand Island and Kearney, Nebraska. Between late February and early April this is a great place to see tens of thousands of Sandhill Cranes. With a little luck, Whooping Cranes can be spotted here in early April, too. The Crane Meadows Nature Center is near Exit 305, and Exit 285 must be taken to reach the Rowe Sanctuary & the Iain Nicolson Audubon Center on Elm Island Road, which is six kilometres from the highway exit. Both of these information centres provide up to date information on the world's largest crane staging area; in the Audubon Center, visitors can also book a blind cabin located next to the cranes' roosting grounds. A visit to the Platte River Whooping Crane Maintenance Trust Center, near the Crane Meadows Nature Center, is also recommended. The trust is dedicated to the conservation of the staging grounds and, in particular, the water supply for the Platte River (www.whoopingcrane.org).

3. The Necedah National Wildlife Refuge, near the small town of Necedah, about 120 kilometres northwest of Baraboo, Wisconsin. From spring until autumn, this refuge is an excellent place to observe Sandhill Cranes and also, increasingly, Whooping Cranes. The information centre is located directly inside the refuge, and there are observation towers and other places that offer good views of the cranes. In the autumn, visitors can watch Whooping Cranes following ultra-light planes on the birds' training flights.

4. The Aransas National Wildlife Refuge near Rockport, north of Corpus Christi, on the Texas coastline of the Gulf of Mexico, is the wintering ground of Whooping Cranes that breed in Canada. A good time to see them is mid-November till early April, and viewing them from tour boats is particularly recommended.

5. The Bosque del Apache National Wildlife Refuge near Socorro in New Mexico, about 130 kilometres south of Albuquerque, is a good place to see tens of thousands of Greater Sandhill Cranes, as well as many other types of birds.

6. Visitors to central Florida who take the turn off US Highway 441 at Kenansville, following the US 523, also via smaller roads, have good chances of spotting Florida Sandhill Cranes (a subspecies of Sandhill). They may also see some Whooping Cranes that have been reintroduced to the area.

Bibliography

Berg, B.: *Mit den Zugvögeln nach Afrika*, Berlin 1924.

Blahy, B.: *Das Lächeln des Kranichs. Ein Tagebuch*, Berlin 2004.

Britton, D. and T. Hayashida: *The Japanese Crane. Bird of Happiness*, Tokio, New York & San Francisco 1981.

Deutsche Lufthansa AG (ed.): *Wenn der Kranich zieht. Eine kleine Kulturgeschichte*, Cologne and Frankfurt/Main 1987.

Doughty, R. W.: *Return of the Whooping Crane*, Austin 1989.

Forsberg, M.: *On Ancient Wings. The Sandhill Cranes of North America*, Lincoln 2004.

Grooms, St.: *The Cry of the Sandhill Crane*, Minocqua 1992.

Hachfeld, B.: *Der Kranich. Ein Lebensbild*, Hannover 1989.

Hase, D.: *Herbstrast der Kraniche*, Linum 2004.

Hayashida, T.: *Cranes of Japan*, Heibonsha (Japan), 2002.

Johnsgard, P. A.: *Cranes of the World*, London & Canberra 1983.

Johnsgard, P. A.: *Crane Music. A Natural History of American Cranes*, Lincoln & London 1998.

Klosowscy, G. and T.: *Zuraw. Ptak Nadziei (Crane. The Bird Of Hope)* Wydawnicza 2000.

Leopold, A., and C. Meine: *Marshland Elegy*, Madison 1999.

Lundin, G. (ed.): *Cranes – where, when and why?*, Falköping 2005.

Matthiessen, P.: *The Birds of Heaven. Travels with Cranes*, New York 2001.

Meine, C. D., and G. W. Archibald (eds.): *The Cranes. Status Survey and Conservation Action Plan*, Gland and Cambridge 1996.

Mewes, W., G. Nowald and H. Prange, *Kraniche. Mythen, Forschung, Fakten*, Karlsruhe 2003.

Munier, V. and Z. Bianu: *Tancho*, Buxières-lès-Villiers 2004.

Nowald, G., and H. Dirks: *Kranichbegegnungen, Kranichwelten*, Düsseldorf 2006.

Prange, H. (ed.): *Crane Research and Protection in Europe*, Halle-Wittenberg 1995.

Prange, H. (ed.): *Der Graue Kranich*, Wittenberg Lutherstadt 1989.

Pratt, J.: *The Whooping Crane. North America's Symbol of Conservation*, Sierra Vista 1996.

Price, A. L.: *Cranes. The Noblest Flyers in Natural History and Cultural Lore*, Albuquerque 2001.

Reich, J.: *Ein Kranichjahr in Mecklenburg-Vorpommern*, Rostock 2004.

Rolfes, W., and H. Elsner: *Unterwegs im Land der Kraniche*, Steinfurt 2006.

Traneving, S. and B.: *Vårens Budbärare Tranan*, Falköping 2002.

Treuenfels, C.-A. v.: *Kraniche. Vögel des Glücks*, Hamburg 1998.

Walkinshaw, L.: *Cranes of the World*, New York 1973.

Weßling, B.: *Kranichgedanken*, Weikersheim 2000.

Wu, C.: *A Thousand Cranes*, Taipeh 2002.

Wu, C.: *The Propitious Crane*, Taipei 2003.

A Thank You to Cranes and People

Cranes play the leading role in this book. Without their unwitting support of my photographic work, this project would never have become a reality. So I am particularly indebted to all the cranes I have pursued and lain in wait for with my camera over the past decades. Apart from providing me with countless photographs, these fascinating birds have also allowed me to see and experience many wonderful moments. But I am also deeply grateful to the many people who have supported my work for this book and without whose advice and help *The Magic of Cranes* would not have been published. At the risk of inadvertently omitting someone from the following list, I would nevertheless like to name a number of people who have assisted me, be it in practical matters, or by sharing knowledge and supplying contacts, or during my travels, or by their correspondence and providing me with information.

This time I would like to begin by mentioning Lutz Laemmerhold, who accompanied this project on behalf of the 'Crane Airline' Lufthansa right from the start—always open-minded and willing to lend his support. Without the three big L's, I would not have been able to present this book—certainly not in this comprehensive way. Thanks also to Herneid and Dr. Rosemarie von dem Knesebeck of the Knesebeck publishing house, who were enthusiastic from the start and supported me with much personal commitment. I wish to thank Dr. Christina Kotte and Veronika Straaß for their dedication and knowledgeable help as editors. Thanks also to everyone else at Knesebeck who was involved in the project, and for their patience in dealing with the author when he had trouble meeting deadlines. Here, also, I would like to thank Manuela Stadter, who created the map. It was a particular pleasure to work with Saskia Kruse, whose creativity ensured that the layout was befitting of such beautiful creatures as cranes. I would also like to express my gratitude to Matthew Gaskins for his engaging English translation of the book.

When it comes to thanking the crane experts and conservationists, I would like to begin close to home: since my youth, Thomas Neumann and I have had a friendship cemented by a passion for cranes. I have learned a great deal from him thanks to his great practical experience in matters of nature, specifically his knowledge of crane conservation. Also, for decades, Walter Schmitz has been caring for the crane pairs that breed in his woods, to which he granted me access with my camera. I also wish to name Dr. Wolfgang Mewes, Dr. Günter Nowald, Professor Hartwig Prange from the steering committee of Crane Protection Germany (Kranichschutz Deutschland) as well as Ekkehard Hinke. May the thanks extend to all members and supporters of this organisation, which has consistently been a source of valuable information. I have always enjoyed my many visits to Dr. Eberhard Henne, Beate Blahy, Klaus and Gisela Uhl and 'their' cranes. I am grateful to Jens-Uwe Heins, whose experience in making films about cranes gave me valuable insights. Anja Kluge, Thomas Fichtner, and Ehrhardt Hohl have also always gladly helped me with my research. Professor Alain Salvi in France, and the brothers and professors Javier and Juan Carlos Alonso in Spain have often been of great assistance to me.

Within the International Crane Foundation (ICF), I would like to extend my profound thanks not only to Dr. George Archibald, Jim Harris, and Dr. Richard Beilfuss, but also to Betsy Didrickson, the head librarian, who not only supplied me with a great deal of material, but also put together a wonderful selection of stamps. I am also indebted to Betsy and Jim for their expert review of the individual chapters of this book. Dr. Felipe Chavez-Ramirez from the Platte River Trust enabled me to spend many hours in crane observation huts near the Sandhill Cranes. Marty Folk, Tom Stehn, and, before this, David Blankenship brought me closer to the Whooping Cranes at Aransas and in Florida. Darrell and Bettye Leidigh were generous hosts and helped me and my wife, who is also a great crane enthusiast, get very close to some Florida Sandhill Cranes.

In Canada, I was able to accompany Ernie Kuyt and Rod Drewien to the Whooping Cranes.

In Russia, too, I was afforded the support of many guides and helpers. I would particularly like to thank Natascha Tsarkova-Kapphahn, Dr. Konstantin Mikhailov, Boris and Yuri Shibnev, Dr. Yuri Darman, Viktor Nikiforov, Dr. Nilolai Germogenov, Dr. Vasiliy Alekseev, Nikolai Egorov, and Sergei Sleptov. Without them and others, my expeditions to the Amur, Ussuri, and Bikin Rivers, as well as to Yakutia, would have been fruitless.

In China, I particularly remember Hong Shou Li and Dr. Li Fengshan; among other crane enthusiasts in Japan, my work was especially supported by Kunikazu and Yulia Momose, Kiyoaki Ozaki, Satoshi Nishida, and Sueharu Matano.

In India, Shahid Ali, Ravi Singh, and Gopi Sundar gave me valuable support; in Nepal, Rajendra Suwal accompanied me to the Sarus Cranes of Lumbini. And in Israel, I was very happy that Dr. Yossi Leshem, Dan Alon, and Yifat Davidson allowed me to access the areas inhabited by cranes.

Finally, in Africa, I was very much supported by Dr. Markus Borner in the Serengeti and by Yilma Dellelegn Abebe in Ethiopia. Warwick and Michèle Tarboton, Vicki Hudson, Katherine Leitch, Glenn Ramke, Kevin McCann, Brent Coverdale, Mick Dalton, Wicus Leeuwner, and Nic Shaw devoted a lot of their time to take me to the crane habitats.

My friends Christian Ratjen and Wolfgang Weber were great companions during several crane excursions. Many thanks, as well, to Monika Holl from WWF, who for more than fifteen years has given me exceptional help in matters of correspondence and computer support.

Last, but definitely not least, a thank you to someone very special: my wife Gogi, who has not only accompanied me on many of my travels to the cranes, but also witnessed (and suffered through) the process of my writing this and other books. For this, too, I thank her from the bottom of my heart.

Carl-Albrecht von Treuenfels

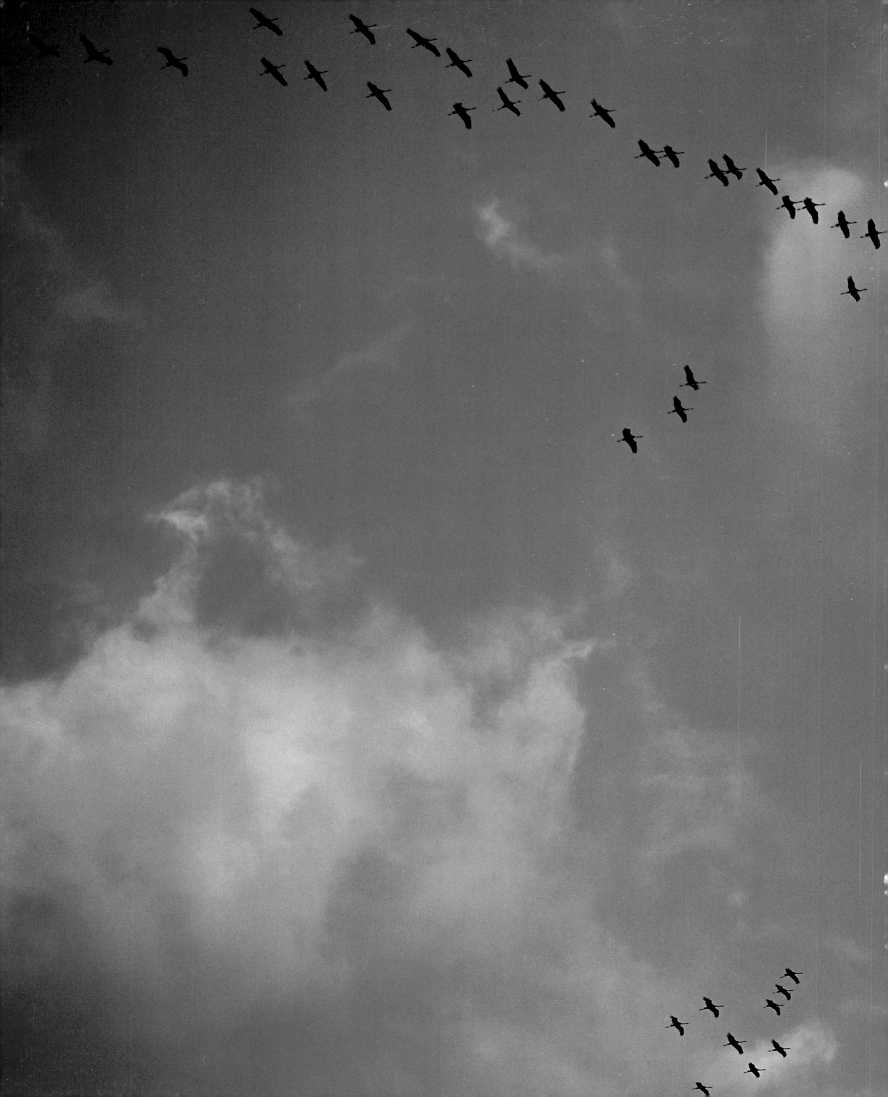